Seeing and Consciousness

Seeing and Consciousness

Women, Class and Representation

Gen Doy

BERG

Oxford/Washington D.C., USA

First published in 1995 by
Berg Publishers Ltd
Editorial offices:
150 Cowley Road, Oxford, OX4 1JJ, UK
13590 Park Center Road, Herndon, VA22071, USA

© Gen Doy

Library of Congress Cataloging-in-Publication Data
A catalogue record for this book is available from the Library of Congress.

British Library Cataloguing in Publication Data
A catalogue record for this book is available from the British Library.

Front cover photograph: with kind permission of Agnews, London.

ISBN 0 85496 960 8 (Cloth)
1 85973 017 5 (Paper)

Printed in the United Kingdom by WBC Bookbinders, Bridgend, Mid
Glamorgan.

Contents

Acknowledgements

I would like to thank all those who helped me in the preparation of this book, whether with academic advice and suggestions or with co-operation in tracing owners of works for permission to reproduce illustrations. Every effort has been made to do this, though I was not always successful. If there are any serious omissions in this regard, I would be happy to rectify them, as this is my responsibility, not that of Berg Publishers. Specifically I would like to thank, in no particular order, Liz McGrath and Avinash Puri, Gill Perry, Marsha Meskimmon, Ryzard Gagola of the Ikon Gallery Birmingham; David King, London; the Museum of Modern Art, Oxford; Wendy Leeks (especially for her thoughts on Courbet's *Sleepers*); Marie-Cécile Miessner, Bibliothèque Nationale, Paris; Roshini Kempadoo; Catherine Cooke; Matthew Cobb and Christina Purcell; Franz Baumgartner, Karlsruhe; Chris Boylan; Adrian Lewis (for lending me his books and for being a kind and considerate colleague); the Inter-Library Loan Service at De Montfort University Library; Judith Smith; Pat Kirkham; Pam Birley; John Roberts (for first inviting me to write on Cindy Sherman's work); Metro Pictures, New York; Leicester Museum and Art Gallery, especially Julia Collieu and Amanda Waddesley; Camille Dorney, Panchayat; the Society for Co-operation in Russian and Soviet Studies, London; Martin Richards; Roger Bradley, Picture House, Leicester; Berg Publishers; Abish Eftekhari; Mark Sandle, for translating some Russian for me; Stephen White, Institute of Soviet and East European Studies, University of Glasgow; Helen Weston, University College, London; Philippe Bordes; Musée de la Révolution Française, Vizille, France; Autograph, London; the Russian Museum, St Petersburg; and the late Dave Hughes. I would also especially like to thank Stephen Knight of the Research Committee at De Montfort University for facilitating a grant to help with the cost of illustrations, travel and typing the manuscript onto disk. Allan Love and John Mackintosh helped me with technical and photographic assistance. I am also indebted to my seminar students on my *Women and the Visual Arts* course for helpful discussions on many of the issues raised in this book. My thanks are due to my mother and father for their encouragement throughout my academic career and their support of my interest in art history. Unfortunately my father died before this book was completed but I thought of him often when I was writing. Last of all I want to thank my sons Sean and Davey for being so patient and (relatively) quiet while I wrote this book. It is dedicated to them with love and optimism for their future.

Gen Doy

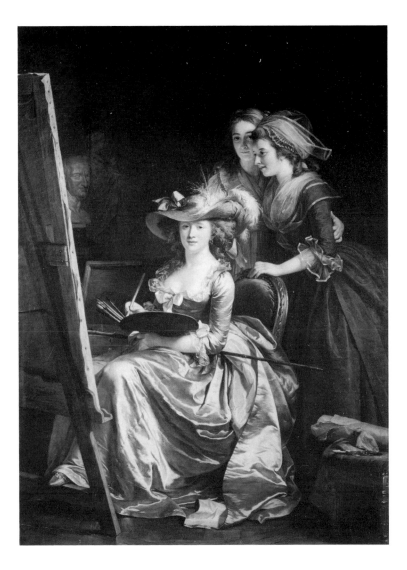

Plate 1 Labille-Guiard, *Portrait of Madame Labille-Guiard and her pupils*, oil on canvas, 210 x 152 cm, 1785, Metropolitan Museum of Art, New York. Photo courtesy Metropolitan Museum.

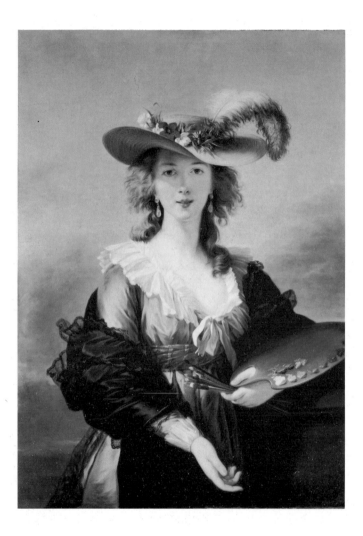

Plate 2 Vigée-Lebrun, *Self-Portrait in a Straw Hat,* oil on canvas, 97.8 x 70.5 cm, 1783, National Gallery, London. Photo courtesy National Gallery.

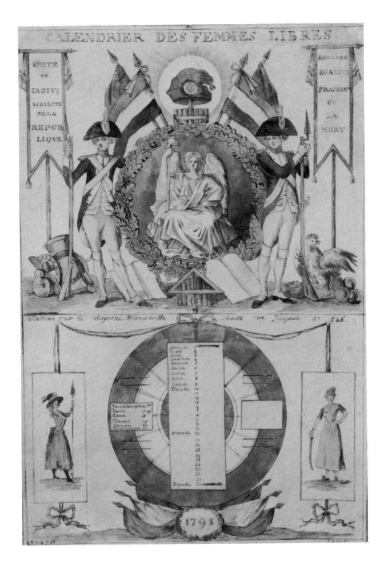

Plate 3 M. Chatté, *Calendrier des femmes libres (Free Women's Calendar)*, drawing and water-colour, 35.5. x 24.5 cm, dated 1795, Musée Carnavalet, Paris.

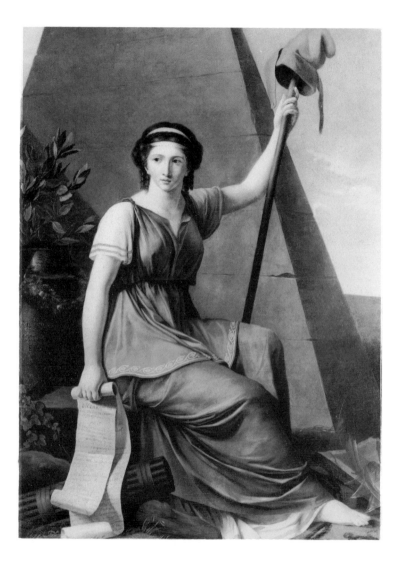

Plate 4 Nanine Vallain, *Liberty*, oil on canvas, 128 x 97 cm, 1793-4 (after restoration), Musée de la Révolution Française, Vizille. Photo courtesy of the museum.

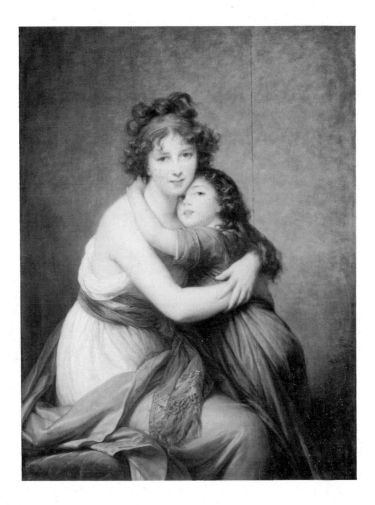

Plate 5 Vigée-Lebrun, *Self-portrait with her Daughter Julie*, oil on panel, 130 x 94 cm, 1788, Louvre, Paris. Photo Réunion des Musées Nationaux.

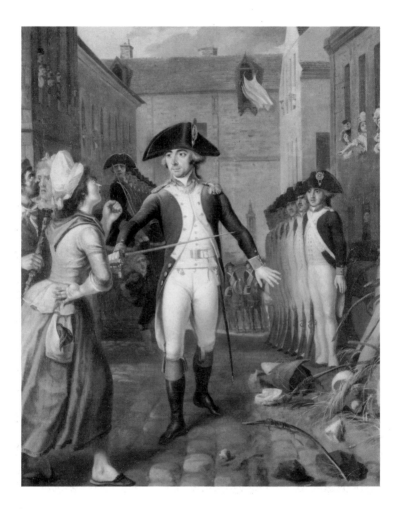

Plate 6 Bézard (or Bézart), *National Guardsmen Opposing Popular Food Requisitions*, oil on canvas, 99.5 x 80 cm, 1792, Musée de la Révolution Française, Vizille. Photo courtesy of the Museum.

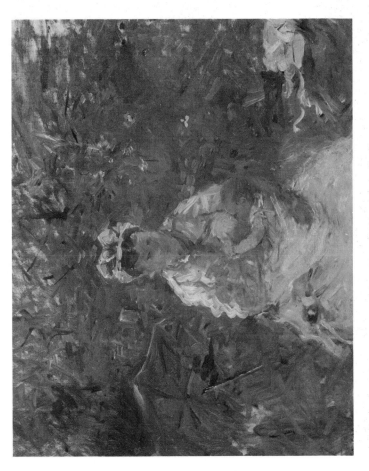

Plate 7 Morisot, *Wet Nurse and Julie*, oil on canvas, 50.2 x 61 cm, 1879 or 1880, private collection.

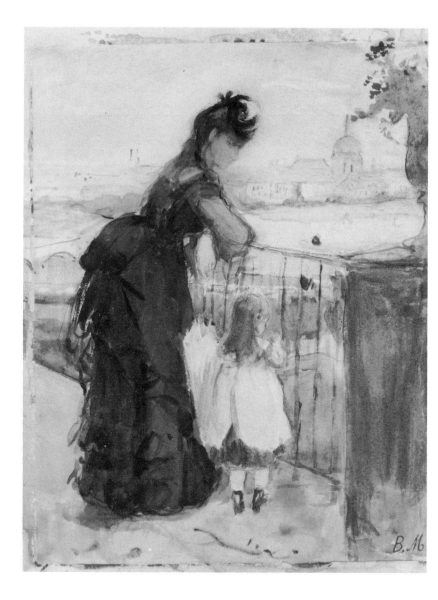

Plate 8 Morisot, *On the Balcony*, water-colour over graphite on paper, 20.6 x 17.5 cm, 1872, Art Institute, Chicago, gift in memory of Charles Netcher II. Photo courtesy the Art Institute of Chicago.

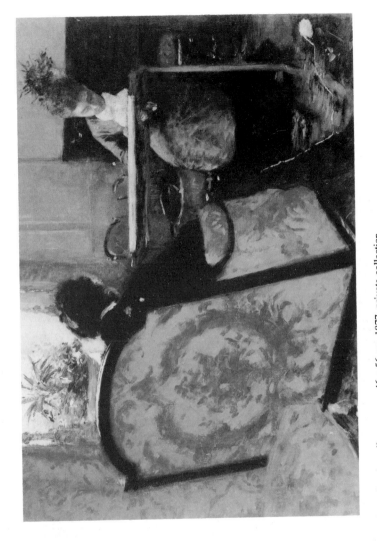

Plate 9 Caillebotte, *Portraits in an Interior*, oil on canvas, 46 x 56 cm, 1877, private collection.

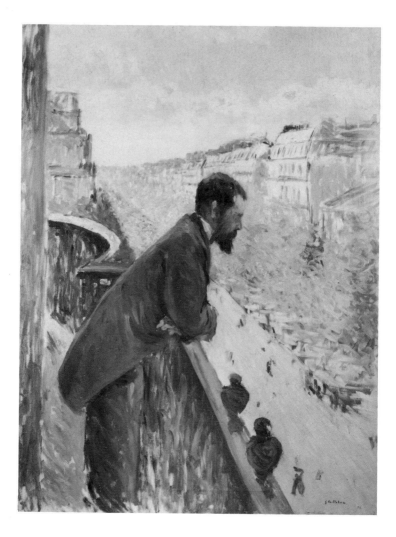

Plate 10 Caillebotte, *Man on the Balcony*, oil on canvas, 116 x 90 cm, later 1870s, private collection. Photo courtesy Brame and Lorenceau, Paris.

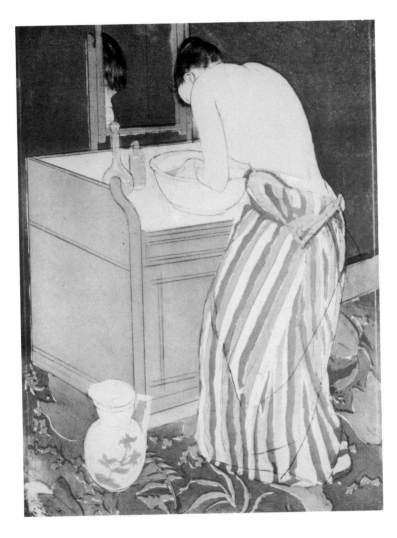

Plate 11 Cassatt, *Woman Bathing*, colour print with drypoint and soft-ground, 36.3 x 26.5 cm, 5th and final state, Bibliothèque Nationale, Paris. Photo courtesy Bibliothèque Nationale.

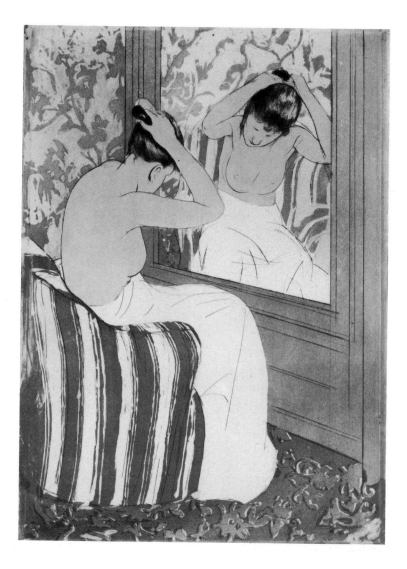

Plate 12 Cassatt, *The Coiffure*, colour print with drypoint and soft-ground, 36.7 x 26.7 cm, 4th and final state, Bibliothèque Nationale, Paris. Photo courtesy Bibliothèque Nationale.

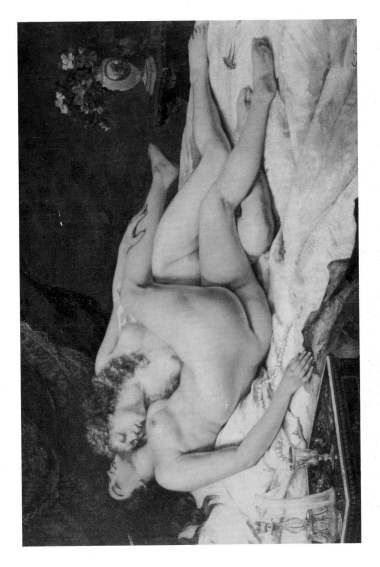

Plate 13 Courbet, *Sleep* (or *The Sleepers*), oil on canvas, 135 x 200 cm, 1866, Petit Palais, Paris.

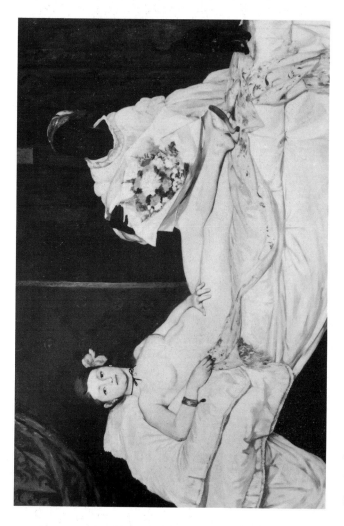

Plate 14 Manet, *Olympia*, oil on canvas, 130.5 x 190 cm, 1863, Musée d'Orsay, Paris. Photo Réunion des Musées Nationaux.

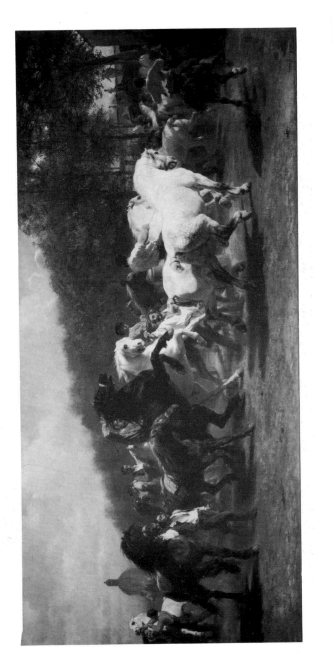

Plate 15 R. Bonheur and N. Micas, *The Horse Fair*, oil on canvas, 120 x 254 cm, 1855, National Gallery, London. Photo courtesy of the National Gallery.

Plate 16 Anon, *Stereoscopic photograph of a Woman*, 1850s, Bibliothèque Nationale, Paris. Photo courtesy of the Bibliothèque Nationale.

DAGUERRÉOTYPIE-PHOTOGRAPHIE

POPULATION OUVRIÈRE EN 1860

ARRONDISSEMENTS	NOMBRE des fabricants employant — plus de 10 ouvriers	de 2 à 10 ouvriers	1 ouvrier ou travaillant seuls	Total	IMPORTANCE des affaires	LOYERS	OUVRIERS SÉDENTAIRES — Hommes travaillant à l'atelier	Hommes en chambre	Hommes Total	Femmes travaillant à l'atelier	Femmes en chambre	Femmes Total	Enfants au-dessous de 16 ans — garçons	filles	Total	TOTAL des ouvriers sédentaires	Ouvriers mobiles (résidant momentanément à Paris)	NOMBRE total des ouvriers	Nombre des apprentis déjà compris dans les chiffres précédents	HOMMES payés à la journée	HOMMES payés à la pièce	FEMMES payées à la journée	FEMMES payées à la pièce
1ᵉʳ	3	13	24	40	1 195 300	57 450	61	10	71	6	*	6	1	*	1	78	*	78	1	41	30	2	4
2ᵉ	5	14	21	40	2 094 000	128 030	117	*	117	19	*	19	3	*	3	139	*	139	3	75	42	9	10
3ᵉ	1	7	16	24	559 000	27 025	31	2	33	4	3	7	2	*	2	42	*	42	2	19	14	4	3
4ᵉ	–	2	12	14	70 000	8 410	6	*	6	2	*	2	*	*	*	8	*	8	*	6	*	2	*
5ᵉ	–	1	4	5	34 000	2 355	3	*	3	4	*	4	*	*	*	7	*	7	*	3	*	*	4
6ᵉ	2	3	9	14	540 960	22 040	56	2	58	5	12	17	*	*	*	75	*	75	*	36	22	5	12
7ᵉ	–	1	5	6	123 500	4 450	3	*	3	5	*	5	2	*	2	10	*	10	2	3	*	5	*
8ᵉ	–	1	5	6	132 000	11 200	14	*	14	*	*	*	*	*	*	14	*	14	*	14	*	*	*
9ᵉ	3	11	7	21	1 244 000	48 750	118	1	119	*	*	*	5	*	5	124	*	124	5	86	33	*	*
10ᵉ	1	3	13	17	288 400	20 715	18	*	18	30	*	30	*	*	*	48	*	48	*	14	4	8	22
11ᵉ	–	2	3	5	147 000	4 850	8	5	13	2	*	2	*	*	*	15	*	15	*	8	5	2	*
12ᵉ	–	1	1	2	11 350	1 200	*	*	*	*	*	*	*	*	*	*	*	*	*	*	*	*	*
13ᵉ	–	–	1	1	6 000	300	*	*	*	*	*	*	*	*	*	*	*	*	*	*	*	*	*
14ᵉ	–	–	2	2	12 500	900	*	*	*	*	*	*	*	*	*	*	*	*	*	*	*	*	*
15ᵉ	–	–	2	2	10 000	750	1	*	1	*	*	*	*	*	*	1	*	1	*	1	*	*	*
16ᵉ	–	–	4	4	*	*	*	*	*	*	*	*	*	*	*	*	*	*	*	*	*	*	*
17ᵉ	–	–	2	2	18 500	1 470	5	*	5	*	*	*	*	*	*	5	*	5	*	5	*	*	*
18ᵉ	–	–	–	–	48 000	1 200	*	*	*	*	*	*	*	*	*	*	*	*	*	*	*	*	*
19ᵉ	–	–	1	1	10 000	600	*	*	*	*	*	*	*	*	*	*	*	*	*	*	*	*	*
20ᵉ	–	–	–	–	2 900	250	*	*	*	*	*	*	*	*	*	*	*	*	*	*	*	*	*
Totaux	**16**	**58**	**133**	**207**	**6 547 410**	**341 945**	**411**	**20**	**461**	**77**	**15**	**92**	**13**	*****	**13**	**566**	*****	**566**	**13**	**311**	**150**	**37**	**55**

Plate 17 *Table of Workers Employed in the Photographic Industry in Paris in 1860, from Rouillé,* La Photographie en France.

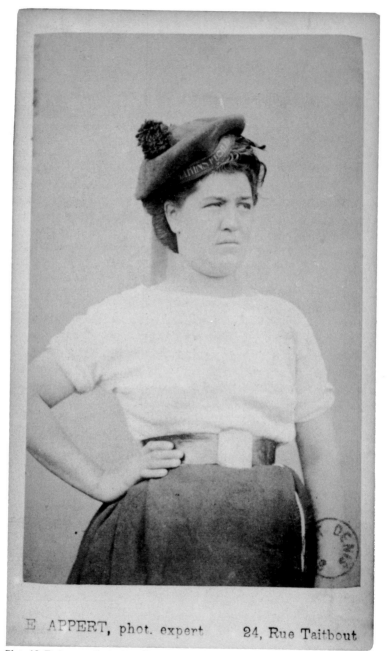

E APPERT, phot. expert 24, Rue Taitbout

Plate 18 E. Appert, *Carte de Visite Photograph of Clara Fournier*, 1871, Bibliothèque Municipale de Saint Denis.

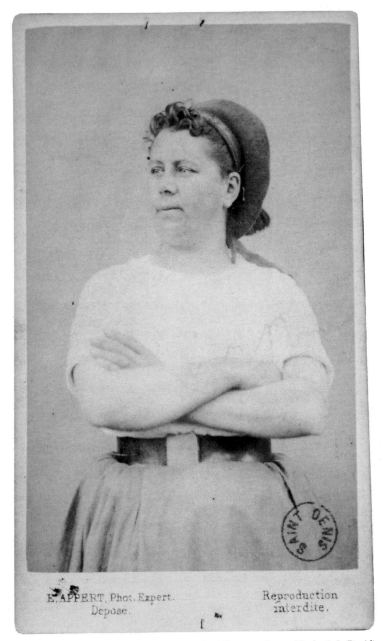

Plate 19 E. Appert, *Carte de Visite Photograph of Hortense Aurore Machu (née David)*, 1871, Bibliothèque Municipale de Saint Denis.

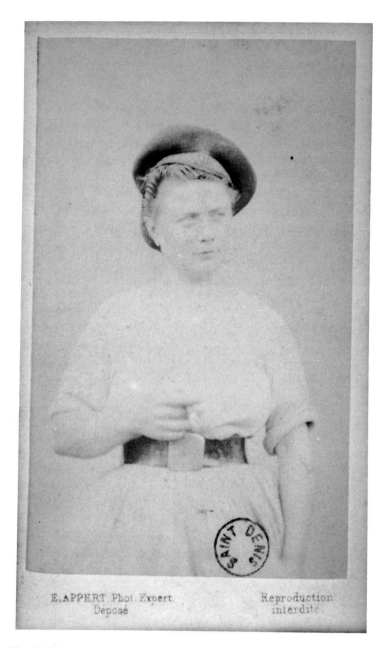

Plate 20 E. Appert, *Carte de Visite Photograph of Christine D'Argent*, 1871, Bibliothèque Municipale de Saint Denis.

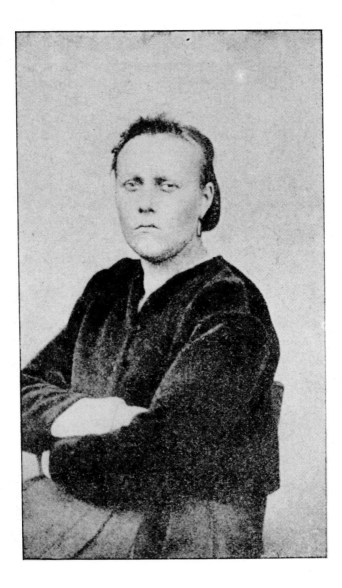

Plate 21 E. Appert, *Carte de Visite Photograph of Catherine Olivier*, 1871, reproduced from
A. Dayot, *L'invasion, le Siège, La Commune, 1870-1871*, Paris, 1901.

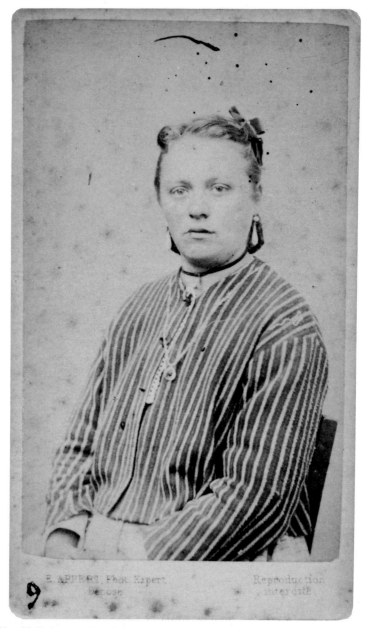

Plate 22 E. Appert, *Carte de Visite Photograph of Léontine Suétens*, 1871, Bibliothèque Municipale de Saint Denis.

Plate 23 E. Appert, *Carte de Visite Photograph of Tranquil*, 1871, Bibliothèque Municipale de Saint Denis.

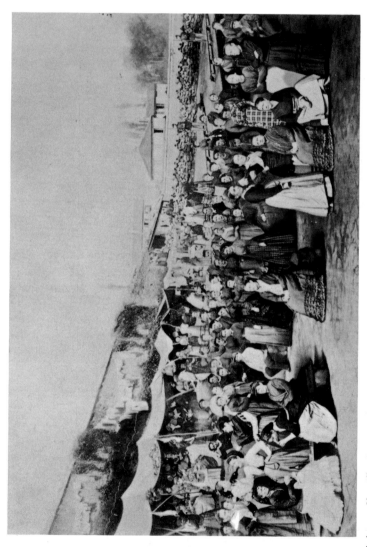

Plate 24 E. Appert, *Versailles. Interior of the Prison yard at Chantiers with Communarde Prisoners, 15 August 1871*, composite photograph, 14.8 x 21.5 cm, Bibliothèque Nationale, Paris. Photo courtesy of the Bibliothèque Nationale.

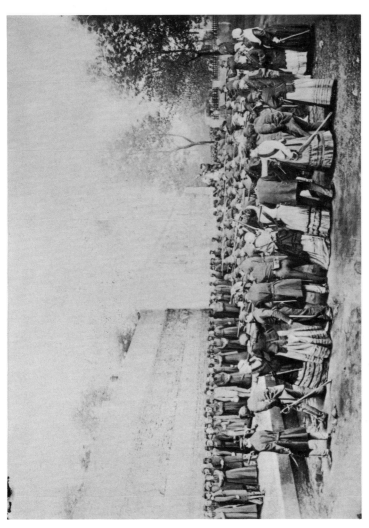

Plate 25 E. Appert, *Murder of the Sixty-two Hostages in the Rue Haxo, 26 May 1871*, composite photograph from the series, *Crimes of the Commune*, 16 x 22 cm, Bibliothèque Nationale, Paris. Photo courtesy of the Bibliothèque Nationale.

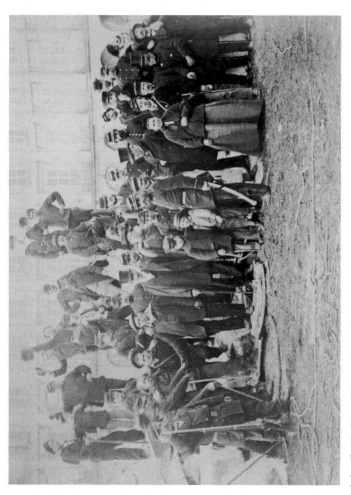

Plate 26 Braquehais, *The Vendôme Column after its Destruction*, photograph, Musée Carnavalet. Photo courtesy of the Museum.

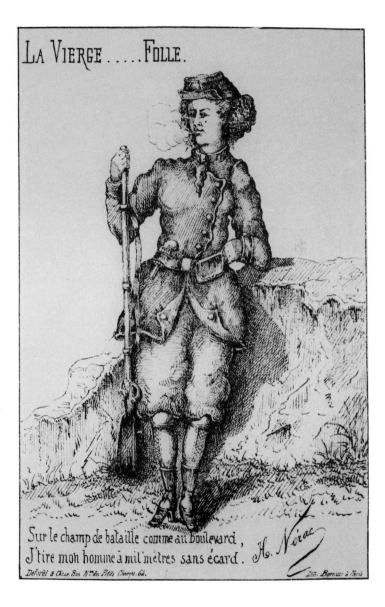

Plate 27 Nérac, *The Foolish ... Virgin*, from the series *Signs of the Zodiac*, lithograph, Summer 1871, Bibliothèque Nationale, Paris. Photo courtesy of the Bibliothèque Nationale.

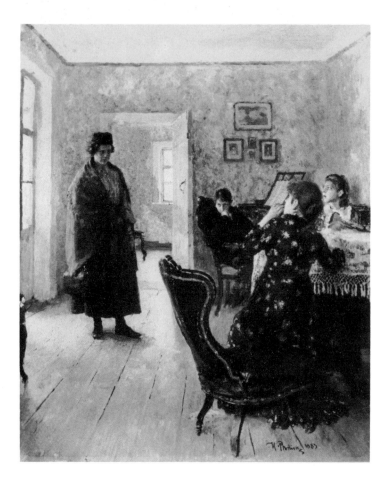

Plate 28 I. Repin, *They did not expect her*, oil on canvas, 114 x 94 cm, 1883, Tretyakov Gallery, Moscow. Photo Witt Library, London.

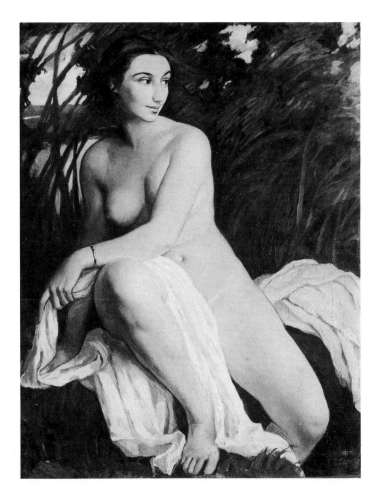

Plate 29 Zinaida Serebryakova, *Bather (Self Portrait)*, oil on canvas 98 x 89 cm, 1911,
Russian Museum, St Petersburg.

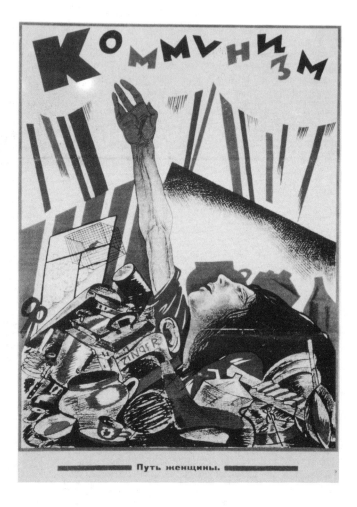

Plate 30 Yuri Ganf, *Communism: The Path for Women*, illustration from *Red Pepper* magazine, printed in red, brown and black inks, 23 x 29 cm, 1923. Photo David King Collection, London.

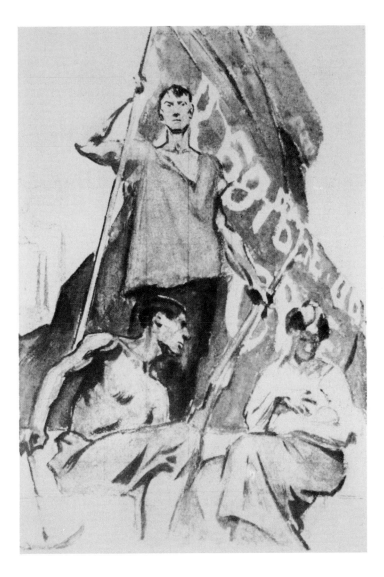

Plate 31 V. Volkov, *Triumph of the Worker*, sketch for a decorative panel for the street celebrations of the first anniversary of the October Revolution in St Petersburg, 1918, dimensions and location unknown.

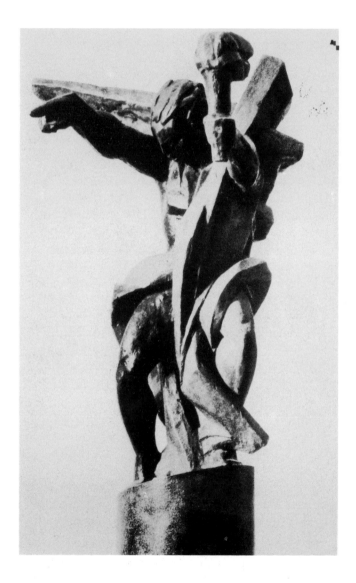

Plate 32 V. Mukhina, *Flame of the Revolution, Design for a Monument to Yakov Sverdlov*, coloured plaster, height 104 cm, 1922-3, Tretyakov Gallery, Moscow.

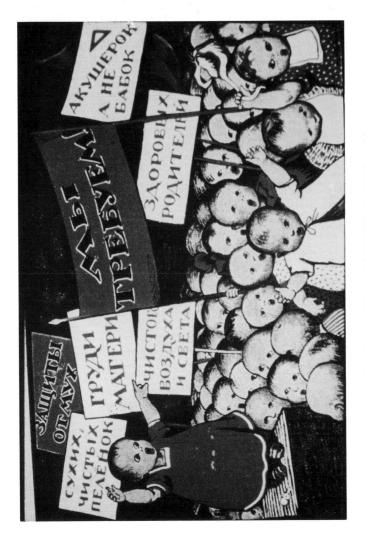

Plate 33 Komarov, *The Meeting (of children)*, painted poster design, early/mid-1920s, Lenin Library, Moscow.

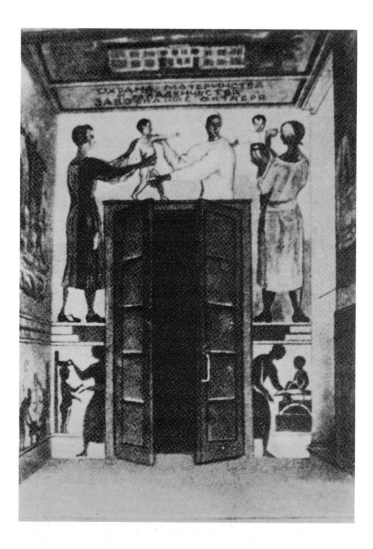

Plate 34 V. Favorskij, *Frescoes in the Hall of the Museum of Mother and Child Protection*, 1933, (destroyed).

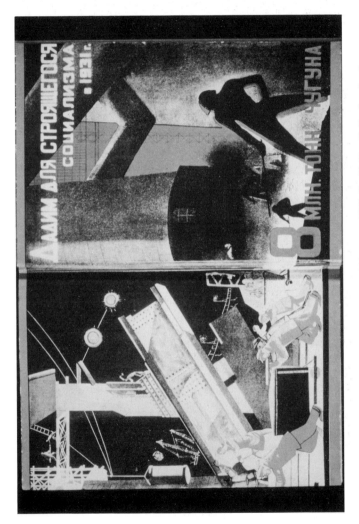

Plate 35 V. Kulagina, *Devote Yourself to the Building of Socialism in 1931*, poster, 1931, David King Collection, London.

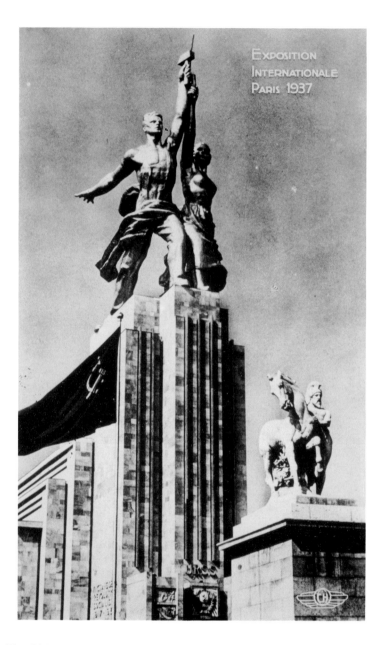

Plate 36 Vera Mukhina, with her assistants N. Zelenskaia and Z. Ivanova, *Worker and Collective Farm Worker*, chrome nickel steel plates on wood, height c.2300 cm, 1937, Park of the People's Economic Achievements, Moscow.

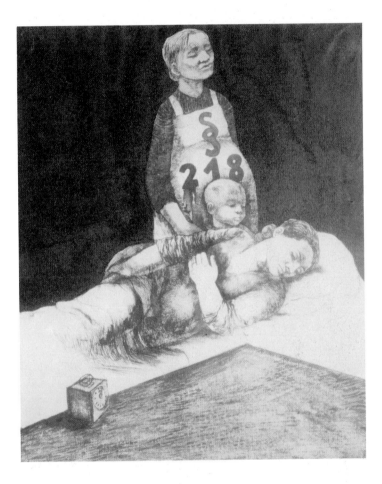

Plate 37 Hanna Nagel, *The Paragraph*, pen-and-ink drawing with water-colour, 29 x 20 cm, 1931, private collection. Photo courtesy of Staatliche Akademie der Bilden den Künste, Karlsruhe.

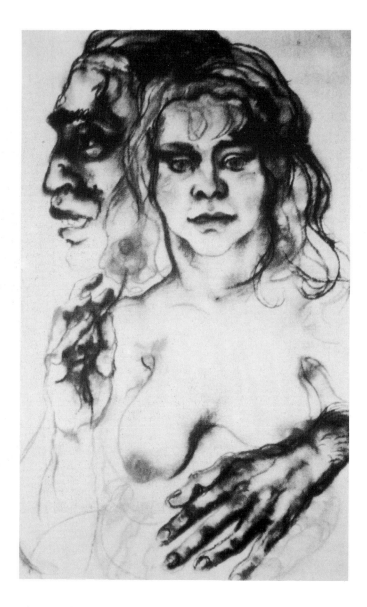

Plate 38 E. Lohse-Wächtler, *A Flower*, pastel, c.42 x 62 cm, c.1930, location unknown.

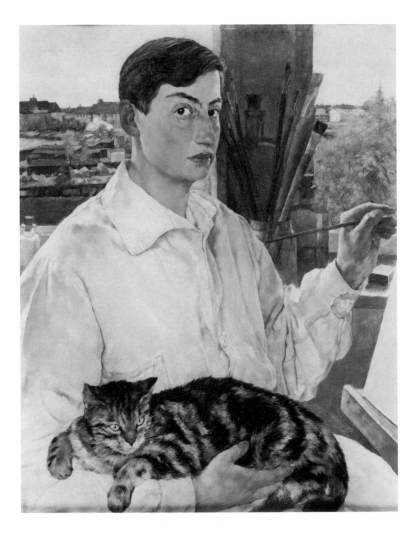

Plate 39 L. Laserstein, *Self Portrait with Cat*, oil on panel, 61 x 51 cm, 1925, Leicestershire Museums, Arts and Records Service. Photo courtesy of Leicestershire Museums, Arts and Records Service.

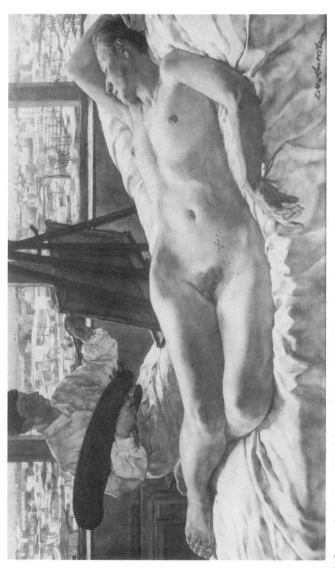

Plate 40 L. Laserstein, *Artist and Model in the Studio, Berlin, Wilmersdorf*, oil on wood, 70.5 x 97.5 cm, 1928, Museum of Fine Arts, Montreal, on loan from a private collection. Photo courtesy of Agnews, London.

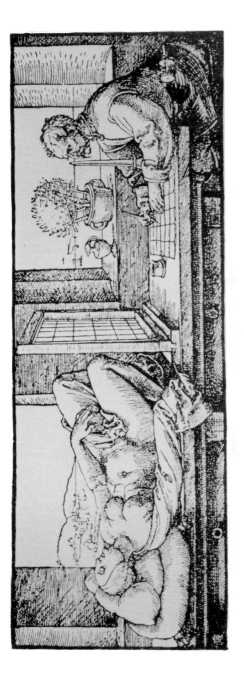

Plate 41 A. Dürer, *Artist Drawing a Reclining Female Nude*, woodcut, 76 x 21.2 cm, c.1527, from the 1538 edition of *Treatise on Measuration (Underweysung der Messung)*.

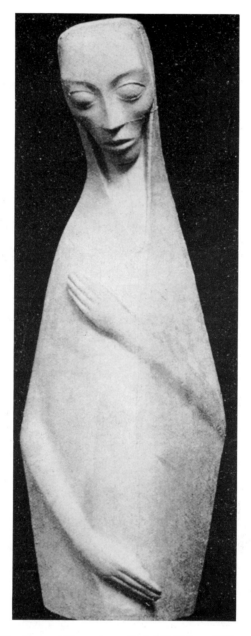

Plate 42 E. Röder, *Pregnant Woman*, terracotta, height 80.5 cm, 1919, acquired in 1921 by Kunsthalle, Karlsruhe (presumed destroyed). Photo courtesy of Berlinische Galerie, Museum für Moderne Kunst, Photographie und Architektur, Berlin.

Dieser Mädchenkopf

ist die Arbeit eines unheilbar irrsinnigen Mannes in der psychiatrischen Klinik in Heidelberg. Daß irrsinnige Nichtkünstler solche Bildwerke schaffen, ist verständlich.

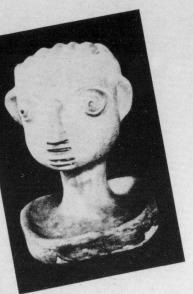

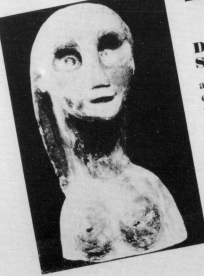

Diese Spottgeburt

aber wurde ehedem ernsthaft als Kunstwerk besprochen und stand als Meisterwerk von E. Hoffmann in vielen Kunstausstellungen der Vergangenheit. Der Titel des Monstrums hieß: „Mädchen mit blauem Haar"; seine Frisur erstrahlt nämlich im reinsten Himmelblau.

Plate 43 Page from the Guide to the *Degenerate Art* exhibition, *Female Heads*, 1937.

Die Dirne wird zum sittlichen Ideal erhoben!

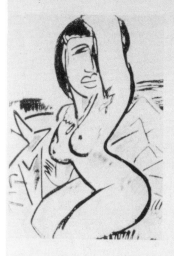

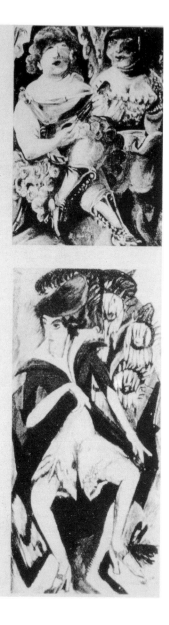

Was die bolschewistische Jüdin Rosa Luxemburg an der russischen Literatur besonders liebte: „Die russische Literatur adelt die Prostituierte, verschafft ihr Genugtuung für das an ihr begangene Verbrechen der Gesellschaft . . ., erhebt sie aus dem Fegefeuer der Korruption und ihrer seelischen Qualen in die Höhe sittlicher Reinheit und weiblichen Heldentums."

Rosa Luxemburg
in „Die Aktion" 1921.

Plate 44 Page from the Guide to the *Degenerate Art* exhibition, *The Prostitute is Elevated to a Moral Ideal*, 1937.

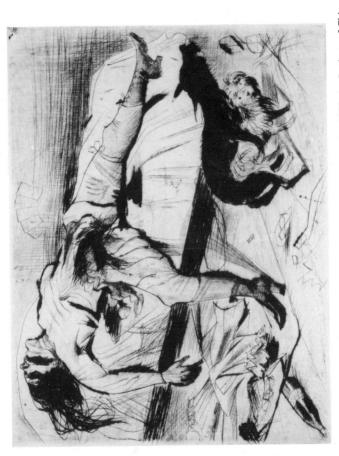

Plate 45 Otto Dix, *Sex Murder*, etching 43.5 x 46.8 cm, from the Portfolio *Death and Resurrection*, 1922, Art Institute of Chicago. Photo courtesy Art Institute of Chicago.

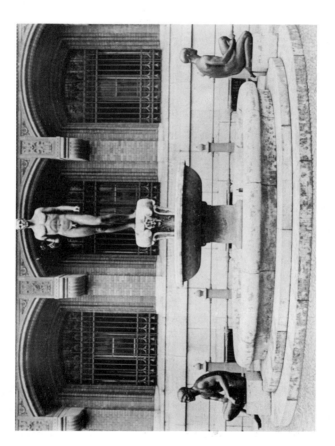

Plate 46 H. Cauer, *Olympia Fountain*, 1935, Rotes Rathaus, Berlin, destroyed. Photo courtesy of Berlinische Galerie, Museum für Moderne Kunst, Photographie und Architektur.

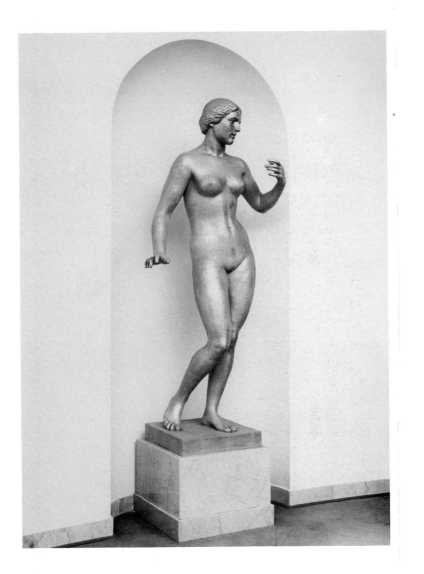

Plate 47 H. Cauer, *Allegretto* bronze, 168 cm high, 1935, Operahouse, Nürnberg. Photo courtesy of Berlinische Galerie.

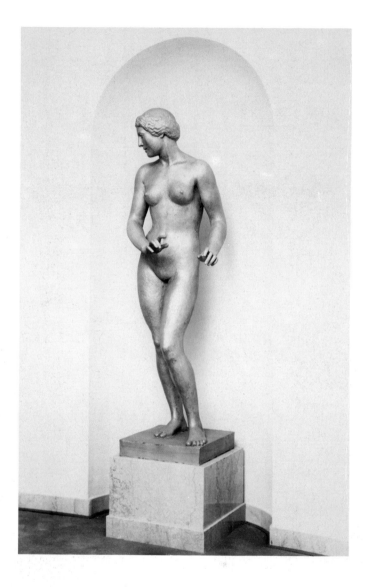

Plate 48 H. Cauer, *Moderato*, bronze, 162 cm high, 1935, Operahouse, Nürnberg. Photo courtesy of Berlinische Galerie.

Plate 49 C. Sherman, *Untitled No.179*, cibachrome photograph, 183 x 126 cm, 1987.
Courtesy Metro Pictures, New York.

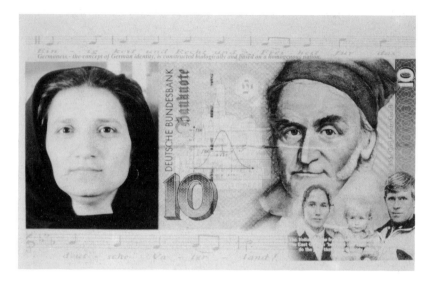

Plate 50 Roshini Kempadoo, panel from the series *European Currency Unfolds, German Marks*, photographs on board, each 152 x 84 cm, 1992. Photo by kind permission of the artist.

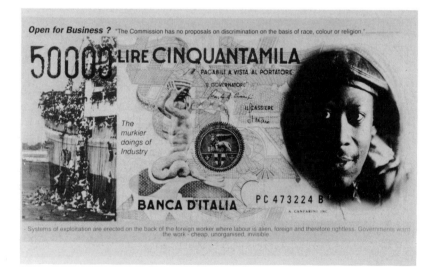

Plate 51 Roshini Kempadoo, panel from the series *European Currency Unfolds, Italian Lire*. Photo by kind permission of the artist.

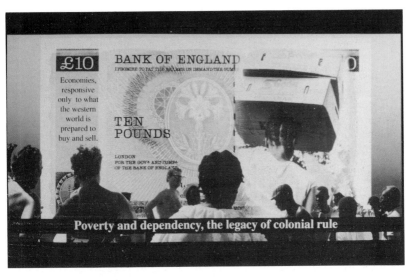

Plate 52 Roshini Kempadoo, panel from the series *European Currency Unfolds, Ten Pounds Sterling*. Photo by kind permission of the artist.

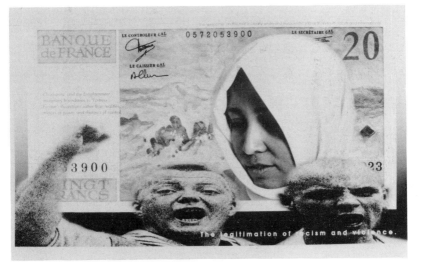

Plate 53 Roshini Kempadoo, panel from the series *European Currency Unfolds, French Francs*. Photo by kind permission of the artist.

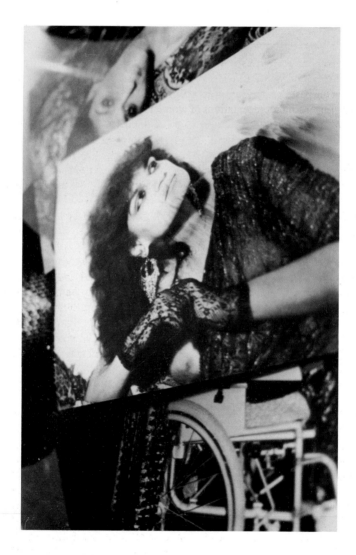

Plate 54 Samena Rana, *Sensual Reflections* (from a series of four), black-and-white print, 18 x 12 cm, by Camille Dorney from original negative, courtesy of the estate of Samena Rana and Panchayat.

Introduction

My aim in this book is to examine some key issues and debates concerning representations of women in the modern period, i.e. from 1789 to the present. In the past twenty years or so, the growth of research and published material concerning representations of women in art has been impressive. In the wake of the modern Women's Movement, female (and male) scholars and art practitioners have turned their attention to the theoretical underpinnings and the practical production of images of women.

However, this book is not intended merely as an addition to this already impressive amount of literature and cultural products. It is the aim of this book to argue for a shift in the methods generally employed hitherto in the study of women's art and imagery of women. As will be argued in Chapter One, the study of women in history and women in art history has generally been assumed to be the province of feminist theory (of one sort or another), and its practitioners assumed to be feminists. The equation of the study of women and feminism is largely unquestioned and, indeed, taken for granted. I will argue that these positions need to be modified. Specifically I hope to show that Marxism, as a method of studying history and cultural production, has been largely, if not completely, ignored and/ or dismissed by scholars engaged in the study of representations of women. Either Marxism has been summarily dismissed as 'blind' to women's issues, or, in the rarer cases when feminist scholars refer to Marxism, they argue that feminist approaches to the study of women's history and culture are vastly superior, more fruitful and methodologically more subtle.

I will argue that the above views have prevented Marxism being taken seriously as a methodology for the understanding of women's culture and representations of women in the visual arts. Part of the problem, of course, is that Marxist art history is itself very under-developed in comparison to the undoubtedly impressive developments in feminist research and academic publications in the recent past. Indeed it may seem a very unfashionable argument to have at the present time, when various achievements in reforms and legislation for women have been won and women's studies courses flourish in institutes of higher education, while most of the countries which many people perceive as examples of 'Marxist' politics and economics in practice are virtually degenerating into barbarism and economic chaos. However it seems to me in this situation to be all the

more relevant to reassert a genuine Marxist understanding of history and culture, and its validity as a method of understanding the role and representation of women in different historical moments.

It is not my aim in this book to 'insert' Marxism into women's studies alongside feminism(s) on an equal methodological footing. I will be arguing for the necessity of a Marxist understanding of women's position in society and culture as a superior method which enables us to understand more fully women's oppression and its consequences, and also the complexities and contradictions embodied in the experiences of women and in their (self) representations.

In Chapter One I look in more detail at the issues outlined above, to show how Marxism has been rejected and/or ignored as a method of studying women and art. This chapter will discuss some of the main theoretical debates around Marxism and feminism(s) which are relevant to women's art and images of women.

Chapter Two will focus on women artists and representations of women in the French Revolution as a key moment when, it has been argued, women suffered a historical defeat, bourgeois ideologies of women as subservient were firmly put in place, and women were represented as allegories of liberty only to be repressed as actual female individuals. I will argue that the situation for women during the French Revolution was far more complex and contradictory than the above position asserts. By looking at the question of class in the French Revolution, I hope to show that a view of the French Revolution and its cultural products as primarily generated by gender opposition can be misleading.

The next chapter will consider mid/late nineteenth-century art in France in order to re-examine some of the arguments advanced by feminist scholars that, from its very inception, Modernism as a concept in art theory, and modernity in art practice, relegated women to a subordinate position, thereby ensuring that 'progressive' art for generations to come would be founded on a masculine/patriarchal set of cultural values and judgements. By examining this argument in more detail I will argue that class is a factor that needs to be given far more weight than hitherto in the understanding of works by French female and male artists of the time.

Chapter Four will examine representations of women from the period of the Paris Commune in 1871. My reasons for doing this are, first, to look at photographs and prints largely excluded from most art historical books dealing with this period and, second, to examine notions of class and mass culture during this period as they relate to gender.

Although the chapter on the Commune will deal with more unfamiliar media and imagery, the reader may have noticed that much of the material so far has been French. This reflects partly the areas where art historical and historical research has been carried out by English-speaking art

historians and feminist historians, but also the crucially important role played by events in France in the formation of modern society and culture. However, I feel it is important to examine other situations in European history in order to test out some of the theories developed by feminist scholars regarding women's art, Modernism and women's oppression. Here too, culture is seen as basically an expression of 'patriarchal' ideology. For these reasons I will look at the role of imagery of women and works by women artists in Russia and the USSR, and in Germany in Chapters Five and Six.

It is not unusual to see parallels being drawn between the imagery of Soviet and Nazi art, but I will argue that the representation of women by artists in these two states raises more complex and interesting questions than the rather facile comparisons we sometimes encounter. Similarly I think we have to question the kind of equation which aligns Modernist art with 'progressive' attitudes to women, and 'totalitarian' art with straightforwardly crude propagandistic 'lies' about how women in these societies actually lived and produced art works themselves. In addition, we need to reconsider, in studying Russian and Soviet examples, whether the argument that women artists were excluded from active participation in Modernism, by its very theoretical premises, really stands up to close scrutiny. Many of the Russian and Soviet avant-garde women were active, leading members of artistic life at this time. Furthermore many of them were engaged in creating completely abstract, non-figurative works. This is an area of art history where both Marxism and feminism(s) need to refocus and reassess previous assumptions. Marxist art history has been chronically weak in attempting to discuss non-figurative works. However feminist scholars too have often tended to be happier discussing images where men and women are represented in a recognisable situation, which can then be discussed in terms of its spacial arrangements, eye contact with the spectator, presentation of a clothed or naked body and so on. I realise that I too have not escaped from the tyranny of the representational! However in discussing non-figurative works by Soviet women artists I would like to make some suggestions which I hope will be fruitful for future work.

The final chapter will look at examples of Postmodern art and theory relating to issues of gender, in the context of recent historical and cultural developments. Taking account of the shift in economic, political and cultural weight to the United States of America in the post-war period, I will look at work by the American artist Cindy Sherman. I will also look at the work of two British women artists of colour, as this is an increasingly relevant issue in the culture of the 'Postmodern' period. While throughout this book I hope to demonstrate the importance of issues of race and sexuality in understanding images of women, I felt that the amount of

information I was able to find from the early modern period did not really allow me to include race and lesbian sexuality in the title of the book, and I felt that I might give a misleading idea of the contents of the book if I did so. However I do attempt to discuss issues of race and non-heterosexual sexual identities, as I think it is important to move away from the view that perceives history and culture as a matter of male/female oppositions.

My illustrations are chosen because either they are crucial to the arguments being followed through or they are difficult to find elsewhere. The reader should not expect a comprehensive illustrative survey of the historical moments discussed in the various chapters throughout the book! Unfortunately I had great difficulty in communicating with art institutions and libraries in the former USSR, and some of the illustrations I would have liked to use were not available to me, basically due to the collapse of the economy, lack of fax paper, photographic materials, etc.

In cases where books were difficult to locate, I have given as much information about their publication as possible.

–1–

Marxist Theory, Feminism(s) and Women's History

In this chapter I will consider some of the debates between Marxist and feminist art historians around the issues of gender, class and representation which have emerged in recent years, mainly in the English-speaking academic world. It will be my aim here to question the notions that all those studying women in cultural production are feminists of one sort or another, and that Marxism is fatally and irredeemably flawed as a method for understanding women in cultural history. It is not my aim here to belittle the immensely valuable contributions of feminist artists and scholars to our knowledge and awareness of women's art in the modern period. Important steps forward have been taken in the development of theoretical analysis, one important example of which is the application of psychoanalysis to our understanding of spectatorship.[1]

What I do want to do, though, is to challenge the notion that focus on gender struggle, as the prime means of understanding historical and cultural change, gives us an accurate understanding of the ways in which women represented themselves, and were represented by men. As a first step, I want to look at some theoretical positions of various influential historians of visual culture over the last few years.

Fairly recently, in 1992, I attended the British conference of the Association of Art Historians at the University of Leeds. T.J. Clark and Griselda Pollock were two of the three main plenary speakers, and the theoretical concerns of the conference were very much presented as a debate between these two individuals, representing opposing viewpoints. Their contributions were certainly perceived as oppositional by large numbers of the conference participants. In an important sense, this was a valid perception of different approaches, but also in some ways a limited one. While it is true that Pollock has become probably the main

1. The literature in recent years on women and art history is vast. For useful bibliographical and historical orientation see in particular Thalia Gouma-Peterson and Patricia Mathews, 'The Feminist Critique of Art History', *The Art Bulletin*, vol. 69, no. 3, Sept. 1987, pp. 326–57, and Lisa Tickner, 'Feminism and Art History', *Genders*, vol. 3, Fall 1988, pp. 92–128.

spokesperson for feminist art history, and Clark the main Marxist art historian of the 1980s, the rather confrontational presentation of their material on that occasion did little to even open a dialogue on the question of whether a Marxist history of women's culture was possible.

Clark, whose books and articles on French nineteenth-century art can be said to have shifted the study of the period onto a new level of debate, opened the proceedings.[2] To underline this oppositional confrontation of different genders and different approaches, Griselda Pollock, Professor of the Social and Critical Histories of Art at Leeds University and a hugely influential figure in women's art historical studies, chose to present a feminist art historical epistolary journey to conscious awareness of the meaning of Manet's painting *A Bar at the Folies-Bergère*, 1882 (Courtauld Galleries, London). It was perceived by the conference participants that Pollock had chosen this work precisely as a 'critique' of Clark's 'patriarchal' discussion of this painting in his book *The Painting of Modern Life*, published in 1985. As we shall see in more detail later, Pollock has had many critical points to make about Clark's approach. However for the moment I will point out what she writes specifically about Clark's discussion of Manet's *A Bar at the Folies-Bergère*.

She claims that Clark's discussion of the representation of 'modernity' in Parisian painting

> is a mighty but flawed argument on many levels but here I wish to attend to its particular closures on the issue of sexuality. For Clark the founding fact is class . . . Although Clark nods in the direction of feminism by acknowledging that these paintings [Manet's *Olympia* (1863) and *A Bar at the Folies-Bergère* (1882)] imply a masculine viewer/consumer, the manner in which this is done ensures the normalcy of that position leaving it below the threshold of historical investigation and theoretical analysis.[3]

In fact Clark does discuss women, sexuality and spectatorship at some length in his book, but what is really at the root of Pollock's dissatisfaction with his approach is that, precisely as she says in one of her briefer statements, for Clark the basis of understanding history and culture is class, not gender. Consequently, for Pollock, who takes the opposite view, Clark will never adequately theorise or present to his readers an understanding of women's oppressed position in relation to modern society and culture.

2. Clark's works include his ground-breaking studies of art in France and the 1848 Revolution, *The Absolute Bourgeois. Artists and Politics in France, 1848–1851*, London, 1973, and *Image of the People: Gustave Courbet and the 1848 Revolution*, London, 1973, and his more recent *The Painting of Modern Life: Paris in the Art of Manet and his Followers*, London, 1985.

3. G. Pollock, *Vision and Difference. Femininity, Feminism and the Histories of Art*, London and New York, 1988, pp. 52–3.

I would argue that Pollock's argument here is not conclusive, for one may quite clearly believe that class is the basic motor force of historical struggle without necessarily being prevented from analysing spectatorship, artistic production and the experience of women. What the key issue is for Pollock and large numbers, perhaps even the majority, of other feminists engaged in the study of cultural history is that gender difference is crucial and far outweighs other historical, social and cultural factors. This is true of different kinds of feminist approaches, as I will discuss later.

The kind of either/or approach epitomised by the format of the Leeds Art Historians Conference is unfortunate, but ultimately true. Either class is seen as paramount in a Marxist analysis of cultural history, or else gender struggle is seen as the most crucial factor in explaining why particular art works are made the way they are. Of course Marxist art historians discuss gender, and feminist art historians discuss class on many occasions. But attempts to construct theoretical foundations of a Marxist feminism and/ or socialist feminism, which unites Marxist and feminist theory on the basis of sound historical investigation have, not surprisingly, been of limited success, as I will explain in more detail later.[4]

Unfortunately Clark made no reply or defence of Marxist theory as a valid means of analysing women's art or the representation of women. His own plenary lecture revealed a scholar who, while still proclaiming himself a Marxist, neither demonstrated this in his method of lecturing, nor any longer seemed very clear theoretically what the practice of a Marxist was. He appeared rather disorientated, politically and in his art historical practice. Clark said that gender oppression 'was the most basic form of oppression' in history, and also that Marxism would virtually have to go back to the drawing board and rethink almost everything. It must be said that most people at the conference were hardly brimming with optimism, as the day on which Clark gave his talk dawned with the news that a Conservative government had, yet again, been re-elected in Britain.

However this was not the main reason for Clark's uncertainties, I think. Although he believes that the former Soviet Union has been state capitalist for many years, he nevertheless seems unclear what, as a Marxist, he would say about the process of its economic disintegration. He further confused his audience by projecting a concluding slide to his talk which showed Simone de Beauvoir and Jean-Paul Sartre with Fidel Castro. The point of this image was left unclarified. Clark's rejection of any notion of a Marxist political party further complicates his position. Summing up, I would argue

4. See for example: M. Barrett, *Women's Oppression Today. Problems in Marxist Feminist Analysis*, 4th edn, London, 1985; L. Vogel, *Marxism and the Oppression of Women. Toward a Unitary Theory*, New Brunswick, New Jersey, 1989; and the interesting articles by Jane Kelly, Josette Trat and the resolution 'Positive action and party-building among women' in *International Marxist Review*, no. 14, Winter 1992, ISSN 0269-3739.

that Clark's position at present is in difficulties for a whole number of reasons, some of them totally outside his control, but a major one is his seeming unwillingness to take on the arguments of feminist art historians. However this stance by Clark, under quite strong pressure, does not therefore prove that a Marxist analysis is incapable of understanding women in relation to the visual arts.

This occasionally bitterly debated opposition between Marxist and feminist approaches to art history is not new and has characterised much of the last fifteen to twenty years, when radical new work was being published in the field of art history. Sometimes referred to as 'the new art history', a body of work investigating questions of class, gender and race in art was produced.[5] At other times, or simultaneously, these developments were described as constituting a project to found a 'social history of art', as opposed to types of art history which largely ignored, or actively argued against considering, wider questions of social, economic and cultural history.

Indeed one of Clark's most influential contributions, which motivated a whole generation of younger scholars, including Pollock (and me), was his writing 'On the Social History of Art'.[6] Clark argued for a 'social history of art' which attempted to understand art works as part of a complex interaction of economic, political and cultural factors. For Clark, this was an attempt to re-elaborate (or perhaps elaborate is more accurate) a Marxist method of understanding art which several earlier scholars had tried to develop. These included Meyer Schapiro and Max Raphael.[7] However Clark's call for a 'social history of art' had certain problematic features, and an insistence on a Marxist history of art would have been clearer, in principle, and might have encouraged more debate in practice as to how, precisely, a Marxist theory of art would relate to issues of gender, race and so on. However this may not be something that Clark could have foreseen.

It has been quite possible for 'social histories of art' to be produced which really do not in any way critically engage with notions of art, creativity, artistic value and other supposedly neutral terms used by art historians. Michael Baxandall's book *Painting and Experience in Fifteenth Century Italy*, published in 1972 by Oxford University Press, could be cited

5. See, for example, A. Rees and F. Borzello (eds), *The New Art History*, London, 1986.
6. T.J. Clark, 'On the Social History of Art', in *Image of the People: Gustave Courbet and the 1948 Revolution*, London, 1973, pp. 9–20.
7. See for example: M. Schapiro, 'The Nature of Abstract Art', *Marxist Quarterly*, vol. 1, no. 1, Jan.–March 1937, pp. 77–98; and M. Raphael, *The Demands of Art*, London, 1968, M. Raphael, *Proudhon, Marx, Picasso. Three Essays in Marxist Aesthetics*, London, 1981, has a very useful introduction by John Tagg which deals with Raphael's contribution to the development of a Marxist art history.

as an example. A similar point has been made by O.K. Werckmeister, who states:

> In the following twenty years [since 1968] art history as the social history of art production irresistibly came to prevail in the discipline, but on grounds other than those advanced by its Marxist critique. The historic reasons for this startling trend remain to be explored. Internally, it was prompted by art history's institutional growth, interdisciplinary expansion, accumulative bibliographical cross-referencing and scientific research technology. In the end, the social history of art became a commonplace pursuit for which only the methods remained subject to debate. It has never yielded any consistent conclusions beyond specific fields of inquiry, on how art is in fact determined by the social process. The term 'context' became the codeword for this state of indeterminacy.[8]

Unfortunately Werckmeister tends to make huge generalisations in his article without really backing up his arguments with specific examples, but there is an important kernel of truth in this particular point. Since few scholars tried to elaborate a Marxist history of art, in practice and theory, all kinds of different approaches could co-exist, not entirely happily, under the banner of 'the social history of art', including approaches which were Marxist and some which were feminist in inspiration. This had not been Clark's original project and he specifically argued against it at the time.

Apart from Clark, the other major Marxist art historian who has been criticised by feminist scholars is Nicos Hadjinicolaou. His book, *Art History and Class Struggle*, translated into English in 1978, was first published in French in 1973. His work was answered by the publication of *Histoire de l'art et Lutte des sexes* in 1977 by Françoise D'Eaubonne. A radical feminist, d'Eaubonne set out to write a book which would oppose Hadjinicolaou's in both argument and structure. She deals with the same periods, the same artists and sometimes even the same paintings as Hadjinicolaou. She makes it clear that her position is clearly opposed to Marxism. She states that 'ideology of sex' predates class ideology (p.12), the primordial impulse of history is gender struggle (p.16), ideology of gender/sex exists as superstructure on the base of sexism (p.22), women are a class of a special and particular kind (p.34) and it is impossible to attribute the oppression of women to the existence of capitalism 'as vulgar Marxism states' (p.35). Her reading of history and culture is imbued with notions of gender opposition as basic explanatory concepts. For example she discusses the French Empire period and sees Mmes de Staël and Récamier united in opposition to a male and bellicose dictatorship of

8. O.K. Werckmeister, 'A Working Perspective for Marxist Art History Today', *The Oxford Art Journal*, vol. 14, no. 2, 1991, p. 84.

Napoleon (p.51).[9]

While arguing from a rather different feminist position, Pollock, in her book *Vision and Difference*, also criticised Hadjinicolaou's book as part of her rejection of Marxism as being flawed, patriarchal and sex-blind. In Chapter Two of this book, 'Vision, Voice and Power: Feminist Art Histories and Marxism', a revision of a paper first published in *BLOCK* magazine in 1982, Pollock sets out her criticisms of Marxist art history (which she also sometimes calls the social history of art). She is especially critical of Hadjinicolaou's book for its economic determinism and reductionism. As far as Hadjinicolaou's book is concerned, however, Pollock is quite right. The method he employs is rather crude and rigid, with no real grasp of the complexities and contradictions of the relationship of visual culture to its economic base. After the opening section of his book, which is a competent demolition job on many of the 'traditional' methods and concepts of art historical study, he investigates a number of paintings (mostly) and prints as examples of visual ideologies of particular class fractions. This kind of 'reading' of class positions from art works is not justified by what Marx and especially Engels wrote themselves about culture in general, although they did admittedly slip into this sometimes when discussing particular works.

However the major problem with Hadjinicolaou's book is that he tends to concentrate on subject matter and so is completely at a loss as regards non-figurative art. Hadjinicolaou apologises for not including any examples of twentieth-century art. 'However it seemed impossible to cite even one painting from our century without embarking on an undertaking which would occupy a disproportionate amount of space in the book . . . apart from the interference of both market and dealers in actual artistic production, there remains the whole question of figurative as opposed to so-called abstract painting, realism, etc., and of their doctrines, ideologies and painters.'[10] And there he leaves the issue.

However Pollock takes Clark to task as well, and dealing with him in the same way as she deals with Hadjinicolaou, comments that the work of these Marxist scholars refers to the 'crude Marxist formulation of all cultural practices being dependent upon and reducible to economic practices (the famous base-superstructure idea)' and 'the paternal authority of Marxism under whose rubric sexual divisions are virtually natural and inevitable and fall beneath its theoretical view . . .'[11] These criticisms can hardly be said to accurately characterise Clark's writing and method. In

9. All references are to F. D'Eaubonne, *Histoire de l'art et Lutte des Sexes*, Paris, 1977.

10. N. Hadjinicolaou, *Art History and Class Struggle*, translated by L. Asmal, London, 1978, pp. 105–6.

11. G. Pollock, *Vision and Difference*, pp. 4,5.

fact Clark tries in his writing to embody the complex and ambiguous ways in which images relate to economics and class (or ways in which they (un)consciously try not to). Clark's writing is sometimes complex, indeed obscure, but I read this as a serious and conscious attempt not to oversimplify a very complicated process of methodological analysis. Nor can Pollock's comments be said to be accurate as regards Marxism and women's oppression, as we shall see. However these views are commonly encountered among many scholars who would undoubtedly see themselves as radicals.

To cite a further example, I quote Craig Owens's essay in *Postmodern Culture*, where he completely accepts feminisms' critique of Marxism as 'patriarchal' and the discourse of Marxism as 'oppressive', and writes:

> One of the things that feminism has exposed is Marxism's scandalous blindness to sexual inequality. Both Marx and Engels viewed patriarchy as part of a precapitalist mode of production, claiming that the transition from a feudal to a capitalist mode of production was a transition from male domination to domination by capital. Thus, in the *Communist Manifesto* they write, 'The bourgeoisie, wherever it has got the upper hand, has put an end to all feudal, patriarchal . . . relations'. The revisionist attempt (such as Jameson proposes in *The Political Unconscious*) to explain the persistence of patriarchy as a survival of a previous mode of production is an inadequate response to the challenge posed by feminism to Marxism. Marxism's difficulty with feminism is not part of an ideological bias inherited from outside; rather, it is a structural effect of its privileging of production as the definitively human activity.[12]

Marx and Engels are referring in this passage from the *Communist Manifesto* to the destruction of feudal social and economic relations and their replacement with capitalist ones – i.e. the wage labour system and the market, where individuals are 'free' to sell their labour to the capitalist. The full quotation is: 'The Bourgeoisie, wherever it has got the upper hand, has put an end to all feudal, patriarchal, idyllic relations. It has pitilessly torn asunder the motley feudal ties that bound man to his "natural superiors", and has left remaining no other nexus between man and man than naked self-interest, than callous "cash payment".'[13] Marx and Engels refer to patriarchal relations in primarily an economic sense here, as part of the feudal system where the lord and master oppresses and exploits the labour of those beneath him under the fiction that this is a natural and God-given state of affairs. This patriarchal form of domination can apply under feudalism to men as well as women. This passage by Marx and Engels

12. C. Owens, 'The Discourse of Others: Feminists and Postmodernism', in H. Foster (ed.), *Postmodern Culture*, London and Sydney, 1985, p. 79, note 17.
13. Marx and Engels, *Manifesto of the Communist Party*, in Karl Marx and Frederick Engels, *Selected Works in One Volume*, London, 1973, p. 38.

does not mean that women are no longer oppressed under capitalism! Owen's interpretation of this passage is proved quite wrong when we consider the numerous books, pamphlets and actual practical work undertaken by Marxists in defence of women's rights and against women's oppression. Why would Engels have written his book on the *Origin of the Family, Private Property and the State* in the 1880s if he and Marx had believed that women's oppression had disappeared under capitalism? Owen's position is a mistaken one. Unfortunately, however, it is one that is commonly encountered. Yet it is fair to say that Marx and Engels did not pay much attention to the notion of women's oppression in the *Communist Manifesto,* and when the term patriarchy is used by them, it tends to refer mainly to economic relations, rather than relations of gender oppression.[14] The realisation that more needed to be done on understanding women's oppression and formulating strategies to tackle it led to Engels' production of the *Origin of the Family*, to which I shall return shortly.

In a more recent paper, Pollock returns to the question of the superiority of feminism over Marxism as a theoretical method of cultural analysis. In an essay published in 1990, Pollock takes a somewhat idealist theoretical stance. She looks back on an earlier article she wrote on 'Images of Women', and argues now that it was based on a mistaken theoretical stance. Now, she writes, the term 'images of women' is a misconception. There is no reality to which 'images of women' refer. Rather all representations of women are constructions and fabrications, so none can be more or less comparable to the 'reality' of women or their social and cultural existence than any other. It is clear that this position is fundamentally opposed to a Marxist belief that material reality is scientifically knowable.

It is apparent from the above that the position of Pollock and other feminist cultural historians such as, for example, Laura Mulvey and Tamar Garb, is fundamentally opposed to Marxism. For them, there is no 'reality' from which representations of femininity or masculinity develop. Rather it is the 'constructions' we see and experience in culture which define our notions of ourselves, our individuality, our sexuality and our understanding of the world. For this reason it is clear that a project seeking to persuade feminist historians of this type to incorporate Marxism into their methodologies would be doomed to failure, and in any case, this is not my project in this book. Rather, by focussing on Pollock's criticisms of Marxism I want to bring to the attention of large numbers of students and academics influenced by Pollock's approach that, contrary to what has

14. For example Marx refers to the patriarchal family as an example of a labour process 'oriented simply to the needs of the producers themselves', see *Capital*, vol. 2, p. 280, in the edition published by Penguin Books in association with *New Left Review*, Harmondsworth, 1978.

been argued, a Marxist study of women's culture is not only possible but necessary. Nor is it a question of 'choosing' Pollock or Clark, but understanding the wider implications of the debate around their positions so that we can move on to develop a Marxist history of culture and of women's contribution to culture. It is not a question of inserting 'feminism' into Clark's work or 'Marxism' into Pollock's, or somehow taking 'the best of both', but of re-elaborating and further developing Marxist work on women and culture.

Pollock then goes on in her 1990 essay to slightly revise her previous dismissals of Marxism as a method, and actually quotes an original text by Marx, which is a distinct step forward from many of her other writings on Marxism. She states that, after all, Marx and Engels never had a theory which stated that the superstructure (culture, politics, etc.) was simplistically determined by the economic base, and that in fact the processes by which base and superstructure are inter-connected are very complex. Culture is 'relatively autonomous' from its economic base. Now this is hardly an original discovery as many cultural historians interested in Marxism will readily perceive. However Pollock seems surprised to discover this, and notes: '*Ironically* [my italics], one of the key texts for understanding the role of representation can be found at the heart of historical materialism.'[15]

There is no attempt to correct misleading criticisms of Marxist theory that appeared in her earlier work, however, and no notion of dialectical materialism as opposed to historical materialism. In fact, as noted above, Pollock even seems to reject the latter. Pollock goes on to say that feminism nevertheless has far more potential for 'radical reworking of ideas about representation' than Marxism. Pollock's theoretical position, as far as I understand it, is aligned to socialist feminism in that she seems to discern two economic systems at work. An economy of capitalism (described and analysed by Marx) and what she calls 'a sexual economy', described and analysed by feminist theory. These exist parallel to one another with, however, more weight being given to the 'sexual economy' and the superiority of feminism as a method for understanding these factors in women's oppression and cultural analysis. However Pollock's attempt to argue that her feminist approach is superior to Marxism in terms of analysis of 'images of woman' (sic) is unconvincing. She concludes that 'Every image of the feminine coded body is at the same time an image of woman and not an image of woman'.[16] I see no reason why a dialectical materialist

15. G. Pollock, 'Missing Women. Rethinking Early Thoughts on Images of Women', in C. Squiers (ed.), *The Critical Image, Essays on Contemporary Photography*, London, 1990, p. 206.

16. Ibid., p. 219.

would have stated otherwise, and how this conclusion demonstrates the superiority of feminist theory as argued by Pollock is rather dubious. Fundamentally Pollock sticks to her analysis of gender difference as the basis of historical development and the main reason why cultural products *are* the way they are. She writes, there are no 'images of women' in the dominant culture – only 'masculine significations figured by deployment of body signs'.

Finally we have to ask what are the practical conclusions Pollock draws from her theoretical arguments. These are rather unclear. Are they in any way at all directed at the 'economic base' as described by Marxism and accepted by Pollock as existing? How do they address the state which guarantees the continued existence of inequalities of race and gender while proclaiming that legislation exists to stamp out discrimination? All this is unclear. What seems to have happened in Pollock's more recent writings is an appropriation of certain Marxist terms by a particular type of academic feminism, and indeed, this is explicitly what she set out to do in the 1980s. She concludes her essay on 'Images of women' (sic) with the sentence: 'Advertising photography is a major scene of representation of sexual difference in this conjunction of two economies of desire, where commodity and psychic fetishism entrance us through their mutual investments in and constant trading of our subjectivities.'[17] The slippage away from any notion of economic base is seen in the use of Marxist terminology without any of the actual content of Marx's and Engels's arguments – form is divorced from content here in rather meaningless terms such as the notion of 'two economies of desire'.

I think that basically this trajectory in the work of Pollock and other feminist art historians has largely resulted from the inability or unwillingness of Marxist art historians to really take on arguments such as those advanced by Pollock. The reasons for this are complex, but a major one seems to be the demoralisation and disorientation of Marxist art historians, such as T.J. Clark and John Tagg, who previously had shown optimism and confidence in the possibility of developing a Marxist cultural analysis which did not shy away from confronting issues hitherto given scant consideration by Marxist cultural historians; for example, issues of gender, psychoanalysis and language.[18]

For these reasons I would like to briefly consider some recent writings by John Tagg. Here is a cultural theoretician who has made useful and stimulating contributions to cultural analysis and debate in the 1980s. Yet

17. Ibid., p. 219.
18. For a notable exception, see the work of John Roberts, especially his introductory essay for the exhibition catalogue *Re-Negotiations: Class, Modernity and Photography*, Norwich Gallery, Norfolk Institute of Art and Design, England, 1993 (ISBN 1872482 08 2).

again, though, Tagg seems to be going through something of a personal reassessment of his theoretical premises and actual practice. In his recently published book, *Grounds of Dispute*, Tagg's introduction indicates his trajectory towards increasingly idealist theory. Tagg, like T.J. Clark, is now resident in the United States (since 1985) and he refers to himself as an exile. A number of the essays in his volume refer to his involvement with the British miners' strike in 1984–5 which went down to defeat after a long, bitter but exhilarating confrontation with the British Government. It is not surprising that many radical writers on cultural history, such as Tagg, appear demoralised and drifting further away from materialism (dialectical or otherwise).

I would like briefly to focus on Tagg's paper 'Articulating Cultural Politics: Marxism, Feminism and the Canon of Art', which he gave as a contribution to a symposium organised by Linda Nochlin, entitled *Marxism and Feminism: Convergence in Art*, held in November 1988. Tagg, like Pollock, rejects deterministic notions of class inscribed at the level of the economic base, and states, even in early Marx:

> much hangs on the play there is in the usage of the word 'determination' and the precise application of the terms 'base' and 'superstructure', inextricably complicated today by the growth of cultural and communications industries which, *like the material practices of language* [my italics], find no comfortable place on either side of the theoretical divide. If we turn, however, to works like the *Grundrisse, The Eighteenth Brumaire of Louis Bonaparte* or, indeed, the central chapters of *Capital* on the development of the factory system and the transition from absolute to relative surplus value, we find very different models in which to think the constitution of class.

Class, therefore, says Tagg, is conceptualised by Marx in these texts as a complex articulation of processes which constitute class subjects. He continues: 'Drawing on such theoretical resources, we are, then, simply able to sidestep tedious and unproductive theoretical disputes about the most fundamental determinant: class, gender, race or ethnicity, where these terms are conceived as essential, originary forms imposed on cultural and political "expressions", and where claims for the logical priority of one must conflict with claims for another.'[19]

There are several important issues at stake here. Firstly the concept that 'material practices of language' are not part of the superstructure is taken from Tagg's particular interest in a type of 'Marxist' scholarship associated with Althusser and Foucault, and most obviously Lacan. Many Marxists would find it hard to accept that language is part of the material base of

19. J. Tagg, *Grounds of Dispute, Art History, Cultural Politics and the Discursive Field*, Basingstoke and London, 1992, pp. 58–9.

society and indeed that the growth of cultural and communications industries in present-day society were *qualitatively* different from the development of printing or the invention of the telephone, and therefore necessitated a revision of Marxist theory of history as a history of class struggle.

Of course Marx sees political ideas and a whole array of social practices as having a very complex and highly mediated relationship to economics, and *The Eighteenth Brumaire of Louis Bonaparte* sets out to demonstrate this. Interestingly, this text is the one also referred to by Pollock in her 1990 article, in order to acknowledge, at last, that Marxism does not equal economic determinism. However, Marx does not really draw the conclusions that Tagg claims. In *The Eighteenth Brumaire of Louis Bonaparte* Marx writes:

> Upon the different forms of property, upon the social conditions of existence, rises an entire superstructure of distinct and peculiarly formed sentiments, illusions, modes of thought and views of life. The entire class creates and forms them out of its material foundations and out of the corresponding social relations. The single individual, who derives them through tradition and upbringing, may imagine that they form the real motives and the starting point of his (sic) activity . . . and as in private life one differentiates between what a man (sic) thinks and says of himself and what he really is and does, so in historical struggles one must distinguish still more the phrases and fancies of parties from their real organism and their real interests, their conception of themselves, from their reality.

So, says Marx, there is a knowable reality, and the basis of that reality which ultimately explains the complexity of motivation, concepts, illusions, unconscious motives, etc. is 'different forms of property' and 'social conditions of existence'. In Engels' Preface to the third German edition, written in 1885, he writes:

> It was precisely Marx who had first discovered the great law of motion of history, the law according to which all historical struggles, whether they proceed in the political, religious, philosophical or some other ideological domain, are in fact only the more or less clear expression of struggles of social classes, and that the existence of and thereby the collisions, too, between these classes are in turn conditioned by the degree of development of their economic positions, by the mode of their production and of their exchange determined by it.[20]

I feel that these problems are not likely to go away because Tagg decides he can interpret Marx's writings to justify his notion that we can 'simply

20. For these quotes see K. Marx and F. Engels, *Selected Works in One Volume*, pp. 95 and 117–18.

. . . sidestep tedious and unproductive theoretical disputes'. I think Tagg's position is more an example of a process whereby, in some ways understandably, quite a number of radical scholars have moved farther and farther towards idealism as material reality appears increasingly violent and barbaric.

It is appropriate here to briefly consider what Marx's and Engels's analysis of history actually was, specifically as it relates to culture and gender issues. I will then look at some of the debates which feminist historians and scholars have raised in their criticisms of Marxism. Some of these criticisms have been raised sympathetically, while others are intentionally hostile and demonstrate rather serious distortions of what Marx and Engels actually wrote. Further, I will show that certain feminist scholars have attempted to define anyone who studies women in history as a feminist, thereby making it impossible, by definition, to be a Marxist concerned to investigate women's history and culture.

There is a short and accessible exposition of Marx's and Engels's views on the relationship of cultural products to their economic base to be found in two letters by Engels. In an extract from one of these letters, to W. Borgius, Engels writes:

> Political, juridical, philosophical, religious, literary, artistic, etc. development is based on economic development. But all these react upon one another and also upon the economic basis. It is not that the economic situation is *cause, solely active,* while everything else is only passive effect. There is, rather, interaction on the basis of economic necessity, which *ultimately* always asserts itself . . . So it is not, as people try here and there conveniently to imagine, that the economic situation produces an automatic effect. No. Men make their history themselves, only they do so in a given environment, which conditions it, and on the basis of actual relations already existing, among which the economic relations, however much they may be influenced by the other – the political and ideological – relations, are still ultimately the decisive ones, forming the keynote which runs through them and alone leads to understanding.[21]

In another letter, to J. Bloch, Engels makes basically the same points, emphasising how complex a process historical development and change is, how all kinds of superstructural elements (such as art, culture, politics, ideas about family life and so on) interact with one another 'amid all the endless host of accidents' whose connections are remote and not subject to proof. In the midst of all this, 'the economic movement finally asserts itself as necessary'. To claim that economics crudely determines everything

21. M. Solomon (ed.), *Marxism and Art, Essays Classic and Contemporary*, Brighton, 1979, p. 31.

else 'neither Marx nor I have ever asserted'. 'Otherwise,' continues Engels, 'the application of the theory to any period of history would be easier than the solution of a simple equation of the first degree.'[22] It is clear from this that later attempts, for example by Stalinists in the Soviet Union, to do precisely what Engels warns against here can hardly be said to be true to the original ideas of Marx and Engels, who explicitly reject crude economistic conclusions as regards the cultural sphere. However errors and distortions of later writers continue to be imputed to Marx and Engels, especially by feminist scholars.

Part of the problem is a tendency to equate Marxism not just with economic determinism, but with *historical*, as opposed to *dialectical* materialism. This problem will be referred to at various later stages, but it is probably worth giving a very basic account of dialectical materialism here. As dialectical materialists, Marx and Engels believed that a scientific understanding of the laws of nature and human history was possible. They saw the world as changing, evolving and interacting elements that were not separable from one another but connected. Movement and change did not come from 'outside' agencies, e.g. God or the 'spirit of the age', but from contradictory and unstable forces within natural objects or social formations. The nature of things changes when quantitative changes become qualitative ones, for example when a person dies or when a party wins a parliamentary election not just with a certain number of seats, but with a qualitatively changed expression of social power. These examples are perhaps over-simplified for, as Engels points out:

> For everyday purposes we know, for example, and can say with certainty whether an animal is alive or not; but when we look more closely we find that this is often an extremely complex question, as jurists know very well. They have cudgelled their brains in vain to discover some rational limit beyond which the killing of a child in its mother's womb is murder; and it is equally impossible to determine the moment of death, as physiology has established that death is not a sudden, instantaneous event, but a very protracted process. In the same way every organic being is at each moment the same and not the same; at each moment it is assimilating matter drawn from without, and excreting other matter; at each moment the cells of its body are dying and new ones are being formed; in fact within a longer or shorter period the matter of its body is completely renewed and is replaced by other atoms of matter, so that every organic being is at all times itself and yet something other than itself. Closer investigation also shows us that the two poles of an antithesis, like positive

22. Ibid., p. 30.

and negative, are just as inseparable from each other as they are opposed, and that despite all their opposition they mutually penetrate each other.[23]

So what we are talking about in dialectical materialism is not how one thing influenced something else, but attempting to understand complex interactions, changing phenomena embodying contradictions within themselves. Classes do this, cultural movements and productions do this. A grasp of dialectics enables us to pose different questions. Rather than ask 'is this a "real" representation of a woman' or 'is this a "progressive" representation of a woman', we could, for example, ask 'how can this representation be *at the same time* both "real" and "constructed", "progressive" and "traditional"'? In what ways will these contradictions be resolved, and, in their resolution, which new ones will arise? How can conscious understanding enable us to change culture and history, for the point of dialectical understanding is ultimately this – not to passively stand back and analyse the 'process' of dialectics at work, which would simply be a form of idealism.

As far as Marxist theory and the oppression of women is concerned, the main text, which is still widely consulted and discussed today, is Engels' classic *The Origin of the Family, Private Property and the State*, published in 1884, and written by Engels partly to make public Marx's views on this topic. It represents views shared in the main by both men. Obviously Engels could not escape the limitations of his own time, and in spite of a conscious attempt to analyse sexual oppression, he is not immune to ideological beliefs of his day. In particular he considers monogamous relationships as something of a relief for women, as opposed to being pestered by the sexual advances of many different men, and, more seriously, he considers homosexuality an unnatural, and scarcely mentionable, form of sexual behaviour.

I do not wish to comment at length here on Engels' book but a few points are important. Firstly Engels did not consider sexual differences beneath his concern, natural or immutable. On the contrary, he tried to argue that different societies in history had viewed sexual difference in various ways. Only with the development of societies based on private property, says Engels, does the fact of being born a woman entail social oppression. This is not just true of capitalism but of all societies based on

23. Ibid., p. 28, from Engels, *Anti-Dühring*. In terms of introducing students to dialectical materialism there is some useful explanatory material in M. Cornforth, *Dialectical Materialism, An Introduction*, 2 vols, London, 1961, reprinted 1984, but this has to be treated with some care. Formally, Cornforth understands dialectics but his Stalinist politics lead him to deny reality if it does not fit in with Stalinist dogma, e.g. socialism *was* built in the USSR. So this book does not really represent a true application of dialectical materialism to understanding the world and changing it, which was, after all, the basic premise of Marxism.

private property. Secondly, Engels shows how differing forms of the state act in the defence of private property, thereby ensuring the continued oppression of women. The obvious implication of this for the socialist movement of Engels' time was the need to go beyond reforms and destroy the state to ensure the liberation of women. Marx and Engels frequently had to argue within the socialist movement in the mid-late nineteenth century for equality for women, for a woman's right to work, and for women's participation in politics. They were certainly far more radical in their support of women's rights than most socialist men of their time.

It is not my aim here to argue that Marxists in the nineteenth century (and later) had fully worked out views on women's liberation and were always free from prevailing ideological notions about women. What I am concerned to show is that the method employed by Marx and Engels in attempting to understand women's oppression and, more importantly, to get rid of it, is fundamentally correct, and can be taken as a basis for further theoretical and practical improvement and refinement.

I basically agree with Engels' arguments in *The Origins of the Family, Private Property and the State*, although I accept that reassessment of parts of the book is necessary. Consequently my study of women in history and culture has been informed by a Marxist belief that history is not primarily based on gender struggle. An understanding of different sorts of class societies is fundamental to an understanding of: (1) women's position in these societies and how the question of class relates to particular individuals or groups of women; and (2) ways in which women represent themselves and are represented by others at particular historical moments in different social configurations.

Feminism, however, has tried to construct alternative views of women's position in society and reasons for their subordinate position. In many books on history and culture written by feminist scholars, it is not made clear from which particular feminist position they are writing, and there is a tendency to talk about feminism as a homogenous body of theory. I admit I have done this myself at times. Given that the literature on feminism(s) is vast, I can only deal with this topic briefly here. The main type of feminist approach met with in books on women's art history is that of socialist feminists, who believe that two parallel systems of oppression have existed, and do exist, in history – an economic system of oppression, and a gender system of oppression. In practice, however, the gender system of oppression is given more emphasis. Sometimes socialist feminists also claim to be Marxist feminists, but this is not always the case. Michele Barrett, asks the question 'what then might be the object of Marxist feminism'? She wants to construct such an investigation, seeks to ally socialism and feminism, but still reiterates the same old criticisms of Marxism:

A Marxist analysis of capitalism is therefore conceived around a primary contradiction between labour and capital and operates with categories that . . . can be termed 'sex-blind'. Feminism, however, points in a different direction, emphasising precisely the relations of gender – largely speaking, of the oppression of women by men – that Marxism has tended to pass over in silence.[24]

Similarly A. Kuhn and A. Wolpe claim:

The problem is that although in our view the subordination of women is to be thus analysed historically in terms of the relation of women to modes of production and reproduction, this particular issue is scarcely addressed within traditional Marxist thought . . . materialist analyses of women's condition, to the extent that they constitute an attempt to transform Marxism, constitute also a move towards the construction of a Marxist feminism.[25]

Actually the problems were less to do with traditional Marxist thought than with later deformations of earlier methods by centrists or revisionists who had very little indeed to do with Marxism. As an example of 'traditional' Marxist thought we could hardly criticise Trotsky's words of 1924: 'In order to change the conditions of life, we must learn to see them through the eyes of women.'[26]

Apart from d'Eaubonne, who, as stated above, is writing from a radical feminist position, socialist feminism is the most likely theoretical position to be encountered among feminist art historians, and the same is true of feminist historians.

Among feminist historians, who have obviously influenced historians of women's art and representations of women very strongly, there is a similar dismissal of Marxism and a distinctly identifiable trend towards a clearly idealist form of structuralism. Materialism, dialectics and women's studies are posited as mutually incompatible entities. Michelle Perrot, for example, argues that methods of historical study have to be changed in order for a history of women to exist: 'bien davantage de changer la direction du regard historique, en posant la question du rapport des sexes comme central. L'histoire des femmes, en somme, n'est possible qu'à ce prix.'[27] In another contribution to the same collection of essays, Geneviève Fraisse argues:

Pendant longtemps, on a justement classé les féminists en les qualifiant de suffragettes, c'est à dire de bourgeoises et d'intellectuelles. Le socialisme a beaucoup aidé à construire cette image car il fallait maintenir une contradiction

24. M. Barrett, *Women's Oppression Today. Problems in Marxist Feminist Analysis*, pp. 8–9.

25. A. Kuhn and A. Wolpe (eds), *Feminism and Materialism: Women and Modes of Production*, London, 1978.

26. L. Trotsky, *Women and the Family*, 2nd edn, New York, 1973, p. 8.

27. M. Perrot (ed.), *Une histoire des Femmes est-elle possible?*, Paris, 1984, p. 15.

entre féminisme et socialisme, comme entre féminisme et syndicalisme . . . il resort que la féministe est *ipso facto* ignorante du problème du travail: cela ne l'intéresse pas. Ainsi la militante féministe c'est non seulement l'exception contre la masse, c'est encore la bourgeoisie ou même la petite bourgeoise qui esquive la réalité première du gain et du coût du pain quotidien.

On the contrary, argues Fraisse, feminism crosses classes and socio-professional categories because women have far more factors which are common to them as women, than the issue of work. Again we see a misunderstanding of the differences between Marxism and feminism here, and the repeated accusation of crude economism directed at Marxist analyses of women's oppression. Indeed in her own essay contribution to the collection Perrot unjustly asserts that Engels 'subordonne pour longtemps, dans la théorie et l'action socialiste, la libération des femmes à la collectivisation de la propriété'.[28]

Joan Wallach Scott, in her book *Gender and the Politics of History*, argues for gender to have an independent analytic status as a category of historical analysis. In Chapter Two of her book she discusses various categories of feminist history, dividing them into groups thus: (1) Feminists who concentrate on theories of patriarchy; (2) feminists who attempt to link with Marxist theory; (3) feminists who use psychoanalysis to explain the gendered production of subjectivity.[29] While Scott has some very useful comments on the dangers of approach (3), arguing that it can sometimes result in reinforcing the notions of binary oppositions of male and female throughout history, she is less incisive on other points. Where I would differ most strongly from her is where she assumes that all women's history is written by feminists. For example she equates rejection of women's history with rejection of feminism in statements such as the following: 'In the case of women's history, the response of most nonfeminist historians has been acknowledgement and then separation or dismissal . . .'[30]

The final feminist historian I want to refer to is Denise Riley. Her book *'Am I that name?'* has been considerably influential, but I have to say that I find her theoretical position rather fudged. She argues that to talk about 'women' and 'women's history' is to talk of essentialist categories which do not exist. The notion of 'woman' itself must be questioned, as for Riley, the main point is to investigate structuralist uses of language: the question is 'not a matter of there being different *sorts* of women, but of the effects of the designation,"woman"'.[31] She writes:

28. G. Fraisse, in *Une histoire des Femmes*, pp. 196-8, and Perrot, ibid., p. 213.
29. J.W. Scott, *Gender and the Politics of History*, New York, 1988, p. 33.
30. Ibid., p. 30.
31. D. Riley, *'Am I that name?' Feminism and the Category of 'Women' in History*, Basingstoke and London, 1988, p. 111.

To put it schematically: 'women' is historically, discursively constructed, and always relatively to other categories which themselves change; 'women' is a volatile collectivity in which female persons can be very differently positioned, so that the apparent continuity of the subject of 'women' isn't to be relied on; 'women' is both synchronically and diachronically erratic as a collectivity, while for the individual, 'being a woman' is also inconstant, and can't provide an ontological foundation.[32]

While I accept that 'women' is not particularly precise as an analytical category of history, though this is not the major point Riley wants to make, I think her method of approaching women's history in terms of the construction of 'woman' by discourse, understood in systems of opposition in the superstructural sphere, is fundamentally flawed. In fact she finds it impossible to square the circle herself, so severely is she hampered by her relegation of material reality to a subordinate position vis-à-vis categories of discourse: 'I'd argue that it is compatible to suggest that "women" don't exist – while maintaining a politics of "as if they existed" – since the world behaves as if they unambiguously did.'[33]

My position in this book is that we can use the category 'women'/'woman', since we are talking of this group of people as oppressed as a category. However I do think it is important to discuss 'different *sorts* of women' – different in terms of class, different in terms of their historical situation, different in all kinds of ways. But a theoretical method is needed which links particularities to general theoretical method, otherwise we are left with relativism or empiricism. While I accept that notions of 'woman' change according to various historical factors, I will argue that changes in notions of 'woman' or 'man' are explicable in terms of the material bases of the societies these notions exist in. The way such terms encompass contradictory processes in particular social situations can also help explain why and how notions of 'woman' and representations of 'woman' may change, in a way that an idealist scheme such as Riley's does not. Consequently her attempts to fuse her theoretical framework with her historical research are ultimately rather uneasily managed.

It is relevant here to note some helpful and stimulating books discussing Engels' exposition of the historical processes which resulted in the subordination of women. The first, *Engels Revisited*, is a collection of essays discussing the arguments in *The Origins of the Family*. The essays are written from a socialist feminist standpoint: 'The issue for socialist feminism is to establish a materialist analysis of women's subordination that, in emphasising class politics – does not follow Engels in assuming that concepts of emancipation, freedom and equality are always similar

32. Ibid., pp. 1–2.
33. Ibid., p. 112.

in their implications for men and women.'[34] It is doubtful whether Engels assumed this at all! However the essays try to grapple with Marxism's contribution to the understanding of women's oppression in some rather interesting, if curious, ways. Engels' book is hailed 'as a pathbreaking attempt to develop a feminist methodology' and his book 'contains the germ of a feminist methodology'.[35] The famous passage where Engels states that 'According to the materialistic conception, the determining factor in history is, in the final instance, the production and reproduction of immediate life' is taken as a basis for the development of the socialist-feminist thesis of the two parallel systems of oppression, economic and sexual. Interestingly though, Engels' consideration of social aspects of reproduction is seen as 'non-Marxist'.[36] In the context of Engels' book as a whole, it is quite clear that he sees forms of reproduction of humankind as changing throughout history in accordance with different economic bases of society, from the clan, the extended family, to the 'monogamous' couple. However it is interesting here to see that where a Marxist analysis does attempt to theorise questions of reproduction, this is seen as non-Marxist. A similar re-categorisation of Marxist women also takes place, as we shall shortly see.

A more interesting and very well researched collection of essays dealing with Engels' arguments is the collection *Women's Work, Men's Property*. In particular, the essay by Lila Leibovitz argues that production came first and that sexual division of labour, along with incest taboos and marriage exchanges, appeared late in human history. She argues that 'the institutionalisation of the sexual division of labour created the conditions which *reduced* physical sex differences', in that production could be more efficiently undertaken for the benefit of the whole group. 'Thus,' she writes, 'I do not go along with the structuralist argument that women were subordinated to men as soon as basic cultural institutions emerged.'[37] Thus there are still those prepared to argue, even in the light of up-to-date evidence unavailable to Engels, that his basic method was correct in arguing that property forms based on private property, not gender differences, are where we ultimately must seek the explanation for

34. J. Sayers, M. Evans, N. Redclift (eds), *Engels Revisited, New Feminist Essays*, London and New York, 1987, p. 97.
35. Ibid., pp. 11, 12.
36. See the essay by M. Gimenez, 'Marxist and non-Marxist elements in Engels' views on the oppression of women', in *Engels Revisited*.
37. L. Leibowitz, 'In the Beginning . . .: The Origins of the Sexual Division of Labour and the Development of the First Human Societies', in S. Coontz and P. Henderson (eds), *Women's work, Men's Property: The Origins of Gender and Class*, London, 1986, p. 74.

women's oppression in history.[38]

Finally in this section of my argument, I want to look at the claim that Marxism has had nothing to offer the theory and practice of the struggle for women's liberation. As I studied Marxism over the years, I came across many women (and men) who, as Marxists, fought for women's liberation from oppression and exploitation. Most of them had political differences with feminist movements of their times and voiced these differences verbally or in writing. Historical documentation can confirm this. What I discovered, though, was an appropriation by feminism of all of these people simply because they had fought for women's liberation – the argument is, of course, that anyone who does this must be a feminist, just as anyone who studies women's history is a feminist. Marxists, by definition, it is argued, cannot take women's issues seriously.

For example, in a recent publisher's catalogue from Cambridge University Press describing a book by R.C. Elwood, *Inessa Armand. Revolutionary and Feminist*, we are told Armand was 'a leading Soviet feminist from 1917 to 1920'. K. Honeycutt's PhD thesis, Columbia University 1975, is entitled *Clara Zetkin: A Left Wing Socialist and Feminist in Wilhelmine Germany*. A. Meyer, in an essay written in 1978 refers to Zetkin as 'recognised as one of the chief feminists in the Communist movement'.[39] Perhaps worst of all, however, is the designation of Kollontai as an 'unconscious feminist' by Françoise Navailh. In a section of her essay sub-headed 'Kollontai, une féministe malgré elle', Navailh writes: 'Kollontai propose une synthèse de marxisme et de féminisme inavoué (elle l'a toujours combattu) . . .'[40] The idea that Kollontai as a conscious revolutionary, a Menshevik first, then a Bolshevik, who based her work on consciously attempting to understand the society of the Russian Empire, to combat its economic exploitation and ideological subjugation of women, could unconsciously be a repressed feminist is quite wrong. I think at times Kollontai made some tactical mistakes in condemning feminism too harshly on a few occasions, but it is undeniable that she was, correctly in my view, a consistent opponent of the whole notion of cross-class feminism. After one of her many speeches attacking this notion at the expense of the needs of working-class women,

38. For further comments on Marxist theory and differences with feminism(s), see the section 'Feminism's Fatal Flaws', in *Communism and Women's Liberation*, Jill Daniels, Gen Doy, Sue Thomas, Din Wong, editorial collective, London, 1980, and the updated version of this pamphlet, *Marxism and Women's Liberation*, London, 1994, published by the League for a Revolutionary Communist International, BCM Box 7750, London WC1N 3XX.

39. See D. Atkinson et al., *Women in Russia*, Brighton, 1978, p. 111.

40. See F. Thébaud (ed.), *Histoire des Femmes en Occident*, vol. 5, *Le XXᵉ Siècle*, Paris, 1992, p. 217.

'Kollontai's hostile remarks . . . evoked the cry "Strangling is too good for you" from an irate feminist'.[41]

It is no wonder really, in the light of the arguments I've outlined above, that many women students and feminist activists sincerely believe that Marxists made little contribution to 'the woman question', since obviously any who did are redefined as feminists.

It will be my aim in the remaining sections of this book to show that Marxism, far from being incapable of understanding women's history and culture, has a crucial role to play in re-examining some old 'truths' and posing new questions to women's art history. The position of many feminist historians in accepting patriarchal gender oppression as equally, if not more, fundamental to society than exploitative property forms has, I believe, led some feminist historians to their own form of 'blindness' on the question of women. Marxism as a method has much to offer women's history and women's art history and will develop and enrich itself by engaging with the issues raised in this book. Marxist art history is, I believe, still at an early stage of development. However, as I have argued, there is nothing at all intrinsic to Marxism *as a method* that renders it incapable of analysing the complexities of relating visual imagery to the particular gender presentations generated by artists in specific historical material conditions. The significant contributions of feminist scholarship in the field of visual imagery have done much to transform our view of art history in the recent past. My aim here is to utilise and develop this work from a Marxist perspective in order to, firstly, offer some rather different conclusions in cases where I believe feminist theories have resulted in mistaken viewpoints, and, secondly, to elaborate some preliminary frameworks for opening up a fruitful and constructive debate around work on women's history and visual culture.

41. R. Stites, *The Women's Liberation Movement in Russia. Feminism, Nihilism and Bolshevism, 1860–1930*, new edn, Princeton, 1991, p. 213.

Women and the Bourgeois Revolution of 1789: Artists, Mothers and Makers of (Art) History

In this chapter, I want to re-examine several questions relating to women artists, representations of women and women's position in society in late eighteenth-century Paris. I would like to reconsider aspects of these questions because I feel that, although a considerable amount of work has been done on women and the French Revolution, the conclusions drawn by many authors have been mistaken at worst, or rather rigid at best.[1] The reasons for this, I would argue, are linked to the methodology employed by the authors concerned, which sees the French Revolution as primarily a gender struggle, where 'women' were defeated by 'men'. For example, in her recent book which makes a substantial contribution to scholarship in this area, Madelyn Gutwirth concludes in the final part of her analysis that the radical revolution 'ratified . . . male sex-right. This is largely because the French Revolution itself arrived in the midst of a longer and broader struggle to resist women's advancement in society and to restore an unquestioned male supremacy'. Men of the Revolution did not grant women equality because 'They would have had to acknowledge the deeper human consonances between the sexes, and not hate the feminine and fear the homosexual component of their own personalities'.[2] Gutwirth understands the motor force of historical change as a struggle between genders, and in this she is fairly typical of a number of women art historians. I cite her book as an example of this position because it deals with the French Revolution and representations of women, and because it is a recent example of this method, not because it is unusual in any way.

1. Since the bicentennial of the Revolution in 1989, a large number of books and articles dealing with women and the bourgeois Revolution and representations of women in late eighteenth and early nineteenth-century France have been published. For a useful historical perspective on the study of women in the Revolutionary period, see K. Offen, 'Women's Memory, Women's History, Women's Political Action', in *Journal of Women's History*, vol. 1, no. 3, Winter 1990, pp. 211–30.

2. M. Gutwirth, *The Twilight of the Goddesses, Women and Representation in the French Revolutionary Era*, New Brunswick, New Jersey, 1991, p. 383.

Gutwirth's work is also fairly typical of much writing on representations of women in that the Marxist method is dismissed fairly early on in the book, as having nothing very useful to offer on the subject of women, or even anything of relevance to the cultural sphere: 'Marxist history of the Revolution, concentrating on economic forces, made little room for women as a factor important to its evolution.'[3] This rather crude understanding of Marxism is, as we have seen, not unusual in books discussing women and the visual arts.

In this chapter, I will be arguing from a Marxist understanding of (1) the French Revolution as a bourgeois revolution and (2) women's participation in politics and cultural life at the time.[4] In so doing I hope to show that, far from being a crude and unsubtle obstacle to understanding women's role in history and culture, a Marxist perspective can enable us to gain an understanding of the complexities and contradictions of these issues. As I argued in Chapter One, Marx's and Engels's assertion that 'the *ultimately* determining element in history is the production and reproduction of real life' does not mean that cultural and superstructural 'results' can be crudely deduced from the economic base.[5] Political, ideological and cultural relations interact with economic factors, and I would include gender relations in their interaction with economic factors as well. However I am keen to argue for a reversal of the priorities of economics and gender struggles accepted by, for example, Gutwirth and Pollock, and I want to look closely here at the relationship of economic factors to gender struggles.

The three main issues I want now to focus on are:

1. What did the French Revolution mean for women, and is it true to argue it was a 'world historical defeat for women'?[6] Specifically, what did a bourgeois revolution mean for the professional careers of *women* artists?

3. Ibid., Preface, pp. xv, xvi.

4. Attempts were made recently to 'rewrite' the French Revolution and argue that it was not really a bourgeois revolution which swept away feudalism. See, for example, F. Furet, *Interpreting the French Revolution*, Cambridge, 1981, G.C. Comninel, *Rethinking the French Revolution*, London, 1987, and R. Robin, *La Société Française en 1789, Semur-en-Auxois*, Paris, 1970. For a refutation of these arguments, see D. Hughes, 'Defending the French Revolution 1789–93', *Permanent Revolution*, no. 8, Spring 1989, pp. 75–111.

5. See Engels's letters to Bloch and Borgius in M. Solomon (ed.), *Marxism and Art*, Brighton, 1979, pp. 30,33.

6. This representation is adopted in many studies. See, for example, Pollock in *Vision and Difference*, referred to above, in Chapter One, p. 46, and the article by Margaret George, cited by almost every work in English on this question, 'The World Historical Defeat of the Républicaines Révolutionnaires', *Science and Society*, 40, 4, 1976–7. The term is taken

2. Is it correct to explain the making of images of female allegories during the revolutionary period as a displaced cultural manifestation of the exclusion of women from political life?[7]
3. Can we read images of maternity at this period as simply oppressive manifestations of patriarchal bourgeois ideology? What did child-bearing and child-rearing actually mean for women of different classes in late eighteenth-century Paris, and did the actual experience of women as mothers bring them into conflict with, and even force them to go beyond, bourgeois ideologies of motherhood?[8]

Firstly, with regard to women and the bourgeois revolution in France, we have to realise that this question is very complex and a description of the bourgeois revolution as 'a world historical defeat for women' raises several problematic issues. For example, are we therefore to conclude that women were somehow better off under the disintegrating feudalism of the

from Engels, who coined the phrase 'world-historical defeat of the female sex', to describe the overthrow of mother right in prehistoric times, not the eighteenth century. See F. Engels, 'The Origin of the Family, Private Property and the State', in *Karl Marx and Friedrich Engels. Selected Works in One Volume*, London, 1973, p. 488. A recently published work argues that the Revolution represents 'The Father', and women are the 'rebel daughters'. See S.E. Melzer and L.W. Rabine, *Rebel Daughters*, Oxford, 1992, especially the Introduction.

7. See, for example, Gutwirth, section 2, chaps 5–9; L. Hunt, *Politics, Culture and Class in the French Revolution*, Berkeley, 1984; and L. Zerilli, 'Motionless Idols and Virtuous Mothers; Women, Art and Politics in France 1789–1948', *Berkeley Journal of Sociology*, vol. xxvii, 1982, pp. 89–126 – 'The Jacobins obliterated real women and replaced them with stone statues and live allegories. Subjects were ousted by objects; men reduced female warriors into objective symbols of their own fantasies' (p. 106). The same argument is put forward by Joan B. Landes and N. Schor in their respective essays in *Rebel Daughters* (eds) S.E. Melzer and L.W. Rabine, Oxford University Press, 1992. Gutwirth restates her views in 'The Rights and Wrongs of Woman; the Defeat of Feminist Rhetoric by Revolutionary Allegory' in J.A.W. Heffernan (ed.), *Representing the French Revolution, Literature, Historiography and Art*, Hanover and London, 1992. This view has become 'accepted wisdom' in virtually every article and book now published on the topic, sometimes leading to very dubious misreadings of some of the imagery. See, for example, E. Rand, 'Depoliticising Women: Female Agency, the French Revolution and the Art of Boucher and David', in *Genders*, no. 7, Spring 1990, pp. 47–68, and Ewa Lajer-Burcharth, 'David's *Sabine Women*: Body, Gender and Republican Culture under the Directory', *Art History*, vol. 14, no. 3, Sept 1991, pp. 397–430. For a more rounded discussion of similar issues see Chapter V, 'Women in the Popular Arts', of the excellent doctoral thesis by V.P. Cameron, *Woman as Image and Image-maker in Paris during the French Revolution*, PhD, Yale, 1983, University Microfilms International, Ann Arbor, 1984. In a recent article, Abigail Solomon-Godeau, while accepting wholeheartedly as proven fact 'the virile and purposeful manhood of the revolutionary moment', raises some complex and interesting questions concerning what she describes as 'an internalized division within the patriarchal imaginary'. See 'Male Trouble: A Crisis in Representation', *Art History*, vol. 16, no. 2, June 1993, pp. 286–312.

8. An important article on this subject is by Carol Duncan, 'Happy mothers and other new ideas in French art', *Art Bulletin*, 55, 1973, pp. 570–83, and more recently developed by Gutwirth, ch. 2.

old régime? Many books rightly point out that some upper-class women did have political rights under the old régime because they had inherited rights vested in a piece of land, for example. Also abbesses had certain political rights. Thus some noblewomen and women of the clergy actually voted for delegates of the first two estates to the States General in 1789. In addition to this, a few women of the third estate, particularly widows, managed to take part in some of the primary assemblies.[9] In the process of the bourgeois revolution, these political rights for a few women disappeared. Undoubtedly it was oppressive and discriminatory of the vast bulk of the bourgeois revolutionaries to refuse to grant women the right to legal political rights, but we have to consider whether this was a result, primarily, of gender struggles. We have to consider whether the bourgeois revolution and the overthrow of feudalism opened up far greater possibilities for political and economic activity by women which cannot be measured just in terms of legal political rights granted by bourgeois legislation.

Far greater numbers of women became engaged in political activity than under the old régime, irrespective of whether the Jacobins and Girondins approved legally or not, as will be shown shortly. In fact from August 1792 till July 1794 there was a situation of dual power in Paris with the 'legal' elected representatives of the bourgeoisie, on one hand, and the popular 'sections' where the urban plebeian masses organised on the other. Many of the latter included women. Many *sans-culottes* women and women from the poorer sections of Parisian society were politically active in ways which were not 'legally' sanctioned. For example, the famous march to Versailles in 1789 when women of Paris forced the Royal Family to return with them to Paris, or the mass gathering on the Champ de Mars on 17 July 1791, where signatures to a petition demanding a referendum on the role of the monarchy in the state were organised.[10] About fifty people were killed when this gathering was fired on by the National Guard, commanded by Lafayette. Women were active on this occasion as well and determined to participate in popular forms of political action. A young boy testified that 'we saw many people go up to sign, among them, with her children [was] an old woman, who, not knowing how to write, had one of her children sign for her'. One of the people arrested and interrogated after the Champ de Mars was Louise Evrard, a cook, who understood very well what the political question in the petition was about. It was, she said, intended 'à

9. See J. Abray, 'Feminism in the French Revolution', in *American Historical Review*, LXXX, February 1975, p. 44.

10. For women's participation in political societies and organisations during this period and earlier in the Revolution, see D. Levy et al. (eds), *Women in Revolutionary Paris, 1789–1795*, Chicago and London, 1979. See also M. Cerati, *Le Club des Citoyennes Républicaines Révolutionnaires*, Paris, 1966.

faire organizer autrement le pouvoir exécutif'.[11] While women were certainly excluded from legal participation in politics, this is again not completely explained by gender. Most of the writings by art historians on the French Revolution seem to overlook the fact that not all men were given legal political rights by the bourgeois Revolution either. The distinction between 'active' and 'passive' male citizens was drawn up in 1789, and persisted throughout the Revolutionary period. So it was never really the case that all men enjoyed political rights while all women were excluded from them. Male participation in official political activities was based on property qualifications.[12]

Similarly if we look briefly at the destruction of the feudal economy and the introduction of the free market as a result of the Revolution, we can see that it is not really possible to make a generalisation that women were all much worse off and men were all much better off, as a result of the emergence of modern capitalism in France. This is obviously a huge question and too large to tackle here at any great length, but I would like to make a couple of points about this in general, before looking at how the Revolution affected the careers of professional women artists in particular. Firstly, the question of women and the guilds is significant. Although for many years guilds had been restricting the possibilities for women to join and/or participate in their organisations, women artisans and 'mistresses' of shops viewed the guilds as a protection from economic competition.[13] Already the monarchy had abolished the guilds in France in 1776. Many of the early demands of women during the Revolution were for education and training, as they saw themselves at a disadvantage on the free market without equal access to professional and artisanal qualifications. Different groups of women therefore had different attitudes to the demise of the old régime. Tradespeople, including women, wanted guilds re-established as some form of protectionism, market women were more eager to go with the 'free market', while poor women came into bitter conflict and physical confrontation with the market women in a struggle

11. See the very interesting essay by D.G. Levy and H.B. Applewhite, 'Women of the Popular Classes in Revolutionary Paris, 1789–1795', in C.R. Berkin and C.M. Lovett, *Women, War and Revolution*, New York and London, 1980, ch. 1., pp. 17,18.

12. See A. Soboul, *The French Revolution 1787–1799*, 2 vols., London, 1974. Points regarding 'active' and 'passive' male citizenship are well raised in the article by Joan Wallach Scott, 'French Feminists and the Rights of "Man": Olympe de Gouge's Declarations', in *History Workshop Journal*, Issue 28, Autumn 1989. However I feel her (post)structuralist approach never allows her to break out of a framework of binary oppositions constructed around gender 'discourses', in spite of the historical evidence she herself cites.

13. For women and the guilds in early capitalism see the very useful essay by Merry E. Wiesner, 'Spinning out Capital: Women's Work in the Early Modern Economy', in R. Bridenthal, C. Koonz and S. Stuard (eds), *Becoming Visible. Women in European History*, 2nd edn, Boston, 1987.

over 'price fixing' at the height of the Revolution.[14]

Secondly, if we look at the economic activity of women in Paris at this time, we would have to conclude that women artists were part of a small élite among women. It is estimated that only a tiny fraction of Parisian women achieved any economic independence. Those who did included skilled seamstresses and dressmakers who ran their own ateliers, successful artists and market women with their own stalls.[15]

In a situation where women manual workers were usually paid less than men, women artists were actually in a better position than many other women in that the free market offered them, in theory, an equal chance of selling their work and furthering their economic prospects.[16] The demise of the Academy, and the first 'open Salon' without a jury where anyone could exhibit their work, held out important possibilities for women, though many of these were eventually closed off to them. The examples of the careers of Anne Vallayer-Coster and Elizabeth Vigée-Lebrun can be cited here.[17] However, the point about the 'free market', as many women's petitions and demands pointed out early on in the Revolution, was that not everyone started off in the 'free market' from a position of equality. What, then, can we learn from a brief survey of the careers of some key women artists of this period under the old régime and the Revolution?

Virtually all the women artists at this period were members of the bourgeoisie at one level or another, and this was hardly surprising. Perhaps the best placed in the period before 1789 was Anne Vallayer-Coster

14. See C. Marand-Fouquet, *La Femme au temps de la Révolution*, Paris, 1989, pp. 26ff. Market women were important participants in events during the Revolution and eventually sided with the Jacobins against more radical *sans-culotte* women. They were used to public activities in the market place, talking loudly and shouting to attract customers, and persuading passers-by to listen to them. For market women and their politics see the fascinating book by Dominique Godineau, *Citoyennes Tricoteuses, Les femmes du peuple à Paris pendant la Révolution française*, Paris, 1988, pp. 164ff. Godineau cites the market women's refusal to wear the cockade, as demanded by the Société des Républicaines Révolutionnaires. They retorted that 'only whores and Jacobins wear it'. Later the market women sided with the Jacobins in suppressing the Société who were violently opposing the free market as a means of determining price levels.

15. M.D. Johnson, 'Old Wine in New Bottles: The Institutional Changes for women of the people during the French Revolution', in Berkin and Lovett (eds), *Women, War and Revolution*, p. 109.

16. For women workers, struggles over pay and conditions, and implications of this, see Godineau, pp. 66ff.

17. See A.S. Harris and L. Nochlin, *Women Artists 1550–1950*, Los Angeles County Museum of Art, 1976, p. 37. This catalogue and the catalogue of the exhibition, *De David à Delacroix. La peinture française de 1774 à 1830*, Grand Palais, Paris, 1974–5, are the main sources I have used for information on women artists of this period. Also very interesting, with material from archival sources not in either of these two catalogues, is E. Harten and H.C. Harten, *Femmes, Culture et Révolution*, Paris, 1989, especially pp. 70ff.

(1744–1818), a still-life specialist. She was the daughter of a royal goldsmith who had managed to set up his own workshop. Her mother ran the family workshop after her husband's death, as quite commonly happened. She seems not to have been associated with the Académie de St Luc, which was a useful training and exhibition organisation for a number of women artists until it was closed down by the royal decree abolishing the guilds in 1776.[18] She married a wealthy lawyer and parlementaire which meant access to the very highest ranks of the bourgeoisie.[19] By this time these members of the so-called *noblesse de robe*, who passed on state offices they had bought from father to son, were almost indistinguishable from the old nobility. Vallayer-Coster had already been unanimously received into the Royal Academy in 1770, and her customers were to include the Marquis de Marigny, original owner of her famous *The White Soup Bowl* (private collection, Paris).[20] After Marigny's death this was brought by a conseiller d'Etat, M. Beajon. Marigny also had works by her in his Château de Bellevue. She had connections at Court, and pressure from Marie-Antoinette resulted in Vallayer-Coster being given space in the Louvre beside other artists' ateliers, which was unusual for a woman artist. Labille-Guiard had a long fight over this issue later.[21] However in spite of her high-class connections, Vallayer-Coster's work was not immune from insulting comments of a sexist nature on occasion. Critics did not approve of her portraits, though they liked her still lifes, and one stated that her portraits had no more value than the achievement 'of a man without fingers when he threads a needle, that of doing something badly which the lack of means renders almost impossible'.[22] Possibly because of her royalist connections Vallayer-Coster kept rather quiet in the 1790s. However, there are 444 listed works in the *catalogue raisonné* of her work and obviously this is the output of a prolific and successful professional career. As far as I can see from the available sources, she had no children, but this is not absolutely certain.

18. Harris and Nochlin, *Women Artists*, p. 37.

19. The marriage contract shows the substantial economic considerations inherent in such *haute-bourgeois* alliances, see M. Roland Michel, *Anne Vallayer-Coster 1744–1818*, Paris, 1970, pp. 264–7. Witnesses to the signing of the contract included Marie Antoinette and the Arts Minister D'Angiviller.

20. Harris and Nochlin, *Women Artists*, cat. no. 52, colour plate, p. 82.

21. See Anne Marie Passez, *Adelaide Labelle-Guiard, 1749–1803, Biographie et Catalogue raisonné de son oeuvre*, Paris, 1973, pp. 27ff.

22. Harris and Nochlin, *Women Artists*, p. 180. Although probably intending them as complimentary remarks, Michel too makes points about the artist's gender and her work: 'Des caractéristiques avant tout féminines se dégagent de ce que nous connaissons de son oeuvre: un goût pour la finesse, la précision, le détail exact, autant de points qui lui permettent de manifester ses aptitudes à une transposition aussi exacte que possible de la nature'. See Michel, *Anne Vallayer-Coster*, p. 82.

Some interesting conclusions can be drawn from this brief survey of her work in the eighteenth century. Firstly, she had no trouble being accepted into the French Academy and received high praise as a still-life painter; secondly, still life cannot always be seen as the humble undervalued sphere of domestic genre on a small scale as often described in books on women's art – one of her works (no.53) mentioned in the Harris and Nochlin catalogue *Vase of Flowers with a Bust of Flora*, 1774, is 154 x 130 cm – and her patrons were *noblesse de robe* and *noblesse d'épée* and royal family. However, as soon as she tried to exhibit portraits, unfavourable comparisons were made with superior 'masculine' skills.

Most of the books on women's art inform us, rightly, that women were largely unable to produce history paintings until this period due to lack of access to proper training.[23] They were therefore mostly relegated to the inferior genres of still life, portraiture, genre, landscape, etc. We have seen, however, that still-life painting could command prices and patrons, particularly if the artist possessed the skills required and the necessary social connections. Portraiture was no 'easy' alternative to history painting, despite the success achieved in this genre by Vigée-Lebrun and Adélaïde Labille-Guiard, which I will consider shortly. Academic doctrine and its hierarchy of genres did not always coincide with the demands and tastes of patrons and art buyers before or during the Revolution. Whereas the 'ideal' of the Academy and the King's arts ministry in the last years of the old régime was history painting, and the Revolution also sought to clothe the bourgeois struggle for power in the language of classical history painting, the reality of the market was very different. Some women did try to move into the field of history painting at this time, but they were unlikely to suffer economically if they did not, because there was a limited demand for history paintings. From 1791 onwards the open Salons expanded, exhibiting increasing numbers of works by women artists. Portraits, landscapes and genre scenes vastly outnumbered history paintings. For example, from 1789 to 1808, subjects from ancient history made up less than 4 per cent of all works exhibited at the Salons.[24]

The open Salons gave more artists and more women artists a chance to put their work on the market and display it to a larger number of potential

23. There is some evidence, contrary to the categorical statements in many books on women's art, that women artists did study from male nude models, the foundation of elevated art, although this was very unusual. In Chapter Two of her doctoral thesis, Vivien Cameron discusses studies of male and female nudes by the artist Pauline Auzou, which she was able to locate during her research. She suggests that Regnault, Auzou's teacher, must have allowed female students access to nude models but simply kept quiet about it. It is possible this happened in other studios when artists were prepared to take on female students, as this fact in itself indicated a 'liberal' attitude.

24. *De David à Delacroix*, exhibition catalogue, p. 109.

customers. These trends continued into the period of consolidation of the bourgeois state in the nineteenth century. As Harris and Nochlin point out: 'In the 1801 Salon, out of a total of 192 painters exhibiting about 28, or 14.6% were women; in 1810, out of 390 painters exhibiting, about 70, or 17.9% were women; in 1822, out of 475 painters exhibiting, about 67, or 14.1% were women; and in 1835, out of 801 painters exhibiting, about 178, or 22.2% were women.'[25] Given this information, it is difficult to sustain the argument that the French Revolution was a historic defeat for women artists, although disputes about their official position in art organisations continued in the early 1790s.

To develop this point, I want to consider some aspects of the careers of two portrait specialists active both in the *ancien régime* and during the period following the Revolution, Labille-Guiard and Vigée-Lebrun.[26] Both were Academy members, although shortly after they were admitted in 1783 the Academy had limited women members to four. Their works and careers are rather different; artistically and politically their responses to the Revolution also diverged.[27]

Labille-Guiard (1749–1803) was the daughter of a fashionable haberdasher. As a daughter of the bourgeoisie she was convent-educated from the age of six to eleven but then, unusually, trained as an artist and exhibited with the Académie de Saint-Luc. She married a minor state functionary (clerk) in 1769 and separated from him with a *séparation des*

25. Harris and Nochlin, *Women Artists*, p. 46. There were three women artists exhiiting in 1789, nineteen in 1791, thirty in 1793. See Harten and Harten, *Femmes, Culture et Révolution*, p. 71.

26. It is a rather interesting point that there were few women landscape artists in France at the time, and this genre does not seem to have attracted many female students. Vivien Cameron, in her doctoral thesis (p. 108), mentions some landscape works by women, including two exhibited at the open Salon of 1791 by Mlle Briceau. A critic writing in 1789 also mentions some landscapes by a Mlle Serrazin, according to Cameron. Perhaps women were discouraged from landscape work because it would involve them in activities outside the home, but if bourgeois women had been accompanied by chaperones this problem would have been solved. More work needs to be done on this interesting topic, as questions remain unanswered. For example, if we are to believe the claims of many historians, women were associated with nature and men with culture, in patriarchal ideology. Surely then women landscape artists would be encouraged as engaging in a particularly appropriate 'feminine' form of art. Perhaps these women landscapists existed and are awaiting discovery.

27. Marie-Jo Bonnet compares Labille-Guiard and Elizabeth Vigée-Lebrun and states that, in spite of their different artistic and political approaches, their common bonds as women are of overriding significance: 'Très vite en effet, les femmes peintres vont découvrier qu'elles sont femmes avant que d'être peintres.' See M.-J. Bonnet, 'La Revolution d'Adélaide Labille-Guiard et Elizabeth Vigée-Lebrun ou Deux femmes peintres en quête d'un espace dans la société', in vol. 2, of *Femmes et la Révolution Française*, Toulouse, 1989, pp.339–44. This three-volume work is full of very interesting papers from a conference held at Toulouse University and published by Presses Universitaires du Mirail, Toulouse.

biens (economic separation) ten years later. She had no children although she also later lived with the painter François Vincent. She had quite a number of female pupils (nine in 1783) some of whom lived in her household and one of whom stayed on after her death. This was Gabrielle Capet (1761–1817), who was helped by Labille-Guiard to become a painter, though she came (unusually) from a very poor background.[28] During the 1780s some bourgeois or perhaps even noble women would become benefactors and paid for young women without income to study with Labille-Guiard. For example, a Mme Victoire paid 1200 livres a year, plus small expenses, so that Mlle P. Hubert could live in Labille-Guiard's household and train with her.[29] Labille-Guiard had patrons from the bourgeoisie and the Royal Family. After the Revolution she painted leaders of the Revolutionary bourgeoisie. Her main setback caused by the Revolution was the forced destruction of a history painting including a member of the Royal Family on which she had been working for two and a half years. Although she was paid 8,000 francs compensation, this was a cruel blow, especially to a woman artist.

Labille-Guiard's attitude to the Revolution is interesting because she supported the bourgeois Revolution, in its early stages, at least, and argued for educational and professional opportunities for women to be provided by the state, not by well-off benefactors. She argued for more women Academy members, though not as full members, and in 1791 made proposals for training young women artists. Her suggestions were referred to approvingly by Talleyrand who stated that Labille-Guiard 'a su anoblir les arts en les associant au commerce, et en les appliquant aux progrès de l'industrie'.[30] Labille-Guiard argued long and hard for a studio in the Louvre but was refused until 1795 on the grounds that her young pupils might incite the male artists to immoral conduct. In 1793 Labille-Guiard took advantage of the Revolutionary divorce reforms and legally broke from her husband. Also in 1793 she joined the Société Républicaine des Arts. Harris & Nochlin say it was symptomatic of Revolutionary hostility towards women that they were immediately banned from this body.[31] This does not appear to tally with the information given by Harten and Harten

28. See biographical information in Harris and Nochlin, *Women Artists*, p. 195.
29. See Anne-Marie Passez, *Adelaide Labille-Guiard*, p. 22.
30. A.-M. Passez, p. 35. She 'has been able to ennoble the arts by linking them to commercial enterprise, and applying them to the progress of manufacture'.
31. Harris and Nochlin, *Women Artists*, p. 45. This statement, 'proving' the defeat of women by men in artistic organisations is repeated often in the literature. It is also stated by Vivien Cameron in her well-researched thesis. See also Viktoria Schmidt-Linsenhoff, 'Gleichheit für Künstlerinnen?', in the very useful catalogue *Sklavin oder Bürgerin? Französische Revolution und Neue Weiblichkeit 1760–1830*, Historisches Museum Frankfurt, Jonas Verlag, 1989, pp. 114–32. (ISBN 389282 - 015 - 5.)

who say that a large number of women were members – 21 painters, 2 sculptors and 4 engravers.[32] After the decree banning all women's clubs in late 1793 and the suppression of the *enragés*, the most radical elements within the bourgeois Revolution, women were banned from the Société. But this decision was later reversed and women were allowed back on an equal basis.[33] However four months after that the Society itself was dissolved along with other popular societies. If this is correct then the universal opposition to women cited by Harris and Nochlin would have to be questioned. For the decision on the exclusion of women to be reversed, there must have been considerable dissent and campaigning within the Société, by both men and women, I suspect.

It is obvious that, if women had already been excluded, it must have been a majority of men who overturned the previous decision and voted to allow women back in. Now there is little doubt that many men at that time saw women as unsuited to many professions and social activities carried out by men. However what seemed to happen in this case was quite a complex and shifting struggle between economic pressures and conscious (and unconscious) notions of gender roles reflected in the voting decisions of the male Société members. Professional and economic considerations had been important factors in the opposition of radical artists to the French Academy in the early Revolutionary period. It has been argued that a system of production of art works as exchange values, rather than as use values, had been developing before the French Revolution, i.e. private commissions were co-existing alongside more production for anonymous buyers on the market. Members of the Academy were prohibited from having a shop or being art dealers. All exhibitions other than the Salon were banned except the Exposition de la Jeunesse. Many Academicians wanted access to the market, freedom to exhibit and the possibility of engaging in economic transactions for themselves, as David would later do by charging individuals for admission to see his painting *Intervention*

32. Harten and Harten, *Femmes, Culture et Révolution*, p. 71.

33. Harten and Harten, in a note to p. 72, state that the minutes of the debate which overturned the previous decision to exclude women is on p. 333 of H. Lapauze, *Procès-verbaux de la Commune générales des arts et de la société populaire et républicaine des arts*, Paris, 1903. In fact the relevant minutes are on p. 334 and I will quote them here as they seem to have been ignored by all except Harten and Harten: 'Un membre propose à la Société d'admettre dans son sein les citoyennes artistes et de rapporter son arrêté qui les en exclus. Cette proposition est appuyée et combattue; on propose l'ajournement. Enfin on demande daller [sic] aux voix et la proposition mise aux voix il est arrêté que les citoyennes exerçant l'un des quatre arts qui ont le dessin pour baze seront admises comme membres de la Société républicaine des arts . . . l'assemblée passe à l'ordre du jour motivé sur ce que le mode d'admission pour les citoyens peut sans inconvenient être le même pour les citoyennes.' Séance du 2 Brumaire (Yr III, Boizot in the chair).

of the Sabine Women (Louvre).[34]

However the art market in the early 1790s was in severe difficulties and male artists may have been tempted to exclude women painters from direct competition with them for an increasingly small pool of financial resources. At the same time, however, the fact that male artists reversed their decision to exclude women from the Société before it was closed down appears to indicate a conscious acceptance by many males that it was wrong to discriminate against women in principle, even if their own short-term material interests suggested the opposite. This rather contradicts the view of Viktoria Schmidt-Linsenhoff that sexual politics was more important in artists' organisations than the problems of the art market.[35] In fact we can see that there are some very complex, contradictory and changing processes involving economics and ideology at work here. Economic factors do not result in obvious and straightforward ideological responses.

Labille-Guiard's commitment to a professional career for women in the fine arts is evident in her powerful self-portrait *Un tableau (portrait) de trois figures en pied, représentant une Femme occupée à peindre et deux Elèves regardant* (plate 1). The pupils are Mlles Capet and Carreaud de Rosemond, and the work was finished and exhibited at the Salon in 1785. The author of *L'Avis important d'une Femme sur le Salon de 1785*, whose identity we do not know, writes: 'C'est un homme que cette femme-là, entends-je dire. Comme si mon sexe était éternellement condamné à la médiocrité et ses ouvrages à porter toujours le cachet de sa débilité et de son ignorance.'[36] Several male reviewers were impressed with the force and vigour of the clear and monumental construction of the work. Labille-Guiard's work was technically accomplished and as this work demonstrates she was obviously prospering from her career as a teacher and artist. She was perceived to be taking on 'male' attributes at the same time as she presents herself as an attractive, independent woman, helping other women along the same career route. Her father's bust by Pajou is the only icon of masculinity in the image and is probably included to imply he would have been proud of his daughter's achievements, rather than to imply patriarchal authority, as it occupies a relatively minor position in shadow. As Harris & Nochlin point out, through this painting Labille-Guiard has also managed to get her two pupils noticed at the Salon thus circumventing the rule restricting exhibiting women artists to four. Labille-

34. See the useful essays by Annie Becq, 'Artistes et marché', pp. 81–95, and Udolpho Van De Sandt, 'La peinture: situation et enjeux', pp. 333-57, in *La Carmagnole des Muses. L'homme de lettres et l'artiste dans la Révolution*, edited by J.-Cl. Bonnet, Paris, 1988.
35. Schmidt-Linsenhoff, *Sklavin oder Bürgerin?*, p. 118.
36. *De David à Delacroix*, pp. 512–13.

Guiard is seated in the act of painting what is probably a portrait of the spectator as s/he looks at the artist and her pupils. But the artist's gaze is the dominant one as she is the creator of the image. One pupil looks out at the spectator/client, while the other compares the portrait with 'reality'. The women seem physically close and at ease in their surroundings in spite of the magnificent dress and hat of the painter. This skilfully executed portrait was compared favourably with Jean-Laurent Mosnier's piece of self-advertisement, *Portrait of the Artist in his Studio*, 1787, which was described by a contemporary critic as a misguided attempt to rival that of Labille-Guiard.[37]

In the painting by Mosnier, the artist is shown seated in the centre, looking out towards us, as if for our congratulations and approval. To the right is a portrait he is working on. Two young women, one of whom is in the portrait, look admiringly at the unfinished painting. Thus the women are there to admire Mosnier's work and be the 'object' of it, which is very different to the status of the two represented women standing behind Labille-Guiard.

The career of Vigée-Lebrun (1755–1842) is well known so I will only provide some brief information here. By 1789 she had already earned more than a million francs, most of which had been squandered by her husband with whom she had a disastrous marriage. She would have actually benefitted from the divorce reforms introduced by the Revolutionaries. However she was a royalist and her memoirs make clear her disgust at the *sans-culottes* she saw on the streets of Paris before her hasty departure as an *émigrée*. Her husband, who was living separately from her since he remained in Paris, petitioned the Revolutionary government, along with a number of artists, not to seize her assets in the 1790s, but Lebrun divorced her as an *emigrée*, possibly to safeguard himself, in 1794.[38]

Vigée-Lebrun developed her own strategies of self-presentation through the medium of self-portraiture. Vigée-Lebrun's famous *Self-Portrait in a Straw Hat* of 1783 (National Gallery, London) (plate 2) transforms the 'object' of Rubens' portrait of his wife Hélène Fourment into the 'subject' (the 'artist' Vigée-Lebrun) in control of the production and reception of

37. *De David à Delacroix*, p. 74 and cat. no. 135. V. Cameron in her thesis points to some of the subtleties of Labille-Guiard's iconographical references in this portrait. A bust of a vestal virgin by Houdon is shown in the background, suggesting a parallel between vestal virgins who in their third decade instructed younger candidates, and Labille- Guiard and her artistic trainees. While Labille-Guiard almost certainly was not a virgin when she painted this, she was aged thirty-six and perhaps could have been seen in a witty classical allusion as a 'priestess' of her art. Michel, *Anne Vallayer-Coster*, illustrates a work by this artist entitled *Jeune Vestale montrant le buste de Vesta*, of 1778, p. 46, cat. no. 317.

38. See the entry on Vigée-Lebrun in Harris and Nochlin, *Women Artists*, and Vigée-Lebrun's memoirs, *Souvenirs de Madame Vigée Le Brun*, 2 vols., Paris, no date.

her work.[39] Griselda Pollock has argued that this work demonstrates the unbridgeable gulf that bourgeois society created between the notion of 'woman' and that of 'artist'. I rather think that the whole point of the work is to show how a woman can be an artist, a skilled professional, and an articulate interpreter of revered artistic models for her own ends. I would suggest, however, that the opposite of what Pollock argues is the case, and that through the medium of self-portraiture both Vigée-Lebrun and Labille-Guiard were able to demonstrate the validity of being a woman and an artist (Vigée-Lebrun) and woman, artist and teacher (Labille-Guiard).[40]

The career of Marguérite Gérard (1761–1837) is also relevant here. She was a very successful artist, never married and had no children.[41] Her route to artistic training and success was through her sister, the wife of Fragonard. Marguérite Gérard lived in the Gérard-Fragonard household all her life, dying in 1837 after a long and fruitful career as a genre painter. Her father was a perfume producer in Grasse. She certainly benefited from the bourgeois Revolution and, according to Harris and Nochlin's researches, Gerard 'amassed an impressive personal fortune, investing her earnings from the sale of paintings in real estate and government annuities'.[42]

Although this is a limited sample, I think we can still draw some tentative conclusions regarding women artists, bourgeois ideology and the effects of the Revolution. None of these women particularly fit into the

39. A similar argument was developed in a paper by A. Rosenthal at a conference on 14 November 1992 in Brighton, organised to accompany the Angelica Kauffman exhibition at Brighton Museum and Art Gallery. See also the analysis of this painting in the forthcoming book edited by Ann Bermingham and John Brewer, *The Consumption of Culture: Word, Image, and Object in the 17th and 18th Centuries*, by Mary Sheriff, 'The Im/modesty of her Sex: Elizabeth Vigée-Lebrun in 1783'. Paula Rea Radisch offers a rather different argument, concluding that Vigée-Lebrun's self-portraits place her as part of 'a representation of woman situated squarely within the Rousseauian camp': *'Que peut définir les femmes?* Vigée-Lebrun's Portraits of an Artist', *Eighteenth-Century Studies*, vol. 25, no. 4, Summer 1992, p. 466.

40. See also S. Diaconoff, 'Ambition, Politics and Professionalism. Two women painters', in F. Keener and S. Lorsch (eds), *Eighteenth Century Women and the Arts*, New York, Westport, London, 1988, p. 230.

41. It is interesting that many of Gérard's works depict mothers and children. The relationship between supposedly dominant ideology and women's actual lives is posed here. Interestingly, Vivien Cameron mentions, in Chapter 11 of her thesis, that the artists Mmes Benoist and Auzou each had three children but did not show themselves as mothers in their work. Cameron speculates that their interests as artists took priority over their family responsibilities. I would suggest it is possible they did not wish to show themselves as mothers in public images of themselves. This should be compared with Vigée-Lebrun's portraits of herself and her child, and suggests that, with more research, we might discover a post-Revolutionary shift by some women artists away from images which attempt, in some way, to publically articulate supposed contradictions between their professional and personal lives.

42. See Harris and Nochlin, *Women Artists*, p. 197, for the entry on M. Gérard.

bourgeois ideal of 'womanhood'. They avoid having children if they can, they avoid getting married, or else if they do, their marriages do not conform to the contented love match complete with happy breast-feeding children encouraged by Rousseauesque ideas. Of course their lives did not fit such notions of womanhood because they had professional careers, their own income and property. Staying single and/or avoiding pregnancies made this a lot easier. The increased opportunities for women artists, the open Salon and the expansion of the art market in the 1790s and early nineteenth century gave more impetus to the contradictions implicit in the bourgeois notion of 'womanhood' and the potential, and actual, economic opportunities for women professionals. Of course lower-class women in eighteenth and nineteenth-century Paris were expected to work. They worked before the Revolution and after and this was seen as absolutely normal. Women workers had their own struggles and demands during the Revolution and we should not lose sight of this simply by focussing our attention on women of the bourgeoisie, from whose ranks most artists came. I will discuss representations of *sans-culotte* women later in this chapter.

One way in which the relationship of women's activities to Revolutionary imagery has been articulated and analysed is in the study of allegory. I would like to look briefly at some of the arguments about women and allegory during the Revolutionary period as I think, here also, a consideration of class and economics rather than post-structuralist theories of gender discourse will lead us to rethink some positions argued in recent literature. Hunt and Gutwirth have argued that the appearance of females in allegories accompanies, and is explained by, the exclusion of women from political and public life at this time.[43] Similarly Alex Potts, in an interesting article, recently argued that depictions of erotic male nudes of the Revolutionary period appropriated to themselves 'the "desirability" conventionally associated with images of women'. He saw this as having 'everything to do with the official exclusion of women from direct participation in the symbolic languages, as well as the realities, of public life at the time'.[44] However as we have already seen, lower-class men were

43. See Note 7 above and also the article by Joan B. Landes, 'Representing the Body Politic: The Paradox of Gender in the Graphic Politics of the French Revolution', in S.E. Melzer and L.W. Rabine (eds), *Rebel Daughters*, pp. 15-37; and in the same book, M. Gutwirth, 'The Rights and Wrongs of Woman: the Defeat of Feminist Rhetoric by Revolutionary Allegory', pp. 150–68; and the essay by L. Hunt, 'The Political Psychology of Revolutionary Caricatures', in the exhibition catalogue, *French Caricature and the French Revolution, 1789–1799*, Grunwald Center for the Graphic Arts, Wight Art Gallery, University of California, Los Angeles, 1988, pp. 33–40.
44. A. Potts, 'Beautiful Bodies and Dying Heroes: Images of Ideal Manhood in the French Revolution', *History Workshop Journal*, Issue 30, Autumn 1990, pp. 1–21.

also excluded from legal bourgeois political life though *not* because of their gender. Hunt explains how attempts were made by the Jacobin leadership to replace female allegories of Liberty with the figure of Hercules with a club in the late autumn of 1793. She links this to the suppression of the women's clubs, but at the same time the Jacobins were seeking to stamp out the most radical of the male clubs as well, for primarily political reasons, as for example with the arrest of the *enragés* in autumn 1793. Allegories of Hercules might therefore be read not as a substitution of 'maleness' for the suppressed 'other' of active women, but also as linked to attempts to suppress the force of armed male *sans-culottes*. This is obviously a question which needs more investigation.[45]

A problem with Potts's argument is that some of the 'beautiful' male nudes, e.g. Girodet's *Endymion*, 1791 painted in Rome, Salon 1793, and Fabre's *Death of Abel* at the Salon of 1791, were painted either in a place or time when it was far from clear that women were going to be 'officially excluded . . . from direct participation in the symbolic languages, as well as the realities, of public life at the time'.[46] According to Harten and Harten, images of political and military women were disapproved of by the Jacobins and tended to disappear in late 1793, then, after the summer of 1794, allegories of woman as Republican goddess are also eliminated.[47] They locate the most fruitful period of women's participation in the production of Revolutionary art works in the years 1793–4. This seems to indicate that the Jacobin dissolution of the women's clubs did not have the effect of suppressing women's *artistic* production. As Harten and Harten rightly point out the liberalisation of the salons and access of more women to the art market went along with their increasingly formalised exclusion from official bodies under the Directory. This contradiction at the heart of women's position under capitalism remained unresolved throughout the nineteenth century and obviously still exists today.[48]

45. There are also examples of imagery which attempt to combine traditional attributes of Hercules, e.g. the club, with Liberty and her attributes, so the opposition between the two is not always present. See, for example, *French Caricature and the French Revolution* catalogue, p. 229, *Liberty with Club*.

46. G. Bernier, *Ann Louis Girodet 1767–1824. Prix de Rome 1789*, Paris, Bruxelles, 1975, cites letters to show the *Endymion* was begun in late summer 1790 in Rome and was inspired by a bas-relief at Villa Borghese. Bernier sees in the painting 'une délectation homosexuelle dont les Salons de l'Epoque verront bien des exemples du à d'autres pinceaux', p. 16.

47. Harten and Harten, *Femmes, Culture et Révolution*, p. 50.

48. It is worth quoting their findings here: 'Notre étude de la production artistique révolutionnaire – production d'oeuvres se référant à la politique, à l'histoire et à la culture de la Révolution – nous a montré que les travaux de ce type se limitaient essentiellement aux années 1793–1794, autrement dit à la période où, d'une part, les femmes avaient la plus grande participation et les plus grandes possibilités d'expression dans le cadre de la

However Potts's argument about the 'beautiful' male bodies in French painting of the Revolutionary period does raise some very interesting issues which merit more research. He links these images with 'a dislocation in definitions of male subjectivity in post-Revolutionary society', where 'the male body seeks to appropriate to itself the full charge of erotic desirability conventionally associated with images of woman'. Potts is reluctant to reduce the appearance of these male nudes to the influence of Winckelmann, the theorist of neoclassicism who is known to have been a homosexual.[49] Potts explains he is intentionally using the term 'homoerotic' instead. While I agree that it would be very dubious to approach these images as clear examples of homosexual art, I am concerned that Potts's approach could unintentionally lead to an undervaluing and underresearching of homosexuality and representation during this period. It would be a mistake to write homosexuality out of existence by discussing these works in terms of discourses of 'the masculine' and 'the feminine'. I was not able to discover much in my own research, but what did emerge were examples of ambiguous and complex gender imagery which should lead us to question notions that the Revolution produced clear categories of masculine and feminine imagery, and that the former was superior to the latter.

Vivien Cameron quotes a source in 1794 (sic) which comments on the large amount of homosexual and lesbian behaviour, which the source associates with the Court under the old régime.[50] Until repealed by the Revolutionary government in 1791, French laws stipulated that sodomy was punishable by death.[51] However it is argued by some historians of lesbian and gay studies that it was not until the nineteenth century that

vie culturelle, et où, d'autre part, les espoirs d'une société démocratique et égalitaire étaient aussi les plus grands. Ces espoirs allaient de pair avec une conception socio-culturelle du rôle de l'art radicalement modifiée.' (Harten and Harten p. 74.) This whole section of their book is very useful.

49. Potts, 'Beautiful Bodies . . .', p. 16. But see K. Parker, 'Winckelmann, Historical Difference and the Problem of the Boy', *Eighteenth-Century Studies*, vol. 25, no. 4, Summer 1992, pp. 523ff.

50. V. Cameron, *Woman as Image . . .*, ch. 111, note 104. However I expect she means 1784, as explained below. J. Merrick, 'Sexual Politics and Public Order in late Eighteenth-Century France: The *Mémoires Secrets* and the *Correspondance Secrète*', in J.C. Fout (ed.), *Forbidden History. The State, Society, and the Regulation of Sexuality in Modern Europe*, Chicago and London, 1992, pp. 174–5, cites the *Mémoires secrets*, the source mentioned by Cameron. This mentions that in 1784 (not 1794) 'pederasts' and 'tribades' had 'never before paraded their "vices" so scandalously. Previously associated with aristocrats and wits, "pederasty" had allegedly become so fashionable that it now "infected" the entire social heirarchy, from dukes to the common people'.

51. See M. Rey, 'Police and Sodomy in Eighteenth-Century Paris: From Sin to Disorder', in K. Gerard and G. Hekma, *The Pursuit of Sodomy: Male Homosexuality in Renaissance and Enlightenment Europe'*, special issue of *The Journal of Homosexuality*, vol. 16, no. 1/2, 1988, pp. 144–5.

social notions of lesbianism and homosexuality existed in their modern sense.[52] References to blurring of clear-cut sexual boundaries were common in the 1790s. For example, the Panthéon Society (a political club), which had both men and women members and men and women officers, was referred to for this reason as the *Club Hermaphrodite*, and André Chenier's poetry contains such lines as: 'Dans cet âge où le jeune adolescent ressemble ancore à une vièrge . . . qu'il a une voix argentine . . . qu'il est incertain et peut devenir un homme ou une fille . . .'[53]

In a more recent article, Abigail Solomon-Godeau has attempted to take Potts's argument further by investigating images of androgynous male nudes as emblems of 'male trouble' in a crisis of masculinity. However she basically still adheres to the 'repression of the female in the symbolic order' argument, while arguing that the male images onto which the feminine is displaced, are more complex than what she rather inaccurately refers to as 'virile, heroic icons of Jacobin manhood'. While Solomon-Godeau has produced some interesting work, I feel that the images of male nudes do not always mean what she claims, and she takes examples from 1791 to 1817, which covers some very different historical and political situations.[54] Furthermore I think it very likely that some images of erotic male nudes in the post-Revolutionary period are examples of consciously homosexual, not just homoerotic, art, for example the fine work by J. Broc, representing the homosexual myth of *The Death of Hyacinth*, 1801 (Poitiers Museum). Furthermore could we not hypothesise that the blurring of clear sexual differences might have progressive meanings, among others, rather than being yet another manifestation of the repression of the feminine and the related devaluation of real women? Or is this process co-existently progressive and regressive in differing degrees?

It is not particularly surprising to note that the vast majority of allegorical images of women during the Revolutionary period were the work of men. However there is one very interesting design for a print, apparently unpublished, by Marguerite Chatté, a drawing and water-colour entitled *Calendrier des Femmes Libres* (plate 3).[55] Little is known of

52. On this aspect of lesbian history see M.J. Bonnet, *Un choix sans équivoques*, Paris, 1981. See also J.C. Fout (ed.), *Forbidden History. The State, Society and the Regulation of Sexuality in Modern Europe*, Chicago and London, 1992.

53. These lines are quoted as a literary parallel to David's Painting *The Death of Bara* (Musée Calvet, Avignon), by D. Wisner in his article 'Les portraits de Femmes de J.L. David pendant la Revolution Française', in *Femmes et la Revolution Française*, vol. 2, Toulouse, p. 179. For the Panthéon Society see the very interesting book by R.B. Rose, *The Enragés. Socialists of the French Revolution?*, Sydney, 1965, reprinted 1968, p. 60.

54. A. Solomon-Godeau, 'Male Trouble: A Crisis in Representation', *Art History*, vol. 16, no. 2, June 1993, pp. 286–312.

55. This is discussed by Harten and Harten, pp. 83–4, V. Cameron in Chapter V of her thesis, and in the exhibition *Sklavin oder Bürgerin*, catalogue number 1.64.

Marguerite Chatté other than her address given on the drawing. She may well have had her own print shop. The two female figures in the lower half of the print are similar to previously produced prints of 1791 and 1792. The date of 1795 is surprising, as the women's clubs had been closed by then and the texts on the banners held by the National Guardsmen are those of Year 11, 1793. Perhaps this was an earlier project which Chatté dated later when she was thinking again of trying to publish the print. The two women are armed, an important issue at the time. The right to bear arms was a privilege of active, not passive, citizens. Olympe de Gouges had demanded the right for women to bear arms, and, more vociferously, so had politicised *sans-culotte* women. These women sent a deputation to the Legislative Assembly in 1792 demanding pikes, sabres, pistols and arms of other kinds, together with permission to exercise on Sundays and holidays.[56]

There is, however, a fairly large allegorical painting by a woman artist still in existence. This is the *Liberty* (plate 4) by Nanine Vallain, which hung in the Jacobin Club until it was removed after the fall of the Jacobins.[57]

This is a quite unusual and significant painting by a woman artist, but of course other similar works may have been lost or even destroyed.[58] Nanine Vallain (Mme Pietre) was a pupil of David and Suvée, and was one of a number of successful female artists to emerge from David's studio. David appears to have encouraged his female pupils and was 'severely reprimanded' by the Academy in 1787 for allowing three women art students to visit his studio in the Louvre for lessons.[59]

It may well have been through David's influence that Nanine Vallain's painting was accepted by the Jacobin Club. We do not know whether it was done as a patriotic offering by the artist or if it was a paid commission. The face of the figure is interesting and it seems to me that there is something of an individualised woman here, rather than simply a vague and generalised allegory. However it may have been considered

56. See R.M. Dekker and L.C. Van De Pol, 'Republican Heroines: Cross-Dressing Women in the French Revolutionary Armies', in *History of European Ideas*, vol. 10, no. 3, pp. 353–63, especially p. 354. See also figs. 6 and 7, in J. Harris 'The Red Cap of Liberty. A Study of Dress Worn by French Revolutionary Partisans 1789–1794', in *Eighteenth-Century Studies*, vol. 14, 1981, pp. 283–312.

57. Harris and Nochlin, *Women Artists*, p.47.

58. This is the opinion of Harten and Harten. David's *Marat* only escaped destruction by being painted over and hidden in his studio. Vallain's *Liberty* suffered damage down the right-hand side. The repaired painting is now in the Musée de la Révolution Française, Vizille, near Grenoble, and measures 128 x 97 cm. A useful leaflet on this painting is available from the Museum.

59. Harris and Nochlin, p. 186. As yet I have been unable to discover whether David said anything either for or against women artists in any meetings of the artistic societies during the Revolution.

presumptuous at the time for an artist to paint his/her own features as Liberty or Hercules, whereas the royal family and aristocracy had never felt any qualms about representing themselves in allegorical guise. This *Liberty* also has a club as one her attributes. Little is known about this work of Mme Vallain, though she was a member of the Société Populaire et Républicaine des Arts under her married name of Pietre.[60] According to the researches of Harten and Harten, in 1793–4 women artists produced nineteen images of Revolutionary martyrs, fifteen allegories, eight historical paintings and three paintings of other subjects (Brutus and Rousseau) all concerned with Revolutionary politics.[61] Although this is not a vast amount, and Vallain's work is by far the most interesting of these extant, I think we can conclude that women artists certainly did not feel excluded from representing politics at this period and nor did they suddenly stop even after the offensive against women's clubs and the popular societies in late 1793.[62]

The final issue I want to look at, focussing on a *Self portrait of the artist and her daughter* by Elizabeth Vigée-Lebrun (plate 5), is the question of bourgeois ideology and the representation of motherhood. The main article on this question is Carol Duncan's famous 'Happy Mothers and Other New Ideas in Eighteenth-Century French Art' published in 1973. Although very useful in its day, in attempting to examine the relationship of visual imagery of women to a particular class ideology, I feel that it needs some modification. Gutwirth, in the first part of her recently published book, builds on Duncan's earlier work with more detailed research and documentation, but basically the argument remains the same: the men of the bourgeoisie wanted to impose motherhood, breast-feeding and child-rearing on women of their class by attacking upper-class women (who, they argued, did none of these things) and pointing out that wet-nursed children would imbibe the morals and values of an inferior class along with the purchased milk.[63] Gutwirth quotes 'feminist Mme de Miremont' who wrote in 1779: 'Today we are obliged to fight off this new fervour that makes mothers nurse their infants . . .'[64]

I think we have to be rather more careful in trying to work out the

60. Female members are listed in note 40 on p. 197 of Harten and Harten and are taken from Archives Nationales F^{17} 1326 dossier 11.

61. Harten and Harten, p. 76.

62. Harten and Harten, p. 76, argue that at this period portraits of 'great individual men' as representatives of the Revolutionary state give way to (a) images of fathers and sons as martyrs fallen for the Republic *and* (b) women as goddesses of Liberty or Republican heroines. Obviously there remains a good deal of uncertainty about precisely what was going on in terms of the relationship between class, gender and political representations throughout this period.

63. See Gutwirth, *The Twilight of the Goddesses*, p. 181.

64. Ibid., p. 151.

relationship of bourgeois ideology to the actual conditions of child-bearing and child-rearing in the eighteenth century than simply understanding representations of mothers, children and breast-feeding as patriarchal impositions on women. As Gutwirth herself points out, the heaviest users of wet-nurses were working women of the big towns. The death rates of the children put out to wet-nurses were high, and a huge number of children (many the result of sexual relations between servants and bourgeois men) were abandoned in foundling hospitals. Rousseau, one of the main advocates of 'natural' motherhood, child-rearing and so on, forced his partner Thérèse Levasseur to give all her children to a foundling hospital.[65] I have not been able to find estimates for numbers of abortions in eighteenth-century Paris, but sources indicate this practice certainly existed. Diderot wrote of Greuze's *The Beloved Mother*, 1765: 'It says to all men of feeling and sensibility: "Keep your family comfortable . . . give (your wife) as many (children) as you can . . . and be assured of being happy at home".'[66] Actually there is plenty of evidence that men were not too keen on this aspect of 'patriarchal' ideology and many authors wrote attacks on the practice of 'spilling seed' during intercourse, this being the main form of contraception at the time. Although it is not a method that ideally women would want to rely on, as it is largely outside their control, there is evidence to suggest that couples did try by mutual agreement to restrict family size in spite of the 'dominant ideology'.[67]

As noted above, it is the case that a number of women artists either avoided relationships with men, or managed to have no, or few, children. We can see why, without much difficulty. Childbirth could be dangerous and debilitating as the following cases show. Charlotte Vignon, an early member of the French Academy whose father was a painter, was the tenth of twenty-four children. Her mother's life obviously was not a model she particularly wanted to copy. Marie Giroust (Mme Roslin) had six pregnancies and died aged thirty-eight of breast cancer five months after the birth of her last child.[68] In this context having a child, surviving it, and sustaining a career as an artist was quite a remarkable achievement and so I think we cannot simply read Vigée-Lebrun's portraits of herself and

65. Ibid., pp. 29, 48, 59. For working women in full-time employment as the heaviest users of wet-nurses see O. Hufton, 'Women and the Family Economy in Eighteenth-Century France', *French Historical Studies*, Spring 1975, pp. 12–13 especially.

66. Quoted and discussed by Duncan, 'Happy Mothers and Other New Ideas in Eighteenth-Century French Art', reprinted in N. Broude and M. Garrard (eds), *Feminism and Art History*, New York, 1982.

67. See A. McLaren, 'Some Secular Attitudes towards Sexual Behaviour in France: 1760–1860', *French Historical Studies*, vol. 8, part 4, 1974, pp. 604–25, and the same author's book, *A History of Contraception. From Antiquity to the Present Day*, Oxford, 1990. McLaren points out on p.162 that legislation of 1791 stipulated prosecution for abortionists.

68. Both cases taken from entries in Harris and Nochlin, *Women Artists*.

her daughter as 'reflections of' or 'embodiments of' bourgeois ideas of motherhood. They are certainly, in part, all these things but they are also the opposite. They are about the achievements of a woman as professional and a mother. They are about the work and effort, but also the pleasure, that can be part of motherhood in certain situations. In order for ideology to have any hold on people's understanding of the world, it has to have some relation to reality and actual experiences. It cannot simply be an imposition of alien and oppressive ideas.

I want to qualify the view that motherhood and breast-feeding, and its representation too in painting (by women), could be read simply as a patriarchal oppression of women. On the contrary, the fact that many of the *sans-culotte* women were mothers, or due to become mothers, meant that material and physical circumstances impelled them to dismiss the arguments of the bourgeois politicians. This somewhat disappointed some feminists who wrote on the women's activities from the perspective of the 1970s, and they often wished the women's demands had been more about 'women' than about general material and economic needs.[69] But in the late eighteenth century, women of the popular classes made great steps forward in organisation, political consciousness and awareness, even if the bourgeois Revolutionaries did, in the short term, stifle their most radical demands. Women were among the most energetic organisers, even when domestic commitments might at first sight have made it impossible for them to do many of the things which we know they carried out. This often brought them into conflict with other groups. For example in August 1791, two women of colour, Mmes Maillard and Corbin, were expelled from the Société fraternelle des patriotes des deux sexes for 'too much revolutionary zeal'. Among their proposals was the demolition of some statues (probably of royalty).[70]

69. See, for example, Jane Abray 'Feminism in the French Revolution', *American Historical Review*, XXX, Feb 1975, pp. 43–62. Abray termed all activities by women during the Revolution as 'feminist', and then wrote: '. . .women's groups allowed themselves to be distracted too easily. The Républicaines Révolutionnaires let themselves become embroiled in street fights over the wearing of the *cocarde* and the *bonnet rouge* . . . even the fiery Républicaines were more interested in the price of bread than in women's wages', pp. 61–2.

70. See C. Marand-Fouquet, *La Femme au temps de la Révolution*, Paris, 1989, p. 117. Unfortunately I found very few references to the presence of women of colour in France at this period. There is no published work on the history of women of colour in France, as far as I am aware. See however J. Smalls, *Esclave, Négre, Noir: the Representation of blacks in late eighteenth and nineteenth century French Art*, PhD thesis, University of California, Los Angeles, 1991, UMI microfiche. There are some references to women of colour in the slave revolts in the French colonies. See C. Fick, 'Black peasants and soldiers in the Saint-Domingue Revolution: Initial Reactions to Freedom in the South Province (1793–94)', in F. Krantz (ed.), *History from Below. Studies in Popular Protest and Popular Ideology*, Oxford, 1988, p. 259, where the author shows how the male ex-slaves supported the

Women regularly organised themselves, alongside men in some cases, over questions of basic needs. See for example the following report by the journalist Prud'homme from 1793 when *sans-culotte* women protested against food hoarding:

> Already bitter complaints were being heard in the spectator galleries of the General Council of the Commune. It (the Council) replied: 'Go take your complaints to the bar of the Convention'. The advice was heeded. Sunday, among the petitioners, several cried out: 'Bread and Soap!'. These cries were supported outside the hall by large and very agitated groups. The Convention took all that in with considerable coolness and adjourned until Tuesday, when the matter was to be taken up. Far from calming and satisfying (them), this resolution embittered them still more, and upon leaving the bar (of the Convention) the women in the corridors said aloud, to whomever was willing to listen: 'We are adjourned until Tuesday; but as for us, we adjourn ourselves until Monday. When our children ask us for milk, we don't adjourn them until the day after tomorrow'.[71]

Groups of women went to commandeer soap and sugar from warehouses in February 1793. Local people told the women there was no soap or sugar. 'One of these women, letting it be seen she was pregnant by slapping her stomach, said, "I need sugar for my little one." Immediately, all the women said, "We must have sugar".'[72]

In the light of the above, it is worth considering how *sans-culotte* women are represented visually at this time. An interesting painting combining elements of *genre* and contemporary history shows a *sans-culotte* woman angrily confronting a member of the National Guard whose men have come to stop a crowd from successfully making off with some food supplies (plate 6). The technique of this oil painting is detailed and naturalistic, giving the representation of the scene an air of plausibility and verisimilitude. On the right-hand side of the painting, an orderly and regimented line of National Guardsmen line up. Their officer is at the centre of the image with his sword drawn, confronting what we take to be a typical *sans-culotte* woman. On this sword is inscribed 'La Nation et la Loi' (The Nation and the Law). The female figure, the most important of a mixed group on the left, strides forward as if shaking her fist at the officer. The principal figures successfully, I feel, represent contemporary history in a plausible image, partly through the use of naturalistic formal and

women's demands for equal pay. See also R. Goutalier, 'Les Révoltes dans les Antilles françaises. Turpitude des Iles et ses conséquences dans les comportements féminins', and 'Le role des femmes dans l'abolition de l'esclavage' by A. Gautier, in *Femmes et la Révolution Française*, vol. 2, Toulouse.

71. Levy and Applewhite, 'Women of the Popular Classes', p. 20.

72. Ibid., p. 20, quoted from a police report.

technical devices, but also through the utilisation of *genre* painting strategies employing the personification and characterisation of individuals. Thus the main figures embody 'types' taken from contemporary social groups in an image that is, arguably, more 'democratic' in its mode of address and composition than the allegorisation of contemporary historical events. The work is signed and dated July 1792 by Bézard. It is thought that this work may refer to popular requisitions of sugar during the 'sugar crisis' of early 1792, but it may concern some other kind of foodstuff.[73]

The uneasy relationship between the National Guard and the *sans-culotte* women seems quite accurately represented in this painting. The women of the poorer classes of Paris had persuaded the National Guardsmen to accompany them on the famous march to Versailles, in October 1789, when they forced the Royal Family to return to Paris with them. However in July 1791 Lafayette, the commander of the National Guard, ordered his men to fire on those assembled at the Champ de Mars to sign a Republican petition, leaving some fifty people dead. Even before this incident, Lafayette was distrusted by the most militant among the women. In February 1791, Pauline Léon, later to become one of the leading members of the Society of Revolutionary Republican women, led a group of women to sack the house of Fréron. In so doing, they came upon a bust of Lafayette which they symbolically smashed, and threw the pieces out of a window.[74] It is difficult to see how the National Guard would ever have become reliable allies of the *sans-culotte* women and men. In order to join the National Guard, men had to pay a certain amount of taxes, qualifying them as 'active' citizens, which obviously meant that poorer citizens were excluded, and the Guard represented, for the most part, the interests of the Revolutionary bourgeoisie. Furthermore their leaders, at least, were ill-disposed to women militants. When Théroigne de Méricourt called for the founding of a women's militia, a National Guard Commander, named Antoine-Joseph Santerre, observed 'that the men of his section would rather find their homes in order when they came back after a hard day's work than be greeted by wives fresh from meetings where they did not always gain in sweetness'.[75]

Subsistence riots, as some historians call them, were not a new phenomenon in France. However during the Revolutionary period these popular food requisitions became political. Participants felt empowered to take food which was their 'right' as citizens to have, for themselves and

73. I am grateful to Helen Weston, University College London, for drawing this work to my attention. The work is reproduced and discussed in the catalogue *Sklavin oder Bürgerin*, pp. 29–30 and cat. no. 1.10.

74. R.B. Rose, *The Enragés*, p. 56.

75. J. Abray, 'Feminism in the French Revolution', p. 51.

their families. Sometimes they paid nothing, and sometimes they left in the looted shops a financial contribution which they considered a fair price. Traditionally this was an activity of women, but both men and women were arrested by the National Guard in the sugar crisis of 1792.[76] Cynthia Bouton has argued that prior to the Flour War of 1775 men were not involved in these movements. However she says that deteriorating economic conditions pressurised men to take matters into their own hands alongside the women. She shows that many of the men arrested in 1775 were husbands and fathers. Most were in their thirties or forties. Women tended to instigate market 'looting', whereas more men organised requisitions from rural sources, e.g. stores, mills and barges. While women received milder sentences than men after conviction, the behaviour of both sexes was similar. Neither lower-class men or women had any chance of participating in local politics, so they had little option but to act as they did. In conclusion, she writes, 'the grain crisis of 1775 mobilised men whose conditions, interest and perceptions differed less and less from those of women'.[77]

In the context of the sugar crisis of January and February 1792, women led the protests but were soon joined by men. The sugar shortage was a result of the war in the French West Indies. Speculators hoarded vast stores of colonial products such as sugar, coffee and tea, in the hope of future super-profits. Parisian women, notably laundresses and other working women, took petitions to the Commune and the Legislative Assembly but were ignored, hence the recourse to direct action.

There is some debate as to what sort of woman became involved in such activities. Godineau says most women militants were either over fifty or younger than thirty. Bouton also says the typical woman arrested in the Flour Riots was in her late thirties or early forties and the mother of several dependent children.[78] However many women either took children with them to demonstrations and meetings, or perhaps even left them to fend for themselves. An example of the latter is referred to by the deputy Chaumette on 25 November 1793, where he makes full use of the tragic consequences which ensued to deliver a dire warning to women who want to become militants:

76. See Mary Durham Johnson, 'Old Wine in New Bottles: the Institutional Changes for Women of the People during the French Revolution', in C.R. Berkin and C.M. Lovett (eds), *Women, War and Revolution*, p. 118.

77. For this very useful article see C.A. Bouton, 'Gendered Behaviour in Subsistence Riots: the French Flour War of 1775', *Journal of Social History*, vol. 23, Summer 1990, pp. 735–54. However Bouton describes this increasing identification of male and female interests as a process of male 'feminisation', which does not seem to me to depart from the notion of essential gender categories in historical processes, and therefore is rather misleading, and not particularly helpful.

78. Ibid., p. 737, Godineau, *Citoyennes Tricoteuses*, p. 213.

Chaumette dit que le feu a pris chez une de ces femmes qui courent les rues en bonnet rouge et qui veulent régir la république, au lieu de s'occuper de leurs ménages; que par suite de ce désordre et d'une négligence criminelle, deux malheureux enfants ont péri dans les flammes. Le Conseil arrête qu'il sera fait mention de cette affligeante anecdote, pour servir de leçon aux citoyennes qui abandonnent le soin de leurs maisons pour s'occuper d'objets étrangers à leur sexe.[79]

Obviously the situation Vigée-Lebrun found herself in as a mother, given her successful professional career, was far from that of *sans-culotte* women. But my argument here seeks to re-examine representations of maternity as simply unproblematic examples of patriarchal ideology and look at some of the contradictions embodied in that ideology itself, in the relationship of that ideology to material reality, and the position of women from different classes with regard to that ideology. In this context we can see Vigée-Lebrun's self-representation in her *Self-portrait with her daughter* (plate 5) as a shrewd professional self-advertisement of both her skills as a portraitist and as a successful mother. I have argued that this was no mean feat, nor was it free from stress and strain.

Vigée-Lebrun's second daughter after Julie died shortly after birth. The artist recounts in her memoirs her happiness as a mother, but also her annoyance at the fact that giving birth interrupted her work. She complained to one of her friends who told her the birth was imminent that it would interfere with portrait sittings she had arranged with a client. However she then adds that, having worked all day, she had the child that night: 'I shall not attempt to describe the joy which I felt when I heard my child cry; every mother knows it.'[80] Griselda Pollock reads Vigée-Lebrun's *Self-portrait with her daughter Julie* as a pure embodiment of bourgeois ideology.

The bourgeois notion that women's place is in the home and that woman's only genuine fulfilment lies in child-bearing – the 'You won't be an artist; you'll just have babies' – is anticipated in this material rather than professional presentation of the artist. Moreover the painting links the two females in a circular embrace. The child is a smaller version of the adult woman. The mother

79. Annie Geffrey, 'A bas le bonnet rouge des Femmes! (Octobre–Novembre 1793)', in *Femmes et la Révolution Française*, vol. 2, p. 350.
80. It is tempting to speculate whether Vigée-Lebrun's daughter Julie was named after Rousseau's 'heroine' in *La Nouvelle Héloïse*. Vigée-Lebrun admired Rousseau greatly, although her own attitude to women's potential did not coincide with his mysogynistic prescriptions. For her admiration of Rousseau see G. May, 'A Woman Artist's Legacy: the Autobiography of Elizabeth Vigée-Lebrun', in Keener and Lorsch, *Eighteenth Century Women and the Arts*, p. 232. Other sources say Vigée-Lebrun's second pregnancy ended in a miscarriage, see *Elizabeth Louise Vigée-Le Brun, 1755–1842*, Exhibition Catalogue by J. Baillio, Kimbell Art Museum, Fort Worth, Texas, 1982, p. 13.

is to be fulfilled through her child; the child will grow up to a future role identical to her mothers'. The compositional device inscribes into the painting the closing circle of women's lives in the bourgeois society that was to be established after the revolution.[81]

I feel that view betrays a rather rigid and undialectical perception of the relationship of ideology to lived material existence, and also to the contradictions between ideology and the economic base which underpins it. Without investigating the latter, we ourselves will simply take bourgeois ideology at its face value. Women have often been described as the absent 'other' of history. In Vigée-Lebrun's *Self-portrait with her daughter*, this is hardly the case. It is the absent father, Monsieur Lebrun who is the 'other', not Vigée-Lebrun. She, not Monsieur Lebrun, is the person selling her skills to make money. She is both the subject and the object of the image.

In conclusion, I have suggested that the Revolution opened up the possibilities of joint political activity by men and women from the most radical sections of the Parisian population, notably in the close collaboration between the *enragés* and the Société des Républicans Révolutionnaires. The Jacobins attacked and imprisoned members of popular societies in early 1794, having closed down the women's clubs in late 1793. They feared above all the self-organisation of men and women which would threaten bourgeois concepts of property and profit. To challenge such property relations was also to threaten the material base which sustained contemporary ideologies of motherhood and family life.

I have suggested that the bourgeois Revolution was much more complex and contradictory than a simple 'defeat' for women. Some recent work on gendered representation has played down questions of class and historical reality. I have argued for a dialectical perception of the relationship of ideology to lived material existence, and of the contradictions between ideology and the economic base which underpins it.

81. Pollock, *Vision and Difference*, p. 48.

–3–

Gender and Class in Early Modernist Painting: a Reassessment

In this chapter I will consider the issue of 'women' in relation to the development of modern art in France during the Second Empire (1852–70), and the early years of the Third Republic (1871–1914). A discussion of representations of women during the Paris Commune of 1871 follows in the next chapter.

Until fairly recently, one of the prevailing theories of the development of modern painting was that of Clement Greenberg, the American critic. In Greenberg's view of Modernism, as a method of understanding and evaluating the development of painting, painting was distinguished from any other art by its flatness. Paintings moved forward by self-critically engaging with the most ambitious preceding work. The way that paintings were made was more important than any subject-matter. Writing in the 1960s, Greenberg stated, 'Manet's paintings became the first modernist ones by virtue of the frankness with which they declared the surfaces on which they were painted'.[1] In a recent book published as part of a British Open University course on Modern Art, Bryony Fer has pointed out that 'many feminist art historians have seen Modernist criticism's emphasis on a particular notion of "aesthetic value" as a powerful mechanism of exclusion which, by the very terms it sets up, marginalises women artists'.[2]

It is necessary to distinguish between Modernism as a form of explanation for why and how painting changes, and as a means of discerning 'progressive' paintings from 'mediocre' ones; and the separate, but sometimes linked, notion of modernity in painting. These two issues are treated rather differently by feminist art historians in relation to the issue of works by women artists and representations of women in painting. Some see the actual means of painting praised by Greenberg as biased in

1. C. Greenberg, 'Modernist Painting', quoted by B. Fer in her Introduction to *Modernity and Modernism, French Painting in the Nineteenth Century*, F. Frascina, N. Blake, B. Fer, T. Garb, C. Harrison, New Haven and London, 1993, p. 6.
2. Fer in *Modernity and Modernism*, pp. 14,15.

favour of the masculine.[3] Others have concentrated more closely on the emergence of modernity in art in nineteenth-century France, arguing that by definition, women in modern art were positioned by male-dominated society in subordinate roles.[4]

There is a good deal of truth in many of the arguments that have been put forward by feminist art historians concerning Modernism and modernity. Carol Duncan quotes the painter Kandinsky, writing early in the twentieth century, about his conception of artistic creativity:

> Thus I learned to battle the canvas, to come to know it as a being resisting my wish (dream) and to bend it forcibly to this wish. At first it stands there like a pure chaste virgin . . . and then comes the wilful brush which first here, then there, gradually conquers it with all the energy peculiar to it, like a European colonist.[5]

After reading such comments, one has considerable sympathy with feminist critiques of male modernist artists and Modernist art historians who still see artistic creativity as primarily a masculine domain akin to (hetero) sexual domination, not to mention the clearly colonialist and racialist overtones of the above piece of writing.

Although there have been various critical attempts to investigate the emergence of modernity in French nineteenth-century painting as regards gender and/or class, they all, however, accept the work of Manet and the so-called 'Impressionists' as a main focus of debate. Few have tried, for example, to shift the whole notion of modernity in art to the work of Gustave Courbet, which would entail a complete re-evaluation of Greenbergian notions of Modernism and modernity. All the art historians I will consider here seem to be in agreement about when modernity in art really became an issue. T.J. Clark, for example, in his book *The Painting of Modern Life*, offers an explanation of the development of modern painting with its new techniques and 'flatness' in terms of attempts by artists, consciously or unconsciously, to produce visual equivalents of the shifting class identities and lack of fixed meanings in contemporary French society. The petit bourgeoisie became the heroes and heroines of modernity for the painters of the avant-garde. The contradictory and complex nature

3. For example, Carol Duncan, 'Virility and Domination in early twentieth century Vanguard Painting', reprinted in Broude and Garrard, *Feminism and Art History*, pp. 293–314.

4. See especially Janet Wolff, 'The Invisible *Flâneuse*: Women and the Literature of Modernity', *Theory, Culture and Society*, vol. 2, no. 3, 1985, and Chapter 3, 'Modernity and the spaces of femininity', in G. Pollock, *Vision and Difference*. Pollock utilised Wolff's article to develop a complementary analysis of painting.

5. C. Duncan, 'Aesthetics of Power in Modern Erotic Art', *Heresies*, no. 1, 1977, p. 47.

of avant-garde painting made this class identity shifting and unreadable, but at the same time, the subject of art. Thus, for example, Clark argues that the reason for the antagonism of critics to Manet's *Olympia*, exhibited in 1865, was ultimately class.[6]

Griselda Pollock criticises Clark for leaving intact the framework and myths of modernity in his book, and especially, for ignoring, as she claims, the issue of women. For Pollock, a re-examination of women and modernity in French nineteenth-century painting (and the subsequent development of twentieth-century painting) would have to call into question the fundamental premises on which understanding of modern art has been based. This would entail 'a deconstruction of the discourses and practices of art history itself' which work to marginalise and subordinate women, and obviously a completely different reading of all subsequent art.[7]

However another leading historian of French nineteenth-century art and women, Linda Nochlin, has a different position, apparently accepting the aesthetic value and notions of artistic progress and radicalism enshrined in the Modernist canon. In an interesting article on a painting by Berthe Morisot, *The Wet Nurse and Julie* (plate 7), Nochlin writes that the work displays 'a colorism so daring, so synoptic in its rejection of traditional strategies of modelling as to be almost Fauve before the fact'.[8] Further on in the essay, Nochlin praises Morisot's productions as revealing 'the work of the painting' itself, the 'process of painting' and adds:

> In the best of them, color and brushstroke are the deliberately revealed point of the picture: they are, so to speak, works about work, in which the work of looking and registering the process of looking in paint on canvas or pastel on paper assumes an importance almost unparalleled in the annals of painting. One might almost say that the work of painting is not so strongly revealed until the time of the late Monet or even that of Abstract Expressionism, though for the latter, of course, looking and registering were not the issue.

6. This is a problem with Clark's approach to *Olympia*. To argue for, and attempt to carry out, a Marxist analysis of paintings, does not reduce itself ultimately to saying that paintings are about class (or not). This point is also made by Adrian Rifkin in a review of Clark's book in *Art History*, Dec 1985, on p. 494. There is a more constructive attempt to criticise Clark's method of analysis as applied to *Olympia* by C. Harrison, M. Baldwin and H. Ramsden, 'Manet's "Olympia" and contradiction, (apropos T.J. Clark's and Peter Wollen's Recent Articles)', in *BLOCK*, 5, 1981, pp. 34–43.

7. Pollock, *Vision and Difference*, p. 55.

8. L. Nochlin, *Women, Art and Power and Other Essays*, London, 1989, p. 37. There are two versions of this essay. The second, slightly later, is available in T.J. Edelstein (ed.), *Perspectives on Morisot*, New York, 1990, pp. 91–102. They are based on a lecture given in 1987 and 1988. The second version has slightly more detailed information on the subject of wet-nursing. Unless otherwise noted, I will be referring to the version in *Women, Art and Power*, as it is more readily accessible.

Now here is a view which is firmly grounded in Greenbergian Modernism, including the privileging of Abstract Expressionism as the high point of the tradition of Western painting. Whereas Pollock argues for a much more radical project, Nochlin here argues for Morisot as a great Modernist painter who should be given her rightful place ('an importance almost unparalleled') within that tradition.

Thus Morisot is inserted into that Modernist tradition which seeks as its goal the high point of painterly self-interrogation epitomised by American post-war painting. Morisot's 'struggle' as an artist should, says Nochlin, entitle her to the same elevated status in the Modernist canon as 'heroic' male artists: 'Van Gogh's struggle with his madness; Cézanne's with a turbulent sexuality; Gauguin's with the contering [sic] urgencies of sophistication and primitivism.'[9]

There are other important issues raised by Nochlin's discussion of Morisot which need to be considered. In doing so, I would like to question some of the statements made by feminist art historians concerning modernity in nineteenth-century French painting, and the relationship of gender and class to theories of art history and the emergence of 'modern' art. As with the question of women and French art of the Revolutionary period, the issue is a complex one which cannot adequately be tackled by views based primarily on gender as a historical category able to account for not just what art was produced, but how it was produced and why.

Nochlin's discussion of Morisot's painting *The Wet Nurse and Julie* (plate 7) starts off in a manner which is rather unusual in the work of feminist art historians. She draws attention to a passage from Marx's and Engels's *Manifesto of the Communist Party*, beginning 'All that is solid melts into air', and remarks that these words 'could have been designed for the purpose of encapsulating Morisot's painting in a nutshell'.[10] The formal representational means utilised by Morisot link her work, says Nochlin, to the 'profoundly deconstructive project of modernism to which Marx [sic] drew attention'. Nochlin quotes the passage at greater length:

> All fixed, fast frozen relations, with their train of ancient and venerable prejudices and opinions, are swept away, all new-formed ones become antiquated before they can ossify: All that is solid melts into air, all that is holy is profaned, and men at last are forced to face . . . the real conditions of their lives and their relations with their fellow men.[11]

9. Nochlin, *Women, Art and Power*, p. 51 and p. 53.
10. Ibid., p. 37.
11. Ibid., pp. 53–4.

Now while the relationship of Modernism to capitalism is, I would argue, of crucial importance in explaining the emergence of Modernism, it is incorrect to state that Marx and Engels were talking about Modernism in *Manifesto of the Communist Party*. What this passage is arguing is that while previous exploiting classes wanted to 'conserve old modes of production in unaltered form' in order to perpetuate their existence, on the contrary the bourgeoisie has to constantly change and revolutionise the instruments and relations of production. Hence 'everlasting uncertainty and agitation distinguish the bourgeois epoch from all earlier ones'.[12] They are attempting to identify what differentiates an economy and society controlled by the bourgeoisie from other class societies, not describe Modernist culture.

Nochlin, developing her analogy between a Marxist analysis of Modernism [sic] and Morisot's painterly means of representation, moves on to examine the contradictory position of Morisot and the artist in relation to the picture, and the contradictions embodied in the image itself. However, I would argue that Nochlin resolves these contradictions in a feminist, rather than a Marxist direction. While she utilises Marxist terminology, gender is posited as the over-reaching factor: '. . . two working women confront each other here, across the body of "their" child and the boundaries of class, both with claims to motherhood and mothering, both, one assumes, engaged in pleasurable activity, which, at the same time, may be considered production in the literal sense of the word.'[13] While Nochlin is careful to point out that Morisot, the employer and professional artist, is in a very different economic and social position from the employee, the wet-nurse, who is depicted feeding Morisot's daughter Julie, we are told that their identity as 'workers' and 'women' brings them together.

I think we need to be rather careful in seeing the 'work' of the two women as similar. Morisot's work was of a rather different nature to that of the wet-nurse. The wet-nurse's milk was sold on the market as a commodity, either through a public bureau established to place wet-nurses with families, or through private agencies to which richer families tended to turn. While Nochlin points out that the wet-nurse's child would have been left at home in the countryside while her/his mother nursed another child, she does not point out the disturbing numbers of deaths of wet-nurses' own children. Before hygienic means of artificial feeding were

12. Marx and Engels, *Selected Works in One Volume*, p. 38.
13. Nochlin, p. 38.

developed, the life expectancy of wet-nurses' own babies was poor.[14] It is hardly the case, then, that the 'work' of both women can be said to entail similar perceptions of 'motherhood and mothering' that Nochlin claims to discern in their relationship. While of course Morisot's paintings became commodities as soon as they were exhibited for sale in public, she had a far greater control over her conditions of work and the 'products' of that labour than her wet-nurse. For example, she exhibited works at Durand-Ruel's gallery with 'not for sale' on them, and demanded the return of her painting *The Cherry Tree* (1891–2) from the dealer Camentron after he had found a buyer for it. Morisot wanted her own daughter to have the work, and she was financially able to ensure that this happened: 'I've done well not to sell it, I worked on it for so long at Mézy the last year your father was alive, I now possess it and you will see that after my death you will be very happy to have it.'[15]

In addition, the assumption by Nochlin that the two women are equally engaged in 'pleasurable' activity indicates her desire to stress the bond of common gender between the two women, rather than the vast gulf in economic and social status which she considers an important, but subordinate question. Thus while Nochlin's essay opens with the promise of a Marxist analysis of women and early modern painting, the essence of what she ultimately presents is rather different.

If we now consider Pollock's important analysis of women and early Modernist painting, we can see a fundamentally similar approach to gender and class. Whereas Pollock is far more radical in her rejection of Modernism as an art historical method, she, like Nochlin, is keen to stress gender as a unifying historical category which places all women in an inferior position to men, while economic factors are relegated to a subordinate position in terms of their explanatory value.

Pollock's arguments in her essay 'Modernity and the Spaces of Femininity' are probably familiar to some readers, so I will outline them

14. In the version of the *Wet Nurse* essay in Edelstein, *Perspectives on Morisot*, Nochlin points out that wet-nurses working for *haute-bourgeois* families like the Berthe Morisot/Eugéne Manet household could make 1,200–1,800 francs per 'campaign'. However most were not well-paid, e.g. 18 francs per month in 1876. The urban working women were still the heaviest users of wet-nurses in the later nineteenth century, but they had to send their children out to the country, not being able to place or pay for a live-in servant wet-nurse. It appears that bourgeois families were not using wet-nurses much in the 1860s and 1870s. Morisot was probably conforming to *haute-bourgeois* practice in her hiring of the wet-nurse depicted in her paintings. For statistics and information on wet-nursing see G.D. Sussmann, 'The wet-nursing Business in Nineteenth-Century France', *French Historical Studies*, 1975, vol. ix, Fall, pp. 303–28. See also J.-P. Peter, 'Les médicins et les femmes', in J.-P. Aron (ed.), *Misérable et Glorieuse, La Femme du XIXᵉ siècle*, Editions Complexe, Bruxelles, 1984, p. 92.

15. Quoted by Suzanne Glover Lindsay, 'Berthe Morisot: Nineteenth Century Woman as Professional', in Edelstein (ed.), *Perspectives on Morisot*, p. 85.

quite briefly here before raising some questions concerning her method and conclusions.

Pollock, having argued for the rejection of Modernism as a method for understanding and evaluating the development of modern painting, argues that a consideration of the subject-matter and spacial compression of French nineteenth-century avant-garde painting in terms of gender is necessary. Following Janet Wolff, she argues that one of the key literary texts formulating notions of modernity, the essay *The Painter of Modern Life*, published in 1863 by Charles Baudelaire, effectively designated women as subject-matter for the male artist, rather than creators of art. By considering works of male and female avant-garde painters, she shows that there was some overlap between female artists such as Morisot and Mary Cassatt and their male counterparts in representations of private life, but that there was little chance for bourgeois women to represent public scenes of contemporary life because of their gender. The artists' gender also involved living out the 'positionalities in discourse and social practice'. Thus Cassatt and Morisot paintings embody and represent the compressed and restricted experience of the 'spaces of femininity' of female bourgeois life in mid-nineteenth-century France. Pollock uses works such as Morisot's *On the Balcony* (1872) (plate 8) and *The Harbour at Lorient* (1869) (National Gallery of Art, Washington), and Cassatt's *Lydia at a tapestry frame* (c. 1881) (Flint Institute of Arts) to demonstrate an alternative explanation for the production of these paintings to the one offered by Greenbergian Modernism, i.e. that painting develops its 'flatness' as part of an ongoing project of self-criticism as a medium.

Pollock discusses the gendered map of the bourgeois city, whose significant spaces are where the fields of the masculine and feminine intersect and 'structure sexuality within a classed order'. Pollock writes, 'What Morisot's balustrades demarcate is not the boundary between public and private but between the spaces of masculinity and of femininity inscribed at the level of both what spaces are open to men and women and what relation a man or woman has to that space and its occupants'.[16]

Tamar Garb follows Pollock's argument, writing about Morisot's *The Balcony*:

> The vantage point from which Morisot experienced the modern city was much closer to that of other upper-middle-class women than with her peers in avant-garde artistic circles. As such, the focus for her art was the rituals of bourgeois femininity, drawn from the visual culture of modernity's Other side, the home and its inhabitants. It was to the home that our *Flâneur* returned . . . It was the home of the salon, the wife, the children, so scorned by sophisticated metropolitans, which nevertheless formed the stable background for their

16. Pollock, *Vision and Difference*, p. 62.

perambulating. It was from there that they set out in the morning and to which they eventually returned. But for a woman of Morisot's class, it was *the* world, *the* centre, not the downgraded, compromised periphery of modern life. The modernity of the 'masculine' metropolis, when it features in her works, therefore, is a remote, filtered one, its very indistinctness of space and lack of specificity of setting, the result of her view from the outside.[17]

How well do these arguments stand up to close consideration? Pollock's is the more careful analysis and she attempts to consider class factors, as well as some of the contradictions and blurring in bourgeois notions of gender. However her examples are, not surprisingly, chosen to present her case in the best possible light. I would like to suggest qualifying the importance given to gender as an explanatory category of cultural production by Pollock, and by Tamar Garb, by comparing the work of the painter Gustave Caillebotte with some of the works by Morisot and Cassatt on which Pollock bases her case.

Caillebotte (1848–94) painted some very impressive outdoor scenes of urban modernity (one is shown in Pollock, the famous *Paris, a rainy day* 1877), and a large number of private, domestic scenes of members of his own family and friends. In fact, domestic interiors and depictions of intimate scenes were not at all peripheral to a painter such as Caillebotte, but were equally, if not more, important than his Parisian street scenes. Further, Caillebotte's formal 'modernity' has been somewhat overlooked as his paintings do not 'flatten' the picture space but, on the contrary, manipulate space at different levels of illusionistic depth in an attempt to represent the diverse visual experiences of contemporary private and public life.

The critic and writer J.-K. Husymans, discussing Caillebotte's *Interior, Woman at the Window* (1880), wrote in 1883: 'The smell of a household in an easy-money situation is exuded by this interior. Caillebotte is the painter of the bourgeoisie of business and finance at ease, able to provide well for their needs without being very rich, living near the rue Lafayette or around the boulevard Haussmann.'[18]

Husymans accurately placed Caillebotte in a high social rung of contemporary Parisian society. A member of an *haute bourgeois* family, Caillebotte inherited money on the death of his father in 1874. He and his brothers never actually had a job in the sense of going out into the 'male' world of banking, commerce or manufacturing business to increase their

17. T. Garb, Chapter 3 'Gender and Representation', in *Modernity and Modernism. French Painting in the Nineteenth Century*, p. 273.
18. See C.S. Moffett (ed.), *The New Painting Impressionism 1874–1886*, Oxford, 1986, p. 319. This book has particularly good colour reproductions of most of the works exhibited in the 'Impressionist' exhibitions.

capital. Although Caillebotte did paint urban street scenes, the focus of his work and life was domestic and private to a large extent. Tamar Garb's view of the home as 'the downgraded periphery of modern life' and domestic scenes as 'drawn from the visual culture of modernity's Other side' needs to be reconsidered, as this certainly did not apply to Caillebotte, nor to Morisot's husband either, for that matter. For a man of the *haute bourgeoisie* who did not go out to work, life was far closer, I would argue, to women artists of their own class such as Morisot and Cassatt, than to working-class men. We therefore need to qualify Garb's statement that gender identity was much stronger than class difference and that Morisot's experience was far closer to upper-class women who were not artists, than with male artists of her own social milieu. Of course it is true that many 'spaces of modernity' were simply not available to women of the bourgeoisie and therefore they were physically and psychologically prevented from representing them, e.g. the brothel, the café. However we need to be careful of seeing 'the domestic' as a peripheral, subordinate cultural space, equated with the feminine and therefore inferior. The representation of the domestic in the new painting at this time needs more consideration, and I fear that a simple male/public and private, women/private does not adequately account for the representations of the private and the domestic by bourgeois and petty-bourgeois male artists. Also it is clear that working-class women are participants in public modernity but for reasons of class have very little chance of becoming artists, as is also the case with working-class males. So I think we need to qualify and move beyond the notion that gender is the most powerful explanatory concept for the study of early Modernist art in France.

The type of subject and interest in space as embodying experience of modernity which Pollock analyses in the work of Morisot and Cassatt are both present in Caillebotte's work. For example Cassatt's works *Lydia at a tapestry frame* (c. 1881) and *Lydia Crocheting in the garden* (1880), both shown in Pollock, can be compared with Caillebotte's *Portraits* (1877), private collection, showing two elderly women friends of his family engaged in tapestry and crochet work (plate 9).[19] Morisot's *Two women reading* (1869–70), National Gallery of Arts, Washington, can be compared to Caillebotte's *Interior, woman seated* (1880) and his *Portrait of M.E.D* . . . (1878), both private collections.[20]

However it is Caillebotte's balcony paintings that spring to mind when

19. For the Caillebotte, see Moffett (ed.), p. 274, plate 69, and for the Cassatts, see Pollock, *Vision and Difference*, plates 3.8, 3.9.
20. Morisot's painting is Pollock's plate 3.5, and the Caillebotte works can be found in Moffett, pp. 299 and 274. Caillebotte *Interior, Woman Seated* shows a woman reading, very close to the space of the spectator, while a male figure is lying on a settee reading in the background.

comparing the works by women mentioned in Pollock's essay with those of male Modernist artists. Caillebotte did a number of paintings of figures looking out of rooms over balconies or standing on balconies.[21] I would argue that the balcony plays a similar role in paintings by Caillebotte and Morisot. Caillebotte's *Man on the balcony* (plate 10) shows his brother looking out onto the city in the heart of Haussmann's modern Paris. While Morisot and her husband preferred the quieter suburb of Passy, I feel that this does not fundamentally alter the similarity of their images. The balcony is a way to experience the modern city, to be a *flâneur* (*flâneuse?*) without leaving the comfort, security (and sometimes boredom and lethargy) of the bourgeois home. However Pollock has written that we should consider the balustrade images as first and foremost an articulation of opposed positions of masculinity and femininity.[22] I believe a consideration of Caillebotte's *oeuvre* would lead us to qualify this. The balcony itself was seen as a modern architectural feature. The price of land was high in central Paris and the balcony was a means of providing additional space and light for those able to afford the newly erected dwellings of the Second Empire. The balcony turned domestic life outward to the street, rather than towards an inner courtyard. Pierre Larousse's *Grand Dictionnaire Universel du XIX^e Siècle*, 1867, stated:

> Nowadays when the fair sex is no longer condemned to live in the interiors of houses, when the pleasure of seeing passers by and to be seen by them has become commonplace, there are hardly any important houses without open balconies – nowadays the fashion for balconies has become generalized . . . now one can count more than 100,000 in Paris.[23]

Caillebotte worked a great deal at home. Even examples of nudes are shown lying on the settee in his flat or after a bath with a towel (a male nude seen from the rear).[24] His nudes are constructed as private and domestic, though probably painted in the studio that was part of his apartment.

Now if we compare Caillebotte's lifestyle with that of Morisot and Cassatt, I think there are rather more similarities than suggested by Pollock

21. See for example Moffett, pp. 169, 319, 398.
22. Pollock, *Vision and Difference*, p. 62.
23. Larousse, p. 97, quoted by J.K.T. Varnedoe and J.P. Lee, *Gustave Caillebotte. A Retrospective Exhibition*, 1976–7, Museum of Fine Arts, Houston, and Brooklyn Museum, p. 148. Varnedoe gives details of Caillebotte's family background. Though his family's money was made by selling cloth to the army, Caillebotte himself bought a replacement from the lower classes to do his military service. However he did not avoid being called up in the Franco-Prussian War of 1870–1.
24. See M. Berhaut, *Caillebotte. Se vie et son oeuvre. Catalogue raisonné des paintures et pastels*, Paris, 1978, no. 184, plate 44 (Minneapolis Institute of Arts) and no. 267, plate 171 (collection S. Josefowitz, Lausanne).

and Garb. Morisot also came from a well-off family. Her father had 'improved' himself from his skilled artisan background by work, study and marriage into a rich, *haute-bourgeois* family. Morisot's husband, Eugène Manet, never went out to work, since the Manet brothers had also inherited money. Consequently Morisot probably had more economic links with the public world of commerce through her activity as an artist, than did her husband. Thus we need to be careful of categorising men and women of the *haute-bourgeois* artistic circles into fixed role models of gender difference purporting to accurately describe the facts of their lives. It is clear that such oppositions of male/female, public/private, work/ domesticity are far too rigid. They may certainly have been ideologically articulated in much of bourgeois culture but are, to a certain extent, contradicted by reality.

Similarly Mary Cassatt came from a rich family whose wealth enabled both male and female members of the family to devote time to the rituals of private upper-class domesticity.

Now I am not trying to argue here that women in *haute-bourgeois* families were not oppressed as women. They clearly were. Morisot, for example, was unable to participate in meetings to discuss the 'Impressionist' exhibitions because, as an upper-class woman, it would have been seen as improper for her to be present at the Café Guerbois where meetings sometimes took place. Her participation depended on male artists keeping her involved and informed. Also Edouard Manet kept his wife Suzanne at a distance from his art and his male friends. A writer who interviewed Suzanne Manet for a biography of the artist Constantin Guys quotes her as saying: 'I did not know all of my dear husband's friends, because he didn't like [for] me to come often to his studio.'[25]

Pollock does try, however, to preserve the notion of class as an important factor in understanding the works of Cassatt and Morisot. However since she considers gender more important, it leads her to read the works of these women artists as qualitatively different from those of, for example, the male artist Degas. This leads her to some conclusions which I do not feel are accurate. Discussing Cassatt's print *Woman Bathing*, 1891 (plate 11), Pollock writes:

> The majority of women painted by Cassatt or Morisot were intimates of the family circle. But that included women from the bourgeoisie and from the proletariat who worked for the household as servants or nannies. It is significant to note that the realities of class cannot be wished away by some mythic ideal of sisterhood amongst women. The ways in which working-class women were painted by Cassatt, for example, involve the use [of] class power in that she

25. Quote from Gustave Geffrey in N.S. Ross, *Manet's Bar at the Folies-Bergère and the myths of Popular Illustration*, Ann Arbor, 1982, p. 78.

could ask them to model half-dressed for the scenes of women washing. Nonetheless they were not subject to the voyeuristic gaze of those women washing themselves made by Degas which . . . can be located in the maisons-closes or official brothels of Paris. The maid's simple washing stand allows a space in which women outside the bourgeoisie can be represented both intimately and as working women without forcing them into the sexualized category of the fallen woman. The body of woman can be pictured as classed but not subject to sexual commodification.[26]

Now there are some problems with this. We can say that probably (though not certainly) Cassatt did not voyeuristically exploit her semi-nude female models in a sexual sense. However their bodies are certainly sexually commodified because her lower-class, white or black, models, servants in the Cassatt household, are being paid so that Cassatt can look at parts of their bodies without clothing and represent them as she wishes. Commodification is an expression of social relations articulated through economic factors, not gender factors, and the gender of the artist and/or model is not necessarily the key to whether the body represented is commodified or not. We do not know whether the women servants of female Modernist artists were particularly willing to pose or not. They may have been willing and felt flattered by the request or they may have felt in no position to refuse.

While Cassatt was in America during the Paris Commune of 1871, she wrote to a friend about her work on a portrait of her father and a study of the family's black female servant. The study shows a black female figure wearing a scarf on her head with bare shoulders and chest and a shawl loosely draped around her arms. The artist was using the same canvas to work on the portrait of her father, whose head appears upside down in the woman's cleavage. Cassatt writes: 'I commenced a study of our mulatto servant girl . . . I was amused at her finding that I had not made her look like a white person.'[27] Now while Cassatt attempts to represent the black woman without changing her physical appearance to conform to the largely 'white' culture of fine art modes of representation, she nevertheless refers to her as a 'girl' and finds her responses to the issue of race and representation 'amusing'. This is hardly surprising, given Cassatt's historical situation, but it is important not to over-emphasise the fact of common gender between artist and model at the expense of examining the various contradictory experiences within gender, race and class lived, consciously and unconsciously, by women of this period.

The print which Pollock shows, *Woman Bathing* (plate 11), by Cassatt

26. Pollock, *Vision and Difference*, pp. 88–9.
27. N.M. Mathews (ed.), *Cassatt and her circle selected letters*, New York, 1984, p. 74. The oil sketch is illustrated on p. 73, oil on canvas 32 in x 27 in, private collection.

is one of a series of ten colour prints which was printed in an edition of only twenty-five. They are examples of very subtle colour printing, greatly inspired by Japanese prints. Cassatt exhibited the prints in 1891. The ten prints were intended to show 'a loose sequence of everyday female activity – bathing, visiting, letter-writing . . .' The artist also looked 'beyond the domestic interior to the dressmaker's and the city street'.[28] One of the prints in this series, *The Coiffure* (plate 12) clearly shows the woman's breasts exposed through the device of using the reflection in the mirror, placed in such an (unrealistic) way as to allow the spectator an unexpected and privileged view of the woman's upper body, while she herself seems unaware of this. The reflection in the mirror is obviously higher and at a different angle from that which would have actually occurred. It seems unlikely to me, therefore, that we can discount any notion of sexual/sensual spectatorship from Cassatt's images of semi-naked female figures.[29] Furthermore, as Alison Effeny has remarked, one of the connotations of Japanese print representations of women in nineteenth-century Paris was that of sensuality and eroticism, although in Cassatt's work this is 'suitably veiled'.[30] There is a highly satisfying tension in *The Coiffure* between the sharp lines scratched onto the metal plate and the areas of softly toned warm colour on the woman's body (flesh colour), chair (dull pink and white stripes), carpet (rusty pink and beige), the wardrobe (beige) and wallpaper (dusky pink). The rounded contours of the woman, her towel and the armchair are related to the organic forms of vegetation on the wall and carpet, whereas the wardrobe and mirror are shown as severe and geometrically defined.[31]

Pollock and Garb have a tendency to base their conclusions on concepts of masculinity and femininity in art production and in spectatorship which are not firmly grounded in historical reality. One of the areas which requires more research than it has hitherto received is that of the actual historical female spectator of modernity and representations of modern life. Pollock herself, in a footnote to her chapter, points out the importance of 'restoring the female spectator to her historical and social place' as an essential part

28. A. Effeny, *Cassatt, The Masterworks* (sic), London, 1991, p. 31. The artist James Tissot had also executed a series of works on the life of the modern Parisian woman. This interesting series is discussed in M. Wentworth, *James Tissot*, Oxford, 1984, ch. vi. The fifteen large canvasses were exhibited as a series in Paris and London in 1885 and 1886 entitled *La Femme à Paris*.

29. See the charcoal (?) sketch for this subject where the woman is standing with a drapery round her buttocks, which is even more sensual in execution and pose, see Effeny, p. 30.

30. A. Effeny, *Cassatt*, p. 98.

31. There is a good colour reproduction of the print in A.D. Breeskin, *Mary Cassatt. A Catalogue Raisonné of the Graphic Work*, City of Washington, 1979, p. 148, catalogue number 152.

of understanding the shock caused by the public exhibition of Manet's *Olympia*.[32] However this plea for a historical grounding of actual female spectators gives way in her work to an emphasis on a theoretical female spectator constructed by discourses of 'binary positions, activity/passivity, looking/being seen, voyeur/exhibitionist, subject/object'.[33]

Similarly Garb entitles a section of her essay 'The historical viewer'. This sounds encouraging but, if we read further, her aim is not to investigate the statements, views and historical situation of female viewers of art, but to posit in an idealistic, not a materialist, sense, an imaginary female viewpoint.

> It is through the positing of a different viewing position, a symbolically feminine one, which stands outside of dominant modes of thought, that we can question the notion of the universal genderless viewer. This may involve imagining a viewer situated in history who is 'differenced', that is capable of occupying a different viewing position from the imagined dominant one operative within a culture (and such a position could be occupied by a 'differenced' male gaze, a non-heterosexual one, for example, or a non-western one). Or dominant views can be subjected to a differenced gaze, that is the gaze of the historian who looks from a different position and seeks to uncover the power relations at stake in representation.[34]

While it is certainly a valuable educational exercise to imagine a working-class, female, black, lesbian viewing position, I feel that Garb is confusing the issue by describing this as a search for a 'historical' spectator. Theoretical conclusions need to be drawn from, and reciprocally interact with, research into material life. The tendency to turn this relationship of theory and art historical practice on its head has actually hampered the investigation of women as spectators of art in the nineteenth century. There are also serious problems with the notion of a 'feminine viewing position' which posits an essentially gendered classless position shared by all women, which is then moduled by sexuality and race.

Fortunately some writers are beginning to pose the issue in a more materialist way. In a recent book on film, Judith Mayne argues for a reassessment of notions of spectatorship, writing: 'In short, the central question raised is two-fold: what are the histories of spectatorship, and what is historical about spectatorship?'[35] Anthea Callen is at present working on representations of the female spectator of art in later nineteenth-century culture and the publication of her work promises to contribute interesting material to this debate. However from the few details of her research

32. Pollock, *Vision and Difference*, p. 54.
33. Ibid., p. 87.
34. Garb, 'Gender and Representation', p. 278.
35. J. Mayne, *Cinema and Spectatorship*, London and New York, 1993, p. 63.

available at present, it seems that she too discusses the issue primarily in terms of gender opposition, with class relegated to a subordinate position.[36]

Perhaps we should question whether the opposition of male/female in nineteenth-century viewing of art works is of primary importance in any case. Is it not the case that, having understood the ways in which bourgeois ideology presents male and female qualities and characteristics as oppositional and separate, we should be attempting to show how these oppositions can be broken down, in practice and in theory? Since male/female binary oppositions are hardly accurate conceptualisations of the complexities of lived existence, surely the time has come to stop perpetuating them. However, for many feminist art historians, this would be an impossibility, since these basic gender oppositions are the foundations of their historical and cultural world-view.

However one of the main problems is that the views of women (and lower-class people of both genders) on paintings are very often reported by others – often male and almost invariably middle or upper-middle class.[37] Thus the critic for the paper *l'Evénement* in 1878 discusses a notorious representation of a sexual encounter as a male advising a male artist how to make his work acceptable, not only to moralistic male censors, but to young women and their mothers. The work in question is Henri Gervex's painting *Rolla*, 1878 (Bordeaux Museum). Gervex's work was entitled to be hung at the Salon as he had already received a medal. However, the Superintendant of Fine Arts ordered the removal of the work.

36. A. Callen, 'Degas' *Bathers*: Hygiene and Dirt – Gaze and Touch', in R. Kendall and G. Pollock (eds), *Dealing with Degas. Representations of Women and the Politics of Vision*, 1992, pp. 177–9. Note 59, p. 185, refers to Callen's forthcoming publications on this subject, including a chapter entitled 'Gendered Rights: Degas, Cassatt and the Female Spectator'. Hollis Clayson is honest in stating that she has 'not yet' completely sorted out (her) position 'on the relationship of gender and spectatorship'. She writes: 'I am . . . unsatisfied with a psychoanalytic construction of my sexual identity that assumes, for example, that my experience of Degas's (brothel) monotypes would resemble those of all other women more closely than they would, say, the responses of men (*and* women) of my class, ethnicity, education and politics.' See H. Clayson, *Painted Love. Prostitution in French Art of the Impressionist Era*, New Haven and London, 1991, column 2, p. 161.

37. Frances Borzello points this out in Chapter 12 'A Picture of the Poor' of her very interesting book *Civilizing Caliban. The Misuse of Art 1875–1980*, London and New York, 1987. She discusses the attempts of middle-class English people to elevate the poor of London's East End by organising art exhibitions for them and helping them to interpret the works on show. The Reverend Samuel Barnett and his wife Henrietta also hoped the poor would internalise the moral and social 'messages' along with the aesthetic pleasure. For example, a painting of a cow and calf entitled *Mother and Daughter* was accompanied in the catalogue of 1887 by the words, 'Notice – besides the skilful painting – how the artist has put womanhood into the cow and childhood into the calf'. There are reported comments and responses of working-class women in this chapter but it is difficult to know how much the reported comments are selected by middle-class writers and critics because they conform to what the reporters would like to hear, while others are ignored or simply not heard.

A young female nude is shown sprawled out on the bed, her corset and clothes nearby. Rolla, a young upper-class man, who has squandered the last of his family's money on a night of sex with Marion the young woman, is at the window, clothed and about to commit suicide. The critic of *L'Evénement* advised Gervex to 'orientalise' his brothels like the painter Gérôme: 'Put the young Marion on a velvet divan and give Rolla a turban to wear [and] you will be admired by these men; your work will be hung in the exhibition, and without fear a young woman will take her mother to see your "entry".'[38] Gervex explained how, after its removal from the salon, the work was exhibited at a fashionable private dealer's shop on the Chausée D'Antin, in the heart of newly 'Haussmannized' Paris: '. . . pendant trois mois ce fut, en effet, un défilé ininterrompu de visites avec une queue de voitures stationnant jusqu'à l'Opéra.'[39] Thus privately, the rich and fashionable of Parisian society, both male and female, were able to view what was considered unsuitable for women in state-organised exhibitions.

It has often been noted that nudes 'disguised' by mythology or exoticism were put on public view without much fuss whereas contemporary nudes were likely to be heavily criticised, as in the case of Manet's *Olympia*, exhibited in 1865. It has always been assumed that these works were intended for both a theoretical and a historical male spectator. However it is likely that this was not always the case. A version of a *Moorish Bath* scene by Gérôme, the painter mentioned above, was dedicated by the artist to his daughter. The scene shows a naked pale-skinned woman washing herself in a large bathing hall, while a robed black women is kneeling on the floor preparing what appears to be some sort of toiletries in a large dish. As Richard Thompson writes: 'the female nude is subservient to the spectator; she fulfils the contemporary, European assumptions about harem women, while the faceless servant is subservient to her.' (One might add that Gérôme did not necessarily consider his

38. Quoted by H. Clayson, *Painted Love. Prostitution in French Art of the Impressionist Era*, New Haven and London, p. 87.

39. See the catalogue *Henri Gervex 1852–1929*, Bordeaux, Galerie des Beaux-Arts, Paris, Musée Carnavalet and Nice, Musée des Beaux-Arts, 1992–3, p. 30.

40. See R. Thompson, in J. Pollock and R. Kendall, *Dealing with Degas*, p. 149. Versions of the work are shown in G. Ackerman, *The Life and Work of Jean-Léon Gérôme with a Catalogue Raisonné*, London and New York, 1986, nos 240, 240 B1, 240 B2. *Femme turque au bain* (or *Moorish Bath*. 82 x 65.5 cm. The version dedicated to his daugher Madeleine is in the Rhode Island School of Design, Providence, Rhode Island. This is strange, however, since these works were done in the mid-1870s, and Madeleine was born in 1874. So either Gérôme dedicated the work to her when she was born, hence she would be an actual historical spectator but an imagined potential one as well, or else the dedication was written on the painting later and given to Madeleine when she grew up.

putative spectator to be exclusively male. He dedicated one of the three versions of this painting to his daughter Madeleine, no doubt considering that the images' implicit assumptions about sexuality and social control were appropriate for her.)[40]

It is not only the historical nature of the male and female spectator which needs more careful research at this period, but also, as I have argued, the validity of the very categories of male and female as they were historically applied by bourgeois society in the mid-late nineteenth century. It is for this reason that I want now to consider the issue of 'the lesbian' in cultural representations from the period of early Modernism. Tessa Boffin and Jean Fraser, discussing an exhibition organised in 1984 entitled *Difference: On Representation and Sexuality*, write: 'we are . . . concerned that sexual difference theory has almost entirely failed to consider same-sex desire, and seems to have concentrated solely on heterosexual difference.'[41] I feel that this is a valid point which can also be made concerning studies of gender and nineteenth-century representations.

I want to look at the issue of gender representation and representations of lesbians at this period with the aim of breaking down rigid notions of male/female binary opposition. I realise that what I can offer here is tentative, but I hope that suggestive directions for further study may emerge from the very preliminary investigations which follow. Also preliminary are my attempts to offer a Marxist analysis of representations of 'the lesbian'.

Writing in 1979 Robert Padgug stated:

> In any approach that takes as predetermined and universal the categories of sexuality, real history disappears . . . This procedure is reminiscent of the political economy of the period before, and all to often after, Marx, but it is not a purely bourgeois failing. Many of the chief sinners are Marxists.
>
> A surprising lack of a properly historical approach to the subject of sexuality and its subdivisions has allowed a fundamentally bourgeois view of sexuality and its subdivisions to deform twentieth-century Marxism. Marx and Engels themselves tended to neglect the subject and even Engels' *Origin of the Family, Private Property and the State* by no means succeeded in making it a concern central to historical materialism. Most later Marxists' thought and practice, with

Gérôme opposed the admission of women students to the École des Beaux-Arts. Apparently he felt the already competitive art-world was too crowded. Since he felt that 'They are never original, they only copy', he should not really have worried about the threat they posed. He obviously did not believe all patrons and dealers would share his patronising views. He later opposed proposals to allow female and male students to study the male nude model in the same class referring to the situation as a 'return to total savagery (and that is the matter that concerns us)'. See Ackerman, pp. 166–7.

41. T. Boffin and J. Fraser (eds), *Stolen Glances, Lesbians take photographs*, London, 1991, p. 10.

a few notable exceptions – Alexandra Kollontai, Wilhelm Reich, the Frankfurt School – has in one way or another accepted this judgement.[42]

Padgug has certainly got a valid point here regarding same sex sexuality although, as I have argued above, Marxists did attempt to relate sexuality to theories of society and politics as far as women were concerned. Engels discussed women as exclusively heterosexual and failed to break from the prejudices of his age when he wrote in *The Origin* that Greek men, in degrading women, showed the seeds of their own degeneration: 'But the degradation of the women recoiled on the men themselves and degraded them too, until they sank into the perversion of boy-love, degrading both themselves and their gods by the myth of Ganymede.'[43] However such views did not prevent Marxists like Lassalle and Bebel defending the rights of homosexuals though they had little understanding of their sexuality. Even when the Bolshevik state removed legislation criminalising homosexuals after the Russian Revolution of 1917, they did so largely because they felt sexuality was a private matter and that the state should not persecute people for a physical condition they were not able to do much about. Furthermore, Marxists made little reference to lesbian sexuality specifically. However since Padgug wrote his article in 1979 much progress has been made by Marxists both in theorising the relationship of sexuality to class interests, and in practising opposition to lesbian and gay persecution.[44] How, then, can we pursue the understanding of representations of lesbian sexuality in a specifically Marxist way, so as not to fall into the traps pointed out by Padgug?

Care is needed to differentiate between the historical representation of lesbian and homosexual male experience. While some similarities occur, there are very important differences. It is argued that 'modern' notions of lesbians and gay men crystallised around the end of the nineteenth century. Previously homosexuality for men and women had not been an identity to be consciously assumed or with which to be classified by others.[45] Homosexuality for males had been defined as the practice of certain acts designated as criminal. For women, however, it was argued that lesbian

42. R. Padgug, 'Sexual matters: Rethinking Sexuality in History', in *Hidden from History, Reclaiming the Gay and Lesbian Past*, edited by M. Duberman, M. Vicinus and G. Chauncey Jn, Harmondsworth, 1991, p. 55.

43. Marx and Engels, *Selected Works*, p. 494.

44. See, for example, the useful theoretical, historical and programmatic material in *Lesbian and Gay Liberation. A Communist Strategy*, a Workers Power pamphlet published by Workers Power, BCM 7750, London WCI 3XX, England, 1987.

45. There is some debate about this however. See Introduction to *Hidden from History. Reclaiming the Gay and Lesbian Past*, p. 9, and M. Vicinus, 'They wonder to which sex I belong: the historical roots of the modern lesbian identity', in H. Abelove, M.A. Barale, D. Halperin (eds), *The Lesbian and Gay Studies Reader*, New York, London, 1993.

behaviour was the result of distinct physical characteristics, which resulted in active sexuality directed to other women, i.e. a large and protruding clitoris. This view persisted in medical texts and dictionaries in France into the mid–late nineteenth century. Possible 'solutions' to this problem involved the surgical removal of the part of the clitoris that was judged 'excessive'.[46] Parent-Duchâtelet, however, tried to point out that it was futile to try to distinguish lesbians (or 'tribades') by outward appearances: 'J'ai connu nombre de filles adonnées à cet adominable vice se faire remarquer au contraire par leur jeunesse, leur délicatesse, la douceur de leur voix et par d'autres charmes qui n'ont pas moins d'influence sur leurs semblables que sur les individus appartenant à l'autre sexe.'[47] He was at pains to counter the arguments put forward by other doctors, that lesbians could be distinguished by 'manly' traits. Thus for much of the nineteenth century the truly distinguishing feature of the lesbian, a supposedly large clitoris, would be completely hidden except to sexual partners and, occasionally, doctors, and therefore virtually unrepresentable in most visual imagery and simply not able to be seen in outward social appearances. This obviously makes for huge difficulties in:

1. the representation of lesbian sexuality by men and women, lesbians and heterosexuals;
2. the self-awareness of lesbians and the possibilities for lesbians to construct a lifestyle and self-image for themselves;
3. the identification and representation of the nude lesbian.

By the late nineteenth century, the formulation of medical and psychological bases for bourgeois 'norms' of reproductive sexual behaviour were increasingly developed to extend 'ideal' models of sexual behaviour to a wider range of society. Early capitalism had ruthlessly ripped apart family units, destroyed bonds between mothers and children

For additional reading on lesbian and gay history, see V.L. Bullough, *Sexual Variance in Society and History*, Chicago and London, 1976; L. Faderman, *Surpassing the Love of Men: Romantic Friendship and Love between Women from the Renaissance to the Present*, London, 1985; J.C. Fout (ed.), *Forbidden History, the State, Society and the Regulation of Sexuality in Modern Europe*, Chicago and London, 1992; J. Lauritsen and D. Thorstad, *The Early Homosexual Rights Movement (1864–1935)*, New York, 1974; and W.R. Dynes, *Homosexuality. A Research Guide*, Garland Reference Library of Social Science, vol. 313, New York and London, 1987. For more information on French views of Sappho in the nineteenth century, see Joan DeJean, *Fictions of Sappho 1546–1937*, Chicago and London, 1989, Chapter 3.

46. See the excellent discussion in M.J. Bonnet, *Un choix sans equivoques*, chs 2 and 3. This book, rarely mentioned in English-language publications, has been very useful to me in thinking about the issues involved.

47. Quoted in Bonnet, *Un choix sans equivoques*, p. 175.

and exposed young women in factories to sexual persecution by foremen and overseers. By the later nineteenth century lesbians and gay men were more clearly labelled as 'inverting' and 'deviating from' family relations built around heterosexual sex bonds which were seen as ideologically desirable for all classes of society. In the 1880s, Krafft-Ebing divided lesbians into four categories, consisting of women who were not visibly lesbians, women who preferred 'male' garments, women who definitely assumed a masculine role, and women who apart from their genital organs were men.[48] It is clear here that lesbians are being discussed and categorised in terms of male and female roles and characteristics which are seen as counterposed and exclusive to any other ways of conceptualising social sexuality. As a Marxist analysis of this procedure has stated:

> to justify this (sexual) division of labour over the centuries, differing class societies have constructed a culture in which feminine and masculine characteristics in terms of emotions and social behaviour are totally counterposed.
>
> This counter-position stems from socially constructed gender roles not, to any significant degree, from biology. It fragments the human personality. It prevents men and women from assimilating the best elements of both of the rigidly separated categories – masculine and feminine – and thereby transcending what is an extremely destructive divide. In a nutshell then, gender roles are primarily products of our society not of our sexuality.[49]

At the same time, medical opinion argued that the vagina, not the clitoris, was or ought to be, the real focus of sexual activity for women, thereby reinforcing the primacy of reproductive heterosexual behaviour.[50] (At least this saved women from having parts of their clitoris amputated.)

Where then, were these lesbians? Why did they exist? Late in the nineteenth century Havelock Ellis believed that some lesbians actively sought out partners who were potentially heterosexual. Increased educational opportunities, jobs and participation in public life meant that they were able to meet more women and 'convert' them. In 1895 he wrote:

> The modern movement of emancipation – the movement to obtain the same rights and duties, the same freedom and responsibility, the same education and the same work, must be regarded on the whole as a wholesome and inevitable movement. But it carries with it certain disadvantages. It has involved an increase in feminine criminality and in feminine insanity, which are being

48. See C. Smith Rosenberg, 'Discourses of Sexuality and Subjectivity: The New Woman, 1870–1935', in *Hidden from History*, p. 269.

49. *Lesbian and Gay Liberation. A Communist Strategy*, p. 11, col 1.

50. See Bonnet, *Un choix sans equivoques*, p. 179.

elevated towards the masculine standard. In connection with these, we can scarcely be surprised to find an increase in homosexuality which has always been regarded as belonging to an allied, if not the same, group of phenomena.[51]

In a confused way, Ellis is grappling with the ways in which sexuality needs certain social conditions to express itself and develop. The chance to meet other women, to have economic and legal independence, to live outside the family home, were all important factors in the possibilities of discovering sexuality. Significantly, before 1789, lesbianism had been associated with the aristocracy, the Court and in particular Marie-Antoinette and her friends.[52] In 1791 the Revolutionary government decriminalised homosexual activity, stipulating that individuals' private sexual activities should not be penalised by the state. This was re-affirmed in the Code Napoléon of 1810. This is one of the reasons why there was no campaign for homosexual rights in nineteenth-century France, whereas in Germany this demand was an issue by the late 1860s.

When 'private' sexuality surfaced in public, however, it was quite likely to be prosecuted and/or censored as, for example, with Baudelaire's poems on lesbian love, and Courbet's painting *The Sleepers*, both of which I will discuss in more detail shortly. Consequently it may be argued that *any* public representations of lesbian sexuality could be seen as having some progressive significance to them in spite of many other problematic factors. To mention or represent this unmentionable topic at least made same sex activity by women visible.

There was a real lack of overt public culture and available models of lesbian or gay lifestyles at this time. Lesbians were most often referred to in the context of studies of prostitution and it was generally assumed by the authors that prostitutes were likely to be lesbians. Their work was heterosexual sex labour, their leisure was lesbian sex activity.[53] These prostitutes were not working-class women who occasionally engaged in prostitution to supplement low wages, who were seen as completely heterosexual, but prostitutes in registered brothels who hardly ever were allowed out, and had no other work. These supposed lesbians, then, were practically invisible to much of nineteenth-century society.

51. Smith-Rosenberg, in *Hidden from History*, p. 271.
52. See Bonnet, *Un choix sans equivoques*, pp. 131ff.
53. See H. Clayson, *Painted Love*, p. 43. For prostitution in nineteenth-century France, see especially A. Corbin, *Les filles de noce; Misère sexuelle et prostitution au 19ᵉ et 20ᵉ siècles*, Paris, 1978, and the same author's 'La Prostituée' in J.-P. Aron (ed.), *Misérable et Glorieuse. La Femme du XIXᵉ siècle*, Paris, 1980, pp. 41–58; J. Harsin, *Policing Prostitution in Nineteenth-Century Paris*, Princeton, 1985; and the nineteenth-century works by A. Parent-Duchâtelet, *De la prostitution dans la ville de Paris*, 2 vols, 3rd edn, Paris, 1957 (first published 1836), and C.J. Lecour, *La Prostitution à Paris et à Londres 1789–1871*, Paris, 1872.

It is not surprising then that there was great difficulty in terms of negotiating self-images and consciousness both by the women themselves and by anyone representing lesbian sexuality. A variety of strategies open to women can be discerned from the historical material available, including dressing in men's clothing, becoming a nun (sometimes by choice, sometimes as a way for rich parents to 'hide' their family shame from public view), becoming an actress (and wear exotic or male dress on stage), writing emotional letters and poems to other women, and actually living as a partner with another woman.

Wearing men's clothing was legally prohibited, except on grounds of health, by an *ordannance* of the 7 November 1800. However some women did dress in men's clothing without permission and the fines for infringing this ruling were not great; for example, a woman who worked as a metal burnisher was fined three francs in 1830 and decided not to appear in court.[54]

The mid to late nineteenth century was a transitional period as far as notions of same-sex sexuality were concerned. Significantly there are a number of examples of representations of lesbians and examples of lesbian artists clearly identifiable at this time, for example, Rosa Bonheur, Natalie Micas and Victorine Meurend (or Meurent). Before considering the visual imagery, I want to consider what Baudelaire has to say on this issue.

In his famous essay on *The Painter of Modern Life*, written in 1859–60 and published in 1863, Baudelaire develops his notion of the (male) *flâneur*, able to wander freely in the social world as a thinking subject. Women are among the 'objects' of the *flâneur's* gaze, which he can transform into art. The artist, says Baudelaire, should seek out the 'heroism' of modern life. The prostitute is one of these 'heroic' figures, like the poet, prey to ennui and cynicism. The prostitute thus partakes of the 'masculine', and also stands partly outside the norms of contemporary French bourgeois society. She is 'different' and 'exotic'. She displays 'un cynisme masculin, fumant des cigarettes pour tuer le temps, avec la résignation du fatalisme oriental'.[55]

Walter Benjamin argues in his great book on Baudelaire that the poet saw the lesbian as 'the heroine of modernism. In her, an erotic ideal of Baudelaire – the woman who bespeaks hardness and mannishness – has combined with a historical ideal, that of the greatness of the ancient world'. But, as Benjamin points out, Baudelaire's lesbian poems (written in the 1840s but published later) combine an admiration for the heroism and passion of lesbian love with a willingness to abandon them to hell and

54. M.J. Bonnet, *Un choix sans equivoques*, pp. 198–9.
55. C. Baudelaire, *Curiosités esthétiques. L'Art Romantique et autres Oeuvres Critiques*, (ed.) H. Lemaitre, Paris, 1962, p. 498.

damnation. In Benjamin's words, Baudelaire 'had room for her within the framework of modernism, but he did not recognise her in reality'.[56]

Baudelaire wrote to his mother in 1852: 'Je pense à tout jamais que la femme qui a souffert et fait un enfant est la seule qui soit l'égale de l'homme. Engendrer est la seule chose qui donne à la femme l'intelligence morale.'[57] Now this may well have been a calculated ploy by Baudelaire to exaggerate the importance of motherhood in writing to his own mother, as he had a jealous and insecure relationship with her, but it nevertheless indicates that Baudelaire viewed non-reproductive female sexuality as mindless and inferior.

As Benjamin points out, Baudelaire was scathing about actual women, who, as he saw it, 'imitated' men. Discussing Fourierist and Saint-Simonian utopian socialist women, Baudelaire wrote: 'we have never been able to accustom our eyes . . . to all this solemn and repulsive behaviour . . . these sacrilegious imitations of the masculine spirit.'[58]

The utopian socialists of early nineteenth-century France had a very positive view of 'the feminine', and believed in a progressive unity of the male and female aspects of social life and thought. However their abstract approach to these issues did not prevent women members of their organisations being burdened by child-bearing and child-rearing as a result of a freer approach to sexuality. But in the context of early nineteenth-century France it is so refreshing to hear Fourier argue for communal childcare and praise lesbianism because he felt it would contribute to morally uplifting the community.[59] At the age of thirty-five, Fourier discovered his 'goût ou manie du saphisme, amour des saphiennes et empressement pour tout ce qui peut les favoriser'. However the material on lesbianism was edited out of his writings when they were published after his death by Victor Considerant in 1841.[60] It is obviously no accident that Rosa Bonheur, who came from a Saint-Simonian family, was able to love women without feelings of guilt, although her life as a lesbian in the public eye was not without problems of self-image and self-presentation.

Pierre Joseph Proudhon (1809–65) was another member of the French Left who wrote on women and lesbianism, but his views were very

56. W. Benjamin, *Charles Baudelaire. A Lyric Poet in the Era of High Capitalism*, London, 1973, p. 93.

57. J. Bassim, *La femme dans l'oeuvre de Baudelaire*, Neuchatel, 1974, p. 95. For Baudelaire's representations of black women, see E.J. Ahearn, 'Black Woman, White Poet: Exile and Exploitation in Baudelaire's Jeanne Duval Poems', in *The French Review*, vol. LI, no. 2, December 1977, pp. 212–20.

58. Benjamin, *Charles Baudelaire*, p. 93.

59. Fourier was more progressive than Saint-Simon in this respect. See S.K. Grogan, *French Socialism and Sexual Difference. Women and the New Society, 1803–44*, Basingstoke, 1992.

60. Bonnet, *Un choix sans equivoques*, p. 10.

different from those of Fourier. Proudhon's misogyny is well-known, but perhaps a few reminders of his views will refresh readers' memories. Women's brains were inferior to men's, according to Proudhon, so the only roles open to them in modern society were those of 'housewife' or 'harlot', and he opposed women's suffrage. Woman's role was to be subservient to man, stay at home and bring up the man's children. He wrote in a letter to a friend in 1850:

> I have married, at age forty-one, a simple Parisian working woman, with no fortune, but of serious morals and a perfect devotion. As for education, she is a lacemaker; for the rest, she is as little a *bas bleu* as a *cordon bleu* . . . I have made this marriage with premeditation, without passion, in order to become . . . a father of a family.[61]

The backwardness of Proudhon's views on women are on a par with his total opposition to any workers taking strike action.

I would like now to look at Proudhon's comments on lesbianism in conjunction with Courbet's painting *The Sleepers* (plate 13). It has been argued that Courbet's views on society were very heavily influenced by Proudhon, his friend, and that Proudhon's comments on the artist's work give a privileged insight into Courbet's aims as a 'social' artist.[62]

Proudhon, in his book *Du principe de l'art et de sa destination sociale* (1865) discusses several paintings by Courbet representing women. Concerning the *Bather* (Montpellier), for example, Proudhon states that Courbet's female figures are not intended to incite lust. This bather is a bourgeoise, he writes, but people can see what they like in paintings. She might be a 'blue stocking' for some (since literary activity makes women grow fat), or an abbess, or a courtesan since all these 'types' have the same bodily form. Of the *Young Ladies on the banks of the Seine (summer)* (Paris, Petit Palais), he states that the brunette has slightly virile features, seems to be in an erotic reverie and makes the (male) spectator think of satanic seductions, vampires and nymphomaniacs: 'Fuyez, si vous tenez à votre liberté, à votre dignité d'homme . . .'[63] The blonde woman is cold, calculating and ambitious. Together they embody pride, adultery, divorce and suicide. Turning to Courbet's painting *Venus and Psyché*, refused at

61. See C.G. Moses, *French Feminism in the Nineteenth Century*, Albany, New York, 1984, p. 268. Also useful is M. Albistur and D. Armogathe, *Histoire du feminisme français du moyen âge à nos jours*, Paris, 1977, pp. 300ff, and J.F. McMillan, *Housewife or Harlot: The Place of Women in French Society 1870–1940*, Brighton, 1981.

62. See, for example, J.H. Rubin, *Realism and Social Vision in Courbet and Proudhon*, Princeton, New Jersey, 1980. However Rubin does point out that Courbet later attempted to 'transcend' elements of Proudhon's thought.

63. P.J. Proudhon, *Du Principe de l'art et de sa Destination Sociale*, Paris, 1865, p. 246.

the Salon of 1864 (now lost), he interprets it as a lesbian scene designed as a satire on the 'abominations' of the age. However he says contemporary society is looking for dirt and filth and, instead of interpreting Courbet's paintings as critical, society sees them as titillating and scandalous: 'Et voilà ce que vous cherchez tous, race de pédérastes et de tribades . . .' ('race of homosexuals and lesbians').[64]

Now Proudhon seems to be arguing himself into a corner here. Working on the principle of 'it takes one to know one', he decides that society is full of sexual 'degenerates', otherwise they would not even recognise the degenerate sexuality in the painting. Courbet, on the other hand, does see and represent sexual degeneracy, but is not himself a homosexual or a lesbian, he is merely warning people to beware of the evils of contemporary society, lewd women and the horrors of women engaged in sexual activity with one another.

In a recent article on Courbet's *Venus and Psyché*, Petra Ten-Doesschate Chu documents the refusal of the painting by the Salon jury on the grounds of impropriety. She states that the painting 'would have been read by most male viewers as an immoral statement', refers to Proudhon's 'lengthy and passionate exegesis of *Venus and Psyché*' and 'cannot help wondering whether he had any part in the conception of the picture'.[65] I think it is far more likely that Courbet's *Venus and Psyché* and *The Sleepers* were intentionally erotic, as such intended for male spectators, and not primarily intended as warnings against the immorality of contemporary society. However I would also like to argue that the very representation of lesbian sexuality in *Venus and Psyché*, and far more clearly in *The Sleepers*, was a representation of the unmentionable and even inconceivable sexuality of lesbians, and consequently these works had far more complex and contradictory meanings than suggested by (1) Proudhon's 'warning against immorality' thesis or (2) the 'objectification of females for male gratification' thesis.

A Turkish collector living in Paris bought the *Venus and Psyché* and Courbet painted *The Sleepers* for him soon afterwards in 1866. However *The Sleepers* was not sent to the Salon, and we have to remember that the work was not publically available to a large number of viewers. It was however on view before Khalil Bey's sale in December 1867.[66]

This powerfully sensual painting has certain trappings of the 'exotic' associated with lesbians in Baudelaire's poetry. The two bodies lie entwined on the bed with the supposed 'sign' of lesbianism (the enlarged

64. Proudhon, *Du Principe*, p. 262.

65. Petra Ten-Doesschate Chu, 'Gustave Courbet's *Venus and Psyché*. Uneasy Nudity in Second Empire France', *Art Journal*, Spring 1992, p. 41.

66. See F. Haskell, 'A Turk and his Pictures in Nineteenth-Century Paris', *The Oxford Art Journal*, vol. 5, no. 2, 1982, p. 45.

clitoris) hidden, but nevertheless it is clear that physical characteristics here are not what defines the representation as one of lesbian sexuality. The image is quite unusual in terms of a large-scale oil representing any form of sexual activity. I cannot recall seeing any similar heterosexual nude scenes from this period at all. However this painting and the many photographs from the Second Empire showing 'lesbians' were produced to show people acting 'like lesbians' or how lesbians were thought to behave by others.

How can the naked body be defined as lesbian and for whom? The image is almost certainly for a male viewer, and its play with visibility and concealment is perfectly attuned to the very essence of voyeurism. Close physical contact between the figures, even in sleep, has to be introduced for the women to represent lesbians. It is arguable that they are not lesbian bodies but female bodies acting out a lesbian charade, and certainly we know that one of the women, the model for the blonde, J. Heffernan, did have sexual relations with men. But is there not something potentially very disruptive, even within this framework, in the representation of any kind of lesbian sexuality, even when it is obviously not the authentic experience of lesbian subjects?[67]

The lesbian painters that we do know of in the nineteenth century (and there were undoubtedly more that we do not know of) do not appear to have painted any works overtly concerned with representations of female sexuality. This is not particularly surprising, due to the historical and social factors outlined above, but an important factor was the notion enshrined in the legal position of the bourgeois state since 1791, reaffirmed in 1810, that sexuality was a private matter.

Victorine Meurend who modelled for Manet's *Olympia* (plate 14) exhibited paintings at the Salon in 1876, 1879, 1885 and 1904.[68] None of these paintings have been found. The exhibit in 1876 was a self-portrait on wood, the 1879 exhibit was a *Bourgeoise de Nuremberg an XVI*, and in 1885 it was *Palm Sunday*. Victorine Meurend (or Meurent) is known to have lived with at least two female partners in her lifetime and Lipton puts forward the hypothesis that Manet's representations of Meurend may have 'encoded in his paintings his colleague's sexual preference for women'.

67. An early twentieth-century painting of lesbians engaged in physical sexual activity is shown in M. Perrot (ed.), *A History of Private Life from the Fires of Revolution to the Great War*, Cambridge, Mass., and London, 1990, in the section 'The lesbian, symptom of male fantasies', pp. 643–6. It is argued here that the exhibition of this work at the Salon of 1909 did not cause a fuss because male visitors simply saw the image as constructing and reinforcing their sexual fantasies, and that the work simply appealed to the male spectator in a fairly straightforward way.

68. E. Lipton, *Alias Olympia. A Woman's Search for Manet's Notorious Model and Her Own Desire*, London, 1993, p. 57. Lipton's book has the most up-to-date information on Meurend.

She specifically cites the portrait of Meurend dressed as a bullfighter. We can indeed only speculate as to whether *Olympia* was a representation not just of a commodified female body, as courtesan, but of an even more 'hidden' and forbidden lesbian sexuality, not suggested by the proximity of another nude woman, or by 'masculine' clothing.

The work of Rosa Bonheur, aided by her partner Natalie Micas, perhaps constitutes the most public and coherent *oeuvre* of a lesbian artist in nineteenth-century France. Her subject-matter is largely based on scenes of animals and, as such, is in total contrast to the notion of lesbian existence as 'exotic' and extraordinary. Her technique is based on naturalism and verisimilitude, yet many of her works seem almost distanced from contemporary society. Bonheur's family encouraged her art and, as Saint-Simonians, rejected notions of women's inferiority. Bonheur obtained permission from the police to wear men's clothing, but preferred to receive visitors in 'female' clothing. She saw her relationship with Natalie Micas as 'pure' because she had had 'ni amants ni enfants'. However if she had been a man, she wrote, she would have done similar things and no one would have commented on the fact of her relationship with Natalie Micas:

> Quelle aurait été mon existence sans le dévouement et l'affection de cette amie! . . . Et pourtant on a cherché à rendre suspecte l'affection que nous éprouvions l'une pour l'autre. Il semblait extraordinaire que nous fassions bourse commune, que nous nous soyons légué réciproquemont tous nos biens. Si j'avais été un homme je l'aurais épousée et l'on n'eût pu inventer toutes ces sottes histoires. Je me serais creé une famille, j'aurais eu des enfants qui auraient hérité de moi et personne n'aurait eu le droit de réclamer.[69]

After selling *The Horse Fair* in 1855 for what was at the time a huge sum, Bonheur was able to set up home with Micas. Together they produced a small replica for the English dealer Gambart who had bought the original, to facilitate the engraving of the work (plate 15).[70] The original has been interpreted as a representation of the lesbian body by James Saslow.[71]

If this is the case, it further underlines the difficulties faced by lesbians

69. M.J. Bonnet, *Un Choix Sans Equivoques*, p. 201, p. 215.

70. See cat. no. 621, pp. 10, 11, 12 (Bonhear) and p. 101 (Micas) in M. Davies, revised C. Gould, *National Gallery Catalogues, French School, Early 19th Century, Impressionists, Post-Impressionists etc.*, London, MCMLXX.

71. J. Saslow, "'Disagreeably Hidden". Construction and constriction of the lesbian body in Rosa Bonheur's *Horse Fair*', in N. Broude and M. Garrard, *The Expanding Discourse: Feminism and Art History*, New York, 1992. A rather different analysis of Bonheur's 'masculinity' is given in A. Boime, 'The case of Rosa Bonheur: why should a woman want to be more like a man?', *Art History*, vol. 4, no. 4, December 1981, pp. 384–409. A very general introductory survey on the topic of art and homosexuality can be found in E. Cooper, *The Sexual Perspective: Homosexuality and Art in the last 100 Years in the West*, London and New York, 1986.

themselves in constructing a self-image which shattered the ideological stereotypes of male and female socialised identity. Perhaps it was more manageable, after all, to articulate such issues through animal bodies, rather than human ones.

Not only were lesbians marginalised and hidden from bourgeois society as much as possible in being equated with prostitutes almost imprisoned in the *maisons closes*, they were ideologically categorised virtually out of existence. They could only be described in so far as they related to existing notions of 'male' and 'female' identities, which themselves blotted out the contradictions in the lived social and sexual experience of actual men and women. Much has been written concerning 'patriarchal' discourses which have removed women from history. Marie Jo Bonnet sees men and patriarchy as responsible for what happened to lesbians in history. To some extent she is correct. Men with powerful positions in the state noticed the 'invisible' and immediately censored it. Sometimes they also noticed and enjoyed in private. But for years a large number of feminist books on art history have not even noticed. The emphasis on gender struggle and gender opposition based on already ideologically conceptualised notions of 'male' and 'female' has contributed, no doubt unintentionally, to the fact that the lesbian in nineteenth-century French culture has still remained largely 'hidden from history'.

Women, Class and Photography: the Paris Commune of 1871

In this chapter I want to discuss gender and class in relation to photographic imagery from the Paris Commune.

While some feminist art historians, in particular Griselda Pollock, have criticised the notion of an art history of 'canonical' works, mostly executed by male artists, there has been an increasing, rather than a decreasing, tendency for the emergence of a 'canon' of women's art. Now I do not believe that writers such as Pollock are in favour of this at all. The reason for the emergence of so many books on women Impressionists and early women Modernists, and the creation of 'cult' figures such as Frida Kahlo (whose works are eagerly snapped up by Madonna) and Georgia O'Keeffe, may well be ultimately financial concerns on the part of publishers. The number of books and articles on Berthe Morisot and Mary Cassatt, in particular, testify to the persistence of early Modernism as a key area of study in art history, and furthermore to the primacy of the 'fine' art tradition as an area of scholarly concentration. Prints, photographs and other published material are used to 'back up' discussions of 'original' oil paintings, water-colours or fine art prints such as those produced by Mary Cassatt which I discussed in the previous chapter. This in itself is not explicable by, nor specific to, the gender of the scholars.

The use of 'ephemeral' material to elucidate the meanings of oil paintings by famous artists can be seen in the work of T.J. Clark, for example where he refers to prints, press illustrations and photographs to contextualise and analyse Manet's oil painting *A Bar at the Folies-Bergère*.[1] Tag Gronberg does exactly the same in her article 'Femmes de Brasserie', using prints and other printed material to elucidate the meanings of Manet's painting of a beer waitress serving customers. The only difference here is that Gronberg's aim is to focus on the representation of the woman in the

1. This is pointed out by Adrian Rifkin in his review of Clark's book *The Painting of Modern Life* in *Art History*, December 1985, pp. 488–95, and in his article 'No particular thing to Mean', *BLOCK*, 8, 1983, p. 36; 'In Schapiro or Clark . . . popular prints or songs, and their contemporary commentaries and types of appropriation, are made to serve the analysis of the always more comprehensive meaning of a painting from the Louvre . . .'

'famous' oil painting.[2] Adrian Rifkin has written a number of thought-provoking articles on this issue, concentrating on prints and other forms of culture outside the fine art sphere produced during the latter part of the Second Empire (1852–70) and the Paris Commune.[3]

It is noticeable that the culture, and even the fact, of the Commune is largely ignored by most art historians. Given Clark's professed interest in class and culture, it is indeed an astonishing fact that *The Painting of Modern Life* mentions the Commune on seven pages out of three hundred and sixteen, and three of these pages are in the endnotes section of this book.[4] While of course it is not the case that a Marxist art history should necessarily seek to discuss heightened periods of social and political struggle, it is certainly odd that Clark pays so little attention to imagery produced in the Commune.

Similarly writings on this period by feminist art and cultural historians have virtually ignored representations of working-class women and other female participants in the Paris Commune. By considering key photographic images and, to a lesser extent, printed imagery from this period, I want to consider whether these visual media allow for different ways of representing working-class women, and women active in the Commune who were perceived as opposing the French State. Are these forms of images inherently more democratic, as some historians of photography claim? Do they document for us the existence of women from this period or, on the contrary, are the photographs of Communardes being used as oppressive images of categorisation and classification by the state which sought to criminalise women who had been arrested after the fall of the Commune? How do considerations of class and gender enable us to answer these questions?

In order to tackle these issues I will firstly look at the political and economic situation of working-class women at this period, together with some analysis of these questions by contemporary feminists, socialists and Marxists. I will then discuss the question of 'erotic' photography and women at this time, before considering imagery of women produced during the Paris Commune. I hope to demonstrate that photographic imagery of female Communardes is neither simply objectification and

2. T.A. Gronberg, 'Femmes de Brasserie', *Art History*, vol. 7, September 1984, pp. 329–44.

3. See above note 1 and A. Rifkin, 'Cultural Movement and the Paris Commune', *Art History*, vol. 2, no. 2, June 1979, pp. 201–20 and A. Rifkin, 'Well formed Phrases. Some Limits of Meaning in Political Print at the End of the Second Empire', *The Oxford Art Journal*, 8:1, 1985, pp. 20–8.

4. An exception to the excision of the Commune period from art history is the essay by Paul Tucker, 'The First Impressionist Exhibition in Context', in C.S. Moffett (ed.), *The New Painting. Impressionism 1874–1886*, pp. 93–144.

fetishisation by the patriarchal gaze nor, on the other hand, purely domination and objectification by state repression. A Marxist analysis of these images, such as I understand it, seeks to show the unresolved contradictions of social conflict still present in the production and circulation of these images even in the severely reactionary period following the repression of the Commune. I will also argue there is no qualitative difference in this respect between photographs of male and female Communarde prisoners.

By the time of the Second Empire, large numbers of women were active in the workforce. In 1860 there were around 100,000 women workers in Paris, and in 1866 there were 2,768,000 women employed in non-agricultural work in France as a whole.[5] Women were employed in large numbers in the textile industries, printing, fashion trades, domestic service and 'service' work, e.g. washerwomen, ironers. Many women were homeworkers, earning miserable wages, working long hours and forced to buy such materials as needles and threads themselves. Women's pay was never on a par with that of men, although hours and conditions where male and female employees worked together were generally similar. For example, Duveau gives figures of thirteen to fourteen hours per working day for silk workers. The working day varied in summer and winter, with longer daylight hours meaning a fourteen to sixteen hour working day.[6] In the 1860s, women earning from fifty centimes to one franc twenty-five centimes a day would be considered particularly impoverished. A small number of women workers earning more than four francs a day would be considered fortunate.[7] Macmillan gives examples of mid-nineteenth-century women's wages and hours for a number of different jobs including laundry work. A soaping woman would work a fourteen hour day for two francs fifty centimes, and an ironing woman, who would have been more skilled, was paid two francs seventy-five centimes for a twelve hour day. A washerwoman would start work at 6.00 a.m. and perhaps not leave until 7.00 p.m. Seventy-five per cent suffered hernias from carrying heavy loads of washing.[8]

Jules Simon estimated that a family of four living in Paris at this time needed an income of thirty-two to thirty-three francs a week in order to live just above starvation level, and pointed out that only a minority of working-class families made even this small amount.[9] Since in 1857 the

5. See G. Duveau, *La Vie Ouvrière en France sous le Second Empire*, 2nd edition, Paris, 1946, p. 327, and J.F. McMillan, *Housewife or Harlot*, p. 2.

6. Duveau, *La Vie Ouvrière*, p. 287.

7. Ibid., p. 327.

8. Macmillan, *Housewife or Harlot*, p. 69.

9. Jules Simon, quoted in J. Bruhat, J. Dautry, E. Tersen et al., *La Commune de 1871*, 2nd edn, Paris, 1970, p. 36.

price of a dress was 500–3,000 francs, it was clear that many working-class women would have no chance of buying the items that they themselves were producing.[10]

Furthermore, many workers were laid off for months at a time; for example, a woman making artificial flowers would probably earn 420 francs a year and be out of work for four to five months, while a seamstress would earn one to two francs twenty-five centimes a day and be laid off for four months.[11] This had two main consequences for poor unemployed and working women. They would be under considerable pressure to turn to prostitution, and/or be virtually forced to remain in a family unit, since economic independence as a single woman was almost entirely out of the question. For example, the fourteen-year-old daughter of a Parisian dockworker in 1858 earned one franc fifty centimes a day as an ironer, but was expected to give all of this to her family's budget. In fact she herself probably expected to do this as it was the only way members of the family could survive. A number of working-class families would have liked their daughters to train for better jobs, but could not afford the loss of their wages. Teaching was seen as a desirable career move for the daughters of working-class families but their pay was still poor after years of training.[12] Skilled trade apprenticeships also had to be paid for by families and this too meant that few young women were able to train, as their families felt that their daughters' working lives would be interrupted by pregnancies, and hence the money, if it was available, would be better spent on sons' training.[13]

The large number of prostitutes in Paris was commented on with concern by many professional members of the bourgeoisie such as doctors and state officials, and also by members of the intelligentsia, writers and critics. The fear of bourgeois society being 'invaded' by hordes of prostitutes from the lower classes led to an exaggerated estimate of numbers of prostitutes working in Paris.[14] Since most of these prostitutes were unregistered, it is really not possible to arrive at accurate figures for numbers of working prostitutes at this time. However the low wages of the vast majority of women workers made them seem potentially available for prostitution. These economic factors, coupled with bourgeois ideology which imagined a more free and active sexuality among the working

10. H. Vanier, *La mode et ses métiers, frivolités et luttes des classes*, Paris, 1960, p. 207.
11. Duveau, *La Vie Ouvrière*, p. 327.
12. See J.W. Shaffer, 'Family, Class and Young Women: Occupational Expectations in Nineteenth Century Paris', in R. Wheaton and T.K. Hareven (eds), *Family and Sexuality in French History*, Pittsburgh, 1980, p. 183.
13. Vanier, *La Mode et ses métiers*, p. 55.
14. See A. Corbin, *Les Filles de noce*, pp. 42–4.

classes, has resulted in surviving literary and visual material which elides the notions of 'working-class woman' and 'prostitute'.

Perhaps the most telling of these comments were written by Maxime du Camp, discussing a painting exhibited at the Salon of 1861, *La Pourvoyeuse Misère* (*Misery the Procuress*) by Auguste Glaize. A ragged figure of Poverty, a destitute old woman, points to a city where a cart-load of semi-clothed and naked young women is heading. This large painting was accompanied by a text mentioning how these young girls 'grown tired of work' take to vice and debauchery to escape from Poverty. Maxime du Camp, ex-photographer, man of letters and reactionary, sees the spectre of class struggle in the rise of prostitution, as his comments on the painting make clear:

> This picture . . . is the allegorical figuration of what we see every day on our sidewalks and in our theatres, the growing invasion of women of dubious virtue who are today a new element of our society in transition and who, in the always active and intelligent hands of civilisation, are perhaps no more than the instruments of equality, destined to make our inheritance prove illusory or at least put into forced circulation . . . I've often wondered if the lower classes of our society were not carrying on, without being conscious of the fact, the struggle begun at the end of the last century, and whether, in producing these beautiful women whose mission seems to be to ruin and cretinise the haute bourgeoisie and the last remnants of the nobility, they were not continuing quite peacefully the work of the most violent clubs of 1793. Marat today would not ask for the heads of two hundred thousand aristocrats, he would decree the emission of two hundred thousand new kept women, and the results would be the same.[15]

This frequent equation of the publically visible working woman and prostitution seems to have persisted with great efficacy until the present time and has not yet disappeared. A number of art history books discussing representations of working (and working-class women) in nineteenth-century art have tended, I feel, to overestimate the extent to which these women are represented as prostitutes or as sexually available.[16]

15. See T.J. Clark, *The Painting of Modern Life*, pp. 112–13 (translation, slightly edited by me, from p. 113), and also the exhibition catalogue, *The Second Empire 1852–1870, Art in France under Napoleon III*, Philadelphia, Detroit and Paris, 1978–9, catalogue number vi–61.

16. See, among others, Clark's discussion of *A Bar at the Folies-Bèrgere*, Gronberg, 'Femmes de Brasserie', and E. Lipton, *Looking into Degas: Uneasy Images of Women and Modern Life*, Berkeley, Los Angeles and London, 1986. The classic example of this is Manet's *Olympia* where the work is constantly referred to as 'a painting of a prostitute' whereas it is a representation of a courtesan posed for by someone who was very likely never a prostitute. This slippage between 'representation' and 'actuality' is often encountered, as is the tendency to designate almost any working-class woman in nineteenth-century Paris as a prostitute, or a possible one.

As a number of works have pointed out, one of the worries of the French bourgeoisie was how to control prostitution. But to control prostitutes (and/ or become a client) prostitutes would have to be recognisable. For example C.J. Lecour suggested the idea of a special costume for prostitutes. Since dyed blonde hair was associated with prostitution, according to Lecour, perhaps they could wear yellow to distinguish themselves, like Jews.[17]

Some large enterprises, such as department stores, virtually imprisoned female (and male) employees in hostels where they were closely supervised lest they became open to immoral influences. In many cases the families were prepared to have their daughters 'kept out of trouble' in this way. An important example of this form of work organisation and supervision were the 'industrial cloisters', run by nuns. In the region around Lyons, 40,000 young women lived in this way. They got food, lodging and 80–150 francs pay after four years of 'apprenticeship' in the textile 'cloister' at Jujurieux. In this establishment girls aged thirteen and fourteen years worked from a quarter past five in the morning until a quarter past eight at night. Two hours a day were allowed for meals and recreation. Sundays were devoted to religion and some other educational activities. Every six weeks the young women could visit their families. Nuns were often involved in supervising factory work and a religious order was specifically set up to provide industrialists with personnel for this task.[18] Religious institutions who took in sewing and washing undercut the already meagre wages of employed women in the private sector, and these factors combined to make large numbers of working-class women extremely hostile to the Church.

Most of the mutual aid societies created by workers before 1852 did not allow women to join but by 1860 almost 70,000 women were members. However women's subscriptions were higher and they were not entitled to any sick benefit, simply a medical visit and medicaments. Perhaps these rules resulted from the fact that male workers viewed women as more likely to fall ill, but statistics show that they took less time off work for reasons of ill health than men.[19] Women workers joined the tailors' union in 1866 with equal rights and were soon involved in strike action, while in 1869 a large number of women workers in Lyons were involved in a very militant dispute. However the delegate who visited the Congress of the First

17. See C.T. Lecour, *La Prostitution à Paris et à Londres 1789–1871*, Paris, 1872, pp. 45–6. Lecour also suggested museum-type displays at entrances to brothels to show the horrors of venereal disease.

18. See M. Albistur and D. Armogathe, *Histoire du Feminisme Français du moyen âge à nos jours*, Paris, 1977, p. 316.

19. Ibid., p. 314.

International Working Men's Association in 1869 to report on the dispute and receive support was male.[20]

The French state and industrialists were eager to show 'progressive' aspects of women's participation in the workforce. At the 1867 International Exhibition in Paris, women workers were put on display in the Galerie des Machines. The *Journal des Demoiselles* of September 1867 wrote approvingly: 'Voilà une légion de jeunes imprimeuses, en rubans bleus dans la coiffure, en satrau noire sur les vêtements, qui composent et typographient sur place. Plus loin s'agitent, dirigées par des mains intelligentes, des machines à coudre de toutes formes.'[21]

Obviously both feminists and socialists were concerned by the question of women's work. Marxists had rather a distinct position on the question but were in a tiny minority in the labour movement at this time. For reasons of space I am not going to give a comprehensive survey of writings on women's work and working-class women at this time, but will raise some key issues around the arguments of Julie Daubié (1824–74), and the debates which took place at the Congresses of the First International Working Men's Association (1864–76).[22]

Julie-Victoire Daubié was a pioneer in the struggle for women's rights in nineteenth-century France. She was born into a fairly poor family (her father was a cashier in a tin-plate manufacturing establishment) but, through study and hard work, became the first woman to obtain a school leaving certificate and the first to obtain a higher degree, and was working on a doctorate when she died. She wrote numerous articles and several books, discussing economic and political issues concerning women's work and women's rights. Influenced by Saint-Simonian thinking, she attempted to link the improvement of the status of women with social harmony. In 1866 her book *La Femme Pauvre au XIXe siècle* was published, one of a number of feminist works produced in the 1860s by a growing number of feminist campaigners and writers such as Jenny d'Héricourt, Eugénie Niboyet and Maria Deraismes. Proudhon's ideas about women's role in

20. See Vanier, *La mode et ses métiers*, p. 238., and J. Freymond (ed.), *La Première Internationale*, 2 vols, Geneva, 1962, vol. 2, p. 25. See also M. Guilbert, *Les Femmes et l'organisation syndicale avant 1914*, Paris, 1966.

21. H. Vanier, *La Mode et ses métiers*, p. 246. Interestingly, Baudelaire, whose poetry glorified exotic and fascinating female bodies, had complained that he was very dissatisfied with the work the 'équipes femelles' did on the typesetting of his literary work. See Duveau, *La vie ouvrière*, p. 285.

22. General surveys can be found in Albistur and Armogathe, Macmillan, *Housewife or Harlot* and C.G. Moses, *French Feminism in the Nineteenth Century*, Albany, New York, 1984.

society were strenuously attacked by these feminist writers.[23]

Daubié's book *La Femme Pauvre* is of great interest, as it shows a typical example of the solutions envisaged by feminist writers of the 1860s to the problem of women's oppression. The book was originally presented as an entry to a competition organised by the Academy of Lyon and funded by the Saint-Simonian banker Arlès-Dufour. The questions posed were (1) how to obtain equal pay for women and (2) how to open more jobs to women. Daubié's research in answer to these questions is impressive. Daubié was completely committed to equality for women but believed that this could be achieved by various reforms. She points out that she is not a socialist and states that it is not the free market which has been responsible for women's low pay, but governmental measures which deny women equality in civil rights and education.[24] Among measures to solve 'social antagonisms', she advocates paternal responsibility for children at the same time as 'une solidarité plus étroite entre les profits du capital et les services du travail'.[25] Interestingly, she argues that women were better off under the *ancien régime* before 1789, where various charities and gifts of dowries helped single and poor women, than under the rigours of a developed bourgeois society.[26] She points out to her reader that she supports individual freedoms, the family and class harmony, and asks people not to judge contemporary women's rights campaigners by the example of the *tricoteuses* in the French Revolution. She ends her book by pointing out that she is in favour of the vote for both men and women as long as they show themselves intelligent enough to use it, as she is afraid that universal suffrage will bring revolution.

These rather utopian proposals for the collaboration of capital and labour in class harmony, while the capitalist state brings in reforms to improve the lot of women, are rather different from Marxist analysis of the question of women's oppression and the state, on the one hand, and the majority of the French labour movement, on the other, which was largely opposed to women's work outside the home, other than in 'women's jobs' such as teaching. However Daubié herself believed that an ideal society would leave women free for domestic tasks, and primary-school teaching would be training for motherhood.[27]

23. On Julie Daubié, see the Introduction and Preface by M. Perrot and A. Thierce of the edition of *La Femme Pauvre au 19ᵉ siècle*, Paris, 1992, and R.A. Bulger (ed.), *Lettres à Julie-Victoire Daubié (1824–1874), la premiere bachelière de France*, New York, San Francisco, 1992. A collection of manuscripts and letters concerning Daubié is in the Bibliothèque Marguerite Durand at the Hôtel de Ville, Lyon.

24. Daubié, *La Femme Pauvre*, Paris, 1846, p. 44.

25. Ibid., p. 78.

26. Ibid., Introduction, p. xi–xii, p. 226.

27. Ibid., p. 109.

But there is no doubt of Daubié's concern and anger over the plight of women of all classes. She points out how lack of education hampers women's access to skilled and professional jobs, while at the lower end of the employment scale women homeworkers earn thirty centimes for sewing a pair of trousers by hand. These homeworkers had to compete with sewing done by women (and men) in prisons and orphanages, and by women in convents. Three quarters of shirts for sale in shops came from convents and orphanages produced a twenty-piece baby's layette for one franc ten centimes, a ridiculously low cost, due to conditions more akin to slave labour than capitalism.[28] Her careful research provides many examples of low wages and bad conditions in factory and other work.

As regards visual arts, she looks forward to the day when women will enter the Academy of Fine Arts as students rather than models. In Chapter VIII she discusses *Femmes artistes*, pointing out that no women apprentices were allowed at the Gobelins tapestry factory. On photography, she states that there are 100 women working in the photographic industry in Paris but no female apprentices, and the women's salaries are lower than the men's. She remarks on the number of travelling photographers in the countryside and sees this as an ideal part-time or seasonal occupation for 'a host of idle young women' (!).[29] She argues that art is a good profession for women since they can stay at home and do it. To a certain extent this is true but it needs to be borne in mind that there is a vast difference between the status and conditions of a professionally established fine artist, working from home, and a 'homeworker', colouring daguerreotypes by hand and paid on a piece-work system.

Daubié's work is illuminating for the details she gives on women's work and the political analysis she offers. As stated above, even most of the 'advanced' labour movement at this period was not in favour of women working outside the home. In some senses, given the awful conditions and pay, this was understandable. However behind the notions of the physical weakness of woman, the need to protect her and so on, lay the fear of job losses and pay cuts if the employers took on larger numbers of women (and children).

Some of these arguments can be seen in the debates which took place in the Congresses of the First International Working Men's Association, which had a section in France including both male and female members. Marx had been invited to participate in the International after the founding meeting had been organised, and he did his best to influence its politics, including those on women. However the International included a wide range of political views, for example Proudhonism, Chartism and

28. Ibid., pp. 45, 46.
29. Ibid., p. 295.

Blanquism, and the influence of the First International on the Commune and women Communardes cannot therefore be seen as necessarily Marxist.

At the first Congress in 1866 delegates discussed women's work. It was a debate that continued throughout the organisation's existence. Certain delegates argued that women's work should be opposed since it was an example of capitalism's worst attempts to brutalise women. Varlin, from Paris, replied that without work women would have no means of support other than charity and prostitution. Lawrence, from London, argued that conditions of women's work under capitalism needed to be opposed, not women's work itself. The debate was a long and significant (perhaps even bitter) one, with a minority, including Varlin, arguing against the notion of the 'natural' place for women being at home educating and raising children.

The majority returned in 1867 with the same arguments about women's natural place, but the material basis of their views was clear enough: 'Dans la société actuelle, nous ne sommes pas partisans du travail de la femme dans l'industrie, parce qu'il contribue à faire baisser le salaire de l'homme.'[30] The minority position report stated that the low pay of women was due to the capitalist system of the organisation of work and should be combatted by strenuous efforts to involve women in workers' organisations alongside male workers.[31]

The debate rumbled on over the next few years. At the Congress of 1871, a proposal from Marx argued for the formation of special women workers' organisations, without excluding the formation of mixed male and female sections. This, argued Marx, would enable women to discuss among themselves where necessary, and formulate their demands as women workers. Women 'ont plus d'ardeur que les hommes. Il (Marx) ajoute quelque mots par lesquels il rappelle la participation ardente des femmes aux évènements de la Commune de Paris'.[32]

Marx's proposal was intended to help women organise themselves as workers in a struggle against capitalist exploitation, but also to recognise that, as women, they would have particular needs and demands and should have the right to meet, without the presence of men, to discuss them. However this was not seen by Marx as a means to 'ghettoize' women since he argued that these measures should not exclude 'mixed' workers' organisations. Thus Marx's emphasis was on the centrality of women organising themselves as women and workers in opposition to capitalism.

The arguments of Daubié and the delegates to the Congresses of the International give some idea of the political analysis of women workers

30. J. Freymond (ed.), *La Première Internationale*, 2 vols, Geneva, 1962, vol. 1, p. 215.
31. Ibid., vol. 1, p. 221.
32. Ibid., vol. 2, pp. 167–8.

around the time of the Paris Commune, and it was during the Commune that these ideas were put to the test of actual struggle.

Just as many women were involved in the Revolution of 1789, many women were active in the Commune. During the Franco-Prussian War which preceded the Commune, women were active in providing medical care and humanitarian aid and this continued during the Commune. However women also formed political clubs and other organisations, and many took an active part in the fighting or were *cantinières* alongside male soldiers. Women were in the forefront of the demonstration which prevented French Government troops seizing the National Guards' cannons on the hill above Montmartre, when they appealed to the soldiers to mutiny.

The brief period of the Commune's existence, from March to May 1871, was the first example of a form of self-government based on elected delegates from an armed populace, representing mainly the working class and sections of the small bourgeoisie. The French Republican Government surrounded Paris for most of this period with its headquarters at Versailles, and Paris was under siege and military attack until the defeat of the Communard(e)s in 'Bloody Week' late in May.[33]

Severe repression was meted out to supporters of the Commune, male and female, with many murdered and imprisoned by the Versailles troops. Women in particular were accused of being incendiaries, or *pétroleuses*, who burnt down buildings to impede the advance of the Versailles troops, or, as some sections of the bourgeoisie argued, for the sheer hell of it. After the suppression of the Commune, Marx's daughters Eleanor and Jenny were interrogated by police during a visit to Bordeaux as late as December 1871: '. . . they thought that the lamp in which we had warmed the milk for the poor little baby who died was full of "pétrole"!'[34]

There is ample evidence of women's activity during the Commune, and of demands by women for the abolition of prostitution, education, recognition of common-law marriages, political equality, decently paid work and childcare.[35] However, given the views of even radical male

33. There is not space here to go into detailed events of the Franco-Prussian War and the Commune. For good general accounts, see J. Bruhat, J. Dautry and E. Tersen, *La Commune de 1871*, 2nd edition, Paris, 1970, and G. Soria, *La Grande Histoire de la Commune*, 5 vols, Paris, 1970.
34. Letter from Eleanor Marx to Liebknecht, 29.12.71. The baby was the Lafargues' child, E. Kapp, *Eleanor Marx*, 2 vols, London, 1972, vol. 1, p. 130.
35. For demands for the abolition of prostitution by district women's committees of the Union des Femmes, see Albistur and Armogathe, p. 328. There was a massive increase in arrests and harassment of prostitutes along with increased general repression of workers after May 1871. According to Corbin, *Filles de Noce*, p. 158, between June 1871 and January 1872, 6,007 prostitutes were arrested in Paris, twice the usual figure. A demand for the abolition of prostitution and the 'only remedy', work for all women who need it,

socialists, the activity of the women was not always welcomed. Women administrators were sometimes faced with obstructive and patronising behaviour by male officials. Nonetheless as Eugene Schulkind has observed, four male members of the International are known to have taken deliberate initiatives in the direction of equality for women. This is not surprising given the evidence of Varlin's strenuous attempts to argue for this within the International.[36] However Léodile Champseix, writing under the male pen-name of André Léo, criticised the lack of commitment to women's emancipation shown by 'this Revolution' in the paper *La Sociale*. Edith Thomas, in her book on women active in the Paris Commune, quotes the words of a male 'socialist' who dismissed the demands for women's suffrage as irrelevant to working women, since they had no property to legally possess or administer. Thomas continues:

> A wave of the hand and the problem is conjured away once again. This passage throws light admirably on a certain 'socialist' mentality, which denies all importance to the problem of women in society. This mentality, obsessed with the plight of the working class to begin with, is not interested in other forms of social injustice.[37]

As we have seen, this could scarcely be applied to Marxists, and it is even debatable whether it could be applied to other 'socialists' at the time, since they did recognise injustice towards women, but their less-than-progressive solution was to enable women to escape brutalisation at work by returning them to their natural domestic vocation of motherhood.

However it is certainly true that Marxists involved in the Commune directed their efforts to the organisation of working-class women, building links with the International, achieving equal pay and improved conditions for women workers, and demanding that the Commune labour commission provide work for women in the factories and workshops abandoned by the bourgeoisie. Elizabeth Dmitrieff, who had close contacts with Marx, and Nathalie Lemel were among women members of the International who attempted to put these demands into practice through organising the *Union des Femmes pour la Défense de Paris et les Soins aux Blesses*.[38]

from a delegation from the XI^e arrondissment is in C.J. Lecour, *La Prostitution à Paris*, p. 324–5. For proposals for crèches and nurseries see S. Edwards (ed.), *The Communards of Paris, 1871*, London, 1973, pp. 117–20.

36. E. Schulkind, 'Socialist women during the 1871 Paris Commune', *Past and Present*, no. 106, Feb 1985, pp. 136–7.

37. E. Thomas, *The Women Incendiaries*, London, 1967, p. 25.

38. See Thomas and Schulkind; H. Parmelin, 'Les Femmes et la Commune', *Europe*, 1951, nos. 64–5, pp. 136–46; J. Bruhat, J. Dautry and E. Tersen (eds), pp. 179–94; and Claire Goldberg Moses, *French Feminism*, pp. 189–96. See also useful documents and bibliography cited by K.B. Jones and F. Vergès, 'Women of the Paris Commune', *Women's Studies International Forum*, vol. 14, no. 5, 1991, pp. 491–503. On Elizabeth Dmitrieff see Yvonne Singer Lecocq, *Rouge Elisabeth*, Paris, 1977, and S. Braibaut, *Elizabeth*

Various photographic and other printed material representing women active in the Commune was produced. However before considering key examples of this material we need to consider the question of women and their relation to photographic imagery, both at this time and as discussed by recent writers on visual culture.

The main areas of photographic imagery representing women at this time were portraiture and nudes. Portrait photography certainly revolutionised the production of images of individuals during the Second Empire, opening up a mass market for bourgeois and petit-bourgeois clients and photographic practitioners.[39] However working-class women would rarely, if ever, have had portrait photographs taken. The efficiently 'rationalised' production methods in Disdéri's photographic business brought down the cost of portraits dramatically in the early 1850s, by exploiting the *carte-de-visite* format, 6 cm x 9 cm, and by using glass negatives to print multiple images from the negative. This meant that twelve portrait photos now cost twenty francs as opposed to the previous rate of one large portrait for fifty to one hundred francs. Since the average daily wage of a working man at the end of the Second Empire was three francs (sufficient to buy six kilos of bread), and the average wage of women was less, working-class women were very unlikely to have been depicted by photographers as named individuals with a cultural and social identity.[40]

In a very useful article, André Rouillé shows how working-class people were largely absent from *carte-de-visite* portraiture, and when they did appear in photographs were presented as picturesque subjects in a manner akin to *genre* painting, for example, chimney sweeps, barrel organ players and so on. When such scenes as construction sites and bridge building

Dmitrieff, Aristocrate et pétroleuse, Paris, 1993. There is a very interesting manuscript in the Bibliothèque Marguerite Durand, 79 Rue Nationale, Paris XIᵉ, *Manuscrit d'une Communarde Inconnue*, which describes activities of women in the Commune, the author's own political background, and a mass meeting of women just as the Versailles troops entered Paris. She describes a heated argument between Dmitrieff and Natalie Lemel but unfortunately does not say what the discussion was about. The author of the manuscript obviously disapproves of Dmitrieff's appearance (dressed in black, red sash, pistol and thick bushy hair) and prefers the simple, modest appearance of Lemel. In contrast to Dmitrieff, Lemel had a long experience organising in the labour movement and was a middle-aged woman with three children aged twenty-three, eighteen and twelve in 1871. She had left her alcoholic husband who tried to stop her political activities in 1861.

39. See especially A. Rouillé, *L'Empire de la Photographie, Photographie et pouvoir bourgeois 1839–1870*, Paris, 1982, and the excellent discussion of studio portraiture in section 1, *Le Corps Sujet*, in A. Rouillé and B. Marbot, *Le Corps et Son Image. Photographies du Dix-Neuvième Siècle*, Paris, 1986. This book is an indispensable work for the study of nineteenth-century French photographic imagery. See also Ch. 4 of E.A. McCauley, *Industrial Madness. Commercial Photography in Paris 1848–1871*, New Haven and London, 1994.

40. See my article, 'The Camera against the Paris Commune', in *Photography/Politics: One*, T. Dennett and J. Spence (eds), Photography Workshop, London, 1979, p. 15.

appear in stereoscopic photographs in the late 1860s, the workers are shown as part of the general process of construction and not as identifiable individuals.[41] The relationship between actual identifiable individuals and their social significance is qualitatively changed in the photographs of the Commune period, most clearly in the photographs taken of the prisoners, whose individual identity was now seen as the main reason for the photographic image, rather than as totally insignificant.

However the main area where working-class women were visible in photographic imagery was as 'erotic' or 'artistic' nudes (plate 16). Solomon-Godeau has pointed out that before the industrialisation of photography in the 1850s photographic pornography appears to have been a luxury item.[42] The models were assumed to be actual or potential prostitutes, and the meaning of the term pornography in the nineteenth century actually referred to writing about prostitutes. With the mass production of these photographic images, state surveillance and regulation was increasingly enforced. What was considered appropriate for private viewing by the rich was not deemed so for a mass public. Solomon-Godeau points to the huge market for this material, quoting the example of a police raid on a shop in London in 1874 where 130,248 photographs and 5,000 stereoscopic slides were seized.[43]

These images, often hand-coloured, gave an impression of naturalistic verisimilitude and, particularly in the stereoscopic images, of three-dimensionality, as if the actual woman, and not a constructed image, was directly appealing to the spectator, from a small and intimate world accessible only to the viewer holding it in his hand. However these women were not prostitutes, to judge from information about the actual women who modelled for these images. Many of these images are not identified by the photographer's name and address, in order to avoid prosecution. However the models and the businesses who sold the images were more likely to be prosecuted, as the following examples show. In the first case, from 1860, one of the women, a widow, coloured the photographs but did not pose for them. The others, both married and single, and including an eleven-year-old girl, gave their professions as 'lingères ou blanchuseuses' (i.e. women who either made or washed personal or household linen). One of the women testified that she had been paid four francs fifty centimes for her work, which she had argued was too low, but was forced to accept. The punishment meted out to the models was: Louise-Désirée Cotterel and

41. A. Rouillé, 'Les images photographiques du Monde du Travail sous le Second Empire', *Les Actes de la Recherche en Sciences Sociales*, September 1984, no. 54, pp. 31–43. Rouillé also gives examples of wages and photographic prices on p. 42.

42. A. Solomon-Godeau, 'The Legs of the Countess', *October*, Winter 1986, part 39, p. 95.

43. Ibid., p. 96.

Mme Hory, two months in prison and a fine of sixteen francs; Mme Petot, Marie Destourbet and Joséphine Cotterel, one month in prison and sixteen francs fine; and widow Martin, fifteen days in prison.

In the second example, in 1864, a Monsieur and Madame Lamarre, of Nantes, were visited twice by police who seized photographs from their shop, which sold, among other things, jewellery and children's toys. The couple were displaying and selling the nude photographs 'without authorisation', 'affronting public morality'. Madame Lamarre's defence was that she was unaware of the photographs. On the contrary, said the prosecution, she knew she was responsible, because between the first and second visits of the police, she had scratched off the face of one of the women in the photographs to render her unrecognisable. This is interesting as an attempt by the shopkeeper, not necessarily to save herself, but to save the model from arrest and imprisonment.[44]

As far as the production of photographs is concerned, women were involved quite extensively. In 1860, there were ninety-two women employed in photographic production out of a total of 566 in Paris as a whole. However the women were employed in retouching, colouring and mounting the images rather than in the more skilled operations which some of the male workers carried out. There were thirteen (male) apprentices and no female ones. More women were paid on a piece-work system, rather than daily wages, and the women's wages were lower than the male workers, the majority of the women earning two francs and the majority of the men four francs. Nine of the apprentices earned nothing. The highest pay for male workers (two of them) was twenty francs, and for female workers (also two) six francs. The work day was from 8.00 a.m. until 6.00 p.m., including a one hour meal-break. Some photographic businesses laid off workers in the 'off-season', January, February, March and November. I suspect the piece-workers were more likely to be laid off at these times, and therefore slightly more likely to be women. Work in photographic production was seen as semi-skilled in wages and conditions, and rather better than many of the jobs done by women workers at this time, even though they were treated less well than their male counterparts. All the male employees in the survey could read and write, whereas five of the women out of the total of ninety-two were illiterate. However this was a higher literacy rate than in many other types of employment (plate 17).[45]

It is clear that, in the main, the contact of working-class women with the photographic industry during the Second Empire was either in the manual production of the images or else as sessional models for nude

44. These examples are from A. Rouillé (ed.), *La Photographie en France, Textes et Controverses: Une Anthologie, 1816–1871*, Paris, 1989, pp. 419–25.

45. See the document in Rouillé, *La Photographie en France*, pp. 345–9.

studio photographs. Where they were identified as individuals, it was to enable them to be punished if the person selling the photographs had not obtained special permission or a dispensation qualifying the works as 'artistic'.

Solomon-Godeau analyses some of these photographs almost entirely from a psychoanalytical viewpoint. She argues that all images of women, not simply 'pornographic' ones, objectify and fetishise women. She describes what she calls 'the sexual economy of looking' as premised on patriarchal structures which inform the act of looking.[46] Now this argument may sound convincing when applied to erotic photographs but I feel it founders if we attempt to apply it to other photographic material, for example, the photographs of the Communarde prisoners taken after Paris was captured by the government troops. Mechanisms of seeing and looking are not merely unconscious and therefore entirely explicable by psychoanalytic theories of castration and fetishism, but the look of the human subject, whether photographer or model or spectator, is consciously applied to a process of understanding the material world in which we live, and the gathering of information consciously interpreted by our minds in terms of our political, social, cultural and scientific knowledge. The material world with all its contradictions and complexities cannot simply be explained by the conflation of economic and material reasons for cultural production in a term such as 'the sexual economy of looking'. Actual social and economic relations embodied in images are avoided, by recourse to their explanation as examples of a patriarchal system which dominates by the gaze, irrespective of time, place and social conditions. Struggle and conflict are displaced from actual material life to the domain of 'combatting the complex network of relations that meshes power, patriarchy and representation'.[47]

The photographs of Communarde prisoners (plates 18–22) force us to question a number of common approaches to representations of women, such as the male gaze, objectification and fetishism. However, these images are rather more complex and their meanings more contradictory than suggested by the analysis of similar types of photographs by Marxist historians of photography John Tagg and Steve Edwards.

Tagg's book discusses photographs from police, asylum and orphanage records in order to demonstrate the actual material existence of repressive state power embodied in these images. Basing his method on Althusser and Foucault, Tagg argues that ideological state apparatuses are material,

46. See A. Solomon-Godeau, 'Reconsidering Erotic Photography: Notes for a Project of Historical Salvage', in *Photography at the Dock. Essays on Photographic History, Institutions and Practices*, Minneapolis, 1991, Chapter 10, pp. 220, 237.

47. Ibid., p. 237.

not intangible, and that these state apparatuses produce 'régimes of truth' and knowledge. Tagg writes: 'we must cease once and for all to describe the effects of power in negative terms – as exclusion, repression, censorship, concealment, eradication. In fact power produces. It produces reality. It produces domains of objects, institutions of language, rituals of truth.'[48] Now there is a conflation here of the material and the ideological which is not at all helpful in understanding exactly how and why social conflict and change occurs, nor how the state relates to this. This structuralist model turns Marxism on its head by its idealist explanation of the construction of 'reality' and 'objects' by a vague concept of 'power'. State power, of whatever kind, is a product of class and relations and material conditions. It does not produce reality, although it may offer its own preferred scientific and cultural strategies for understanding the real world and defining 'the real'. Consequently Tagg's analysis of photographs of prisoners and 'criminals' tends to lack any notion of the social contradictions embedded in the production and reception of the images, and the photographs are read as images of victims dominated and oppressed by the documentary 'régime of truth' of ideological state apparatuses.

Steve Edwards, in a more stimulating article on a similar topic, is critical of Tagg's method and suggestions. He points out that the basis of Tagg's call for 'a new politics of truth' would imply a 'world without science in which anything can be said because nothing can be tested'.[49] Edwards prefers to apply notions of the 'dialogue' and 'monologue', derived from Bakhtin and Volosinov, to the study of photography and power relations. Edwards argues that Foucauldian photographic criticism, in analysing the operation of power/knowledge, is only looking at the monologic, i.e. use of language where another person remains wholly and merely an *object* of consciousness, and not another consciousness.[50]

Edwards argues that the photographer's studio is a monological site, controlled by the photographer, whereas outside the studio the relations of language change to dialogical, 'the subjects here answer back'.[51] This perception of the interactive complexities of photographic production is an important step forward from Tagg's approach to 'portrait' photography, but I feel that Edwards is not theorising the notion of the photographic image as contradictory, as being repressive and defiant, objectified and conscious, or, if you like, monologic and dialogic *at the same time*.

48. J. Tagg, *The Burden of Representation Essays on Photographies and Histories*, Basingstoke, 1988, p. 87.

49. S. Edwards, 'The Machine's Dialogue', *The Oxford Art Journal*, vol. 13, no. 1, 1990, p. 63.

50. Ibid., p. 65.

51. Ibid., p. 64.

Obviously these contradictory elements will not be embodied in the image to the same degree and will not remain constant throughout the material existence of the image. However this is not really the same as seeing the photograph as an example of modes of language use and relations of communication, as Edwards does. What I am arguing for is a means of understanding the images as embodiments of the contradictions and struggles of the social relations in which they were produced, made by individuals and subject to changing cultural forms and technologies, but understandable primarily in terms of materialist dialectics. However Edwards's use of the monologue/dialogue linguistic analysis can offer a useful way of understanding certain aspects of the street and barricade photographs of Communard(e)s and I will return to this later.

I have selected for discussion a number of photographs of working-class Communardes, along with a male Communard prisoner for comparative purposes (plate 23).[52] Now it was not only working-class women who were active in the Commune. Some of the women were petty-bourgeois in social origins, working as teachers and journalists, and other portrait photographs of them were taken in studio conditions, for example André Léo and Louise Michel. However I want to concentrate here on working-class women for several reasons. Firstly, as I have shown, these women had never appeared in portrait photographs before; secondly, I want to examine the extent to which their images merely construct their inferior position as defined by ideological (and military and legal) state apparatuses; and thirdly, I want to compare them briefly with a photograph of a male prisoner to test the arguments about class, gender and the patriarchal gaze of power.

The photographs were taken by Eugene Appert, 24 Rue Taitbout, who at this time was 'photographe du Corps Législatif' and 'photographe de la magistrature', among other distinctions which he listed on the back of his works. His work had been awarded medals at exhibitions in 1853, 1855, 1859 and 1867. Appert's main concern was to make money. He had taken street photographs of the Communard(e)s previously and now obtained permission to photograph them in prison at Versailles. Photos of Communard(e)s were allowed to be sold only with police authorisation, if the photographer's name and address were stamped on the mounts. These images were on sale in photographic shops but also in, for example, bookstores, tie shops and tobacco shops. A brand of tapioca was being sold with one of Appert's photographs inside the packaging. One shopkeeper

52. The photographic material in the remainder of this chapter is selected from collections I studied in the Bibliothèque Margeurite Duras, Paris, Bibliothèque Nationale, Paris, Bibliothèque Municipale de Saint-Denis, near Paris, the Commune Collection in the Library of the University of Sussex, Brighton, England, and the Victoria and Albert Museum, London.

told the police that he had not intended to break the law, but that his business would suffer if he removed the photographs.[53]

While the images showed the Communard(e)s in prison and criminalised, in one respect, at the same time members of the public could buy them for very different reasons, perhaps out of sympathy, perhaps out of a conscious understanding of what the Commune had begun before it was repressed, or perhaps because the images confirmed their satisfaction at the defeat of the Commune. The sale of the portrait photographs was prohibited in June 1871 although photographs of buildings supposedly destroyed by the Communard(e)s remained on sale. The situation was still politically dangerous for the French state. If the military and the judiciary persisted with their repression, public trials and deportations, the Commune would be kept in the public eye and the severe sentences (including death) would be counter-productive. Paris was still under a state of siege in December 1871 when the military governor of the City forbade the sale of all images connected with 'the insurrection'.[54] This was extended to the whole of France in 1872. The images of the victims were at the same time images of heroes and heroines. Their multiple meanings made them too dangerous for public circulation and their sale was banned by the actual state apparatus, not an ideological emanation of it. Tagg's model tries to argue that the notion of state power as prohibiting, suppressing and censoring is crude and unsubtle, but the facts in this case tend to contradict his views.

However, the Commune proved a turning point in the decision to photograph prisoners as a means of 'documentary' identification. This had been rejected in 1863 as an additional punishment which might hinder rehabilitation, but by March 1872 it was decided to photograph everyone who had received a prison sentence of more than six months.[55]

The actual making of the photographs themselves was riven with contradictory impulses. Appert's desire to make money was paramount. He won over many of the prisoners to sit for him, and apparently in some cases co-operate, by offering them unlimited copies of the photographs. Many of the sitters took advantage of their first photographic appearance by defiantly challenging the photographer. Others were more quietly determined. None of them appear as passive victims. Some of the prisoners hoped that their families would see the photographs and thereby discover that they were still alive. Others gave *carte-de-visite* photographs to some of the prison staff who had treated them decently, inscribed with

53. See D.E. English, *Political Uses of Photography in the Third French Republic, 1870–1914*, Ann Arbor, Michigan, 1984, pp. 65–6.

54. Rouillé, *La Photographie en France*, p. 485.

55. Ibid., pp. 480, 483.

dedications.[56]

The appearance of the women prisoners in photographic images, even in these extremely adverse conditions, gave them a public visibility and circulation that, in the end, the state banned as too dangerous. The images of the women especially threatened any 'easy' re-imposition of bourgeois order, I would agree, since their participation in the insurrection implied, for some, the 'incredible' and ridiculous prospect of women's equality. One of the prosecutors at the Communard(e)s' trials, Captain Jouenne, accused the Commune of enticing women to its banner by fantasies of liberation: 'Have they (the Commune) not held out to all these wretched creatures bright prospects, incredible chimeras: women judges, women members of the bar! Yes, women lawyers; deputies, perhaps, and – for all we know generals? Generals of the Army? Certainly, faced with these miserable aberrations, we must believe that we are dreaming!.'[57] The real possibilities for women's struggle against the bourgeois state which opened up decisively during the Commune are here described as the laughable illusions of gullible women manipulated by cynical male insurgents. As shown above however, this was far from the truth.

The photographs illustrated here were taken in rather spartan 'studio' conditions in prison. Plate 18 shows Clara Fournier in her naval uniform. Hortense David (plate 19) was born in Reims around 1835, and was a widow with two children employed as a brushmaker. She was sentenced to hard labour for life on 16 April 1872 for her participation in the military defence of Paris.[58] Catherine Olivier (plate 21) and Léontine Suétens (plate 22) are dressed in civilian clothing, although Suétens acted as a cantimère of the 135e battalion of the National Guard. She was born in Beauvais, aged twenty-six at the time of the photograph, and a laundress. She was

56. Some of these are in the collection at Saint-Denis. For information on photography of the Commune see my article, 'The Camera against the Paris Commune'; C. Phéline, *L'Image Accusatrice*, Paris, 1985; D.E. English, *Political Uses of Photography*; Louise Michel, *La Commune*, Paris, 1978, pp. 350–1, 367; *Pariser Commune 1871. Eine Bild-Dokumentation*, Neue Gesellschaft für bildende Kunst, Berlin, 1971, produced by the Arbeitsgruppe Pariser Kommune 1871; and R. Hiepe, 'Kommune und Fotografie', *Alltag der Pariser Kommune, Auf den Barrikaden von Paris*, (ed.) K. Schrank, Berlin and Hamburg, 1978, pp. 30ff. Apparently photos were used to identify the dead during the Commune itself. A report in the English paper *The Graphic*, on 15 April 1871, stated: 'Everyone who is maimed will be accorded a pension, and photographs are taken of the killed and hung up in the Hôtel de Ville, so that the deceased may be recognised and claimed by their friends. The widows and children of those killed in the action are all to receive pensions, and the motherless children will be educated at the Commune's expense.'
57. E. Thomas, *The Women Incendiaries*, London, 1967, p. 152.
58. See entry in B. Noël, *Dictionnaire de la Commune. Iconographie et légendes de Marie-José-Villotte*, Paris, 1971, p. 242, and notes on the back of another photo of David in the Bibliothèque Marguerite Durand, Paris.

wounded in fighting at Neuilly and Issy and was sentenced to death as a *pétroleuse* in September 1871. This was commuted to hard labour for life in Guyana.[59]

Christian Phéline writes perceptively about similar photographs of Communard(e) prisoners, and describes how their gaze 'reverses' the violence back through the photographer who, as an agent of the state, is a participant in their repression. This is true to some extent. However Appert was not, primarily, an agent of the state, and the images cannot be seen purely and simply as examples of state repression, given what we know about them. The consciousness of the sitters in these photographs is in conflict with opposing conscious (or unconscious) attempts to objectify or fetishise them.[60] In fact the photograph of the male Communarde prisoner has far more in common with the female images in terms of its meanings and production than differences due to the gender of the sitter (plate 23). The poses and attitudes are not particularly differentiated by gender in these photographs. In the images of both male and female prisoners the same co-existing tensions between objectification and resistance to this process are present.

A work by an English doctor on insanity and crime mentions the Communardes in the chapter entitled 'Tragedy of Woman'. It is clear from this chapter that he is actually sympathetic to feminism and scornful of male attitudes to women: 'Man has asserted himself so much of late, that it appears that even for woman to dare to exist, his permission must first be asked.' However his objections to the Communardes are class-based, rather than gender-based. Their facial structure marked them as criminal types and their behaviour was that of 'acutely maniacal lunatics'. He writes:

> I was in Paris during the last Revolution, and was brought face to face with a number of female Communists, who tried to set fire to and wreck Paris. I examined many of these at the time, and came to the conclusion that they were nothing more nor less than irresponsible criminals whose brains had become affected in consequence of the then existing state of affairs. The majority of these women had a certain peculiar type of cranium; their cheek-bones were very prominent, their foreheads were broad and in many there was a want of expression in their faces; whilst in all there was a deficiency of every normal feeling that we are accustomed to find in the sex. They had degenerated to the verge of actual insane animal brutality.[61]

59. Notes on reverse of photo in Bibliothèque Margeurite Durand, and B. Noël, p. 323.

60. I reject the argument that all photographic images objectify and fetishise women because of (1) the technology involved and (2) the psychic structures of looking which are always, by definition, patriarchal and phallic.

61. L. Forbes Winslow, *The Insanity of Passion and Crime*, London, 1912, pp. 279, 289.

One of Appert's intentions was to produce composite photographs of the 'criminal' activities of the Communard(e)s which would produce profits while re-enforcing the image of the insurgents as bloodthirsty, violent and immoral, whatever their sex. In a series entitled *Crimes of the Commune*, Appert constructed an image composed of different photographs of the women which showed them supposedly assembled in the prison yard. On the left a woman is shown drinking straight from the bottle. Many of the women are identifiable and some examples of this image identify the more 'notorious' women by information on the mount (plate 24). Unlike the technique of photo-montage, which seeks to disrupt the acceptance of surface appearance by the viewer with a 'conscious' perception of its underlying material contradictions, this composite image presents itself as 'real'.

Another in the *Crimes of the Commune* series literally 'reconstructs' the execution of hostages held by the Commune in the Rue Haxo, 26 May 1871 (plate 25). Women wearing obviously 'feminine' dress are prominently positioned here to emphasise the unnaturally horrific nature of the execution. We 'really' see what happens when bourgeois order is challenged; even women carry out armed acts of violence and retribution.[62]

Appert, along with other photographers, had actually taken photographs of groups of Communard supporters during the Commune. Some of these include women and children, though the majority of participants are male. In the photograph by Braquelais, the *Vendôme Column after its Destruction* (plate 26), the compositional format of the extended upper-bourgeois family outside their property, or the factory owner's workers outside his factory, is transformed by the active participation of the group who have just witnessed the destruction, or even helped to destroy, the monument regarded as the cultural epitome of French imperialism. The very title of the image tries to ignore the human agents and preserve the absent monument as central. This 'family group' begins to challenge and subvert notions of static and ordered reality, in so far as this was technically possible. Some raise their caps and wave them in celebration, some look at the camera and physically touch one another as part of a group, rather than a collection of individuals who 'know their place'. Their position in history and culture is now in the making, and their relationship to the photographer therefore is open to change to some extent.

In this context it is worth referring back to Edwards' concept of monologic and dialogic relations of communication. There certainly is dialogue between photographer and subjects here, but not, I think, because

62. The Communard(e)s shot forty-eight hostages, against the advice of the Central Committee. This was at a time when the Versailles troops were in the city shooting suspected supporters of the Commune indiscriminately.

of Edwards' argument that when we leave the studio 'The flux of juxtaposition and opposition that goes on outside of the studio . . . remains recalcitrant to the photographic look. Transitory and unpredictable, the spaces beyond the studio render the patternings of desire and power problematic; unlike the studio mannequin the subjects here answer back'.[63] I would suggest that it is not merely the location of the posed image which is the crucial factor in changing the 'objectification' of the protagonists in front of the lens, but the material and social relations from which the image is produced. All photographic images, I would argue, embody social relations in a dialectical manner. What changes the weight of these contradictions is changed social relations as embodied in the image. The consciousness of being an active subject participating in historical and social change is something that theories positing 'régimes of truth' and 'discourses' of subjectivity do little to elucidate, and much to obscure. These photographic images and their uses are only understandable in their material existence and contradictory plenitude when we approach their study with a method which (1) asserts that the material world is knowable and that (2) consciousness of one's place in history, social and gender relations arises out of material conditions and can intervene, with others, to change these conditions. Ultimately, the images of the Communard(e)s were so deeply disturbing to the French state that it was obliged to prohibit them, to remove them from sight, in the same manner as they removed many of the Communard(e)s themselves, by death, exile and deportation to colonised French possessions overseas.

The use of the photographic medium, which preserves a material trace of actual objects on the image, poses problems for a régime which seeks to impose its own political view of events. While Tagg argues that power 'produces reality', attempts on the part of state institutions to privilege certain modes of representation and address as 'truthful' cannot entirely overcome the oppositional threat posed by the presence of traces of material reality and consciousness preserved, in however a distorted way, in the photographic image. Even the composite photographic 're-constructions' by Appert proved, in the end, too problematic for state authorisation. These images used fragments of photographs to re-present events that actually happened. Hence even the French state in a position of victory after a period of severe repression could not successfully eradicate the traces of social conflict embodied in the photographic images. Appert's photographs were images of repression and resistance at the same time in varying degrees, and in the social and historical context in which they came into being, they could never have been anything else. It is not a case of saying they were one thing or the other.

63. Edwards, 'The Machine's Dialogue', p. 64.

Print material was less problematic for the French state. While illustrated newspapers claimed veracity by accompanying their graphic images with eye-witness accounts, the increasing claim to scientific and retinal 'truth' was in the process of according to photography a qualitatively more significant role as a medium for the presentation of the visual world.

Printed caricatures, on the other hand, could, within the conventions of the genre, construct the most outrageously exaggerated images of events and 'types' of people. The series, *Signs of the Zodiac* by Nérac, is a good example of this (plate 27). The series of lithographs was published in the summer of 1871. The whole concept of the signs of the zodiac suggests the immutability of the structure and movement of our universe, while enabling the artist and viewer to laugh at those who would substitute themselves as agents of historical change.

The print for Scorpio shows a female figure with huge breasts hanging over a bar drinking a mug of beer and thumping her fist on the counter. The legend informs us that this is a typical member of a Club for Women's Emancipation, but really she will soon be *en route* to a mental institution. *La Vierge . . . Folle* shows a reconstruction of a female Communarde fighter, at ease, surveying her surroundings and smoking a cigarette, a sure sign of degeneracy of course. The order of the words in the French title makes the joke more effective. *The Virgin . . . Foolish* introduces the observer to the notion that this figure represents Virgo/A Virgin, which we are supposed to find laughable, then the Biblical reference to the wise and foolish virgins adds other dimensions to the joke, for example, her stupidity, and suggests the expression 'filles folles de leurs corps', (prostitutes or women who enjoy sex). Indeed the woman soldier is presented as a prostitute, who can easily feel at home on the battlefield or the boulevard, and is always able to pick out and 'hit' her man at 1,000 metres. Her exposed legs and tiny feet in high-heeled boots were currently recognisable 'signs' of the boulevard prostitute. As she relaxes, on the lookout while waiting to get her man, her image mobilises, and diffuses by mockery, all the old fears of women in trousers, women as armed and active citizens, working-class women's political and sexual deviancy, and refusal of bourgeois 'norms'. The sub-title of this print refers to 'les Jeannne d'Arc de la Commune', but this female warrior is not saintly, virginal or a fighter against the enemies of France. On the contrary, she is one of the enemies within. Personally I feel that the print cannot avoid suggesting the power and presence of such a figure even in the process of deflating the 'pretensions' of such a woman. However the risk posed by the circulation of these prints is far less than in the photographic images of actual women combatants, as I have tried to show.

In conclusion, I think it is possible to argue that, while images and

photographs are undoubtedly constructed ones, we need to see the way they are made and the modes of representation they utilise as embodying social conflicts and relations which, ultimately, can only be understood in terms of the complexities of their relationship to material reality. To view these images, and the photographs in particular, as the construction of régimes of truth by state power, is to accept a methodological position which is not able to explain the contradictions embodied in these images, nor does it root the power of the state in a specific economic and political configuration on which it ultimately rests. Both psychoanalytic theories of the phallic gaze of power under patriarchy and 'Marxist' structuralism have failed to theorise and analyse the complexities embodied in images of class and gender in a concrete historical manner, as far as such images are concerned.

Russia and the Soviet Union c.1880– c.1940: 'Patriarchal' Culture or 'Totalitarian Androgeny'?

There has been little attention devoted to women artists and representations of women in the Soviet Union in English-language publications. This is perhaps due to the lack of Russian-speaking art historians and also partly due to the continuing emphasis on periods of crucial interest to a Modernist art history, even on the part of women art historians who seek to deconstruct Modernist canons of art and cultural history. The material which is available in English tends to focus on 'great' individual women artists of the avant-garde, such as Liubov Popova or Varvara Stepanova, or groups of mainly avant-garde women artists.[1] I will be attempting in this chapter to look at a wider range of issues relating to women and Russian and Soviet art, as a study of this material calls into question some of the conclusions and methods found in feminist analyses of art and history of the period from the later nineteenth century to the outbreak of the Second World War in the Soviet Union.

Firstly, the idea that Modernist art was founded on premises which theorised women as inferior and, in practical terms, prevented them from taking an active role in developing Modernist art is simply not true if we consider the contribution women artists made to avant-garde art in the Russian Empire. A recent article by Jo Anna Isaak in a special Russian issue of *Hersies* states: 'Western feminist artists and art historians have not yet begun to fathom the importance of the role played by women artists in the development of that practice, nor why the roles for western women artists were so much more circumscribed during the same period.'[2] Indeed this raises interesting issues. Women artists did play an active role in avant-

1. See for example A. Lavrentiev, *Varvara Stepanova: A Constructivist Life*, edited and introduced by J. Bowlt, London, 1988; M. Yablonskaya, *Women artists of Russia's New Age 1900–1935*, London, 1990; and *Women-Artists of the Russian Avantgarde 1910–1930*, Galerie Gmurzynska, Köln, exhibition catalogue, 1979–80.
2. J.A. Isaak in *Heresies*, vol. 7, no. 2, issue 26, 1992, p. 11. This special issue is subtitled *A Journal of Feminist Post-Totalitarian Criticism*.

garde circles and engaged in both collaborative work with male co-thinkers and the development of their own work as individuals and as part of collectives. This was the case well before the October 1917 Revolution which took power from the capitalist state in Russia replacing it with a state based on 'Soviets', legislative and executive bodies composed of the armed people. It is not therefore possible to offer the tempting answer that the crucial participation of women artists in Russian art was due to the replacement of the bourgeois state by a state committed to the liberation of the oppressed.

Griselda Pollock's argument, that after 1789 the French bourgeois state in power defeated women, forced them into domestic roles and ideologically split the notions of 'woman' and 'artist', also needs to be considered. For while I have argued that Pollock's argument does not really consider the contradictions of class, gender and ideology in post-Revolutionary France, could it be that we might have to acknowledge the validity of her argument in a negative sense, as regards pre-Revolutionary Russia? For if, as was the case, there was no powerful bourgeois state in Russia prior to the Revolution, could this explain the emergence of women artists on a much greater and more influential scale than in, for example, France or Germany? This is a question we need to consider in more detail.

As far as the Bolshevik Revolution and women is concerned, we need to look at some of the arguments about the 'male' nature of the Revolution. For example Briony Fer points to the 'male imagery' of the Revolution and states: 'The masculine symbols of the Revolution were indirectly linked to the language of Lenin – the language of proletarian crushing resistance, or wielding power, of imposing iron discipline.' She adds later: 'it is well known that women never (and never have) gained equality in the Party; even in 1922 only 8% of Party members were women.'[3] We need to look at this view of the Revolution in relation to women and gender issues which is also argued in feminist studies of posters and other material during the years immediately after 1917.

Most of the books written about women and the October Revolution persist in describing anyone who concerns him/herself with women, sexuality, reproduction and childcare as a feminist. For example, Gail Warshofsky Lapidus concludes, discussing Lenin's views on the liberation of women, 'clearly the marriage of Bolshevism and feminism was not without deep inner strains'.[4] Margarita Tupitsyn writes of the 'Soviet feminism' of the 1920s, 'such legendary feminists as Alexandra Kollontai,

3. B. Fer, 'What's in a Line? Gender and Modernity', *The Oxford Art Journal*, vol. 13, no. 1, 1990, pp. 85, 86.

4. See for example G.W. Lapidus, *Women in Soviet Society. Equality, Development and Social Change*, Berkeley Los Angeles and London, 1978, p. 53.

Nadezhda Krupskaya and Inessa Armand were instrumental in the success of Bolshevism's despotic machine through political propaganda'. She continues: 'Moreover, the project of communal living inaugurated after the Revolution managed to destroy the earlier existing solidarity among women and led to the creation of 'The New Woman' victimised by the burdens of communal kitchens where she often had to contend against her female neighbors.'[5] The Revolution is seen here as an event which destroyed pre-Revolutionary sisterhood and women's solidarity, and replaced this with competition and antagonism in an unsuccessful and oppressive attempt to foist communal facilities on women. Again we are presented here with the notion of a male-dominated world which submits women to its patriarchal authority. Referring to a poster from 1933, *Women on collective farms*, Tupitsyn writes that it 'illustrates this model of the subordination of women's libido, which is sublimated in labor, to Father's authority'.[6] Tupitsyn's rather wooden notion of history as a gender struggle really does not take into account any of the more complex issues concerning culture, gender, politics and economics during this period. Thus she dismisses as 'curious' and eccentric anomalies any facts that do not fit in with her thesis, and changes other 'facts' that contradict her view. For example she states: 'Curiously, during the Revolutionary period, women, like artists, were primarily utilised in the campaigns of propaganda and agitation. And just like the artists, women's position in society drastically weakened as soon as the Bolsheviks gained a stable power base at the end of the 1920s.'[7]

Lapidus argues that the evidence of the Russian Revolution and its aftermath shows basic flaws in Marxist analysis of women's oppression:

> Not only did a revolutionary transformation of the family prove incompatible with the revolutionary reorganisation of economic and political life, thus contradicting a basic assumption of orthodox Marxism, but growing pressures for political conformity and economic productivity created such intense social strain as to require an actual *reduction* of tensions in communal, family and sexual relations.'[8]

Does what happened after 1917 really contradict the argument that the abolition of the capitalist state was essential for women's liberation? What was the specific configuration of circumstances that confronted the workers' state in the early 1920s? Did the Bolsheviks, male and female,

5. M. Tupitsyn, 'Unveiling Feminism. Women's Art in the Soviet Union', *Arts Magazine*, no. 65, December 1990, pp. 63, 64.

6. Ibid., p. 64.

7. Ibid., p. 67.

8. Lapidus, *Women in Soviet Society*, p. 7.

really think that social oppression would automatically disappear from the 'superstructure' when the economic base was socialist? What was the real nature of Stalinism's policies towards women in the late 1920s and 1930s? Was Stalinism a form of Marxism at all?

It is something of a myth that a pioneering band of women artists existed in the period before Stalin's rise to power, whereas after the imposition of Soviet Socialist Realism as an artistic and literary style by the Stalinist State in the early 1930s, women artists disappeared and were perhaps 'excluded' from art production by the incompatibility of this style with their 'real' feelings as women. Isaak writes: 'It is interesting to note that aside from the sculptors Sarra Lebedeva (1892–1967) . . . and Vera Mukhina (1889– 1963) . . . socialist Realism is remarkable in the history of modern Russian art for the *lack* of women artists. It may be that in its very representation of women it precluded their participation.'[9] I think this statement results partly from an unfamiliarity with Soviet art of the Stalin period which has not been particularly closely researched by Western art historians until fairly recently. With attempts to 'marketise' the economy of the former USSR, Western art dealers and art historians have shown an increased interest in this period of Soviet art, partly due to financial motives. Thus there is now more material in English devoted to a study of art during the Stalin period, notably by M. Cullerne Bown.

In his book *Art Under Stalin* there are works by quite a number of women artists, probably never studied because, like other male artists of the period, their work was considered as qualitatively inferior to examples of Modernist painting and sculpture. For example, apart from Sarra Lebedeva and Vera Mukhina (and her women assistants), *Art Under Stalin* has works by the following artists: Olga Yanovskaya, *Stakhanovites in a Box at the Bolshoi Theatre*, 1937 (Bown, plate 74); Marina Ryndzynskaya, *A Stakhanovite Girl of the Cotton Fields*, 1940, granite sculpture (Bown, plate 77); two works by Serafima Ryangina (Bown, plates 73 and 30); a collaborative work by Evgenia Blinova with Pavel Balandin, *I.V. Stalin among the People*, 1950 (Bown, plate 129); women artists who participated in teams which produced 'brigade' paintings (Bown, plates 140 and 141); Ekaterina Zernova, *Nadezhda Durova*, 1948 (Bown, plate 148) (a very interesting painting of a young woman in hussar's uniform being decorated with a medal for her military actions against Napoleon's armies); a sculpture by Ekaterina Belashova-Alekseeva (Bown, plate 158); Zinaida Kovalevskaya, *Tomato Picking*, 1949 (Bown, plate 168); Mariam Aslamzyan, *Carpet-makers of Armenia Weaving a Carpet with a Portrait of Comrade Stalin*, 1949 (Bown, plate 169); a sculpture by Zinaida Bazhenova, *Head of an Uzbek Woman*, 1947 (Bown, plate 170); two

9. Isaak, *Heresies*, p. 15.

paintings by Tatiana Yablonskaya (Bown, plates 173 and 174); and a collaborative work by Zinaida Ivanova and Nina Zelenskaya with Vera Mukhina and two male sculptors (Bown, plate 171).[10]

Now of course this is not a scientific survey of women artists of the Stalin period but it should be apparent even from these preliminary findings that women artists were not absent from the Soviet art world at this time. Obviously more work is needed on this question, for example, to discover if their backgrounds and training were significantly different from those of the pre-Revolutionary avant-garde, to what extent their works were direct commissions or if the subjects were chosen by the artists themselves. However there was not a great deal of 'choice' for artists in the Soviet Union in the 1930s. Also we should remember that women artists of the avant-garde, such as Stepanova, were producing material for the Stalinist state in the 1930s.

I want to consider the issues raised above by looking at three periods of Russian and Soviet art and society: (1) the later nineteenth century and pre-1917; (2) post-October 1917; and (3) the first Five-Year Plan (begun 1928) to the late 1930s.

The backward nature of Russia as a primarily rural empire, with little developed capitalism, no bourgeois state and no bourgeois democratic rights, meant that women in pre-Revolutionary Russia lived in somewhat different material conditions from their Western European counterparts. The freeing of the serfs in the early 1860s was in great part motivated by the need for a mobile workforce. This workforce also needed to be educated, to some extent, and skilled, if Russian capitalism was to expand and compete with already developed capitalist powers. The development of women's education in later nineteenth century Russia was partly seen as a means to training an increasing number of teachers, midwives and other female medical personnel. More and more families of the nobility were becoming impoverished, making it harder for them to maintain unmarried daughters and other non-productive members. The need to look for work, if only as a governess, altered the subordinate relation of daughters to the upper-class family. There was no real middle-class in the Russian Empire, the nearest equivalent being the merchants. The lack of a dominant capitalism in Russia meant that there was not such a strong bourgeois ideology of motherhood and domesticity for women in nineteenth-century Russia. Only after capitalism started to develop and removed production from the home and family unit did the ideology of

10. M. Cullerne Bown, *Art under Stalin*, Oxford, 1991. However many women artists suffered from Stalin's persecutions. Valentina Koulagina's husband was murdered in a camp, and Vera Ermolaeva (1893–c.1938) was herself killed in a concentration camp. See the entries on these artists in L. Vergine, *L'Autre moitié de l'avant-garde 1910–1940*, French edition, Paris, 1982.

domesticity take hold of certain sections of the population.[11]

For women workers in the cities and women in rural villages, life was extremely hard. The patriarchal family unit persisted among the peasantry where it had been previously cemented by mainly economic considerations. Escape from this to factory work in large towns meant a different life and some degree of independence but terrible working and living conditions. Prostitution was rife, and debates about the regulation of prostitution in later nineteenth century Russia showed the contradictions involved in emerging bourgeois economics and ideology. The notions of 'freedom', the 'individual' and the 'market' were applicable to the 'normal person', not the prostitute. The anti-regulationist physician Tarnovskii stated at a medical congress in 1885:

> [we] cannot allow them the freedom to harm other, healthy citizens, neither in the name of personal freedom, a concept only applicable to the normal person, nor in the name of morality, a concept they are constitutionally unable to grasp ... Free competition delivers prostitution into the power of capital, and puts it on a par with the most immoral commercial operations.[12]

Noblewomen were able to own property and carried out many organisational tasks on their estates, unlike wives of merchants, who did not participate as much in business as their Western European counterparts. Noblewomen also had little to do with the upbringing of their children. Motherhood was a seriously debilitating problem for women of all classes and infant mortality was high. In the 1860s and 1870s, one half of children born in Russia died before the age of two.[13]

Pregnancies were more frequent for upper-class women, as they were in better health than poor women and rarely nursed their own children, which inhibits conception to some degree. The mother of the anarchist Bakunin had eleven children in the first fourteen years of her marriage, Ekaterina Tsevlovskaia, mother of the memoirist Elizaveta Vodovozova, had sixteen children within twenty years and Ekaterina Figner, mother of the revolutionary, Vera Figner, was delivered of eight babies within twelve years.[14] *Coitus interruptus* was the most widely used form of birth control by the early part of the twentieth century, but there does not appear to have

11. See J.A. Isaak, *Heresies*, p. 12, and B.A. Engel, *Mothers and Daughters: Women of the Intelligentsia in nineteenth-century Russia*, Cambridge, 1983, p. 7. Engel's book is an excellent account of women of the intelligentsia in relation to ideology, politics and economics and thoroughly recommended. I am indebted to her book for material in this chapter.

12. L. Engelstein, 'Morality and the Wooden Spoon: Russian Doctors view Syphilis, Social Class, and Sexual Behaviour, 1890–1905', *Representations*, 14, Spring 1986, p. 190.

13. Engel, *Mothers and Daughters*, p. 157.

14. Ibid., p. 10.

been widespread knowledge of efficient contraception in later nineteenth and early twentieth-century Russia. For various reasons, mostly to do with the availability of rubber, contraceptive devices were also extremely rare under the later Soviet state. Engel quotes an exchange of letters between the revolutionary Valerian Smirnov and his partner Rosalie Idelson, at the time a medical student, discussing contraception and other issues. However it is Smirnov who seems to know more than the female medical student and advises Rosalie: 'A woman should be as familiar with her vagina as she is with her nose.'[15] Abortion and infanticide were basically used as methods to regulate family size, and abortion was a criminal offence until legally provided by the Bolshevik state by a decree in the autumn of 1920. Immediately after the Revolution heavy penalties for abortion were revoked.

Women's access to higher education in mid and later nineteenth-century Russia was not won without a struggle. Women students were widely regarded as political radicals, with good reason. Their very presence in universities was seen as subversive. Yarochenko's painting *The Student* of 1883 (Kiev Museum of Russian Art) shows a determined-looking woman with notes under her arm walking along a street. She has short hair and wears a belt over her long-sleeved top.[16] Many women of the intelligentsia became students and large numbers of these became radicalised, joining various political organisations devoted to ridding Russian society of its abuses. They worked among the peasantry and factory workers, and sometimes also carried out terrorist attacks.[17] For example Sofia Perovskaia was one of several women involved with their male comrades in plots to kill the Tsar, finally succeeding on 1 March 1881. Perovskaia refused to flee the country as her lover was in prison, and was arrested on 10 March. As members of the People's Will the terrorists were sentenced to death by hanging. Perovskaia was executed on 3 April 1881.[18]

Engel comments:

During the 1870s, more than 1,000 Russian women made professional or political commitments. By 1880, close to 800 had attended medical school in Russia, and hundreds more had gone to universities and professional schools

15. Ibid., p. 193.
16. Illustrated on the jacket of *Mothers and Daughters* and in colour plate 112 in *Les Ambulants. La Société des expositions artistiques ambulantes 1870–1923*, Leningrad, 1974, text in French and Russian by A. Lebedev.
17. See Engel, *Mothers and Daughters*, and the excellent book by Richard Stites, *The Women's Liberation Movement in Russia. Feminism, Nihilism and Bolshevism, 1860–1930*, Princeton New Jersey, new edition with afterword, 1991. This well-researched and readable work is essential for an understanding of strategies for women's liberation during this period.
18. See *Mothers and Daughters*, pp. 184 ff.

in Russia and abroad. More than 400 women had been arrested for radical activities between 1872 and 1879, and several hundred more acquired police records during the two years of intensified political activity that followed.[19]

By the time of the Russian Revolution of 1917, there had been several generations of women artists and women political activists, which was a situation specific to Russia amongst other European countries. In 1842 the first art school for women opened in St Petersburg. The first woman 'pensionnaire' from St Petersburg visited Italy for six years in 1854. By 1871, women were admitted to the Academy of Arts (30 enrolled in the first year) and by the late nineteenth century were studying in mixed classes with access to nude models. In 1882 seventy-three women painters in St Petersburg formed their own association to support women artists.[20]

Women artists at this period came predominantly from upper-class families of the intelligentsia, with the notable exception of Anna Golubkina (born 1864) whose father was a market gardener with a large and impoverished family. Golubkina was also exceptional in explicitly doing 'political' art work, though this took the form of executing a bust of Karl Marx and donating the fee to a fund for homeless workers, rather than evolving a political art practice or formal radicalism.[21]

In the field of applied arts women were also active, both as patrons and producers, particularly at the artists' colony at Abramtsevo.[22] Furthermore the only progressive professional gallery exhibiting and showing avant-garde art in St Petersburg in the early twentieth century was owned by Nadezhda Dobychina (1884–1949).[23]

Research on these nineteenth-century women artists has not been great, as far as one can guess from non-Russian sources. However there has been some work done by Alison Hilton which is relevant to representations of radical women in nineteenth-century Realist art. Discussing paintings and drawings of women revolutionaries, she points out that a number of male artists chose to show women as participants in radical political and cultural activities. As well as Yarochenko's *Female Student* referred to above, Hilton refers to Repin's *Revolutionary Woman awaiting execution* and Makovsky's *Evening Meeting*, 1875–97 (Tretiakov Gallery, Moscow),

19. Ibid., p. 191.
20. Isaak, *Heresies*, p. 16, and Bowlt, in *Women-Artists of the Russian Avant-garde*, p. 34.
21. See the biographical details for the artists discussed in M. Yablonskaya, *Women Artists of Russia's New Age*, and the chapter on Golubkina.
22. For women producers and patrons of 'arts and crafts' in late nineteenth-century Russia, see the exhibition catalogue *The Twighlight of the Tsars. Russian Art at the Turn of the Century*, Hayward Gallery, London, 7 March–19 May, 1991, and essay by J. Bowlt, in *Women-Artists of the Russian Avant-garde*, p. 36, col. 1.
23. Bowlt, *Women-Artists*, p. 36, col. 2.

where the central figure is a young woman revolutionary addressing members of a group who are shown listening intently to her words.[24] However perhaps the most interesting work is Repin's *They did not expect her* of 1883 (plate 28), the artist's original version of a larger work which ended up as *They did not expect him* (Tretyakov Gallery, Moscow). Repin was working on this subject during the mid-1880s and into the 1890s, and Hilton suggests the changes he made in the gender of the main protagonist and the facial expression of the male revolutionary in the large version are due to Repin's difficulties in finding an adequate visual equivalent to correspond to the changed conditions of political activity after the assassination of the Tsar in 1881. Repin's vision of revolutionary struggle was not gendered in the sense that his works gave importance to both women and male revolutionaries sharing the same lives of struggle and possible death at the hands of the state. However he had strong opinions as to the forcefulness needed to represent such subjects – the art-activity of upper-class women was alien to the depiction of real struggles, which demanded canvas, paint and recognised formats for prestigious visual statements. He wrote in 1883 to a friend while working on his painting: 'With all my meagre strength I strive to embody my ideas in truth. The life around me upsets me too much, it gives me no rest; but demands the canvas. Reality is too shocking to allow one to embroider its patterns peacefully, like a well-bred young lady.'[25] Repin had attended the trials of the terrorists who killed the Tsar: 'What a time of nightmare that was, pure horror ... and I remember the placards bearing the inscription "regicide" that hung on their chests.'[26]

However for a variety of reasons, including probably the likelihood of censorship, an iconography of the revolutionary woman did not develop to any great extent. Women revolutionaries had to read historical paintings, for example, as references to their own situation. While in Siberian exile, Vera Figner (1852–1942), a revolutionary populist, saw an engraving of Vassili Sourikov's painting of 1887, *The Boyarina Morosova*. For Figner, the noblewoman's social origins were forgotten in her reading of the image. The Boyarina is being dragged off on the back of a sledge, defiantly raising her arm aloft. Figner wrote:

> The engraving produced a very moving impression. In iron chains Morozova is being taken to exile and prison where she will die ... her emaciated face is marked by resolution to go to the end ... The engraving spoke of the struggle

24. A. Hilton, 'The Revolutionary Theme in Russian Realism', in H.A. Millon and L. Nochlin (eds), *Art and Architecture in the Service of Politics*, London, Cambridge Mass., 1978, pp. 108–27.

25. Ibid., p. 109.

26. Ibid., p. 110.

for beliefs, or persecution, of death, ... of Sofia Perovskaya – the Tsar's assassin.[27]

By the early twentieth century the Russian avant-garde were in the process of developing specifically Russian traditions (e.g. sources in folk-art, the peasantry as subject-matter) coupled with an awareness of Modernist achievements of artists in Paris, Berlin and Italy. Women artists played an important role in avant-garde art at this time. Women artists were also active in producing more academic work. For example Zinaida Serebriakova (1884–1967) was proposed for election to the Academy just before the revolutions of 1917, but was never elected due to the abolition of academic institutions. Serebriakova was in some ways typical of women artists of this period. She came from a cultured upper-class background which included family members who were poets, architects and graphic artists. She was not interested in Modernist practice or theory, preferring to develop within notions of academic classicism but combining this with subject-matter such as peasants (both men and women), bathers and bath-houses and family scenes which were basically from a genre tradition. The result was an impressive monumentalising of strong, clear figures with a weight and power suggesting allegory rather than naturalism. Her *Bather* of 1911 (plate 29) is a nude self-portrait of great power and assurance. It does not appear to have caused any particular controversy as a nude self-portrait for it was purchased from the *World of Art* exhibition in 1912 by the Russian Museum, St Petersburg.[28]

However the fact that women could enter the Academy or literally bodily participate in the classical art tradition as identifiable nudes was seen as completely irrelevant by certain members of the avant-garde, male and female. In a pamphlet of 1915, Malevich identifies the impetus of progressive modern art as a move beyond representation to the non-objective, to the 'suprematism of pure feeling'. He writes: 'The group of suprematists – *K. Malevich, I. Puni, M. Menkov, I. Kliun, K. Boguslavskaya* and *Rozanova – has waged the struggle for the liberation of objects from the obligations of art.'[29] Malevich praises the Futurists 'who forbade the

27. E. Valkenier, *Russian Realist Art. The State and Society: The Peredvizhniki and their Tradition*, New York, 1989, p. 92.

28. For Serebriakova, see the chapter on her in Yablonskaya, *Women Artists of Russia's New Age*, and catalogue numbers 1.47–1.51, in *Tradition and Revolution in Russian Art, Leningrad in Manchester*, exhibition catalogue, Manchester, 1990. For illustrations of Serebriakova's impressive female nude bathing scenes of 1911, 1912 and 1913, and her female nude figures for the decoration of Kazan station, Moscow, 1915–16, see V. Knyazeva, *Zinaida Evgenia Serebriakova*, Moscow, 1979 (in Russian). *The Bather* appears to be taken from the allegorical figure of *Glory* in Paul Delaroche's *Hemicycle* at the École des Beaux-Arts, Paris, 1841.

29. Malevich, 'From Cubism and Futurism to Suprematism: The New Painterly Realism', in J. Bowlt (ed.), *Russian Art of the Avant-garde. Theory and Criticism*, revised edition, London, 1988, p. 135.

painting of female hams, the painting of portraits and guitars in the moonlight. They made a huge step forward: they abandoned meat and glorified the machine.'[30] However even this was insufficient. Objects had to be representationally abandoned. Thus the conquest of the nude by a woman painter was, in the terms of the Suprematists, not even an issue for artists.

Bryony Fer has argued, in an interesting article on avant-garde art in the early 1920s, that Constructivist works, such as those by Popova, Stepanova and El Lissitsky, move beyond gendered notions of art towards the concept of a non-artist who is neutral and who does not express an individual gendered personality in his/her work.[31] She argues that 'masculine' science and 'feminine' art are brought together in the visual productions of Constructivism. Now on one level this is probably true, but on another level we could say that a similar non-gendered art emerged from the Suprematist group, and also we have to ask whether historically the notion of gendered art production was even an issue for these members of the avant-garde. I think it probably was not. This is not to argue of course that women were not oppressed in Russian society. Of course they were. However within certain avant-garde circles, it seems very likely that there was collaboration between male and female artists on an equal basis. Either their works moved beyond notions of gender (if in fact they perceived them as an issue in the first place) or they collaborated with one another so closely that it is impossible to distinguish who produced specific works or parts of works, e.g. the collaboration of Stepanova and Rodchenko, or Kulagina and Klucis. Unfortunately, art history has later tended to discuss most of these works as if they were the sole creation of the male artists/ designers. In a recent interview Alexandra Korsakova stated:

> At that time artists were never labelled as men or women. Rather, you saw that some of them were artists, while others were mere designers . . . Still, at the beginning no one fenced off the women artists. At that time there was nothing of that sort being done.
>
> But basically so many things were not the way they are now. Conditions were entirely different. At that time everyday life was not ruined to the extent it is now. Women were not so aware of their femininity. It worried nobody if a woman artist had children or not, or if she took her children with her or left them and went away alone.[32]

However in a later comment Korsakova hints that having children and a career still entailed conflict and worry for the mother.

30. Ibid., p. 125.
31. B. Fer, 'What's in a Line? Gender and Modernity', *The Oxford Art Journal*, 13, 1, 1990, pp. 77–88.
32. *Heresies*, p. 93.

Now Fer's article is useful in that it tries to go beyond notions of 'masculine' and 'feminine' although it takes these binary oppositions as its starting point. However for others, the productions and theories of the Russian avant-garde simply confirm the superiority and, indeed, fundamental necessity of a feminist viewpoint. Jo Anna Isaak quotes Griselda Pollock, arguing that the dismantling of notions of individual bourgeois creativity is a feminist project as 'it is only feminists who have nothing to lose with the desecration of Genius. The individualism of which the artist is a prime symbol is gender exclusive'. Isaak herself writes that the Constructivist and Productivist work of the avant-garde in the early 1920s designing clothing and furniture was inherently feminist: 'it can be argued that a utilitarian or materialistic art practice is inherently a feminist art practice.'[33]

I would argue that the work of the avant-garde in the period 1915–25 does not really support these claims. Indeed members of the avant-garde agreed that their practice was anti-bourgeois and, in some cases, socialist and revolutionary, as a result of the October Revolution. There is no theoretical reason why an artistic practice which produces artefacts of use to women is, as Isaak argues, inherently feminist. The Bolshevik Revolution resulted in many gains for women, as I shall discuss later, but I have come across no book which argues that the Bolshevik Revolution was a feminist one! Indeed the commitment of certain avant-garde male and female artists/designers to productivism, the industrial design and manufacture of objects required for daily life, did begin to break down gendered notions of art and design, although obviously these did not disappear completely. Rodchenko and Tatlin designed and modelled clothing as well as Stepanova, for example. While the majority of the machinists were women, there were attempts to address this division of labour. An article in *Komsomolskaya Pravda*, 30 June 1928, wrote: 'We will reunite, boys and girls of the Komsomol who go to cutting and sewing classes, those who work permanently in textiles, textile designers and the like . . .'[34]

The second main period I want to examine is the period around 1917. In so doing I want to look at the discussions concerning the extent to which the Bolsheviks took women's liberation seriously, and, related to this, the ways in which art during this period represented women and issues relating to women and the family.

Before 1917 there was quite a large feminist movement in Russia, composed of several different organisations. Some were genuinely

33. Ibid., p. 14.
34. L. Zaletova, F. Ciofi degli Atti, F. Panzini et al., *Revolutionary Costume. Soviet Clothing and Textiles of the 1920s*, New York, 1989, p. 180.

concerned about the plight of working-class women, while others were more concerned to achieve the vote for educated upper-class women. As in other imperialist countries like Britain and Germany, many feminists supported 'their' government in the World War. A demonstration of 40,000 women including students, workers and women of the intelligentsia marched after the February Revolution of 1917 carrying placards with slogans such as 'The Woman's Place is in the Constituent Assembly' and 'War to Victory'.[35] Socialist women had devoted much of their energy in the pre-Revolutionary period to winning women (especially working-class women) to revolutionary politics and away from the politics of feminism, which argued that the state should grant reforms which would abolish women's oppression. The Marxist argument was, of course, that a state based on the ownership of private property would never eradicate women's oppression, and that (while its short-term reforms might be welcomed) only the destruction of the state would pave the way for a socialist economic system that did not have women's oppression necessarily built into its very structures.

The Constituent Assembly gave all adults over twenty the vote in July 1917. The following report shows something of the differing class perceptions of women's equality at this period of intense social and political struggle:

> . . . one of the feminists, in a flurry of enthusiasm, approached a crowd of women queued up at a bakery. 'I congratulate you, citizenesses', she announced. 'We Russian women are going to receive (our) rights'. The women, tired of waiting in line, looked at the lady with indifference and lack of comprehension. Then a nearby soldier smirked and said: 'Does that mean I can't hit my wife?' At this the crowd livened up. 'Oh no you don't, honey', they shouted. 'None of that. You just try it. Nothing doing. Let ourselves be beaten any more? not on your life. Nobody has the right now.'[36]

When Russian workers seized power in October 1917 under the leadership of the Bolshevik party, the necessary first steps were taken to found a state committed to the eradication of oppression and exploitation. However the first years of the Soviet state were years of terrible hardship. The country was at war, and then invaded by foreign armies who were sent to help the White generals retake power. There was an economic blockade by other imperialist powers which meant shortages of virtually everything, since industrial production was not even at pre-war level. It is necessary to remember that all the plans of the Soviet state to eradicate

35. Stites, *The Women's Liberation Movement in Russia*, p. 292. For attitudes of some feminists to their female servants see Stites, pp. 222–3.

36. Ibid., p. 294–5.

illiteracy and the oppression of women, and provide housing, childcare, catering, etc. were put forward in a situation of war, material destitution and world isolation. The Bolsheviks saw the Soviet Union left on its own as other revolutions were defeated in Hungary, Germany and Italy.

The first Family Code of 1918 'constituted the most progressive family and gender legislation the world had ever seen'.[37] Women were given legal equality with men, and the distinction between legitimate and illegitimate children was abolished. Divorce was permitted at the request of either partner. Adoption was prohibited, in the belief that the state should care for destitute children, not the individual family, and to prevent peasants from exploiting adopted children as cheap, or even slave, labour. The Tsarist legal code was abolished, thus ending the criminalisation of prostitution and homosexuality.[38] Prostitutes were encouraged to work, but not arrested for prostitution. Arrest was reserved for brothel-owners and pimps, and men who bought prostitutes were exposed to social censure.[39] Pregnant women workers were protected by legislation on maternity leave and were given the right to nurse their children three times during the working day.

The Bolsheviks emphasised the need to socialise domestic tasks without which women would never be able to play their full part in society. Inessa Armand said in 1918:

The bourgeois system is being done away with. We have entered the period of socialist construction. Private, separate domestic economies have become harmful anachronisms which only hold up and make more difficult the carrying out of new forms of distribution. They must be abolished. The tasks carried out earlier by the housewife for her family within her tiny domestic economy must become independent branches of social labour. We must replace the thousands and millions of tiny, individual economies with their primitive, unhealthy and badly-equipped kitchens and primitive wash-tubs by clean and

37. W.Z. Goldman, 'Women, the Family and the New Revolutionary Order in the Soviet Union', in S. Kruks, R. Rapp, M. Young (eds), *Promissory Notes. Women in the Transition to Socialism*, New York, 1989, p. 62.

38. S. Karlinsky, 'Russia's Gay Literature and Culture: The Impact of the October Revolution', in *Hidden from History, Reclaiming the Gay and Lesbian Past*, p. 357. Karlinsky is somewhat anti-Bolshevik and quotes a Russian émigré, Nina Berberova, who, when told that Americans thought homosexuality had been legalised by the Soviet leaders in 1917 'thought it too funny for words. But in that case, the abolition of the old Code had also legalised murder, rape and incest. We had no laws on the books against *them* in 1917–22 either'. In an interview from 1933, Trotsky actually made it clear that while he thought incest eugenically undesirable, it had nothing to do with criminality. 'I question, for example, that humanity would have been the gainer if British justice had sent Byron to jail' (for having sexual relations with a member of his own family). See L. Trotsky, *Women and the Family*, New York, 1973, p. 54.

39. Trotsky, *Women and the Family*, p. 10, from the Introduction by Caroline Lund.

shining communal kitchens, communal canteens, communal laundries, run not by working women housewives but by people paid specifically to do the job.[40]

Lenin shared this view of housework: 'Very few husbands, not even the proletarians, think of how much they could lighten the burden and worries of their wives or relieve them entirely, if they lent a hand in this "woman's work".' As a result, he says, 'the domestic life of the woman is a daily sacrifice of self to a thousand insignificant trifles'. In 1919 he said: 'Petty housework crushes, strangles, stultifies and degrades (the wife), chains her to the kitchen and the nursery, and she wastes her labour on barbarously unproductive, petty, nerve-racking, stultifying and crushing drudgery.'[41] Kollontai and Trotsky also shared these views. Kollontai wrote: 'Instead of the working woman cleaning her flat, the communist society can arrange for men and women whose job it is to go round in the morning cleaning rooms.'[42] Significantly both male and female workers were to be employed in socialised housework. Furthermore in 1922 a Supreme Court decision ruled that housework was a form of socially necessary labour and should not be considered as 'not-work'.[43] However this decision could be seen to indicate that the state itself was not able to provide the resources to do away with 'family' housework altogether.

But by no means all of the Bolsheviks took women's issues seriously. Trotsky and others argued that conscious efforts would have to be made to educate men (and women) to enable them to reject the ideological baggage of the pre-Revolutionary society. There is no denying the fact that sexist behaviour still existed within Soviet society and the Bolshevik Party itself after 1917. However what Marxists had argued was that the economic base did not *automatically* give rise to certain superstructural developments. These could be influenced subjectively by conscious agents of change. What they also said was that a post-capitalist economy was a necessary basis for this conscious eradication of oppression to take place. The reasons why the Bolshevik state was unable to move towards a Communist society and the liberation of women were the result of a number of specific material factors, and not something inherent in revolutionary politics, as has been argued. For example Gail Lapidus argues that limitations in definition and prospects for women's liberation had emerged by the end of the 1920s: 'These limitations were intrinsic to the values, goals and organisational structure of the Leninist system.'[44]

40. E. Waters, 'In the Shadow of the Comintern: The Communist Women's Movement, 1920–43', in *Promissory Notes*, pp. 33–4.
41. Stites, *The Women's Liberation Movement*, p. 378.
42. See Alexandra Kollontai, *Selected Writings*, A. Holt (ed.), London, 1978, p. 255.
43. See W.Z. Goldman, *Promissory Notes*, p. 62.
44. Lapidus, *Women in Soviet Society*, p. 93.

Even Kollontai is castigated for her emphasis on women's role as mother, on the grounds that this role was imposed on women under Stalinism:

> She (Kollontai) likewise failed to mention the question of birth control. Knowing as we do that in 1936 abortion was to be made illegal and that for a whole era the mother-heroine was to be held up as a model for women to follow, it must seem that Kollontai's approach to the problem was inadequate and perhaps that these inadequacies were to have a direct connection with the regressions of Stalinism.[45]

A magazine illustration by Yuri Ganf from 1923 (plate 30) shows the stultifying and oppressive effects of housework on women's lives. The woman is almost submerged by pots and pans, sewing materials, washing-up and an old dirty sock. Her home is a prison, a death trap, crashing down on her, while she raises her hand in desperation towards the word 'Kommunism'.

Visual material of this period often tackled issues of women's work, literacy, childcare and so on. Women's roles were questioned and attempts made to re-construct different lives in a situation never encountered before in world history. A poem entitled *Daughters of October* by Ksenia Bykova published in *Kommunistka* in 1922 tries to articulate the excitement and energy of the 'new woman', who triumphantly ends up casting aside gender as a defining category of her existence:

> They came
> Not in diamonds or flowers.
> They were born in October
> On the barricades, in the streets.
>
> They wear finery: jackets, caps,
> Blood red kerchiefs;
> They shake hands until it hurts,
> And their expression is bold, profound.
>
> With the sound of new, red songs,
> With cries of horror from the Philistines
> They blow up the family's lamp molds
> Madly rejoicing in the light.

45. Holt, in Kollontai, *Selected Writings*, p. 118.

Love with censers, love with altars
They cast away, smiling –
Love is free, as themselves,
The boundaries are broken for them.

Not knowing the slave's boredom, they
Rush between life and labor,
Pressing forward the Spring of science,
Quenching their thirst for knowledge.

Their violent beginning
Opened the doors to a new age,
And shouted loudly to the world,
'I am a person'.[46]

There are not many studies specifically devoted to the representation of women in early Soviet art. The ones that exist state that art of the Revolution was largely a 'male' preserve emphasising 'male' values. For example Elizabeth Waters writes: 'for the most part, political iconography was not characterised either by innovation or by excellence, its producers – almost all of whom were, like other artists, male – belonging to the rank and file of the profession,' and:

> . . . it was the male figure that was chosen to personify the Bolshevik régime. The reason might seem a simple one: the October revolution after all, was largely a male event, and those virtues the Bolsheviks admired – singleness of purpose and strength of will – were traditionally understood as male attributes to be represented most convincingly by the male figure. It was only natural, surely, that the symbolic order hammered into shape in the heat of a civil war should be a masculine one and that patterns of signification thus established should persist for many years.[47]

Similarly Victoria Bonnell writes: 'the Bolsheviks sought to establish the hegemony of their interpretation of the past, present and future – their own master narrative' and that the images of women produced by the early Soviet régime show that 'Gender images are intrinsically about issues of

46. From B.E. Clements, 'The Birth of the New Soviet Woman', in A. Gleason, P. Kenez and R. Stites (eds), *Bolshevik Culture: Experiment and Order in the Russian Revolution*, Bloomington, 1985, p. 228. Lamp moulds were used to make icon lamps. See, for comparison, Toby Clark, 'The "new man's" body: a motif in early Soviet Culture', in M. Cullerne Bown and B. Taylor (eds), *Art of the Soviets. Painting Sculpture and Architecture in a One-Party State, 1917–1992*, Manchester and New York, 1993, pp. 33–50.

47. E. Waters, 'The Female Form in Soviet Political Iconography, 1917–32', in B. Clements, B. Engel, C. Worobec (eds), *Russia's Women, Accommodation, Resistance, Transformation*, Berkeley, LA, Oxford, 1991, pp. 227, 228.

domination and subordination'. The images of male and female workers embody 'roles (which) are unmistakably gender-marked, indicating male domination' and 'The juxtaposition of man and woman in those images conveys a relationship of domination: the male blacksmith is clearly the superordinate figure; the woman is his helper. Male domination was visually connected in this way to proletarian class domination'.[48]

The issue is rather more complex than these two scholars suggest. We have already seen that a number of both men and women believed that women's liberation was necessary and that conscious attempts to change both the material conditions of women's lives, and cultural practices and productions was required. However it is unreasonable to expect such a culture, visual or otherwise, to emerge in a short time, devoid of references to previous ideological notions of gender roles. Nor is it valid to see representations of gendered figures as an example of continuing male oppression, as Bonnell appears to argue. Furthermore the cases of both these scholars are weakened by their decisions not to discuss any posters by women artists. Now I am quite sure that it is the case that these artists were in a minority, but surely some discussion of women poster artists was called for in these two articles. For example the poster *The Internationale* of 1919 by Boguslavskaia (attributed) should have been mentioned and the fact that it shows no female figures at all was surely worthy of discussion. It seems to me quite likely that many women artists may have perceived the October Revolution as a male affair, while women actually involved in the events of 1917 probably did not. Boguslavskaia also executed sketches for street decorations for the first anniversary of the October Revolution and a collection of lithographs *October 1917–1918: Heroes and Victims of the Revolution.*[49] There are also the poster works of Elizaveta Sergeevna Kruglikova, whose silhouette poster of 1923 shows a young girl trying to read from a book exclaiming 'Oh, Mama! If you could learn to read, you could help me!'.[50]

Waters discusses a famous poster by Adolf Strakhov, *International Women's Day* 1920, which shows a woman worker wearing a headscarf in front of factories, and states that the demand for images of strong and independent women increased. She quotes one club propagandist writing

48. See V.E. Bonnell, 'The Representation of Women in Early Soviet Political Art', *The Russian Review*, vol. 50, July 1991, pp. 267, 270, 278, 281. The 'blacksmith' poster referred to is by N. Kogout, 1920.

49. See *Tradition and Revolution in Russian Art*, pp. 100–1.

50. Ibid., pp. 129–30. There is also a poster by Ludwig Knit from 1920, *Female Moslem Workers*, where emancipation seems to involve women in waving a banner while bearing their breasts. See p. 53 of the catalogue *100 Years of Russian Art from Private Collections in the USSR*, D. Elliott and V. Dudakov (eds), Barbican Art Gallery and Museum of Modern Art Oxford, 1989.

in 1927: 'We have seen carefully made posters calling on working women to attend club meetings [in which] a mighty figure of a male worker holds the text in his hand. Of course it is male workers rather than female workers who look at it.'[51] Waters takes this as evidence to show that the Bolsheviks were rather unsuccessful in their modes of address to women, but it may well have been an attempt (albeit misunderstood) to convince men to encourage and/or accept their wives' participation in political activities. It was recognised that many men, even in the party, did not encourage women's active participation in politics on an equal basis. Women were murdered in some cases for attempting to change their own lives. For example in Uzbekistan in 1928 203 women were murdered for this reason and in 1930 these crimes were classified as counter-revolutionary and therefore subject to the death penalty.[52]

However 'traditional' images of women should not simply be categorised as yet more examples of male domination and insensitivity. For example in a sketch for a decorative panel for the first anniversary celebrations of the October Revolution in 1918, *Triumph of the Worker* (plate 31), a woman is shown breast-feeding her child, while a standing male holds a banner and a rifle, and a seated male holds a hammer. It is certainly possible on one level to see this as re-enforcing an image of women as mothers and nurturers, not taking an active part in revolutionary struggle. But at the same time we have to bear in mind the terrible conditions in which the majority of proletarian women bore and reared children.[53] Maternity leave and nursery facilities at work to enable women to breast-feed their children was progressive in the context of the situation in 1917, and should not be read simply as an attempt to perpetuate the notions of such political figures as Proudhon, who believed women's nature destined her for motherhood and domesticity. However the attitude of leading Bolsheviks to motherhood requires discussion in more detail at a later stage.

The other major public artistic project of the young Soviet state was Lenin's idea for the construction of a series of monuments in the major towns. A large number of these monuments were planned to commemorate famous figures who had contributed radical political and cultural achievements to human history. As far as I can discover, only three female

51. Waters, *Russia's Women*, p. 235.
52. Lapidus, *Women in Soviet Society*, pp. 69–70.
53. Stites, *The Women's Liberation Movement in Russia*, p. 164–5. Kollontai viewed the opportunity of mothers to nurse their own children as a progressive gain, writing in 1918: 'Capitalist morality allowed the existence of children's homes with their incredible overcrowding and high mortality rate, forced women to suckle the children of others and to foster out their own, and trampled on the emotions of the working mother, turning the citizeness-mother into the role of a dumb animal to be milked' (*Selected Writings*, p. 140).

figures were mentioned in the various lists put forward: Sofia Perovskaia, Rosa Luxemburg and Joan of Arc.[54] Griselli's project for the monument to Sofia Perovskaia emphasised geometric forms. Foundations for the monument to Rosa Luxemburg and Karl Liebknecht, the German revolutionaries murdered with the collusion of the German state in January 1919, were laid on 19 June 1920.[55] Joan of Arc seems to have been rejected as a candidate, not surprisingly, for while she was a militant figure for her cause, politically and ideologically she was somewhat suspect! It is certainly true that the majority of the chosen figures were male; however this is not particularly surprising. Candidates had to be dead, not too obscure, and while not necessarily socialist, they could not be counter-revolutionary. Chopin was included, for example. Perhaps the suggestion and then exclusion of Joan of Arc hints at an attempt to find suitable female candidates for the monuments who were historically familiar without being politically dubious.

Women sculptors such as Sarra Lebedeva (Robespierre) and Vera Mukhina (Sverdlov) were given commissions for some of the work. Mukhina's project for a monument to Sverdlov (plate 32) of 1922–3 is an impressive attempt to embody the movement and dynamism of avant-garde art in a public monumental work. It was intended not just as a personal monument to an individual, but a material equivalent of the concept of the revolutionary spirit – alive, dynamic and combining movement with permanence. Mukhina started her designs based on Hercules destroying the birds of Stymphalus, but in the final model favoured 'a winged female figure bearing a torch in her hand'.[56]

A large number of representations of women during the 1920s, however, concerned the relationship of women to their children, and this topic deserves some detailed discussion. No legislation, however

54. See J.E. Bowlt, 'Russian Sculpture and Lenin's Plan of Monumental Propaganda', in *Art and Architecture in the Service of Politics*, pp. 182–93, and C. Lodder, 'Lenin's plan for Monumental Propaganda', in M. Cullerne Bown and B. Taylor (eds), *Art of the Soviets. Painting, Sculpture and Architecture in a One-party State*, Manchester and New York, 1993, pp. 16–32. Tatlin's famous project for a *Monument to the Third International* was also part of this scheme. Mayakovsky welcomed its radical formal structure and remarked 'It was the first monument without a beard' (Lodder p. 27). Presumably this would also have applied to Perovskaya, Luxemburg and Joan of Arc!

55. For artistic commemorations of Luxemburg and Liebknecht see J.A. Walker, exhibition catalogue *Rosa Luxemburg and Karl Liebknecht, Revolution, Remembrance, Representation*, Pentonville Gallery, London, 1986.

56. Yablonskaya, *Women Artists of Russia's New Age*, p. 224. I must confess that I have not seen the original of this model and am not entirely convinced that the figure is clearly female from the reproductions I have seen. Yakov Sverdlov, a key figure in the Bolshevik Party and close collaborator of Lenin, died of influenza as a result of overwork in March 1919. See the entry on him in H. Shukman (ed.), *The Blackwell Encyclopaedia of the Russian Revolution*, Oxford, 1988, p. 384.

progressive, could alter the physical links between mother and child, or the physical need of the child for the nurture of the mother's body in pregnancy and early life. As Trotsky put it later, 'the boldest revolution, like the "all-powerful" British Parliament, cannot convert a woman into a man – or rather, cannot divide equally between them the burden of pregnancy, birth, nursing and the rearing of children'.[57] What a socialist society must do, though, is to allocate state resources to public nurseries, laundries, eating facilities, house-cleaning and repairing of clothing, so that the individual woman would not be burdened by these tasks. However several leading Bolsheviks, including Kollontai, emphasised child-bearing as a social duty for women in a workers' state. Women should provide the children necessary for the state, and the state should fulfil its duty to the mothers. Kollontai contrasted what she saw as the selfishness of upper-class women who had abortions for 'frivolous' reasons, and the material reasons for the practice of abortion by working-class women and the peasantry. She wrote, after abortion had been legalised by the Bolshevik state in November 1920:

> Soviet power realises that the need for abortion will only disappear on the one hand when Russia has a broad and developed network of institutions protecting motherhood and providing social education, and on the other hand when women understand that *childbirth is a social obligation*; Soviet power has therefore allowed abortion to be performed openly and in clinical conditions.
>
> Besides the large-scale development of motherhood protection, the task of labour Russia is to strengthen in women the healthy instinct of motherhood, to make motherhood and labour for the collective compatible and thus do away with the need for abortion.[58]

Now this was a rather utopian idea considering that the young workers' state lacked the material resources to provide the economic infrastructure to support the millions of children that would result from Kollontai's proposals. Already huge numbers of abandoned children roamed the Soviet Union completely destitute. The population of Russia had certainly dropped massively since 1914, but there was no shortage of children in the here and now. In any case even under Communism women might not necessarily want children. Kollontai assumed that they would, if it no longer entailed hardship and suffering. However it is a far cry from Kollontai's utopian notions of motherhood to the prohibition of abortion under Stalin, for first pregnancies in 1935 and for all pregnancies in 1936.

In spite of the legislation, due largely to shortages in hospital beds and facilities, abortion was not 'free on demand'. Women seeking an abortion

57. Trotsky, *Women and the Family*, p. 61.
58. Kollontai, *Selected Writings*, pp. 148–9.

had to apply with the relevant documents to a commission composed of a doctor, representatives of the Department for the Protection of Motherhood and Infancy, and the *Zhenotdel* (the Bolshevik organisation for political work among women). The presence of members of the Zhenotdel may originally have been intended to keep an eye on the doctors, but in different circumstances this could conceivably degenerate into bureaucratic control of working women's rights. However at this point, in 1924, the commissions were set up to allocate abortion beds in terms of the need and degree of social deprivation of the women requesting one.[59] This process confirms the analysis that Trotsky gave for the gradual rise of a privileged bureaucracy, set above ordinary workers, who supervised and allocated an inadequate pool of material resources.[60] Obviously the whole idea of appearing before a committee with the necessary documents put a number of women off, and women (especially in rural areas) continued to turn to local abortionists. Many ended up in hospital anyway, with serious complications, making the shortage of beds even worse. By the 1930s there were twice as many abortions as births, based on the official figures, which discounted backstreet abortions.[61]

In 1926 the Soviet state had to modify various provisions of the family code because it simply had no resources to substitute for the family. Adoption was allowed, and alimony rights were extended to the unemployed. In practice, without state provision of child care, equal pay for women, and the partial retreat of the Soviet state under the introduction of the New Economic Policy, many women actually suffered from the large number of divorces and 'free' unions.[62] Trotsky wrote later: 'Unfortunately society proved too poor and little cultured. The real resources of the state did not correspond to the plans and intentions of the Communist Party. You cannot "abolish" the family; you have to replace it. The actual liberation of women is unrealisable on a basis of "generalised want".'[63]

Some interesting issues concerning the representation of motherhood and child care have been researched by Elizabeth Waters, though she does not really investigate the economic and political factors behind the failure

59. See the very interesting article by Wendy Goldman, 'Women, Abortion and the State, 1917–36', in B. Clements, B. Engel, C. Worobec (eds), *Russia's Women*, pp. 243–66.

60. For the economic and political factors involved in the development of the bureaucracy, rather than the 'withering away' of the state, and Stalin's rise to power, see the excellent analysis in the chapter 'From Soviet Power to Soviet Bonapartism: The Degeneration of the Russian Revolution', in *The Degenerated Revolution. The Origins and Nature of the Stalinist States*, Workers Power and the Irish Workers Group, 1982, ISBN 0 950813303. See also M. Dobb, *Soviet Economic Development Since 1917*, London, 1966.

61. W. Goldman, in *Russia's Women*, p. 263.

62. See W.Z. Goldman, in *Promissory Notes*, pp. 74–5.

63. Trotsky, *Women and the Family*, pp. 63.

of the Bolsheviks to socialise child care and liberate women. She too reiterates the view that 'sexual difference was accepted by the Bolsheviks as fixed and natural'.[64] It is not altogether clear what she means by this; whether she means Bolsheviks accepted physical sexual difference as fixed and natural or whether she means social sexual differences were accepted as fixed and natural. Of course people can have sex change operations if they have the financial resources and bravery to sustain the pain but really it is true that basically male bodies cannot give birth to, or breast-feed children, as Trotsky meant in his reference to 'legally' making men and women the same. In this sense, yes, Bolsheviks were guilty of thinking men could not produce and breast-feed their own children, but in the sense that they sought to change social oppression of women and their bodies, Waters' statement is wrong.

However her study of child care posters raises some interesting points. The posters discussed by Waters were produced for Okhmatmlad (Department of Motherhood and Infancy Protection). They decorated the walls of clinics and the premises of the *Zhenotdel*, places frequented by women, but they were also displayed in libraries and at local exhibitions where visitors may also have been male.[65] The posters show women receiving treatment during and after pregnancy under the supervision of qualified medical personnel in clean hospitals, and babies avoiding the bad old methods of child care such as swaddling, dummies, chewed feed and stuffy rooms. Waters states that 'the association of women with mothering and childcare is taken for granted throughout the period under discussion, from the early twenties to the mid-thirties'.[66] Now while this is true, in the main, we should remember this tendency was reinforced by the material shortage of resources and it was not the plan of the early Soviet state to make individual mothers responsible for the rearing of their children.

In a painting by A. Komarov, used as the basis for a poster for an Okhmatmlad exhibition in the mid-1920s, *The Meeting* (plate 33), the babies are listening to a young agitator and organising themselves to demand, for example, 'mothers milk' and 'healthy parents'. Another poster in this same series, says Waters, also makes a 'gesture towards a male audience', and a poster advertising 'Motherhood and Infancy week' shows

64. E. Waters, 'Childcare posters and the modernisation of Motherhood', *SBORNIK: Study Group on the Russian Revolution*, 1987, part 13, p. 89.

65. Ibid., p. 66. In another article Waters discusses methods of mothercraft teaching through displays on agit-trains as well as poster and printed material. She also mentions radio broadcasts in 1927 on pregnancy, child care and abortion. E. Waters, 'Teaching Mothercraft in Post-Revolutionary Russia', *Australian Journal of Slavonic and East European Studies*, vol. 1, no. 2, 1987, pp. 29–56.

66. Waters, 'Childcare Posters', p. 657.

children carrying a banner demanding 'Give us sensible fathers'.[67]

However although Waters examines posters from the period of the first Five-Year Plan (1928–32), she does not see any qualitative difference in the material from the early and from the later 1920s because her view is that basically women were seen as mothers by the Soviet state, whether in its healthy or degenerated period.

In the 1920s, the Soviet state was unable to progress on the road to socialism as the Bolsheviks had hoped. Although based on a post-capitalist economy, the Soviet state was isolated, materially under-resourced and, due to the shortages, the state bureaucracy grew stronger rather than weaker. Stalin struck at the Left and the Right of the party, physically removing by violence or exile all his opponents. In December 1924 Stalin first put forward his theory of 'Socialism in One Country' although he was not in a position to impose this until later. Given a sufficient period of peaceful relations between imperialism and the USSR it would be possible to achieve socialism without international revolutions in more developed countries, according to Stalin. Industrialisation and collectivisation of agriculture at breakneck speed were necessary for this plan, along with the complete crushing of any independent proletarian political power. The first Five-Year Plan saw some notable successes. At a time when world capitalism was reeling under the effects of severe recession, Soviet production increased by 250 per cent.[68] This, in one sense, demonstrated the superiority of the planning principle over the determination of production by the law of value, where production is for profit, and ruled by this fact.

However this seeming advance was contradicted by the counter-revolutionary and undemocratic bureaucratic methods which robbed the workers of any real participation in running the economy of their own, now degenerated, workers' state. The first Five-Year Plan and the consolidation of Stalin's faction in power therefore saw a number of contradictory factors in the position of women in the Stalinist state. More crèches were provided as the number of women workers rose from nearly three million in 1928 to over thirteen million in 1940.[69] However the increase in crèche places did not cover the huge increase in women requiring child care. Protective legislation for women, particularly maternity leave, and pay declined proportionately with the increase in female labour. Women therefore were subjected to an increasing burden of work, child care and housework. The retreat from early Bolshevik

67. Ibid., p. 92.
68. *The Degenerated Revolution, the Origins and Nature of the Stalinist States*, p. 21.
69. M. Buckley, *Women and Ideology in the Soviet Union*, Hemel Hempstead, 1989, p. 113.

legislation on women's rights accompanied a political counter-revolution which attacked mainly proletarian men and women, but also Jews, lesbians and homosexuals, national minorities and gypsies, as well as any political opponents.

Images of women produced during the period after 1928 have been interpreted in different ways by art historians. W. Holz sees women in Stalinist art as depicted simply as 'body beings'. As heroic workers, sportswomen or nudes, they have no mind, only a physical presence.[70] Irina Sandomirskaya sees Stalinist art as the culmination of a process designed to 'dehumanize' people and create a 'totalitarian androgyn'. She starts her argument with a discussion of language reform under the early Soviet state which abolished masculine and feminine endings to words. This progressive attempt to 'de-gender' language is seen by Sandomirskaya as an attempt to 'nullify the meaningful opposition between masculine and feminine'. This 'dehumanizing process' began in 1917, she says, and culminated in the construction of the 'Soviet androgyn'

> through the negation of all the positive values developed by our civilisation and traditionally applied to man rather than woman. As the male population was being exterminated in concentration camps and numerous wars, the female underwent socialist training by standing in queues for bread or queues in the waiting room of the National Security Committee for information about the repressed relatives, working herself to death in factories and on farms, and bringing up her children to be true Leninist-Stalinists who disowned their enemy-of-the-people father.[71]

For Margarita Tupitsyn, Stalinist culture is patriarchal, embodying the representation of male desire founded on the repression of women by the Father's authority.[72] So women in Stalinist culture are objectified images of phallocratic power, or else seen as genderless objects completely dehumanised. But is this really all there is to it? Are there no positive aspects to this imagery at all? Are there no contradictions here?

It is certainly true that while proclaiming equality for women the Stalinist state made the lot of proletarian and peasant women worse. The Zhenodtel was closed down because 'The woman question was now officially "solved"'. Stalin stated in March 1937:

> The Soviet system has ended exploitation for good and done away with women's lack of rights and their slavery. Woman of the Union of Soviet Socialist Republics – is a new woman, an active participant in the administration of the

70. W. Holz, 'Allegory and iconography in Socialist Realist Painting', in Taylor (ed.), *Art of the Soviets*, p. 79.

71. *Heresies*, p. 56.

72. *Arts Magazine*, Dec 1990, p. 64.

state and in the running of the economy and cultural life. Such women have never existed and could not have existed before.[73]

However the worsening lot of proletarian and poor peasant women was in contrast to the privileged life led by wives of the bureaucratic caste who controlled the state. Trotsky wrote:

> The situation of the mother of the family, who is an esteemed Communist, has a cook, a telephone for giving orders to the stores, an automobile for errands etc., has little in common with the situation of the working woman, who is compelled to run to the shops, prepare dinner herself, and carry her children on foot from the kindergarten – if, indeed, a kindergarten is available. No socialist labels can conceal this social contrast, which is no less striking than the contrast between the bourgeois lady and the proletarian woman in any country of the West.[74]

Wives of the bureaucracy also had privileged access to abortion after it was banned in the mid-1930s. At the same time divorce was made more difficult and homosexuality criminalised.[75] This emphasis on strengthening of the family and heterosexual reproductive sex obviously influenced the kind of visual images that the Stalinist state favoured. However it also related to the mode of representation of the art works. Abstract and non-objective art had been finally deemed unacceptable in the early 1930s with the proclamation of Soviet Socialist Realism as the art of the workers' state. Zhdanov explained in 1932: 'Firstly, we must know life in order to be able to depict it truthfully – not scholastically, lifelessly or merely as "objective reality"; we must depict reality in its revolutionary development.'[76] So this art was to be true to life but, at the same time, not true to life, showing both what was, and what should be.

This period in Soviet art saw the production of many servile glorifications of Stalin in the Soviet Socialist Realist mode. One such painting, *Stalin at the Belomor Canal* of 1937, in the Museum of Art, Kharkov, Ukraine, was the subject of a British television programme in 1993. The artist, Dmitri Nalbandyan, was interviewed. He condemned abstract art as 'immoral' and 'formalist'. 'A normal person gives birth to children and enjoys real art. That's what's wrong these days. Lesbians and homosexuals are all over the place – they're no longer sent away.' The

73. Buckley, *Women and Ideology*, pp. 108–9.

74. Trotsky, *Women and the Family*, p. 72.

75. See for example J. Evans, 'The Communist Party of the Soviet Union and the Women's Question: The Case of the 1936 Decree "In Defence of Mother and Child"', *Journal of Contemporary History*, October 1981, p. 757–75.

76. See the exhibition catalogue, *Soviet Socialist Realist Painting, 1930s–1960s*, M. Cullerne Bown and D. Elliott, Museum of Modern Art Oxford, 1992, p. 5.

forced labour toiling on the canal included homosexuals, gypsies, artists, dancers and political opponents of Stalin. Tens of thousands were worked to death as they were being 'rehabilitated'.[77]

In a less obnoxious statement, the artist V. Favorskij also felt Soviet Socialist Realism was the style best suited to his monumental 'social' decorations of the Museum for the Protection of Motherhood and Childhood in Kropotkin Street, which was being finished in 1933 (plate 34).[78] This building no longer exists as a museum. Frescoes by Favorskij decorated the bottom hall and the upstairs room had frescoes by Bruni and coloured bas-reliefs by Vera Mukhina entitled *Bath Time in the Nursery School* and *First Steps*.[79]

Favorskij's frescoes with figures one and a half times life size showed, according to the artist, that the protection of mothers and children in a socialist state was undertaken as part of a larger plan for the reorganisation of everyday life. A nurse takes charge of the children of a factory worker and a collective farm-worker. On the side walls were scenes of women in modern town and city life and winter and summer walks. A critic described the side walls as more 'impressionistic' and colourful in execution.

It is not absolutely clear what was in the Museum for the Protection of Motherhood and Childhood, but it seems likely that the exhibition of material organised by the Moscow *Okhmatmlad* described by a foreign visitor in the early 1930s was transferred there when the newly refurbished building was completed. This visitor, an Austrian woman and probably a member of the Communist Party, describes an exhibition of several thousand items including posters, photographs, diagrams, casts, tables, anatomical models, child care items and so on. Many of these were in glass cases, and women, often with their husbands, were given group tours of the exhibition. 'One item of special interest in the exhibition of the Moscow *Okhmatmlad* is a collection of good reproductions of various old German, Italian and Dutch masters whose Madonnas are letting the child drink from a horn, which is shown as something exceedingly injurious.' A book was available for visitors to write their comments and one male visitor wrote of his great interest in the guided tour. He wrote in enthusiastic tones, but

77. BBC2 Television programme *Every Picture Tells a Story*, 'Serving the Sultan'.

78. See H. Gassner and E. Gillen, *Zwischen Revolutionskunst und Sozialistischen Realismus, Dokumente und Kommentare Kunstdebatten in der Sowjetunion von 1917 bis 1934*, Köln, 1979, pp. 487–90, and Y. Molok (ed.), *Vladimir Favorsky*, Moscow, 1967, pp. 249–51.

79. Thanks to Andrew Lord of the Visual Aids Library, Society for Co-operation in Russian and Soviet Studies, for information on the Mukhina bas-reliefs. My thanks also to Dr Catherine Cooke for information about the building. The building still exists at No. 20 Kropotkin Street, Moscow (now renamed Prechistenka Street). It has been very difficult to find information about this building as it was transformed into the Office of Services to the Diplomatic Corps at some later date and therefore shrouded in secrecy.

also betrayed a rather 'bossy' attitude to his wife: 'I shall make my wife come straight away tomorrow. The exhibition is of the greatest interest both for me and for her. I have learned many truths here for the first time. Factory worker N.N.'[80]

However the actual quality of most nurseries and crèches left much to be desired, with the best places taken up by children of bureaucrats and of Stakhanovite workers. Stakhanovite workers were named after Stakhanov, who in August 1935 smashed his work norm by mining 102 tons of coal in six hours with the help of a hand-picked team and special provisions. Workers were urged to emulate him by increasing production to almost superhuman levels. In October 1935 Makar Tashtoba exceeded his work norm by 2,274 per cent when he mined 311 tons of coal in one day.[81]

These workers were generally disliked by their workmates and rewarded by the bureaucracy. Women too were encouraged to emulate Stakhanov. Valentina Kulagina's poster of 1931 entitled *Women Workers, shock workers, strengthen your shock brigades* calls on women to take their place in the drive to go beyond the plan. Another poster reproduced as a book-cover design of 1931 by Kulagina shows male and female workers straining every nerve to fulfil production targets in heavy industry: *Devote yourself to the building of socialism in 1931. 8 million tons of cast iron* (plate 35). Interviews with workers appeared in the press. For example *Stakhanovka* Petrova stated:

> I was given a machine. At first I studied how to use it, then they gave me two. Next I transferred to three. On stakhanovite days I moved to work on four, then six . . . Our group overfulfilled the plan all the time and moved to six machines, but there are backward groups in our factory. We stakhanovites help them. Our task is to pull the backward workers up to the level of advanced ones.[82]

Wives of Stakhanovites were encouraged to put pressure on their husbands at home. A conference of wives of shock workers was held in 1936. The aim was to get the women to go round blocks of flats looking

80. F.W. Halle, *Women in Soviet Russia*, translated from the German original of 1932 by M. Green, London, 1933, pp. 159–60. E.M. Konius, *Puti razvitiia sovetskoi okhrany materinstva i mladenchestva (1917–1940), (The process of Development of Soviet Maternity and Infancy Protection (1917–1940))*, Moscow, 1954, illustrates, in rather poor quality reproductions, some fascinating visual material on mother and child care, including brochures addressed to women of the Asian Republics, exhibitions devoted to the theme of mother and child protection, a group of young women listening to a lecture in the Moscow museum (p. 302) and an illustration of Vera Mukhina's bas-relief decoration for the Museum of children playing as the contents of a watering can are sprayed over them (p. 300). This is now lost.

81. *The Degenerated Revolution*, p. 24.

82. Buckley, *Women and Ideology*, p. 114.

for wives of 'non-stakhanovites' so that they could 'work on their husbands', 'show an interest in his work' and encourage him to do better. Women proudly stated at the conference how they subordinated their own personal and cultural development to the needs of their men, in the interests of the economy. A fitter's wife announced:

> I help my husband in every possible way. I try to be cheerful and do not make him worry about taking care of the home. I assume most of the chores myself. At the same time I try to help my husband by advising him. Everything that I know I pass on to him. I look for the necessary literature for him so that the time he would have spent searching for it, he can spend studying it.[83]

Women were encouraged to become shock workers in agriculture as well. By the mid-1930s women were being praised as heroine beet growers, cabbage harvesters, cotton and flax growers and cattle breeders. Women tractor drivers engaged in 'socialist' competition.

The Soviet land code, ratified in 1922, had been a compromise between the Bolsheviks and a peasantry who had not, in the main, been won over to socialism. Gender equality was an important element in this legislation giving women equal rights to land, property and a share of the household assets.[84] However it did not, and could not, abolish by decree the traditional male-dominated family structure and customs of the peasant household, which required organised propaganda and education on a large scale.

It was argued by the Stalinist bureaucracy that collectivisation of agriculture would result in equal rights for women by destroying the patriarchal family. Now in one sense this could have been true but the disastrous imposition of collectivisation on the Soviet peasantry was in complete contradiction to the methods of Marxism which argued for the self-emancipation of workers and the oppressed. Amid official claims of 'spontaneous' movements to embrace collectivisation peasants were forced into ramshackle collectives with few resources or equipment. Peasant families killed their own livestock as a method of resistance. Numbers of livestock decreased and agricultural output dropped considerably in the first years of collectivisation. Peasants had to submit to an internal passport system in 1933 and were effectively tied to their collective.[85]

It is in this context that I want to look at Vera Mukhina's monumental group *Worker and Collective Farm Woman*, 1937 (plate 36), executed for the Paris Exposition where it was positioned on top of the Soviet Pavilion. This massive work constructed from steel plates fixed to a wooden support

83. Ibid., p. 116.
84. W.Z. Goldman, *Promissory Notes*, p. 64.
85. *The Degenerated Revolution*, p. 19.

was completed by Mukhina with the help of two women assistants, N. Zelenskaia and Z. Ivanova. Elizabeth Waters states that the main purpose of the work was 'a celebration of the alliance of the working class and the peasantry' while at the same time constructing sexual inequality by identifying the female with the peasantry. The Soviet state certainly saw the peasantry as secondary to the proletariat in the building of socialism, but they also saw agriculture as essential. Waters writes: 'In depriving the peasant of his former power, collectivisation opened the way for the "feminisation" of the peasantry.'[86] She concludes that women played a secondary role 'standing for women or the peasantry, subordinate social groups. Woman was the Other, or rather Others, since her personality was split'.[87]

This argument is clearly different from Sandomirskaya's which sees sexual difference as a valuable and 'human' quality, crushed by the Soviet state and neutralised. Waters sees gender difference preserved and emphasised, and the category of 'Woman' maintained as an inferior one throughout the Soviet period. I do not think either of these approaches adequately tackles the complexities of both objective and subjective factors in the period after 1917. Nor do they clearly differentiate between the early years of the Soviet Union, when as a healthy workers' state it had the potential to move towards a socialist economy and the eradication of social oppression, and the Stalinist period, when an attack was made on what women had gained previously. However even within the Stalinist vision of womanhood a massive contradiction was embodied. Women were recruited into the workforce on a huge scale but the conditions under which this occurred were oppressive rather than liberating. Far from disproving Marxist theory, that economic activity in the workforce was a step towards women's liberation, we can see that Marx was correct in saying that the economic base has no *automatic* effect on cultural and political developments in the superstructural sphere. A process which in different circumstances could have resulted in greater emancipation for women became a further burden to them. The static and heavy models of 'socialist' women in Stalinist art have little inner dynamism or momentum. Why should they have, since 'socialism' has already been achieved and women already liberated? Mukhina and her assistants created an impressive monument both to woman and the achievements of women sculptors, but

86. Waters, *Russia's Women*, p. 241.

87. Ibid., p. 242. V.E. Bonnell also argues that 'political' artists 'feminised the image of the peasantry as a social category. Mukhina created the definitive statement of that feminisation, using gender differences to convey the hierarchical relationship between the worker (male) and peasant (female) and, by implication, between urban and rural spheres of Soviet society'. See pp. 80–1 of her article, 'The Peasant Woman in Stalinist Political Art of the 1930s', *American Historical Review*, 98:1, Feb 1993.

its inception was due to a political clique which suppressed and denied the aspirations of millions of oppressed male *and* female workers and peasants in the Soviet Union.

There is a further problem with reading Mukhina's *Worker and Collective Farm Worker* as a construction of the subordinated Other, i.e. the peasantry. The July 1918 Constitution of the young Soviet Republic had disenfranchised the urban and the rural bourgeoisie. In order to ensure the dictatorship of the proletariat and the eventual withering away of the state, and, indeed of classes themselves, the franchise was weighted so as to give one seat in the Congress of Soviets for every 25,000 urban voters, and 125,000 provincial voters. In the provincial soviets the vote was weighted to one seat for 2,000 city voters and one for 10,000 rural voters.[88]

However in 1936 as Mukhina was commissioned to execute her sculpture, Stalin decreed a new Constitution. Having purged the army to remove and murder any potential opposition, Stalin proclaimed that the first phase of Communism had been achieved, the working class was no longer the proletariat and the peasantry had been integrated into the socialist economy. The former bourgeoisie and White Guards were given the vote, and elections were now by individuals voting in secret ballots, not openly by class and industrial groupings.[89] Trotsky was scathing in his critique of Stalin's reasons for carrying through these proposals. He pointed out that Stalin was dissolving the proletariat into 'the nation', weakening its political weight and bureaucratically decreeing it non-existent. If this really were the case, said Trotsky, then the state power should have virtually disintegrated, if classes had actually disappeared. But on the contrary, Stalin's machine of terror and suppression strengthened, rather than weakened, the state apparatus as distinct from the workers and poor peasantry.

Trotsky wrote:

> The arrival at a socialist society is characterised not only by the fact that the peasants are put on an equality with the workers, and that political rights are restored to the small percentage of citizens of bourgeois origin, but above all by the fact that real freedom is established for the whole 100 per cent of the population. With the liquidation of classes, not only the bureaucracy dies away, and not only the dictatorship, but the state itself. Let some imprudent person, however, try to utter even a hint in this direction: the G.P.U. will find adequate grounds in the new constitution to send him to one of the innumerable concentration camps. Classes are abolished. Of Soviets there remains only the

88. *The Degenerated Revolution*, p. 8.
89. I. Deutscher, *Stalin*, Harmondsworth, 1966, pp. 377–8.

name. But the bureaucracy is still there. The equality of the rights of workers and peasants means, in reality, an equal lack of rights before the bureaucracy.[90]

So, in the context of 1936–7, Mukhina's sculpture was not about the peasantry as *subordinate* to the proletariat, but as equal, to 'prove' the validity of Stalin's argument that there was no need for the dictatorship of the proletariat because socialism had been achieved.

Unless we attempt to look at the position of women in relation to the economy of the Soviet Union and the political degeneration of the workers' state, factors which affected males as well as females, we are not really able to come up with adequate readings of the art works. As I have tried to show, many of the readings of these works see them as basically 'reflections' of oppressive attitudes to women, without any internal contradictions, or indeed any contradictory relationship within economically and ideologically interrelated spheres. Nor does this 'reflection' of attitudes approach really enable us to understand how women can identify with any of these works and even produce them. Where do these attitudes to women come from in any case? The answer, as usual, is patriarchal society, for feminist scholars from the West, while for Russian feminist Sandomirskaya the problem is a totalitarian anti-humanism which forcibly seeks to eradicate the valuable and life-enhancing qualities of gender difference. In my view neither of these analyses really grasps, the material roots of efforts to liberate the oppressed in the early Soviet state, and the reasons for the failure to achieve this along with the political degeneration of the first workers' state. A theoretical approach primarily focused on gender does not really provide the methodological basis to do this.

90. L. Trotsky, *The Revolution Betrayed. What is the Soviet Union and Where is it going?*, New York, 1980, pp. 263–4.

–6–

Women and Nazi Art: Nazi Women and Art

Soviet Socialist Realism has been compared to the art of the Third Reich in its rejection of Modernism in painting and its suppression of the freedom of the individual. Such comparisons of the culture created by these two social formations have also been linked to their political aims. In his book *Art Under a Dictatorship*, written during the Cold War period, Lehmann-Haupt equates Nazi Germany and the Stalinist Soviet Union in terms of lack of freedom and political democracy, and compares them unfavourably with the post-Second World War United States:

> We should be able to apply these criteria toward the solution of some basic questions about the value of the creative individual and the nature of his freedom in a democratic society. Also, our conclusions should help in defining more clearly the cultural opportunities and obligations of the U.S. in its present position of world leadership.[1]

Much the same argument is advanced in a recent book by Igor Golomstock, *Totalitarian Art*. In his Introduction, Golomstock links Lenin, Stalin, Mussolini and Hitler in a chain of oppressive anti-individualism and anti-Modernism. Golomstock opens his book by quoting an exchange of views between senior officials present at the beginning of the talks on German-Soviet friendship on 27 May 1937. The Nazi representative stated: 'In spite of all the differences in our *Weltanshauung*, there is one common element in the ideology of Germany, Italy and the Soviet Union: opposition to the capitalist democracies.' Golomstock continues: 'This shared ideological element soon led to the pact between Stalin and Hitler which, to all intents and purposes, unleashed the Second World War.'[2]

Golomstock here has adopted a highly suspect model of cultural and historical analysis. According to his argument it was not material or economic factors which led to the Nazi-Soviet pact of 1939 but a similarity

1. H. Lehmann-Haupt, *Art Under a Dictatorship*, Oxford, 1954, p. xx.
2. Golomstock, *Totalitarian Art in the Soviet Union, the Third Reich, Fascist Italy and the People's Republic of China*, London, 1990, p. ix.

of ideologies which not only led to the pact but caused the Second World War. Formal cultural similarities are completely divorced from their content in Golomstock's analysis. The whole of the latter part of his book is devoted to the illustration and juxtaposition of art works from Nazi Germany and the Soviet Union without any commentary, to show that the two cultures come from the same kind of societies. In this section of the book, the illustrations are supposed to 'speak for themselves' and 'state the obvious', i.e. that images which look the same must come from the same kind of social system and mean the same thing.

These methods are suspect enough, but in addition, there are factual errors in the book and superficial similarities are presented as proof of the damning identity of Fascism and Communism. For example on page seven Golomstock points out that both Communists and Fascists call one another 'comrade', the implication being that these political parties are ultimately identical in their undemocratic and totalitarian nature.

The intellectual weakness and factual errors of Golomstock's work would perhaps lead many readers to reject his conclusions. However less obviously flawed analyses of Nazi and Stalinist culture approach their material using similar methods. For example, in an article called 'The Soviet Pavilion in Paris' Sarah Wilson analyses the cultural and political significance of the Soviet Pavilion at the 1937 Exposition Internationale (World Fair), where Vera Mukhina's sculptural group (plate 36) and Boris Iofan's pavilion were placed directly opposite the German pavilion which was surmounted by a huge eagle. I will quote at some length from Wilson's discussion of the two pavilions to show how her approach is similar to that of Golomstock:

> The 1937 pavilion itself and the Palace of the Soviets model were conceived as incontestable symbols of world power. Inside the pavilion, behind the Lenin statue on a wall under a barrel vault, Stalin's words of 'peace' (my epigraph) resonated with his insistence on the Soviet Union's right to its own territories – its *Lebensraum* . . . the comparison afforded between Socialist Realist and National Socialist art was striking, emphasised, of course, by the pavilion's placement. In Albert Speer's edifice, models of the Nuremberg stadium and the Haus der Kunst in Munich paralleled that of the Palace of the Soviets; bronzes of naked athletes, the Lenin and Stalin sculptures, academic realist paintings, contemporary, mythologized or 'medievalist' replaced the portraits of generals and crowds of peasants, but the state programme for the arts was just as visible. It is no coincidence that talks marking the beginnings of the Nazi-Soviet rapprochement started on 27 May 1937.[3]

3. S. Wilson, in M. Cullerne Bown and B. Taylor (eds), *Art of the Soviets*, pp. 111–12.

The two artistic styles are the same, they visually embody a desire for domination and world power, and therefore the Nazi-Soviet pact is explicable by the similarity of the two régimes. Wilson tries to further suggest the equation of Stalinism and Fascism by using the German term 'Lebensraum' to describe Stalin's designs for territorial power. In a footnote to this section, Wilson sees a clinching fact in the similarity of Stalinist and Nazi culture and politics in the careers of the two main sculptors involved in the work on the pavilions: 'Like Hitler's sculptor, Arno Breker, Mukhina had been trained in Paris.'[4] Now it is hardly an extraordinary discovery to point out that both Stalinist and Nazi sculptors were similar because they trained in Paris! If we used this argument we would conclude that virtually everyone in twentieth-century art was trained to produce 'totalitarian' art works because they had shared the formative experiences of Mukhina and Arno Breker! Once again, superficial similarities in form are used here to conclude that their *content* is the same, i.e. the pavilions were similar, both countries sought to dominate the world, therefore it is not surprising they formed a pact and fostered the same sort of art productions.

In terms of the treatment of women, too, Nazi and Stalinist régimes have been seen as similarly reactionary. Janet Evans writes of the USSR under Stalin:

> The motherhood obsession has been condemned as reactionary and indeed many of the incentives provided to encourage women to bear more children were similar to those introduced in Nazi Germany at the same time. The statement made at a Nazi Party rally in 1935 on this matter: 'The woman too has her battlefield', was not unlike comments which could be heard in the USSR.[5]

Writing of Stalinist art, Jo-Anna Isaak states: 'As in Germany under National Socialism, there were many images of female fecundity; bare-breasted harvesters or nursing mothers were very popular, as were nude female athletes or bathing scenes that allowed the artist to depict the nude in numerous postures.'[6] Now concerning the first of these statements, the emphasis on childbearing in the mid-1930s, Evans is partly correct. However there were many other countries and historical periods when state policy was to restrict women's access to abortion and birth control, and encourage the birth of healthy and socially desirable children, for example in early twentieth-century Britain, or in France after the First World War. We need to look further than these superficial similarities before we can

4. Ibid., p. 118.
5. J. Evans, in *Journal of Contemporary History*, Oct. 1981, p. 763.
6. *Heresies*, p. 20.

analyse the real content of the Stalinist and fascist states as regards women and their representation in culture.

The common denominator of all the approaches referred to above is that they do not start with an examination of the material bases of the societies concerned before drawing conclusions about the cultures of the two states in the 1930s. Similarly they read the culture as being a direct expression of the economic ambitions and political programmes of the Communist and Nazi Parties (because after all they suppressed all individual expression and dominated art totally). Even in the cases of Stalinist and Nazi art, culture should not be analysed in this reductive manner. However these writers do worse and draw conclusions about the meaning of the social systems of Nazi and Stalinist states *from the culture*, and not the other way around. Finally these writers divorce form from content in a completely undialectical manner. Just because *forms* of culture are similar, it does not follow they mean the same thing(s), and the writers mentioned above therefore end up making rather unhelpful and vague generalisations describing the meaning of these works as 'totalitarian', 'undemocratic' and 'anti-individualist'.

We need to ask, what really lies behind the similarities between Stalinist and Nazi culture, for there are indeed similarities. Were these states really identical, and are they both similar examples of states which viewed women simply as breeding fodder?

In order to examine these questions I am going to look at the nature of the Soviet state in the 1930s, some discussions of Nazi culture and the nature of the fascist state in Germany. I will also look at the question of whether Nazi policy on women and representations of women were more a development of what was already happening in imperialist countries prior to the rise of the Nazis, than identical phenomena to those found in the Stalinist USSR at the same period.

The Soviet state, based on post-capitalist property relations, had not 'withered away' as Marxism argued that it would in a healthy workers' state. In fact in an isolated country based on materially scarce resources, state bureaucracy increased and the state machinery of planning, legislation and the military became increasingly distanced from the control of the workers themselves. Since Stalin had evolved his theory of 'socialism in one country' to explain and legitimise his policies, the prime motive was the preservation and survival of the Soviet Union, not the spreading of social and political revolution on a world scale. Stalin's foreign policy devolved from this. His policies led the German workers to tragic defeat at the hands of the fascists because of the Communist Party leadership's line that it was impossible to have a united front with any social democratic forces against the fascists. Having been responsible for the destruction of the German workers' organisations, Stalin switched to advising

Communist Parties to enter into 'Popular Fronts' (or People's Fronts), with their own 'democratic' bourgeoisies, for example in France. Stalin believed his alliances with the capitalist democracies would safeguard the USSR against Nazi Germany, but as the capitalist states of Europe refused to intervene against the fascists in Spain, and accepted Hitler's 'Anschluss' of Austria in 1938 and the seizure of Sudetenland, Stalin moved to ally the USSR with the Nazis. Within the Soviet Union, party members and military commanders who favoured alliances with democratic imperialists were murdered. Stalin's manoeuvres did not succeed in any case, and were achieved at the cost of the disillusionment, despair and sometimes even death of many ordinary Communist Party members on a world scale.

At the end of the war, Stalin similarly came to agreements with the victorious imperialists at Yalta which were designed to safeguard the Soviet Union and its bureaucracy at the expense of world revolution. In the last period of the war and just after, the Soviet Union destroyed anti-capitalist movements in Eastern and Central Europe as part of its agreement with imperialism over respective spheres of influence. The Greek Communists were betrayed and defeated. In Rumania, for example, King Michael was brought back, decorated by Stalin and restored to the throne.[7] It is hardly true to say, then, that the Soviet pavilion can be read as demonstrating the USSR's aims of world domination in 1937. This was anything but the case.

However the ways in which the state apparatus of the Stalinist Soviet Union and Nazi Germany related to their economic base did indeed show similarities. For different reasons, these state apparatuses were relatively detached from the relations of production in the two countries. The state bureaucracy and military apparatus was not controlled directly by either the workers in the Soviet Union, or the bourgeoisie in Nazi Germany. The two states were examples of what Marx had described as Bonapartism. In his discussion of Louis Napoleon's Second Empire in France, Marx explained how the bourgeoisie was at times incapable of ruling in its own right and delegated its political control to a strong, dictatorial figure who would, seemingly, stand above conflicting social interests and enable the bourgeoisie to operate successfully while not in direct political control of the state. This, I will argue, was also the case in Nazi Germany, where the German capitalists were willing to hand over the political apparatus of the state to Hitler who, they rightly judged, would rule by terror and violence in the interests of big capital. This relative autonomy of the state from economic relations of production was also the case in the Soviet Union, where Trotsky argued that Soviet Bonapartism had, through a political counter-revolution, removed the state apparatus from control by the workers, whose ownership of the Soviet economy the Stalinists had

7. *The Degenerated Revolution*, p. 41.

usurped and alienated from them.

Thus in the mid-late 1930s, the Soviet and Nazi states were similar in form, their policies based on remaining in power by physical terror, relatively detached from their material bases, but presiding over different sets of property relations, or 'content', if you like – post-capitalist in the USSR and monopoly capitalist in Nazi Germany.

It is important to understand this because it is not possible to understand the meanings of the cultural productions of these states if we have misunderstood their real nature. If we take the appearance for the essence, we will draw some very misleading conclusions about the nature of Stalinism and fascism and how they relate to women (and men).

I want to look now at two discussions of Nazi Germany and its culture which I believe to be dangerously misleading and in need of correction, before considering women in Nazi Germany.

In the book *The Nazification of Art*, Brandon Taylor and Wilfried van der Will are keen to argue for a reassessment of Nazi Germany and its culture. Van der Will argues that we must reject 'vulgar' Marxist analyses of fascist Germany, stating 'it is impossible to explain the power of National Socialism in Germany in terms of conflicting economic and class interests'.[8] Taylor and van der Will refer to the 'vulgar Marxist theory that Fascism was an off-spring of capitalism' as mistaken, and add that big business did not substantially fund the Nazis, so that 'the vulgar Marxist argument of conceiving German Fascism as merely the executive arm of capitalism' is also wrong.[9] This view fails to understand the relatively autonomous nature of the Nazi state. Similarly, it ignores the fact that while individuals and small businesses funded the Nazi Party initially, after 1929 big business gave Hitler significant support. Furthermore, contrary to the original aims of the Nazis, big business was left untouched by the Nazi government, and given huge subsidies, tax relief and state commissions for, e.g. building and armaments, while trade unions were mercilessly destroyed and protective legislation removed from the workforce. D.G. Williamson writes: 'In open contradiction to the original Nazi programme, the years 1933–6 saw the steady growth of cartels and the influence of big business over the economy – between July 1933 and December 1936, for example, over 1,600 new cartel arrangements were signed.'[10] In contrast to the Soviet economic plans, Hitler's economic plans ensured the massive profits of big capitalists.

8. B. Taylor and W. van der Will (eds), *The Nazification of Art, Art Design, Music, Architecture and Film in the Third Reich*, Winchester, 1990, p. 14.

9. Ibid., pp. 9–10.

10. D.G. Williamson, *The Third Reich*, Harlow, 1982, p. 28. On the Nazis' economic policies, see also R.J. Overy, *The Nazi Economic Recovery 1932–1938*, Basingstoke, 1991 reprint.

Two examples from the sphere of culture should illustrate this. Nazi Germany saw the increased growth of monopolies in the film industry. By 1943–4 the German film industry was effectively under state control, making huge profits for private capitalism through use of imported foreign forced labour and increased shift working, and paying a large amount of taxes to the state.[11]

In architectural projects, state building programmes ensured huge profits for building firms, increased monopolisation and destruction of small firms, which was quite in contradiction to the earlier stated aims of the Nazis, which had been to dismantle big businesses and to encourage the growth of small shops and business enterprises. State funds ensured 'unheard-of corporate profits' for the building industry. 'Between 1932 and 1939 the gross income of the Frankfurt company Philipp Holzmann A.G., one of the largest German building firms, rose by almost 900 per cent.' However this was rather exceptional. Nevertheless government subsidy for building rose from 67.5 per cent in 1936 to 80 per cent in 1938, and by the beginning of the war it was 100 per cent.[12] While Hitler argued that his building programme benefited 'the larger community of the nation', a consideration of the economics behind the building programmes contradicts his statement that Nazi policies reversed those of 'the bourgeois and liberal era, [when] funds for public buildings were cut more and more while the industrial plants, banks, exchanges, department stores, hotels and so forth of bourgeois capitalist interest groups flourished'.[13] Because forced labour and concentration-camp labour in stone quarries was used in the Nazi building programmes, the profits involved for the companies were huge.[14]

Taylor's and van der Will's contention that the Nazi state did not further the interests of capitalism is, to say the least, debatable. Another dubious argument is their attempt to construct a view of Nazi culture as an early form of Post-Modernism which paradoxically tried to destroy a carefully selected 'Modernist' past, while remaining itself 'part of a wider Modernist dynamic in which all forms are to be renovated and life as a whole is to be transformed and improved'.[15] Taylor argues 'The masculine bias of National Socialist culture is certainly comparable with that of the

11. J. Petley, *Capital and Culture. German Cinema 1933–45*, London, 1979, p. 86. This book gives an excellent analysis of the interrelated economic and ideological aspects of the cinema industry during the Third Reich.

12. See B. Hinz, *Art in the Third Reich*, Oxford, 1979, pp. 233–4.

13. Speech by Hitler of 1937 quoted by Hinz, p. 191.

14. Hinz, p. 195. For an excellent account of why and how most of the magnates of heavy industry and bankers with a stake in heavy industry backed the Nazis by the summer of 1930 and enabled it to win the electoral victory of September 1930, see D. Guerin, *Fascism and Big Business*, New York, second edition, 1973.

15. B. Taylor, *The Nazification of Art*, p. 143.

Modernism we think we know and understand'.[16] Again we see here a tendency to make rather superficial comparisons without really investigating the precise material situation in which events take place, thereby equating the Nazis' physical destruction of Modernist painting and sculpture with Post-Modernism of the 1980s and 1990s.

One strand among the arguments put forward by contemporary Post-Modernist theory is the idea of destroying totalising 'master' narratives of Modernism. But how then can this be seen as similar to Nazi culture, which physically liquidated culture which did not fit into its own view of Aryan cultural development? This is hardly comparable to contemporary theoretical critiques of Modernist theory or rejections of non-figurative art. In any case Nazi feminists attempted to argue for a 'matriarchal narrative' of Aryan history, as we shall see later, in opposition to attempts to exclude them from positions of political leadership in the party. It is hardly surprising that we can detect such aspects of Modernism as innovation, change and technological development in the Third Reich, which we would expect from a capitalist economy on a war footing in any case. Engineers as a group were heavily represented in the Nazi Party, and Goebbels argued that only National Socialism was able to infuse the 'soulless framework of technology . . . with the rhythm and hot impulses of our time'.[17]

Thus Taylor and van der Will argue against a Marxist analysis of Nazi culture in favour of Nazi culture as an example of Post-Modernism, which explains neither why nor how Nazi culture developed. It is historically flawed, in any case, since there were many examples of naturalistic painting produced during the 1920s in Germany, notably the works described as examples of Neue Sachlichkeit; so why are these not put forward as examples of Post-Modernism rather than the Nazi material?

Indeed this is argued by Benjamin Buchloh in his influential article 'Figures of Authority, Cipers of Regression', where he argues:

> It would certainly appear that the attitudes of the Neue Sachlichkeit and Pittura Metafisica [in Italy] cleared the way for a final takeover by such outright authoritarian styles of representation as Fascist painting in Germany and Italy and socialist realism in Stalinist Russia.

Buchloh argues that 'Marxism through its reflection model, with its historical determinism absolves artists from their responsibilities as sociopolitical individuals' and does not adequately explain the relationship 'between protofascism and reactionary art practices'. Now Buchloh is

16. Ibid., p. 142.
17. Speech of 1939 quoted in J. Herf, *Reactionary Modernism. Technology, Culture and Politics in Weimar and the Third Reich*, 1987, p. 196.

mistaken here in claiming that Marxism believes that people are simply moulded by their economic and material circumstances (how would they ever change them in a revolution?), and he offers rather inadequate alternatives by simply comparing representational paintings from a variety of countries and historical periods, on a purely formalistic basis, as examples of authoritarian art. For Buchloh, the relationship of culture and economics all boils down to a generalised parallel between representational/non-representational art and booms/slumps in the economy:

> It should not be forgotten that the collapse of the modernist paradigm is as much a cyclical phenomenon in the history of twentieth-century art as is the crisis of capitalist economics in twentieth-century political history.[18]

There is also a contradiction in Buchloh's argument for, in agreeing with Carol Duncan's analysis of early twentieth-century German Expressionism, he writes: 'In as much as this sexual and artistic role is itself reified, *peinture* – the fetishized mode of artistic production – can assume the function of an aesthetic equivalent and provide a corresponding cultural identification for the viewer.'[19] According to this view the actual material nature of the paint and its application embody the role of the male creator, his sexuality and his virility in early Modernist art. However, since much representational work in Germany in the 1920s and 1930s rejects Modernist *peinture*, can this not be seen as potentially less codified as male creativity, and therefore less oppressive of women? But Buchloh argues, on the contrary, that a return to sharply defined figuration was a forerunner of repressive totalitarian culture. Basically Buchloh takes formal and stylistic factors out of their specific material contexts, compares them with apparently formally similar phenomena and draws over-generalised conclusions. None of these methods are particularly useful in analysing the depiction of women in figurative art from 1920s and 1930s Germany.

There is one author, however, who attempts to analyse representations of women by Nazi men using psychoanalytical theory. I will make some comments on this book as I believe it raises some particularly worrying issues. In his first volume of *Male Fantasies*, Klaus Theweleit sets out to analyse representations and descriptions of women in relation to the 'fantasies' of members of the Freicorps who became the core of Hitler's SA. Theweleit argues that Freudian theory cannot explain the attitudes of these men, as they do not 'repress' their desires for violence and murder.

18. B.H.D. Buchloh, 'Figures of Authority, Ciphers of Regression, Notes on the Return of Representation in European Painting', *October*, 16, Spring 1981, pp. 84, 85.

19. Ibid., p. 110.

He argues that the egos of the Freicorps men were defective and unformed and therefore did not repress their fantasies. The ceaseless motion of 'desiring production' drives the fascist male to kill and mutilate. Theweleit writes: 'What fascism promised men was the reintegration of their hostile components [female interior and male exterior] under tolerable conditions, dominance of the hostile 'female' element within themselves . . . When a fascist male went into combat against erotic, "flowing", nonsubjugated women, he was also fighting his own unconscious, his own desiring-production.'[20] Theweleit's argument continues:

> fascism is not a matter of form of government, or form of economy, or of a system in any sense . . . We need to understand and combat fascism not because so many fell victim to it, nor because it stands in the way of the triumph of socialism, not even because it might 'return again', but primarily because as a form of reality production that is constantly present and possible under determinate conditions, *it can, and does, become our production. The crudest examples of this are to be seen in the relations that have been the focus of this first chapter, male-female relations, which are also relations of production.* Under certain conditions, this particular relation of production yields *fascist* reality; it creates life-destroying structures.[21]

So, if I understand this correctly, fascism is a form of 'reality production' which at certain times produces certain forms of male-female relations, which are also relations of production. This rather circular form of idealist argument specifically sets out to remove the study of fascism from any material basis and muddies the waters even further by using Marxist terminology in a completely un-Marxist way. Are we supposed to accept that 'fascist reality' is ultimately the result of male-female relations of production in particular circumstances? Apparently so.

Barbara Ehrenreich, in her Introduction to the book, defends Theweleit's thesis and his refusal to draw a line between the fantasies of the Freikorpsmen and the psychic ramblings of the 'normal' man. Ehrenreich also dismisses Marxist theories of fascism which she says see fascism 'as the inevitable outcome' of capitalist development. She also refers to 'the stock Marxist theories' which 'obliterate the human agency in fascism'.[22] She cites no examples of any writings by Marxists to support this, and once again Marxism is swept aside as a means of understanding history, to be replaced by a very dangerous and unmaterialist method. Theweleit does not explain, for example, whether these men were destined to become fascists from an early age as soon as their egos did not form

20. K. Theweleit, *Male Fantasies*, vol. 1, *Women, Floods, Bodies, History*, Oxford, 1987, p. 434.
21. Ibid., p. 220–1.
22. Ibid., p. xi.

properly, nor, it seems to me, could it explain why women could become Nazis. As Frevert points out, some 3,500 women were trained as SS guards in the women's concentration camp at Ravensbrück and assigned to the women's sections of other camps. Attracted by adverts promising high wages and promotion, 'They acted no differently from their male colleagues, torturing and abusing women prisoners, crushing babies against walls, and killing children while their mothers were forced to look on. They selected suitable women for work and for medical experiments, and sent the rest to the gas chambers.'[23]

How, then, are we to address the meaning of fascism, its relation to capitalism, and its relation to women's role in society and culture? How did the rise of fascism affect women and why did so many women support the Nazis? To answer these questions we first need to consider the period prior to the Nazi seizure of power in 1933.

By 1917 the number of working women in Germany had risen to 15 million from appproximately 9.5 million before the war.[24] However these workers experienced drastic reductions in protective legislation. According to Thönnessen, the Council of People's Deputies (November–February 1919) and the later National Assembly passed measures which gave men their old jobs back after the war. Women were badly hit by this. The National Assembly passed decrees of 28 March 1919 and 25 January 1920 which stipulated that people were to be dismissed in the following order of priority:

1. Women whose husbands were employed.
2. Single women and girls.
3. Women and girls who had only 1–2 people to look after.
4. All other women and girls.[25]

This was probably intended to head off revolutionary activity on the part of demobbed soldiers returning home. Within two months in early 1919 women's employment was back to March 1914 levels. Women got the vote at the end of 1918 and many voted for the social democrats, the SPD, showing that women were not inherently conservative, as many had argued before women's suffrage was won. However women's vote for the SPD declined in subsequent elections.[26]

By 1925 the figure for women employed in agriculture had fallen to

23. U. Frevert, *Women in German History: From Bourgeois Emancipation to Sexual Liberation*, Oxford, Hamburg and New York, 1989, pp. 249–50.

24. W. Thönnessen, *The Emancipation of Women. The Rise and Decline of the Women's Movement in German Social Democracy 1863–1933*, London, 1976, p. 84.

25. Ibid., p. 91.

26. Ibid., p. 114.

55 per cent of all employed women and more women were active in industry, crafts and services by this date. By 1925 there were almost 1.5 million women clerical workers. Almost all these women were single and two-thirds were under twenty-five.[27] This was the material basis of the 'new woman', 'modern' with short hair, cigarettes and political rights, 'traditional' in that their 'female' jobs were low-paid. According to the Union of Female Retail and Office Staff, almost half its members under twenty-five earned a maximum of 100 Reichsmarks per month which, after insurance deductions, left them below the poverty line. This youthful 'independence' was seen as an interlude on the way to marriage.[28]

The psychologist Alice Rühle-Gerstel wrote in 1932:

> These jobs are dubious: as semi-pure as the silk in the stockings and skimpy tops worn by shop girls, and as mixed up as their minds . . . Economic situation: proletarian; ideology: bourgeois; type of occupation: male; attitude to work: female. Beaming figures, casting a light that is sparkling and attractive, and yet which highlights their very ambiguities; but in any case figures iridescently confident of their social and spiritual existence.[29]

Women's wages were generally lower than men's for similar work and many women would have given up work if they had been financially able to. As economic crises worsened, conservative and right-wing campaigners increased their efforts to have women from 'double-earning' families sacked. The Reich government in 1932 passed a law under which the civil service was legally bound to dismiss married female employees.[30]

However even the SPD had a pretty 'conservative' notion of women's role in society, especially since the more radical members had split off from the party. At the SPD's National Womens Conference in 1921 Frau Dr Schöfer said: 'Woman is the born guardian and protectress of human life; that is why social work must seem so very appropriate to her. By allocating to women the task of guarding over human life we simultaneously provide a positive answer to the question whether women have a task in politics at all.'[31]

The policies of the Nazis on these issues were similar but more forceful and imposed by terror, in many instances. One of their methods for raising the male employment figures was to sack women and young men. A decree of 28 August 1934 gave labour offices full power to dismiss women and men under twenty-five. Employers would then hire older men and pay

27. Frevert, p. 179.
28. Ibid., p. 183.
29. Ibid., p. 178.
30. Ibid., pp. 197–8.
31. Thönnessen, p. 136.

them the same low wages as their predecessors.[32] Presumably this also left young men free to spend more time in fascist youth organisations and become potential members of the armed forces.

However the Nazis' extreme form of nationalism can be seen to have roots in the right-wing nationalism of pre-1933 Germany. It was not something alien to 'democracy' or even particularly 'masculine' in essence. To demonstrate this, I will look briefly at the nationalist policies on sexuality and reproduction put forward by sections of the BDF (Bund Deutscher Frauen). R.J. Evans has traced the rightward-moving trajectory of this organisation from 1908 onwards. In the general assembly of the BDF in 1908, speakers opposed the legalisation of abortion, as Germany needed people 'to populate the colonies we have, and the colonies we still have to conquer'. In any case, it was argued, only the laziest and stupidest women would fail to utilise abortion rights and the German race would degenerate. However abortion should be allowed if 'the mother or father was idiotic, alcoholic, syphilitic, crippled, epileptic or tubercular'. As Evans points out, these views were moving from the 'lunatic fringe' to the mainstream of German feminist politics.[33] Some argued that everyone should have a medical examination before marriage. In 1911 Else Lüders, arguing for women's suffrage, claimed that only women would ensure that racial hygiene was discussed in parliament. Her article in a suffragist magazine in 1912 argued that women were bound to oppose racially mixed marriages, since they were bearers of the next generation. In the same year Adele Schreiber argued that drinkers should be sterilised.[34]

After 1919 the BDF stressed that it would unite German women across party and creed to 'express their national identity, safeguard social health, morality and family life'. Men and women should develop socially 'according to their nature and qualities'. The BDF campaigned against immorality (including adverts for contraceptives) and were active in condemning films and other forms of culture which did not meet with their approval.

The Union for German Women's Culture wanted specifically 'German' clothing (not Paris fashion). The German-colonial Women's League wanted to prevent racially mixed marriages in the colonies and its membership rose from 18,000 in 1919 to 20,000 in 1931, although Germany no longer had any colonies for them to work in.[35]

Under the leadership of professional middle-class women, the BDF grew to encompass the 'urban' housewives union with 200,000 members

32. Guerin, p. 196.
33. R.J. Evans, *The Feminist Movement in Germany 1894–1933*, London and Beverley Hills, 1976, p. 159.
34. Ibid., p. 167.
35. Ibid., p. 239.

by 1931. The second largest group was the liberal white-collar association with 100,492 members, and thirdly the 'rural' housewives union with about 90,000 members.[36] Its politics were increasingly right-wing and represented largely middle-class interests, according to Evans, who estimates that many BDF members voted for the Nazis. However more younger women joined the Nazi women's groups than the BDF, which was seen by them as rather dull. Evans writes 'The women's movement could do nothing but extend a warm welcome to Adolf Hitler and the Third Reich' because large sections of its middle-class members had been arguing along similar lines for years prior to the Nazis taking over the BDF. Evans quotes the programme of the Women's Teachers' Association, which had close links with the BDF, from 1921 to make his point:

> The German school must co-operate in the preservation and strengthening of the community of German people (*Volksgemeinschaft*). It must bring up young people to have a strong character, a moral, religious and consciously German personality . . . To the preservation of the national and cultural unity of the school system as a whole, must be added for girls' schools the necessity of educating young girls to a deeper conception of the nature and value of womanhood, and of women's duties and responsibilities to the family and the *Volk*.[37]

It can be seen, therefore, that many women were likely to actively embrace Nazi policies or tolerate them, and in fact they did. Evans points out that professional, middle-class women did very well out of the economic and social situation of the later 1930s, and anyway the Nazis' public pronouncements on women and employment, for example, eventually came into conflict with the needs of a war economy.[38]

During the Weimar Republic, the state was anxious to raise the birth rate and impose a view of sexuality geared to reproduction and family life. In the Weimar Republic there were penalties against abortion, sterilisation and advertisement of contraception. Large numbers of illegal abortions resulted in many cases in serious injury and death. Estimated numbers of illegal abortions rose from 5,000 in 1923 to around 1 million in 1928, with 4,000 female deaths.[39] While the Communist Party (KPD) were the only party asking for free state provision of contraceptive facilities, as a right for all, advocates of racial hygiene advocated access to birth control to curb numbers of the 'insane', 'epileptics' and 'alcoholics'; for example

36. Ibid., p. 241.
37. Ibid., pp. 258–9.
38. Ibid., p. 263.
39. C. Usborne, *The Politics of the Body in Weimar Germany*, Basingstoke, 1992, p. 102.

the trade union leader Paul Levy in a conference speech of 1928.[40] Quite a number of 'eugenic' sterilisations already took place in the Weimar Republic, and Usborne points out this was not an unusual procedure in 'democratic' countries, e.g. the frequent sterilisation of male criminals in the 1920s in the USA.[41]

The abortion laws were amended in May 1926. Article 218 commuted penal servitude to simple imprisonment for women who had had abortions and for their accomplices. For anyone performing commercial abortions the sentence was increased to fifteen years in prison with the same penalty for selling abortifacients. The maximum sentence for the woman was one day in prison instead of the previous six months minimum.[42]

The Church also emphasised procreative sex and 'family' morality. The 1930 Papal Encyclical *On Christian Marriage* equated abortion with murder and prohibited birth control as a crime against God and nature.[43] Consequently it is no surprise to see that in another Encyclical of 1931 the Catholic Church demanded an end to the employment of married women.[44]

However many women and men campaigned against the laws restricting abortion rights through meetings, demonstrations, educational and propaganda activities. For example the publisher Münzenberg's journal *Weg der Frau* (*Woman's Way*) sponsored a huge art exhibition in Berlin in October 1931 called *Women in Need*. Works attacking paragraph 218 (and 219) were exhibited to draw attention to the 'fate of woman as mother, worker, unemployed worker and victim of outdated morality'. One of the works by Alice Lex-Nerlinger was seized by police and confiscated.[45] Käthe Kollwitz also produced works on this topic.[46]

Hanna Nagel's *The Paragraph*, 1931 (plate 37), tries to give visual form to the complexities of the issues of abortion, motherhood and class. The standing pregnant figure wears a working overall and the woman on the bed is also dressed very simply. The image is predominantly black and

40. Ibid., p. 138.
41. Ibid., p. 150.
42. Ibid., p. 197.
43. Frevert, p. 187.
44. J. Stephenson, *Women in Nazi Society*, London, 1975, p. 27.
45. See the very useful article by A. Grossmann, 'Abortion and Economic Crisis: the 1931 Campaign against paragraph 218', in R. Bridenthal, A. Grossmann and M. Kaplan (eds), *When Biology Became Destiny. Women in Weimar and Nazi Germany*, New York, 1984. Lex-Nerlinger's poster is illustrated in this book and is now in the Märkisches Museum, Berlin. A group of proletarian women push over a huge cross marked 'paragraph 218'.
46. See M. Meskimmon's essay, in *Domesticity and Dissent. The Role of Women Artists in Germany 1918–1938*, exhibition catalogue, Leicestershire Museums, Arts and Records Service, Leicester, 1992, p. 29. This catalogue is a very useful and accessible introduction to the work of women artists at this time and includes illustrations of little-known works.

white with connotations of poverty, 'social realism' and seriousness. Only the paragraph 218 letters are in red, and the water-colour paint runs down from the two like blood. Danger and pain are here for the women. The head of the child is placed over the womb of the standing figure and is related by its position to the developing foetus. The potential child in the woman is a source of new life but at the same time of potential misery and drudgery for the impoverished and tired mother. Similarly complex is the figure of the woman lying on the bed. Her position could imply labour or, more likely, the pain and risk of a dangerous illegal abortion. Is the standing woman simply a friend who helped the lying figure abort herself or an older version of the same woman, implying that the situation has not changed for generations of women, and the time of suffering and poverty must end? Where the image is particularly successful is in its representation of the issues of abortion and maternity as complex and sometimes contradictory. The tenderness of the mother for her child is here, as well as the decision to undergo pain and trauma in the termination of pregnancy. It is a very effective image in countering the arguments of pro-life anti-abortionists who, even today, imply that women thoughtlessly and selfishly seek abortions for the most frivolous of reasons. The mental and physical pain represented by Nagel is seen as something that women should not have to experience. Legal safe abortion and access to proper contraceptive facilities would have prevented suffering and maternal deaths in Weimar Germany, as campaigners argued at the time.

However under the Nazis the state control of fertility, for men and women, became even more strenuously enforced. Nazi Germany wanted economic self-sufficiency. The Nazi state supervised banks and foreign trade. Its state capitalist policies also entailed an extremely nationalist and racist attitude to reproduction. In this sense it does show similarities with the Stalinist state in the later 1930s, where the programme of 'socialism in one country' meant 'managing' the production of human resources as part of a state plan based on nationalism, not internationalism. Also Russian chauvinism meant that sections of the bureaucracy wanted the birth of more Russians and the decrease of the birth rate in the Muslim republics. Instead of taking the view that the world had enough resources to feed its population on an international scale if world revolutions destroyed the operation of the law of value in food production, the Stalinists of the Soviet Union (and later in China) coerced the population into producing more (or less) children as required. In Nazi Germany abortions were completely prohibited in 1933 (previously a very few had been available to rape victims, bearers of unhealthy foetuses, etc.), and along with this legislation eugenic sterilisation was legalised and voluntary sterilisation prohibited. However these laws were applied on a class and race basis. Men and women with undesirable racial, intellectual and social capabilities were

sterilised. Between 1934 and 1937 about 80 men and 400 women died in the course of the operation. Later mass sterilisations were carried out by X-ray in concentration camps. A medical student observed in 1936 that some of the poor women were 'morally so inferior, that they welcomed sterilisation . . . Many said bitterly "that children only cost money; only the rich can afford them"'.[47]

Homosexuals and patients in mental institutions were sterilised and later murdered in camps. The mass sterilisations in the camps were carried out on Jewish women and gypsy men and women. Bock points out: 'Among women, the good housewife and industrious mother could be sure to evade sterilisation. Unwed and poor mothers with "too many" children, women on welfare, and prostitutes could not be so sure.'[48]

Thus it is not the case that Nazi Germany was simply an example of extreme patriarchal oppression of women by men, where 'women' were forced to become breeders. Only the right kind of class and racial background qualified men and women to reproduce. Otherwise undesirables of both sexes could expect forced sterilisation and ultimately death after their labour capacity had been exhausted in the camps. This latter fate befell Elfriede Lohse-Wächtler (1899–1940). Lohse-Wächtler was a radical, politically-minded woman who attended Communist Spartakusbund meetings, dressed in 'masculine' clothing, cut her hair short and smoked in the street. Her marriage of 1921 was breaking down in the later 1920s after her husband managed to ruin her financially. She had a nervous breakdown in 1929. They finally broke up in 1931. Lohse-Wächtler then went to live with a group of gypsies. She was designated as a 'degenerate' by the Nazis and placed in an institution where she painted intensively. She was gassed in a concentration camp in 1940. Much of her work is lost unfortunately. Her pastel *A Flower* (plate 38), which is probably a self-portrait, shows her as partially trapped and merged into a male figure, but she looks outwards to the viewer and holds out a flower, as if to suggest her interests and physical identity are not merged with those of the male figure who looks off in a different direction while keeping his hand on her body. While her breasts look vulnerable and soft, her face is strongly formed and her gaze thoughtful, if unfocussed.[49]

Lohse-Wächtler's case is typical of the treatment of women artists by the Nazis, not in so far as she was murdered but because her designation as 'degenerate' was not based on the fact that she was female. In theory, the Nazis had no objection to women artists as women. They objected to

47. See G. Bock, 'Racism and Sexism in Nazi Germany: Motherhood, Compulsory Sterilization, and the State', in *When Biology was Destiny*, p. 280.

48. Ibid., p. 287.

49. The entry on Lohse-Wächtler in U. Evers, *Deutsche Künstlerinnen des 20 Jahrhunderts. Malerei, Bildhauerei, Tapisserie*, Hamburg, 1983, pp. 209–10.

their work utilising criteria of race, politics and artistic judgements based on what constituted 'German' culture. As we shall see, women artists found it easy enough to produce such German art along with the admittedly more numerous male painters and sculptors encouraged by the Third Reich.

While the Nazis encouraged an art which appealed to the petty-bourgeois tastes of their mass base, rejecting Modernism as Bolshevik, Jewish and un-Aryan, large numbers of artists were prohibited from teaching and exhibiting their work.

Middle-class women largely benefited under the Nazi state. As Frevert points out: 'They ran the courses, attended mainly by young factory and office workers, guiding them how to be "proper" mothers and housekeepers, while in their own homes a servant girl would tidy up, do the cleaning and prepare meals.'[50] The Nazis had tried to cut women's (and younger men's) jobs to ensure more adult male employment, but by the end of the war they wanted women to take up factory jobs. Most middle-class women refused, and avoided going to work in spite of coercive measures. Meanwhile German proletarian women, Polish and Jewish women were submitted to exhausting work régimes at the factory conveyor belt. However 'German women, at least, had to be worn down slowly enough to carry them beyond the childbearing years' so that they might produce some racially acceptable children before their bodies were totally ruined.[51]

Nazi art sought to represent ideal racially pure male and female forms. According to Paul Schultze-Naumburg's *Nordic Beauty*, of 1937, 'race has a much stronger influence on physique as it "imprints" the race's ideal on the Nordic female as much as the male'.[52] While leading Nazis wanted to exclude women from participation in the higher levels of the party, Nazi feminists argued for the right to work and fight alongside their male comrades. Referring to ancient Nordic myths and the work of Bachhofen on 'mother-right' in early societies, they argued that the earliest societies had been matriarchies. The Jews had corrupted modern society, they said, and therefore 'the woman question' could only be solved 'in the Germanic spirit' in an anti-Semitic, National Socialist state.[53]

The League of German Girls fostered an image to replace that of the

50. Frevert, p. 234.

51. See the excellent article by Annemarie Tröger, 'The Creation of a Female Assemblyline Proletariat', in *When Biology was Destiny*, p. 249. By 1944 there were 32,000 day nurseries catering for 1,200,000 children as the Nazis tried to increase the number of German women workers in the war economy: L.J. Rupp, *Mobilizing Women for War. German and American Propaganda, 1939–1945*, Princeton, New Jersey, 1978, p. 171.

52. Quoted by Annie Richardson, 'The Nazification of Women in Art', in *The Nazification of Art*, p. 66.

53. L.J. Rupp, *Mobilizing Women for War. German and American Propaganda, 1939–1945*, pp. 19–21.

'new woman' of the Weimar Republic. It was a Nazi organisation for young, healthy, dynamic women who had little interest in the older women's organisations. Their 'German' identity was to take precedence (supposedly) over class and politics. They were no longer slaves to French 'fashion' but wore plain clothing, 'Nordic' plaited hair and no make-up. Styles of bodily shape accentuated by tailored clothing which changed with the whims of the modern fashion industry would be replaced by 'timeless' body structures of Aryan womanhood.[54] The clarity of expression of this form in art was 'the sign and proof of its Germanness'.[55]

There was some discussion, however, as to what visual mode of representation would best suit the Nazi political and artistic programme. In a very useful article Christine Fischer-Defoy shows how in the early and mid-1930s sections of the Nazi organisations argued for Expressionism or Neue Sachlichkeit as the basis of a truly German art. The issue was not decided until the 1937 so-called Degenerate Art Exhibition and its counterpart, the Great German Art Exhibition. The issue of visual art and political positions is an important one, and much misunderstood. Buchloh argues that 'the attitudes of Neue Sachlichkeit cleared the way for a final takeover by outright authoritarian styles of representation'. Now it is debatable whether artistic modes of representation in themselves can clear the way for what follows, and in any case Neue Sachlichkeit had exponents who joined the Nazis and many who did not. It was economic and political forces which primarily influenced the emergence of the final definition of German art, not primarily the visual art practices which preceded 1937. Fischer-Defoy cites the interesting example of Georg Schrimpf, an artist who had joined the German Communist Party in 1919, left in 1926 and later was appointed by the Nazis to a teaching position in 1933. Schrimpf's past made him suspect however and he was dismissed in 1937 although defended by the Nazi student leader at his college. Interestingly, his work was held by Nazi sympathisers to express through Neue Sachlichkeit 'a truly German visual approach as opposed to the imported Impressionism of France, Germany's "hereditary enemy"'. The critic Richard Brie found in Neue Sachlichkeit's 'timeless' tendency (as opposed to the socially critical tendency) 'true breeding', 'commitment to discipline and loyalty', 'masculine clarity', order, simplicity and craft. Brie saw parallels with the exemplary craftmanship of Dürer.[56]

German naturalism of the 1920s, which is slightly different from, but related to, Neue Sachlichkeit, also had exponents who later modified their

54. Frevert, p. 211.
55. Richardson, *Nazification of Art*, p. 68.
56. C. Fischer-Defoy, 'Artists and Art Institutions in Germany 1933–1945', in *The Oxford Art Journal*, 9, 2, 1986, p. 21, reprinted in Taylor and van der Will (eds), *The Nazification of Art*, pp. 89–110.

work in order to accommodate the need to produce 'great German art' for the Nazis, for example, Constantin Gerhardinger.[57] However it is far too generalised a statement on Buchloh's part to see representational art and an interest in 'old masters' as *necessarily* regressive and akin to the politics of totalitarianism, as I hope to show with reference to the work of the painter Lotte Laserstein.

Laserstein (1898–1993) worked as an artist and teacher in Germany until she decided she would have to leave Nazi Germany for good in 1937. As she was one-quarter Jewish she was subjected to various harassments by the state. Her mother's apartment, where she worked, was impounded, her collection of Toulouse-Lautrec posters was seized, her studio was closed in 1935 and she found it very difficult to obtain materials for her work. Her mother, who was not Jewish at all, was eventually murdered in Ravensbruck because she had helped Lotte's sister Käte to hide from the Nazis.[58] Laserstein had to supplement the family income by, for example, illustrating a massive anatomy textbook, and this may have partly accounted for her accomplished grasp of the structures of the nude, in her case the female nude in particular. Laserstein's work is figurative and refers back to German artists of the nineteenth century and the Renaissance. However I do not think that we can read this as necessarily regressive, and Buchloh's argument seems to indicate to me a lingering desire to dismiss figurative art as intrinsically inferior to non-figurative Modernism, which he implies is radical by its very nature.

At any rate, Laserstein's *Self-portrait with cat*, 1925 (plate 39), shows a format very typical of Renaissance portraiture (e.g. Holbein's work) and moreover is executed on wood panel.[59] While this was not completely uncommon at the time it does suggest a conscious attempt by Laserstein to refer back to the 'Old Masters' of German Renaissance art, perhaps by inserting herself into this tradition as a modern 'old mistress'. Laserstein's technique is very accomplished and the freshness of execution and clarity of form and texture in her work really is impressive. This work was in fact exhibited with *Head of a Mongolian* and *Artist and Model in the Studio, Berlin, Wilmersdorf*, 1928 (plate 40), in the 1937 Paris World's Fair, but her works were not allowed in the German pavilion due to her racial

57. See E. Züchner's essay, in the exhibition catalogue, *Profession ohne Tradition. 125 Jahre Verein der Berliner Künstlerinnen*, Berlinische Galerie, Museum für Moderne Kunst, Berlin, 1992, p. 263.

58. See C. Stroude and A. Stroude, 'Lotte Laserstein and the German Naturalist Tradition', *Women's Art Journal*, 1988, vol. 19, part 1, pp. 35–8, and the essay 'Lotte Laserstein und Charlotte Salomon: Zwei künstlerische Entwicklungen unter den Bedingungen der NS-Zeit', in *Profession ohne Tradition*, exhibition catalogue, pp. 151–8.

59. Actually quite a number of works by women artists in the exhibition *Domesticity and Dissent* were done on small panels, and this may have been partly motivated by financial considerations as well as aesthetic ones.

'impurity' and were hung in the general pavilion.

So what do Laserstein works mean? Are they figurative and 'regressive' as Buchloh might argue, and would they be compatible with Nazi definitions of great German art if only Laserstein had not been one-quarter Jewish? Her work raises some quite complex issues for which there is really no single answer.

Friedrich Rote, in his essay on Laserstein and Charlotte Salomon, develops an interesting comparison between Laserstein's *Artist and Model* and Dürer's woodcut illustration for his treatise made to instruct artists in perspective (plate 41). Rote argues that Laserstein's painting does not display the woman's body as an object of desire, and compares this to the Dürer print where the male artist representing scientific knowledge has the power and skill to control unruly nature, as embodied by the naked female model with her dishevelled drapery. The rather messy pose of the model is brought under control and disciplined by the optical framework invented and manipulated by the male. This teaching aid also teaches the relative positions of model and artist. Rote describes how Laserstein depicts herself painting in her overall, like a surgeon, detached from the model as a doctor would be when operating on the naked body of a female patient. Hence desire is neutralised as Laserstein carries out a profession, apparently with detachment, not sensuous feeling for the model's body.

In her book *The Artists Model*, Frances Borzello demonstrates not only the assumptions by sections of society that artists' models prostituted themselves with artists, but how in many cases male artists did expect and pay for sexual intercourse with their female models.[60] But is this assumed relationship perhaps part of the meaning of Laserstein's work? She is fully clothed with short hair and her body displays no obvious signs of femininity. The model, Traute, has quite an androgynous look with a thickish waist and is posed in a way which flattens out her breasts and makes the top part of her body, neck and face look quite sexually indistinct in terms of male or female. We are only offered the area of the model's crotch as a way of deciding on a single gender identity. Artists seduce their models, but does Laserstein? While she paints herself detached from the model, fictionally painting her from behind, really we know that she has displayed Traute's body in all its glory in a golden light seen from the front at the same time as she paints herself in the background. The viewer's gaze comes right into the painting over the model's body, so I think it is hard to argue that desire is not an issue here. But is it a representation of a desire that needs to be articulated in ways which mean changing the relationship of male/female, artist/model? And what is the role of the spectator in all this?

60. F. Borzello, *The Artists Model*, London, 1982.

We know that the work was exhibited and that even in 1937 the City of Berlin made her an offer of 2,500 marks for the work, which she rejected as her dealer had told her to hold out for 4,000. The painting might well have been seen as a contemporary addition to the tradition of German naturalism but I do suspect there are a number of aspects of Laserstein's works which really cannot be defined as simply regressively representational, as Buchloh reads the ideological implications of figurative art in the 1920s.

With the *Degenerate Art* exhibition and the corresponding *Great German Art* exhibition, both of which opened in Munich in 1937, the Nazi leadership finally decided upon a policy of how fine-art works were ideally supposed to represent a vision of life under the thousand-year Reich. According to an interview given by a Munich painter, Frau Troost, the wife of the famous architect, assembled a group of 'moderate' Modernist works, to which Hitler violently objected. Even this middle-of-the-road Modernism was to be rejected in the Great German art exhibitions.[61]

The *Degenerate Art* exhibition was well attended, and recently discovered film shows that many women were among the visitors. Most appear well dressed and middle class (or lower middle class), holding their handbags carefully and wearing hats and coats indoors as they go round the exhibition. It is worth looking at the *Degenerate Art* exhibition and the question of women to see if there is any attempt by the Nazis to denigrate works because they were done by women, or particularly attack the whole idea of the woman as artist. As far as I can see this was not done. However the issue of women and their representation is mentioned, as we shall see.

The Nazis seized around 16,000 works from the collections of German museums and selected about 600 of them to display as 'degenerate' and a waste of tax-payers' money. Included in the exhibition were works by Nolde, a German Expressionist Nazi Party member, and the sculptors Barlach and Lehmbruck. Annie Richardson has shown from a study of the memoirs of a young Nazi woman that in fact this Nazi had been brought up to admire 'moderate modernism' by her wealthy right-wing parents, and felt 'bored thoroughly' by the works in the *Great German Art* exhibition. This young woman, Melita Maschmann, deplored 'the scandalous lack of taste' in most of the anti-Jewish propaganda and points

61. British television Channel 4 programme, *Without Walls, 'Good Morning Mr. Hitler!'*, 1993. This programme also has interviews with women who took part in the 1939 three-day cultural event accompanying the *Great German Art* show of that year. Towards the end of the programme there is also an interesting piece of film showing female art students studying from the male nude model. For the footage taken at the Degenerate Art exhibition see the programme made by British TV's BBC 2, *Entartete Kunst*, for the *Late Show*, 1992.

out that the female youth movement leaders (like her) were a cultural élite who were able to discern 'good art' from 'propaganda'.[62] Richardson raises a number of very worthwhile points about the female spectator of Nazi art, to which I will return shortly.

The *Degenerate Art* exhibition included only four women artists' works: Emy Röder's sculpture of a pregnant woman, 1919 (plate 42); Maria Caspar-Filser's *Landscape*, 1932; an Expressionist print by Jacoba van Heemskerck; and a brass statue of a woman dancer by Margarethe Moll.[63] Many other women artists' works were declared 'degenerate' but were not on show. Partly this was due to the fact that less women's work had been purchased for large sums by museum curators, and therefore could not be used so effectively as anti-Modernist propaganda. However in the sale of 'degenerate' art in June 1939 in Lucerne the Nazis included Modersohn-Becker's *Self-Portrait with an Amber Necklace*, 1906, which had been in the Kestner Museum, Hannover (now in Bremen), and Marie Laurencin's *Portrait of a Girl*, 1913–14, which had been confiscated from the City Museum, Ulm, and is now in the Musée des Beaux-Arts, Liège.

The 'guide' to the *Degenerate Art* show does not condemn women's art *per se*, for various references to women, sexuality and morality make it clear that the Nazis and their supporters wanted to see a particular sort of woman represented in ways acceptable to them as male and female Nazis. The term 'abortion' is interestingly used twice in the 'guide' to denigrate modern art works. Firstly on page six, in a quotation from a speech by Hitler from 1933 where he states, 'Of course, the more stupid a thing made from stone and materials, the more likely it is to be something really new, because earlier ages did not allow every fool to insult his contemporaries with the abortions of his sick brain'. Then on page twenty-seven (plate 43), in a technique frequently used by Nazi art critics (or 'reporters' as they were renamed), a work by a Modernist artist Eugen Hoffmann is juxtaposed with an art work done by a psychiatric patient, and Hoffmann's sculpture is described as an 'abortion'. Obviously, in view of the Nazi state's policies on abortion and sterilisation, an abortion must, by definition, describe something inferior and degenerate, since the foetuses carried by Aryan women were all supposed to be carried to full term.

On page fourteen the subject-matter of 'degenerate' art is condemned

62. Annie Richardson in *The Nazification of Art*, pp. 60–1.

63. The most up-to-date visual material and documentation on the *Degenerate Art* exhibition is in S. Barron (ed.), *'Degenerate Art'. The Fate of the Avant-Garde in Nazi Germany'*, Los Angeles County Museum of Art, Harry N. Abrams, New York, 1991. Some artists had works in both the *Degenerate Art* exhibition and the *Great German Art* exhibition of 1937 which suggests that there was still some confusion as to what absolutely decided 'degeneracy' in a few cases.

for the fact that 'the harlot is held up as an ideal in contrast to woman in bourgeois society' and the world is portrayed as a brothel peopled by harlots and pimps. 'Among these works of painted and drawn pornography there are some that can no longer be displayed, even in the 'Degenerate Art' exhibition, in view of the fact that women will be among the visitors.'[64] Presumably this means there were no women on the selection committee. Instead of 'a glorious and beautiful type of human being', as seen at the Olympic Games in 1936, modern art shows us only 'misshapen cripples and cretins, women who can arouse only revulsion . . .', such as the wooden sculpture by Christoph Voll, *Pregnant Woman*, which is reproduced on page nineteen.

Page seventeen (plate 44) illustrates some Modernist representations of prostitutes along with a quote from the artistically radical magazine *Die Aktion*, 1921, in which the 'Bolshevik Jewess' Rosa Luxemburg comments on the theme of prostitution in Russian literature, where the prostitute is shown as a heroic figure rising above the corruption that capitalist society has forced on her.

Although not specifically mentioned in the guide certain more problematic representations of female nudes were included in the *Degenerate Art* show, including Otto Dix's etching from the 1922 series *Death and Resurrection* where a horribly mutilated dead woman in underwear is shown lying on a bed with her legs wide apart (plate 45). It is possible, I think, that such images of violent sex-murders raise questions about the motives of the artists, who are usually said to be sympathetic to the plight of women forced into prostitution and thereby at risk of becoming murder victims at the hands of their clients. Dix, Beckmann and Grosz are all said to be commenting on the evils of capitalism by showing naked women as victims but Dix also appears to have had private sexual motives for executing such subjects. For example a water-colour by him showing a naked woman with her throat cut lying on the floor of a room with her legs entangled in bedclothes is dedicated to his wife on her birthday.[65] It is possible to see why some female spectators would find this kind of image demeaning and offensive to women, and the Nazis certainly attempted to make the most of any excuse they could find to mobilise a predominantly petty-bourgeois following against Modernist art.

The Nazi state and individual Nazi leaders are known to have patronised women artists, the most famous example being Leni Riefenstahl the film-

64. The 'guide' is translated and reproduced by S. Barron, pp. 358–90.
65. The water-colour of 1922 is in the Otto Dix Stiftung, Vaduz, and is illustrated in colour in the exhibition catalogue *Otto Dix 1891–1969*, Tate Gallery, 1992, p. 142, plate 66. See also B.I. Lewis, '*Lustmord*: Inside the Windows of the Metropolis', in C.W. Haxthausen and H. Suhr (eds), *Berlin. Culture and Metropolis*, Minneapolis and Oxford, 1990, pp. 111–40.

maker. Hitler wrote in *Mein Kampf*: 'The great majority of the people have a disposition so feminine that their opinions and actions are determined much more by the impression produced on their senses than by pure reflection. The masses are little receptive to abstract ideas. On the other hand they can be most easily taken hold of in the domain of the emotions.'[66] Whatever else this shows, it indicates Hitler's acceptance of stereotypical bourgeois notions of male and female qualities, although he merges the 'female' in the ideological sense with the predominantly male attendance at his military rallies in actuality. His uniformed followers at rallies would be 'female' under his leadership and control. While espousing these ideological definitions of the male and the female with their corresponding qualities, Hitler, and other leading Nazis, did not particularly care whether the people who catered for 'the masses' were *actually* men or women. Furthermore most examples of Great German Art are hardly overt appeals to the emotions, but are subjected to strict control.

This is particularly true in the sculpture of the Third Reich as we see in the work of Hanna Cauer (born 1902). Cauer came from a family of sculptors. In 1930 she was the first woman to win the Prix de Rome. In April 1933 Cauer wrote to the new Nazi government eagerly asking for advancement and commissions and welcoming 'our national leadership', since, she said, she had been thwarted at every turn by a 'Jewish-Marxist clique' totally opposed to her 'German artistic creativity'.[67] Cauer was close to Goebbels, Hitler and her patron, Interior Minister Frick. Among her commissions were monumental figures and fountains, including the *Olympia fountain*, with male nude figures in front of the town hall in Berlin, of 1935 (destroyed) (plate 46), the Goddess Athene, exhibited at the *Great German Art* exhibition in 1939, two figures for the foyer of the Nuremberg Opera House, 1934–5 (plates 47, 48), a fountain for the Ministry of the Interior, Berlin, now destroyed, and busts of Winifred and Wieland Wagner for Wagner's house in Bayreuth. She earned 7,300 marks in 1936 alone, while many women artists earned only about 100 marks from their work in a year. Hitler gave her a special gift of 5,000 marks in 1937, her work was awarded a gold medal at the Paris World Exhibition of 1937. At the *Great German Art* exhibitions her works were exhibited in the central courtyard with those of Arno Breker and Josef Thorak.[68] Cauer never had any problems during the war with shortages of materials for her work, coal or food. Goebbels and Hitler visited Cauer's studio and that of her friend Marie von Kalckreuth. They thought it 'very pleasant'.

66. Quoted in D. Guérin, *Fascism and Big Business*, p. 64.
67. Quoted by D. Cierpialkowski and C. Keil, in *Profession ohne Tradition*, p. 388.
68. M. Bushart, 'Der Formsinn des Weibes. Bildhauerinnen in den zwanziger and dreissiger Jahren', in *Profession ohne Tradition*, p. 149.

While Cauer's work was exceptional in being on such a large scale, the Nazis gave more public and private commissions to women sculptors. Many of the works were on a small scale, typically animals or portraits. They also encouraged the production of carved wooden figures, for example from oak or nutwood. This linked them to the great tradition of German Renaissance woodcarving, as in the work of Tilman Riemen-schneider, for example.

In the *Great German Art* exhibitions, there were proportionately more female sculptors than painters. About a sixth of the women exhibiting were painters and half were sculptors, which did not reflect the real weight of numbers of these respective groups.[69] In the exhibition of 1940 there were eighteen women painters and thirty-four sculptresses.[70] Some works were openly sympathetic to National Socialism like, for example, the *Hitler Youth Drummer Boy* of 1939, by Anni Spetzler-Proschwitz.[71] Cauer's statue of *Athene* appeared on the front page of an issue of the *Völkischen Frauenzeitung* in 1939 above an article proclaiming that artists (male) were emerging from all walks of life.

A comparison of women artists in the *Degenerate Art* exhibition and the *Great German Art* exhibition catalogue of 1937 shows that the Nazis certainly did not discriminate particularly against women. As mentioned above, the 'degenerate' show contained only 4 works by women from a total of nearly 600 on show, while the *Great German Art* exhibition had 44 works by women from a total of nearly 900.[72] These were mostly small-scale bronzes, plaster and terracotta models, water-colours, prints, silver and bronze medals, drawings and oil paintings, plus a double portrait in marble. The most obviously 'German' were *Still Life with Peasant Crock and Bread*, an oil painting by Lena Mahrholz, no. 463, and *Portrait of SS Standartenführers Hermann Behme*, oil, by Else Wex-Cleemann, no. 836. Hanna Nagel exhibited two pen drawings, nos 515 and 516. Hanna Cauer's work was on a larger scale than most of the other women's exhibits. A plaster model of her Opera House niche figure was on show.

Cauer's figures, whether male or female, are completely in tune with the other nude sculptures discussed by Annie Richardson, and it is curious that she does not show any of Cauer's statues, preferring to discuss works by male artists such as Richard Scheibe, or Georg Kolbe. However Richardson's great merit is that she avoids the 'easy' answer that all these female nudes are for theoretical (and actual) male spectators. She rightly

69. Ibid., p. 136.
70. Ibid., p. 137. Bushart also gives examples of private purchases made by Hitler and Göring.
71. Ibid, p. 136, illustration 121.
72. *Grosse Deutsche Kunstausstellung 1937 im Haus der Deutschen Kunst zu Munchen*, Offizieller Ausstellungskatalog, Munich, 1937.

argues that for Great German Art to work, it had to address women as female spectators, not male ones. She explains that the architectural aesthetic, as it appeared in allegorical sculpture, 'was important in its address to women' as the bodily form of woman it represented was woman as 'bearer of the race', and this interpellation would lose its efficacy if not geared specifically to a female spectator.[73] Richardson tries to discuss 'what these sculptures "might have evoked" because art history has sought in vain for a method equivalent to oral history to uncover subjective meanings for a range of viewers'.[74]

At the risk of sounding overly empirical, it might be a useful idea to ask surviving women how they understood the art of the Third Reich, because these sources of oral history still exist, unlike the many voices that were stilled for ever by the Nazi state. Of course many interviews with surviving Nazis and their contemporaries are notoriously difficult to 'decode' as anyone who has listened to Leni Riefenstahl can testify. However such historical source material has probably not been assembled partly because art historians may have shied away from the very notion of female Nazis and female Nazi artists, and also because the emphasis of much research on spectatorship has been overly abstract. Furthermore the view of fascism as simply another, but more vicious, chapter in patriarchal history has not helped matters. What attractions fascism had to offer women of the bourgeoisie and petty-bourgeoisie can be seen in the art of the period as well as the economic policies. No obstacles were put in the way of Hanna Cauer, and in fact she received every encouragement as a woman willing to devote her skills to the cause of fascism. Since it appears that a considerable number of women exhibited in the *Great German Art* exhibitions, perhaps it is time to reassess the relationship of middle-class women in particular to Nazi culture, both as makers and spectators of art. Views of Nazi art as straightforwardly propagandistic with no inner contradictions, affirming a male military aesthetic, while constructing the female as mother or sex-object for the male spectator do, I feel, need some readjustment.

73. Richardson, in *The Nazification of Art*, p. 68.
74. Ibid., p. 53.

dogma
Rapture

The Postmodern, Gender and Race

In this chapter I want to look at some aspects of Postmodern theoretical analysis of visual culture as they relate to gender, race and photography. Debates on the implications of Postmodern theory are still being investigated by many writers and artists. While some feel Postmodern theoretical methods are progressive, and that their focus on deconstruction unmasks the fiction of ideological 'master-narratives' of history, others feel that the fragmentation and lack of centralising focus causes difficulties for any project which seeks to develop a coherent and conscious view of gender and racial oppression in history and society. The destruction of the essential subject, whether black or female, may also entail the passivity of the individual faced by diffuse and shifting 'discourses' which, in the absence of a materialist method of understanding the world, results in the construction of the individual in a way that is far more deterministic than the perceived Marxist method that post-structuralism seeks to discredit. However every work of deconstruction is at the same time a work of construction. Absolute deconstruction is an impossibility, and more so for the visual artist who, in interrogating images of gender, race and identity, always leaves something else to take the place of the 'deconstructed'. This deconstruction cannot be seen on its own, but in a dialectical relationship with construction, which it is at the same time. As the late Samena Rana put it:

> I want to compile a book of photographs about defying stereotypes of disability and of Asian women as passive, weak, meek little creatures that don't have a voice. I want to make photographs that challenge and come to some kind of conclusion.[1]

Thus Rana's view of deconstruction implies that it is undertaken with the idea of shifting the spectator forwards in her/his perceptions so that a new synthesis will emerge from the spectator's past and present experience and consciousness. However this is an ongoing process. As reality changes,

1. S. Rana, in S. Gupta (ed.), *Disrupted Borders An Intervention in Definitions of Boundaries*, London, 1993, p. 168.

so will the artist's works engage with new processes of deconstruction/ construction.

The debates within and around Postmodernism have ranged from the highly idealist post-structuralist, to attempts to formulate a materialist interrogation of the relationship of Postmodern theory to the economic underpinnings of 'late Capitalism', notably in Jameson's essay 'Post modernism, or the Cultural Logic of late Capitalism'.[2] Jameson's article has several contentious aspects, an important one being his agreement with Mandel's argument that capitalism has passed beyond its imperialist stage, described and analysed by Lenin as 'the highest stage of Capitalism', and a new type of capitalism has emerged, that of multi-national capital which has penetrated and transformed enclaves of pre-capitalist organisation on a world scale.[3] It is debatable whether this is a qualitatively new form of capitalism, or is a development of the imperialist stage of capitalism analysed by Lenin based on increasing monopolisation, merging of banking and industrial capital and the export of capital rather than goods.

In addition, Jameson has been criticised for a certain dogmatism in his attempt to escape 'theories of random difference and disorder' as he 'embraces a theory of domination without resistance or revolt and a theory of capitalist development devoid of unevenness or contradictions'. This is to be contrasted with the revolutionary Marxist method of Marx, Lenin and Trotsky, says Warren Montag:

> The lesson to be learned from [their] writings is the opposite of any dogmatism: they show us that a given conjuncture can be grasped only on the basis of the antagonisms material to it. In fact a conjuncture is no more than an accumulation of contradictory and conflicting forces of different origins and which produce different effects.[4]

Thus the basis of much Postmodern thought, namely that totalising theories such as Modernism and Marxism are outmoded, disproved or simply wrong, is very much open to question, I feel. Why should we not be able to analyse the contemporary world and its culture through dialectical materialism? This 'argument' has been stated, rather than demonstrated, by Postmodern critics and theorists, and more often than not the 'evidence' for this conclusion is said to be the collapse of the 'Marxist' régimes of Eastern Europe. Given that there has been virtually nothing Marxist about these states and the politics of the Communist

2. Published in *New Left Review*, 146, July–August 1984, pp. 53–92.
3. Jameson, *New Left Review*, p. 78.
4. W. Montag, 'What is at Stake in the Debate on Postmodernism?', in E.A. Kaplan (ed.), *Postmodernism and its discontents. Theories, Practices*, London and New York, 1988, pp. 94–5.

Parties, both East and West, for decades, their continuing disintegration is hardly proof of the failure of Marxism. What would have to be demonstrated would be the impossibility for Marxist theory to adequately explain and analyse these events and the material bases of the collapse of Stalinism, and I do not think that this impossibility has been demonstrated.

Although there are differences within the sphere of Postmodern thought, much of it has functioned as a means to further remove the study of culture from investigation by a Marxist method based on dialectical materialism, as Marxism has been designated as a totalising master-narrative, Eurocentric, male-dominated and damned for its unforgivable premise that the processes behind development and change in the material world are knowable by conscious subjects who are capable of changing their material conditions. I would like later to turn to what some writers on art produced by black women and women of colour say on the subject of Postmodernism, Marxism and subjectivity. Firstly though I would like to examine some issues concerning Postmodern theory and representations of woman by focussing on the work of the American photographer Cindy Sherman.

Griselda Pollock, in a recent article, has argued that feminists need to move from a focus on 'women' to a focus on 'sexual difference and its troubled origins in psychoanalytical theories'. In this way, she argues, feminists can move away from the exclusive man/woman focus to also look at difference in terms of race, class and the sexuality of lesbians and gay men. Thus, she argues:

> Contesting the canonical discourse with art as pure and perfect object and artist as perfect imperial subject, feminists propose a different object – sexual difference – and a radically different concept of subjectivity whose processes are inscribed upon, traced in and fragmented by, the cultural texts which compose the local but still hegemonic modern culture of the west/north.[5]

While Pollock argues for sexual difference as *the* means of understanding race and class oppression and their 'traces' in cultural texts, I want to look at the photographic work of Cindy Sherman and that of some contemporary British women artists of colour in order to argue for the validity, indeed necessity, of a Marxist approach to culture in the Postmodern period. This period, I believe, is just that, a period within the imperialist epoch of world economic and cultural development and not a qualitatively different epoch commencing with the regeneration of capitalism on a world scale after the Second World War, as Jameson argues in his definition of 'late-capitalism'.

5. Pollock, 'Trouble in the Archives', *Women's Art Magazine*, Sept/Oct 1993, p. 13.

[handwritten: Is this stage a improvement]

Also I think it would be difficult to argue that 'late capitalism' or 'Postmodernism' could be said to reflect qualitative improvements in the position of women, the world's political and economic spheres or in the sphere of culture. Huge areas of the world exist where women have few (if any) democratic rights, where abortion is completely banned, and where female infanticide is practised, to name but a few of the continuing examples of women's oppression. Academic feminism of the imperialist world can sometimes mistakenly overlook the plight of women in the semi-colonial world, and generalise from a partial, and relatively privileged, position, to speak in the name of 'post-feminism' for all women.

So how can we situate Postmodern theory and photographic practice in the context not of 'late-capitalism' but in a period where imperialism continues to restructure its economic base and dominate large sections of the globe, with all that this entails for the oppression of the vast majority of the world's population on the basis of class, race and gender. And is either sexual difference or the decentering of the subject in Postmodernism a key to our understanding of the culture and ideology of contemporary society on the basis of growing imperialist antagonism and exploitation on a global scale? *[handwritten: work grew]*

Sherman's career began in the mid/late 1970s, but it was really in the 1980s that her reputation, and her sales, became established and grew quite dramatically. A catalogue of an exhibition of her works in 1990 stated that she had produced 238 publicly registered works by then. By looking at the same catalogue we see a large increase during the 1980s in exhibitions, reviews and critical articles about her work. The list of museums and collections open to the public containing examples of her work in 1990 is truly international – in the USA, Europe and Australasia. Only one public collection in a semi-colonial country, however, had an example of her work in 1990 and that is in Mexico City.[6] In addition, her work has been purchased by private collectors on a large scale. The best-known examples of this in Britain are the Saatchis, almost as famous for their economic activities running advertising campaigns for the British Conservative Party as for their collection of contemporary art. The Saatchis' collection combines the appearance of being a resource open to the public, with total control by the owners – e.g. works are sold when the Saatchis want to sell and bought in the same way. A contradiction at the heart of the success of Sherman's work is the ownership and exhibition of her work by collectors whose apparent ideology of consumerism, glossy media imagery and capitalist lifestyles her work challenges. *[handwritten: Ironic to nol]*

6. Catalogue of the exhibition *Cindy Sherman*, Padiglione d'Arte Contemporanea di Milano, 4 Oct–4 Nov 1990, by M. Meneguzzo, Milan, 1990; see bibliography and list of collections open to the public with works by Sherman.

However there are many audiences for Sherman's work, not all of whom read the same meaning in her images. Her popularity with students is apparent. I cannot offer a statistical or scientific documentation of this, but the number of pages ripped out of glossy art magazines in our college library indicates the student population prefers Sherman's work to that of, for example, Barbara Kruger and Mary Kelly. (Of course I am assuming here that art-history and fine-art lecturers do not rip pages out of library material or cut them out with Stanley knives!)

Sherman has on many occasions pointed out that she is not particularly interested in critical theory, either in terms of the understanding of her works once they are made, or in terms of the making of them by the artist herself. In this sense she is an interesting foil to Kruger and Kelly, whose practice is informed by an awareness of a body of post-structuralist theory on discourse, language and the construction of the viewing 'subject'. It is interesting to note that in the recently published volume of theoretical writings on art edited by Paul Wood and Charles Harrison, *Art in Theory 1900–1990*, published by Blackwell, Oxford, Cindy Sherman is referred to once in 1,127 pages of text, whereas both Kelly and Kruger have texts written by them included in the anthology. We should perhaps ask ourselves what, if any, implications this has for ideas about the relationship of practice and theory. Are Kelly and Kruger 'better' or 'more interesting' artists because a knowledge of structuralist and post-structuralist theory informs their work? Can we read Sherman's work as 'kitsch', as defined by Greenberg in his writings on 'Avant-Garde and Kitsch', because it is too figurative, too close to commercial culture and mass media imagery and not 'difficult' enough to really qualify as avant-garde? Or has Sherman's determination not to exploit the potential for mass-reproduction inherent in the photographic medium, as it developed in industrialised capitalism, re-affirmed her 'artistic' if not avant-garde status? Does theoretical awareness and understanding necessarily produce 'good' art? If not, then this is a serious problem for the vast bulk of Postmodern artists from Victor Burgin to Mary Kelly.

Perhaps Jo Spence was one of the few practitioners of photographic work to combine an accessible integration of theory and practice in his/her work without diluting important theoretical problems or patronising her/his audience. Unfortunately I have not the space here to further develop comments on Spence's contribution to photographic practice and theory. However I feel there is a particularly interesting investigation to be made of Sherman as a Postmodernist who really is not interested in theory, if we are to believe her own comments in interviews. For example, she says in a recent interview, concerning her series of *Untitled Film Stills*, 'I never thought of it as some sort of, oh, idea about the male gaze, you know . . .' and 'No, I have never been a fan of criticism or theories, so that actually

none of that affected me and still doesn't', and 'Many of my pieces are much more innocent than they are interpreted'.[7]

Now of course it is quite often the case that artists are not the most articulate in explaining the meanings of their works or the reasons for their production, but I think what is raised here are the questions of ideology and consciousness in Sherman's works, and the complex and contradictory ways in which works of art, cultural products and so on can be affirmations and subversions of particular views of the world *at the same time*. This is what, in my view, makes Sherman's work interesting and complex, because in her work we see a dialectical process working itself through her approach to photographic images, from the black-and-white untitled film stills to the grotesque disintegration of the world portrayed by glossy colour photography in the later 1980s works. This process did not really come about because of Sherman's theoretical understanding of subjectivity, the male gaze or the crisis of capitalism – she has said that she is not a feminist and to my knowledge has never been described as a socialist – but because of the historical and cultural situation her works are produced and exist in. Without this historical reality, Sherman's works would not look the way they are – indeed they would not exist.

However the contradictions and tensions present in Sherman's works are not simply 'reflexions' of her experience living in a capitalist society in the USA, but the results of both conscious and unconscious aspects of Sherman's existence in a particular historical and economic conjuncture as an actually existing, conscious individual. In spite of the critical writings which happily seize on Sherman's works as pure masquerade, role playing, and visual discourse unrelated to the 'real' Cindy Sherman (and of course there is a sense in which this is true of her work), there nevertheless *does* exist a person who made these images. What is more worthwhile to consider is *why* does Sherman use the visual strategies that she does and why are so many of the theoretical articles written on Sherman's work so eager to argue that the text (of her work) is so much more important than any material reality it might refer to? In fact, for much of Postmodern theory, material reality is unknowable and fragmented; we as individual subjects are theoretically denied the possibility of knowing material reality since we are ourselves constructed by various texts and discourses, through which subject positions are created for us. Hence material reality is not just unknowable but unchangeable by conscious intervention. In this idealist view of things, there is no room for an analysis of the processes by which individuals or social groups can achieve any conscious awareness of their situation and change it. A materialist view would obviously reassert

7. David Brittain interview with Cindy Sherman in *Creative Camera*, Feb/March 1991, pp. 34–8.

that ideas and concepts are created by people, not the other way about.

I think there is a real problem here for the sort of theoretical position that has been argued by Griselda Pollock and Laura Mulvey, among others. If we all enter into gendered subject positions already prepared for us at an unconscious level, for example, how do we explain the fact that individuals (and groups) ever consciously analyse and reject these positions? Where is there any notion of dialectics or contradiction or consciousness in these theoretical models, apart from using the odd Marxist term on occasions? How are we supposed to understand how Sherman was able to reject media images of female stereotypes, fashion models and beauty, when, on the one hand, she is being 'construed as a particular gendered subject' all the time by media texts and discourses and, on the other hand, she herself has said she never consciously used any theoretically developed position which led her to criticise the dominant images of women in commercial mass imagery? I would argue that most of the writings on Sherman's work have not really managed to tackle very many of these issues concerning the production of her work since many of them are written from a fundamentally anti-materialist stance, and, what is more, appear to have very little idea of dialectical materialism. For, after all, it is dialectical materialism that is the theoretical basis of Marxist theory and practice, not just historical materialism. This mistake has, as we have seen, led many radical critics to scorn and reject Marxism as a method of cultural analysis because they see it as hopelessly crude and deterministic.

Now of course this does not mean that the work of Cindy Sherman, for example, can be understood as a manifestation of class struggle or anything so simplistic. What it does mean is that discussions about her critical reputation, the meaning of her work, the spectator it may or may not address, the representation of the female body and the possible psychoanalytic significance it has, need to be understood, ultimately, in terms of the situation of Sherman herself as a producer of art works which are understood in terms of both the values of the international art world, and the critical apparatus of the radical intelligentsia in a decaying and crisis-ridden imperialist-dominated world. As stated above, there is little evidence that I can find to argue for a cultural significance of Sherman's work outside of imperialist countries at present. None of the critiques and explanations of Sherman's work have sought to address these issues. Most have concentrated on the fragmentation of the subject, either as the body portrayed or as the viewer, without really trying to conceptualise the material context in which Sherman's work is produced. Of course that was not the aim of these writers, for example, Laura Mulvey, to whose recent article on Sherman I shall return later. As I pointed out earlier, it is understandable that many radical critics have moved further and further towards idealism as material reality appears more barbaric, and more

difficult to intervene in. The writers' theoretical positions also need to be understood in relation to their particular time and place, political and economic situation, and, yes, the individual consciousness of the writer. It is not only a question of understanding the works of Sherman in this way. This, then, is the theoretical context in which Sherman's work has been discussed by radical cultural analysts. What then, of the material conditions of the 1980s in which her international reputation was established?

In an interview in 1983 Sherman stated: 'I like the idea of big editions and cheap art, and the closest I get to that is every year when I do a large edition of a hundred and twenty-five that are sold at the gallery for like fifty dollars.'[8] This is probably referring to the untitled film stills, which now cost 10,000 dollars.[9] In a period of world recession, Sherman's prices have rocketed, and there are obvious reasons why she does not produce large editions of her work. In a useful chapter of the book *The State of the Art*, dealing with the international art market, published in 1987, Sandy Nairne quotes Robert Hughes, who states:

> Twenty or thirty years ago, dealers in New York used to struggle against dealers in Paris or London, each affirming the national superiority of their artists. Those transatlantic squabbles are now extinct. What you have instead, on the multinational model, is associations of galleries selling the one product in New York, London, Dusseldorf, Paris, Milan. The tensions of national schools are dissolved.[10]

It is true of course that markets and marketing are now international concerns, but there remains an unresolved (and unresolvable) tension between the internationalisation of profit and national economic, political and cultural interests. The utopian project of the creation of a European superstate with its own market is a current manifestation of these irreconcilable aims, and also of the fundamental economic interest which will override long term political strategies, as in the recent example in 1993 of German banks going against the political aims of the German government regarding the European exchange mechanism. In the continuing world recession, trade wars are threatened by the USA to maintain its own national economic interests. The USA, still the most powerful political and military force in the world, as demonstrated by its 'smart bombs' during the Gulf War and its invasion of Somalia, is,

8. Interview with Paul Taylor, *Flash Art*, Oct/Nov 1983, p. 78.

9. Information kindly provided by the print and photography department at the Victoria and Albert Museum, London.

10. Nairne, *State of the Art*, London, 1987, p. 65. The quote from Hughes dates from late 1984.

however, economically weak. The American Dream is now a nightmare for many US citizens. The political triumphs of the USA and other imperialisms in the winning of the Cold War, hailed as a triumph for democracy, have resulted in chaos and barbarism in the former Yugoslavia, and the continuing disintegration of the economy of the former Soviet Union.

In this period of so-called post-feminism, thousands of women continue to die from backstreet abortions and suffer other miserable forms of oppression, including mass prostitution, in imperialised countries (and indeed in imperialist ones). In addition, the 1980s saw the emergence of AIDS on a massive scale. In 1981 the first cases of AIDS were reported in the USA and by 1983 the virus had been identified. The World Health Organisation estimates that as many as six million people may be infected with AIDS in Africa alone. However while the World Health Organisation tries to develop basic precautions to prevent the spread of the virus, its own funders, primarily the USA, are clawing money out of the countries where the disease is killing most people, in demands for payment of international debts.[11]

The physical disintegration of the body is not simply identifiable as a trajectory in Sherman's work in the 1980s but has become a physical reality for millions of people. Sexuality and contact with body fluids is an increasing source of potential death. It is thus possible, I think, to read the transformation of the body in Sherman's work of the 1980s in this wider context (plate 49). Paradoxically this disintegration and dismemberment is presented in large glossy images printed in saturated colour reminiscent at one and the same time of advertising imagery and 'high' art objects. Her use of the grotesque body may be paralleled by that of Rabelais in the early modern period, with his use of forms of 'popular' culture in 'high' culture. Bakhtin, in his book *Rabelais and his world*, argues that the grotesque body, as constructed by Rabelais in the early sixteenth century, is literally an embodiment of a qualitatively new conception of the relation of the physicality of the body to an understanding of the world. It moved away from a medieval hierarchic picture of the world to a humanistic focus on the body as the relative centre of the cosmos. Rabelais presented the grotesque body in all its materiality. However for Rabelais the comic and grotesque body 'reflected the struggle against cosmic terror and created the image of the gay, material bodily cosmos, ever-growing and self-renewing'.[12] However Sherman's photographs of the later 1980s show

11. See Clare Heath, 'AIDS, capitalism and oppression', *Permanent Revolution*, no. 9, Summer/Autumn 1991, pp. 149 ff.

12. M. Bakhtin, *Rabelais and his world*, Cambridge, Massachussetts and London, 1968, p. 340. I am indebted to John Roberts for the suggestion that Sherman's depiction of the body might be studied in relation to Bakhtin's analysis.

grotesque bodies in a far from optimistic light. The relationship of these bodies is to a very different world than that understood by Rabelais. Here the disintegration, dismemberment and putrefaction is an embodiment not of optimistic self-renewal, but of a gradual collapse of bodily coherence which, though interrogated, was still apparent in the black-and-white untitled film stills of the later 1970s and early 1980s. However as if to retreat from the further development of this trajectory, Sherman in 1989 made her body into 'art' in a rather different and far less threatening sense, with the production of images showing herself in the guise of 'old master' type paintings, albeit with grotesque trappings of false noses, breasts and so on.

Sherman's critical reputation has not diminished with the increasing emphasis on the horrific and grotesque in her self-presentation. While radical critical writings on her work provide almost a 'who's who' of cultural studies in the 1980s, there were other less radical attempts to analyse her work running in parallel to post-structuralist theoretical writings. Sherman herself has ambivalent comments to make about what is practically a 'star' status in the art world: 'Hype, money, celebrity. I like flirting with that idea of myself, but I know because my identity is so tied up with my work that I'd also like to be a little more anonymous.'[13] Madonna, in a recent interview on British television about her book *Sex*, explained to watching millions that the person in the book was another, it was someone acting out roles and masquerades as in Cindy Sherman's photographs. All this has been interpreted as a radical challenge to notions of fixed 'femininity' constructed by the male gaze in patriarchal society, but it really is dubious to what extent Madonna subverts objectification of the female body in images designed for profit-making, even if the recipient of the profit is the author/producer. In a recent article, Laura Mulvey compares Cindy Sherman's and Madonna's strategies for 'debunking of stable identity', and mentions Madonna's awareness of the disintegrative 'side of the topography of feminine masquerade in her well-documented admiration for Frida Kahlo'.[14] However Kahlo was not just concerned with female self-image in her activities, she was also a political activist, and a tendency to ignore this has not helped develop an analysis of Kahlo's work which would attempt to relate her political views and activities to her presentation of herself as a Mexican, a woman and an artist.

Sherman's strategies of self-presentation are interesting because they consciously set out to engage with mass-media images of women which attract and distance at the same time. In the course of the 1980s the weight

13. *Flash Art*, Oct/Nov 1983, p. 79.

14. Laura Mulvey, 'A Phantasmagoria of the Female Body: The work of Cindy Sherman', *New Left Review*, 1991, vol. 188, July/Aug, p. 149.

of this contradiction goes further in the direction of distancing and criticism. The untitled film stills show Sherman involved with her B-movie pseudo-sources, yet aware of the mechanisms at play in the positioning of the woman as both subject and object of the image. Sherman goes on to interrogate the format and photographic 'genre' of the centerfold, and the fashion and beauty advertising image. She consciously aims to destroy dominant notions of beauty and desirability: 'I'm trying to make fun of fashion. I'm disgusted with how people get themselves to look beautiful, I'm much more fascinated with the other side.'[15]

In 1984 Sherman was commissioned to do fashion photographs for French *Vogue*. This commission was rather a bold attempt to tackle the whole 'look' of fashion photography on its own home ground and with access to its own audience. Not surprisingly, the odds were heavily weighted against Sherman and she felt she had to compromise. Her aim had been to debunk the ideological premises on which glossy fashion photos were constructed:

> They expected me to do with their clothes what I had done with this other company . . . make kind of cute, funny pictures. From the beginning there was something that didn't work with me, like there was friction. I picked out some clothes that I wanted to use. I was sent completely different clothes that I found boring to use. I really started to make fun of, not really of the clothes, but much more of fashion. I was starting to use scar tissue on my face to become really ugly. This stuff you put on your teeth to make them look rotten. I really liked the idea that this was going to be for French Vogue, amongst all these gorgeous women in the magazine I would be these really sick-looking people.[16]

Although Sherman felt rather disappointed with what happened, this series of photographs and her ideas about the commission demonstrate quite clearly the deeply contradictory position of Sherman and her work's engagement with the imagery and modes of address of mass-media photographs. What is also noteworthy is Sherman's conscious desire to criticise and oppose these images using their own techniques and means of diffusion. However, it is clear that this was not realistically a strategy likely to succeed, and Sherman's works are more easily accommodated by the notion of 'art' to be exhibited in 'art' galleries, and marketed by 'art' dealers. What is also of great interest, and I think raises a problem for many of the theoretical analyses of representations of women, is that Sherman has obviously become not just fascinated and engaged by media images, but consciously critical.

15. P. Schjeldahl and L. Phillips, *Cindy Sherman*, Whitney Museum of American Art, New York, 1987, p. 15.

16. Nairne, *State of the Art*, p. 36.

Now the problem posed for the kind of post-structuralist theories which argue that subject positions are already constructed for us, that discourse and language construct the subject and that there is no 'reality' to which images and texts actually refer, is this – how do they explain the process by which Sherman moves to a conscious decision to destroy particular types of imagery of women? If women enter into gendered subjectivity at an unconscious level, how are they consciously supposed to ever be able to criticise the ideology and social practices that oppress them? It seems to me that none of the linguistic and psychoanalytic theories currently in vogue in writings about representation and women even try to explain this. Unless we take a materialist view of Sherman's development, and argue that it is likely to be her own experiences in a 'real' material world which prompted her to question and eventually try to destroy dominant notions of fashion and beauty, I really don't see how Sherman as an individual was ever likely to escape from the subject positions she was already 'written into' as this idealist argument would have it.

I feel that this is a major problem with analyses such as Laura Mulvey's. Her articles 'Visual Pleasure and Narrative Cinema' and 'Afterthoughts on Visual Pleasure and Narrative Cinema' written in the mid-1970s and reprinted in her book *Visual and other Pleasures*, 1989, set out to examine the reasons why women watching Hollywood films took pleasure in what Mulvey argued was their own objectification by the technical and cinematic means of the film medium and its consumption by the cinema-goer. Sherman seems to have taken great pleasure in these same Hollywood productions. Mulvey argued that the female spectator viewed the film by taking on the gaze of the male, embodying social and psychological power over the fetishised representation of the women in the film.

Now, leaving aside the problems of applying an analysis of film straightforwardly to still imagery, there are still some serious problems with Mulvey's thesis. Again, if all this happens on an unconscious level, how do we explain the emergence of women (and men) artists and film makers who consciously try to criticise, and develop alternatives to, dominant visual culture? Also the idea of voyeurism and scopophilia being applied to the cinema and the still image needs to be carefully considered. There is a difference between the pleasure people get from looking at photographs and so on, and the conditions Freud tries to analyse where his patients cannot achieve sexual fulfilment other than through fetishistic voyeurism. There is a qualitative difference here between watching an image and having an orgasm watching an image. If the spectator gazes at many images her/his pleasure will quantitatively add up, but it won't necessarily qualitively transform her/him into a 'male voyeur'. Furthermore every visual image, especially the photographic image, has to be looked at, so are we supposed to accept that the visual image at all times and under all

conditions and irrespective of the identity of the spectator will objectify and fetishise what it represents? This is a pretty pessimistic view, to say the least. Also, is Mulvey arguing this is the case under capitalism or under all societies where women are oppressed? Is it the case that the mechanism and processes of the unconscious and conscious in relation to social existence have trans-historical validity?

The situation is made no clearer in Mulvey's recent article on Sherman's work. She argues that Sherman attempts to defetishise the female body, but comments: 'it is hard to trace the collapse of the female body as successful fetish without re-presenting the anxieties and dreads that give rise to the fetish in the first place, and Sherman might be open to the accusation that she reproduces the narrative without a sufficiently critical context.'[17] This sounds like an impossible task, especially if the photographic image by its very nature is supposed to objectify and fetishise in any case. Also, there is still no theoretical conceptualisation offered by Mulvey of how the female subject achieves any consciousness and critical awareness. Now it is not the case that psychoanalytic theory is, in itself, idealist, but I would argue this has been a definite characteristic of the use of psychoanalytic theory by such writers as Mulvey, Pollock and Craig Owens. Freud himself saw the mechanism of the conscious and unconscious as related to the preservation of the social status quo, as one of the functions of repression was to deal with sexual desires which would destabilise social norms and practices if they were consciously acted upon.

Obviously the processes by which socially disruptive desires and needs are repressed and the ways in which we become 'conscious' of the unconscious, and indeed of the fact that our experience has been lived through ideology, are of great interest to dialectical materialists. We need to learn more about the ways in which socially oppressive subject positions are internalised, and how they can be overcome. But this means rescuing psychoanalysis from idealism. Trotsky, writing in his *Notebooks on Dialectics*, 1933–5, says:

> psychoanalysts are frequently inclined towards dualism, idealism and mystification . . . But by itself the method of psychoanalysis, taking as its point of departure 'the autonomy' of psychological phenomena, in no way contradicts materialism. Quite the contrary, it is precisely dialectical materialism that prompts us to the idea that the psyche could not even be formed unless it played an autonomous, that is, within certain limits, an independent role in the life of the individual and the species.[18]

17. Laura Mulvey, *New Left Review*, p. 146.
18. L. Trotsky, *Notebooks on dialectics. Writings on Lenin, Dialectics and Evolutionism*, translated and with an introduction by P. Pomper, New York, 1986, pp. 106–7.

In a timely plea for consideration of the historical nature of spectatorship in which actual viewing subjects can be situated in their materially specific conditions of viewing, Judith Mayne has pointed out the inadequacies of many previous applications of psychoanalytic theory to the cinematic viewing position. She states her main criticisms as follows: 'The spectator is seen as passive; no allowances are made for differences of race, culture or gender in actual, rather than theoretical, spectators; history is given no place in the argument; and finally that psychoanalysis is used in an abstracted, almost deterministic way.'[19] The ways in which the use of psychoanalysis in an abstract way has ignored the black spectator will be referred to again later in this chapter.

Sherman's monstrous and grotesque images of decay and ugliness attempt to articulate the kind of imagery through which the unconscious represents repressed fear and terror. As such her images are a critique of a world view which sees the female body as coherent, beautified, idealised and glamourised. Her own processes of applying make-up and wigs developed from the late 1970s where various body and facial disguises were applied to enable Sherman to simultaneously participate in, and interrogate, movie images. From 1983 onwards her use of make-up, wigs, plastic and rubber breasts, noses and buttocks, scar tissue, and so on, constitutes a destructive parody of the glamourisation of the body. The socialised fears with which women are brought up and taught to internalise – fear of being 'unattractive' and 'undesirable', even 'ugly', are here thrust by Sherman right at the spectator on a large scale. I feel these images are just as much for a female as a male spectator, irrespective of what psychoanalytic theorists say about the 'theoretical' spectator that they posit. These images create and destroy the spectator's expectations and desires at the same time. They also create and destroy the 'artist' Cindy Sherman at one and the same time.

However we still have to ask why Sherman's works have been so successful in the international art world. Is this not a huge contradiction if her works are so destructive of canons of beauty and desirability? In attempting to answer this question I would like to look mainly at two articles on Postmodern photography by Douglas Crimp and Abigail Solomon-Godeau.

Crimp's article, written in 1980, obviously could only refer to Sherman's early untitled film stills. He locates her work in Postmodern photography, which in turn he sees as part of two trends developing out of the 1970s – the resurgence of expressionist painting and the triumph of photography as art. Both of these developments return a sense of 'aura' to the work of art. Crimp is of course referring here to Walter Benjamin's

19. J. Mayne, *Cinema and Spectatorship*, London and New York, 1993, p. 52.

argument in his famous essay, 'The Work of Art in the Age of Mechanical Reproduction', of 1936. For Benjamin, the work of art had a unique existence in time and place, an authentic presence in social ritual. The development of photography and film, says Benjamin, has the potential to destroy the notion of the aura of the individual authentic art work. This potential is destructive and constructive. 'Its social significance, particularly in its most positive form, is inconceivable without its destructive, cathartic aspect, that is, the liquidation of the traditional value of the cultural heritage . . .'[20]

Crimp goes on to argue that the young Postmodern practitioners of photography-as-art restore the aura to the art work, but only to displace it and show 'that it too is now only an aspect of the copy, not the original'.[21] Cindy Sherman, he claims, destroys the fiction of the self, thereby adding to the destruction of the auratic presence of the photograph as art. I find this argument a little problematic, since it is also social, cultural and economic factors which influence whether the photograph is regarded as a work of art, not just what the individual work does, or does not, intend to do. Sherman certainly does not exploit the potential for mass reproduction of the photographic medium as it was developed in industrial capitalism. Her photographs need to be seen in relation to traditions of the artist's print, as well as photography and painting, or even 'records' of events staged by the performance artist. Benjamin's vision of the potential of mass-reproduced imagery as socially and culturally progressive rather ignored economic considerations. On the one hand, capitalism sells films, cameras, photographic development and reproduction services to a mass of purchasers. But where scarcity means increased value, then the photograph's potential for mass reproduction is not exploited. Social, cultural and, primarily, economic factors determine whether the photographic negative is used to produce an 'art image' or a mass-reproduction image. Sherman's images are very much part of the 'art' tradition, not just because there are no massive 'editions' of them (her term) but because of their existence in, primarily, a context of galleries, criticism, collections, and the notion of a professionally-trained artist working in a studio. (Her earlier photographs were often taken on location.) As mentioned above, Sherman's attempts to 'show' her work in mass-circulation magazines did not result in her work reaching a 'mass' audience, but rather encouraging her to move back to the gallery and museum world.

20. Benjamin, quoted in F. Frascina and C. Harrison (eds), *Modern Art and Modernism*, London, 1982, p. 219.
21. D. Crimp, 'The Photographic Activity of Post Modernism', *October* 5, Winter 1980, part 15, pp. 98, 99.

Benjamin's essay also raises the interesting notion that if the essential defining component of photography as a medium is reproducibility, then Modernist photography would be photography that interrogates and analyses this aspect of itself. This has not been the case in many instances until Postmodernism, I would argue. When most people think of what Modernist photography is, they think of works like those of Man Ray or Edward Steichen. However there are different types of Modernism in photography, including propaganda images like those of Heartfield, or, ideological and cultural deconstructions like those of Hannah Höch. This causes problems in seeing photographic Postmodernism as a qualitatively different phenomenon from photographic Modernism. There was never the huge emphasis on formal self-criticism and non-figuration in photographic Modernism as there was in the dominant painterly notion of Modernism. Mass reproducibility and formal Modernism do not necessarily coincide in Modernist photography. In a sensibly written and very useful article, Janet Wolff, like others, suggests that 'the radical relativism and scepticism of much Postmodern thought is misplaced, unjustified, and incompatible with feminist (and indeed any radical) politics. The project of Postmodernism as cultural politics is more usefully seen as a renewal and continuation of the project of Modernism . . .'[22]

For Abigail Solomon-Godeau, however, Sherman's work has simply been recuperated by the art institutions which help preserve Modernism in art, and its critical edge has been blunted. In her article 'Living with contradictions', recently reprinted in her very useful book, *Photography at the Dock*, Solomon-Godeau examines the process of recuperation whereby works by, for example, Sherman, Levine and Kruger, had 'directly challenged the pieties and proprieties with which photography had carved a space for itself precisely as a modernist art form'.[23] Solomon-Godeau places considerable emphasis on the ability of institutions and academic and cultural practices of the art world to define and incorporate particular photographic works into a corpus of imagery valued for authorial presence, originality, authenticity, etc. This, of course, means that it is very difficult to subvert these values from within the institutions that work to preserve them, but, as the title of Solomon-Godeau's article suggests, radical artists live with these contradictions, and indeed the contradictions are present within the institutions and practices of the art world. Otherwise how could we explain the purchase and critical success of Sherman's huge coloured images of worms, vomit, rotten junk food, dismembered bodily

22. J. Wolff, 'Postmodern Theory and Feminist Art Practice', in R. Boyne and A. Rattansi, *Postmodernism and Society*, Basingstoke, reprinted 1991.
23. A. Solomon-Godeau, *Photography at the dock, Essays on Photographic History, Institutions and Practices*, Minneapolis, 1991, p. 127.

forms, and so on?

However Solomon-Godeau argues that Post-modern photography's critical potential vis-à-vis mass media images of fashion and advertising has collapsed. Writing in 1987, Solomon-Godeau argues that in contemporary photography:

> Post modernism as style, on the other hand, eliminates any possibility of analysis insofar as it complacently affirms the interchangeability, if not the coidentity, of art production and advertising, accepting this as a given instead of a problem ... Now firmly secured within the precincts of style, postmodernist photography's marriage to commerce seems better likened to a love match than a wedding of convenience. Deconstruction has metamorphosed into appreciation of transformation, whereas the exposure of certain codes has mellowed into self-referential devices.[24]

However she illustrates Sherman's *Untitled Film Still*, 1979, where Sherman lies on a sheet wearing a shirt and pants, looking sensually dreamy, lipsticked mouth slightly open, a trashy-looking sensational novel by her side. I think if Solomon-Godeau had chosen a later example of Sherman's work she might have had a less clear-cut case. Solomon-Godeau then goes on to discuss the work of Heartfield as critical practice and concludes that really this is insufficient as a model for contemporary critical photographic practice. Solomon-Godeau seems not to consider Heartfield's work as Modernist, and I think she has a tendency to see a critical political stance as something basically incompatible with Modernist formal critical awareness. This is rather problematic, I think. While she says Heartfield's great importance is that he meshes political criticisms and politics of representation, she does not see this as in any way associated with Modernism, as basically her concept of Modernism is that of 'Official art photography' and 'art practices predicated on signature styles'.

However Solomon-Godeau's essay is a usefully thought-provoking piece. She attempts to explain the market success of Postmodern American photographers. Although photography fetches lower prices than painting 'despite the prevalence of strictly limiting editions and employing heroic scale', in 1980, the work of, for example, Sherry Levine, hardly sold at all and was understood only by a small number of artists and critics.

> When this situation changed substantially, it was not *primarily* because of the influence of critics or the efforts of dealers. Rather, it was a result of three factors: the self-created impasse of art photography that foreclosed the ability to produce anything new for a market that had been constituted in the previous

24. Ibid., p. 143.

decade; a vastly expanded market with new types of purchasers; and the assimilation of postmodernist strategies back into the mass culture that had in part engendered them.[25]

Unfortunately Solomon-Godeau does not go into any detail about the 'vastly expanded market with new types of purchasers', which would have been useful. Would the Saatchis belong to this 'new type of purchaser'? However I find it hard to believe there are vast numbers of Saatchis out in the market buying Postmodernist photographs. More work on this would be useful, but the literature on Sherman says very little about her patrons and prices, nor does much material exist which attempts to situate her work in its historical and economic milieu.

However before concluding this discussion of Sherman's photographic work I should mention some other types of criticism of it. Some reviews are simply dismissive of her work, some try to incorporate it into a 'fine art' tradition, and some see her as a continuing part of a heroic creative myth of the tormented individual finding sublimated equilibrium through the creation of 'Art', in this instance to escape being female.

In the catalogue of the Saatchi Collection, Sherman's work is linked to the history of painting, rather than that of photography, and her lighting effects compared to Mannerist and Baroque art ('as with Baroque art, there is a great theatricality in Sherman's work'). Her attention to surface detail apparently stands in the tradition of Velasquez and Matisse![26] This is analysed as an example of the 'human presence returning to art'. Even more bizarre is an article by Donald Kuspit, then editor of *Art Criticism*, who reads Sherman's work as a (successful) attempt to go beyond the contradictory experience of womanhood, to artistic fulfilment:

Sherman's art can bring repulsive, ugly scenes under aesthetic control, make them aesthetically appetizing – this surely signals Sherman's profound ambivalence about her experience of her womanhood, something she abhors yet enjoys, and brings under control by putting it to artistic use. It is this artistic use – her wish to excel with a certain aesthetic purity as well as to represent inventively – that reveals her wish to heal a more fundamental wound of selfhood than that which is inflicted on her by being a woman.[27]

In some respects, Sherman's successful career in the 1980s was helped by her reluctance to engage in any critical or theoretical debates, claiming that theories about women, the fragmentation of the subject, etc. were interesting, but not consciously intended by her. They were a kind of 'side

25. Ibid., pp. 136–8.
26. *Art of Our Time, The Saatchi Collection*, 4, London, 1984, p. 20.
27. *Artscribe International*, Sept/Oct 1987, p. 43.

effect', in her words. This obviously made it possible to have the most diverse views on the critical potential and cultural radicalism of Sherman's work. Also, in some ways, by focussing always on notions of the 'feminine self', radical critics largely ignored the specific historical and economic situation in which Sherman's work was produced and changed. We need to ask why did it change, not just how it relates to psychoanalytical theory, for example. Since feminism sees all societies in history as patriarchal, then the formation of the subject is posited as broadly similar over vast periods of time, encompassing ancient Greece to crisis-ridden imperialism. This is not very helpful in trying to understand exactly what contradictions exist within an individual's or a social group's conscious and unconscious articulations of how they understand the world, and images they choose to construct of it, and which they produce to exist within its culture. Also Sherman's decision not to use texts with her photographs, with the explicit intention of making them more ambiguous, also has the possible result of increasing the diversity of meanings that can be given to them by the different audiences for her work. However use of a text is not an automatic guarantee of escaping from galleries, museums and the museums' and Modernist notion of the apolitical avant-garde, even if that is the conscious intention of the artist. Ultimately the directions of the contradictions and tensions in Sherman's work, both conscious and unconscious, will be influenced by factors over which she, as an individual, does not have a great deal of control.

I want now to look at the theoretical and material context for the production of recent photographic work by women photographers of colour in Britain, as this differs in some significant ways from that of Sherman and raises rather different issues.

Postmodernist theory has generally been welcomed by writers on contemporary 'black culture' in Britain. The deconstructionist project of much Postmodern theory has resulted in a move away from the notion of the essential 'black subject' who was burdened with the knowledge and voice of the whole of the black community, which was, after all, divided by class, gender and sexuality like any other. Some hailed the deconstructionist project as specifically linked to the experience of racial 'minorities'. For example Pratibha Parmar wrote in 1988: 'This postmodernist tactic lays emphasis on difference, on otherness and plurality and rejects the hegemonic drive to universality, which in the past has effectively served to suppress minority voices and perspectives.'[28] David A. Bailey and Stuart Hall, while calling for ongoing theoretical and practical work on black representation, argued that 'Identities are (then)

28. P. Parmar, 'Transitory Moments', in *Critical Decade Black British Photography in the 1980s, TEN 8*, Photopaperback, vol. 2, no. 3, Spring 1992, p. 58.

permanently decentered, and there is no master identity as class or nationality that can gather all these strands into a single weave. In short, we are all involved in a series of political games around fractured or decentered identities'.[29] The 'big ideologies of Marxism and modernism' were rejected by blacks, gays and women who, finding a voice, 'relativised the universalist truths of the avant-garde and the vanguard party', according to Kobena Mercer.[30]

Theoreticians of 'black culture' and its audience were critical of aspects of psychoanalytic theory as utilised by white middle-class feminists, however, and the interest of black writers and critics in Postmodernist theory has tended not to emphasise psychoanalytic approaches. With good reason, Bell Hooks remarks: 'Feminist film theory rooted in an ahistorical psychoanalytic framework that privileges sexual difference actively suppresses recognition of race, re-enacting and mirroring the erasure of black womanhood that occurs in films, silencing any discussion of racial difference – of racialised sexual difference.'[31]

However certain theorists of 'black culture' see debates on Postmodernism as 'ethnocentric'.[32] It is clear from most of the comments made by theorists of 'black culture' on Marxism, however, that they are in agreement in seeing Marxism as incapable of offering any analysis of black oppression or black culture. There is some justification for this, as anyone faced with the simplistic economism of certain larger political groupings on the British Left will readily observe. The idea that by entering into joint strike action, or by going on demonstrations about pay rises, black and white workers will consciously throw off the ideological internalisation of generations of racism and 'Unite and Fight' is crassly simplistic. However this is not a Marxist analysis of racial oppression or a programmatic political answer to it. (Marxism has to address problems of the racially oppressed on issues of race, not just issues of economics.)

Yet Marxism is perceived as such economism by, for example, Paul Gilroy when he writes: 'Where lived crisis and systemic crisis come together, Marxism allocates priority to the latter while the memory of slavery insists on the priority of the former. Their convergence is also

29. *Critical Decade*, p. 21.

30. 'Back to my Routes. A postscript on the 80s', in *Critical Decade*, p. 34.

31. Bell Hooks, *Black Looks. Race and Representation*, Boston, Mass., 1992, p. 123. See also M. Diawara, 'Black Spectatorship: Problems of Identification and Resistance', *Screen*, vol. 29, no. 4, Autumn 1988, pp. 66–76, and Jane Gaines 'White privilege and working relations: Race and Gender in Feminist Film Theory', *Screen*, vol. 29, no. 4, Autumn 1988, pp. 12–27. I find it rather odd that Gaines sees Laura Mulvey's theses as emerging out of British Marxism (p. 14).

32. K. Mercer refers to 'the ethnocentric character of Fredric Jameson's totalising commentary on postmodernism' and 'ethnocentric debates on "postmodernism"' in 'Black Art; the Burden of Representation' in *Third Text*, 10, Spring 1990, pp. 68, 70.

undercut by the simple fact that in the critical tradition of blacks in the West, social self-creation through labour is not the core of emancipatory hopes.'[33] We may add that Marxism does not argue this about white people either. Once again we see Marxism designated as purely concerned with the economic, having nothing to say about cultural tradition or indeed the way we understand our experiences in the material world, past and present.

In her book *Black Feminist Thought*, P.H. Collins mentions Marxism only briefly, and then refers to 'Marxist positivism' and 'Marxist social theory, itself an analysis of social structure rooted in Western either/or dichotomous thinking', and states: 'A Marxist assessment of the culture/ nature dichotomy argues that history can be seen as one in which human beings constantly objectify the natural world in order to control and exploit it.'[34] Since women are identified with nature, it is clear for Collins that Marxism is ruled out as having anything particularly useful to offer on the subject of the position of women of colour in society, and their cultural productions.

There is obvious scornful dismissal of 'white patriarchal Marxism' in the prose poem accompanied by photographs by the British artist Sutapa Biswas, which commences:

Dear Trotsky, In the heavens the devil sat on God's right hand side, and you sat on his left – a really dialectical condition . . .[35]

This betrays scant knowledge of dialectics, but lots of antagonism to its method.

However one of the most disturbing discussions of Marxism and racial oppression that I encountered was in Edward Said's influential book, *Orientalism*. I found the passages in question quite misleading, if not dishonest, and I would like to spend a little time on them here, as Said's book has been so widely read.

Said's book discusses how the discourse of 'Orientalism' constructed an exotic but inferior object of study for 'the West'. He states that 'American Marxist theorists in particular, have avoided the effort of seriously bridging the gap between the superstructural and the base levels in textual, historical scholarship'.[36] So, I might add, does Said himself. He states that 'every writer on the Orient, from Renan to Marx . . . saw the

33. Paul Gilroy, 'It Ain't Where You're From, It's Where You're At . . . The Dialectics of Diasporic Identification', *Third Text*, 13, Winter 1990/91, p. 13.
34. P.H. Collins, *Black Feminist Thought, Knowledge, Consciousness and the Politics of Empowerment*, New York and London, 1991, pp. 69, 207, 235.
35. See S. Biswas, 'Tracing a History – What ever happened to cricket?', *TEN 8*, no. 22, p. 10.
36. E. Said, *Orientalism*, Handsworth, 1987, p. 13.

Orient as a locale requiring Western attention, reconstruction, even redemption'.[37] In another passage, Said claims 'Writers as different as Marx, Disraeli, Burton and Nerval could carry on a lengthy discussion between themselves, as it were, using all those generalities unquestioningly and yet intelligibly'.[38] Marx is thus categorised with all other white, Western, oppressive users of 'Orientalist discourse' and, therefore, Said implies, really is much the same as the rest of them. Is this true though? Let me take you through Said's argument and his proof of Marx's contamination with 'Orientalist' discourse.

At the very beginning of Said's book stand two quotations: 'They cannot represent themselves; they must be represented', Karl Marx, and 'The East is a career', Benjamin Disraeli. The placing of these quotations suggests Marx is perhaps (1) talking about 'the Orientals' or, if he is not, then (2) talking about people who are 'inferior' and therefore must be represented by someone 'superior' Said says later in the book:

> The idea encouraged is that in studying Orientals, Muslims or Arabs 'we' can get to know another people, their way of life and thought and so on. To this end it is always better to let them speak for themselves, to represent themselves (even though underlying this fiction stands Marx's phrase ... for Louis Napoleon: 'They cannot represent themselves; they must be represented').[39]

Actually Marx is not talking about Louis Napoleon at all, but about the small-holding peasants who voted for Napoleon III, living in separate units, and fragmented in identity. They did not form a class, had no community and no political organisation. Marx continues: 'They are consequently incapable of enforcing their class interests in their own name, whether through a parliament or through a convention. They cannot represent themselves, they must be represented.'[40]

By the time this argument arrives in an article on 'Black Art' by Kobena Mercer, the quote is used to designate Marx and Marxism as oppressive, disempowering and implicitly Eurocentric: 'Foucault and Deleuze proposed the "specific intellectual" as an alternative self-image ... because they recognised the political and ethical violence implicit in Marx's statement that "They cannot represent themselves: they must be represented".'[41]

In a very misleading discussion of an article by Marx on the British in

37. Ibid., p. 206.
38. Ibid., p. 102.
39. Ibid., p. 293.
40. Marx and Engels, *Selected Works*, p. 171.
41. K. Mercer, in *Third Text*, 10, Spring 1990, p. 72. The footnote here refers to Said's book, not Marx's original text on mid-nineteenth-century France.

India, Said argues that Marx's initial humanitarian response of pity and repugnance at the sufferings of the Indian masses is overtaken by standard Orientalist ideology, and 'as human material the Orient is less important [to Marx] than as an element in a Romantic redemptive project'. He adds 'Marx is no exception. The collective Orient was easier for him to use in illustration of a theory than existential human identities'. Marx's sympathies were 'censored' because he was a white Westerner and the victims were only 'Orientals'. 'What that censor did was to stop and then chase away the sympathy, and this was accompanied by a lapidary definition: Those people, it said, don't suffer – they are Orientals and hence have to be treated in other ways than the ones you've just been using.'[42]

It is hard to know whether this is an honest but wrongheaded reading of what Marx is saying or a conscious attempt to portray Marxism as racist and oppressive to the colonised world. Marx's articles from the early 1850s on India are trying to show how the British for 'the vilest of reasons' destroyed the foundations of the social order in India for their own ends. The agricultural and industrial base of Indian society based on the village system was ruined. However these villages were also, says Marx, the foundation of backward despotism and the caste system. For Marx, this is a process parallel to, for example, the destruction of village life in England by the agricultural and industrial revolutions, as the bourgeoisie destroy the old economic and social order, but at the same time create the foundations for their own potential destruction. It is quite possible to argue Marx's language was not free from ideological connotations of the barbarous but exotic nature of India, but the main thrust of Said's argument is to accuse Marx and Marxism of something far more serious, as if Marx was oppressive to 'Orientals' in a way which he was not to white victims of capitalism. This is obviously quite serious, but Said is careful only to accuse Marx of 'Orientalism'.

If Said had bothered to discuss Marx's other articles he would have seen Marx refer to India as:

> that great and interesting country, whose gentle natives are, to use the expression of Prince Saltykov, even in the most inferior classes, "plus fins et plus adroit que les Italiens", whose submission even is counterbalanced by a certain calm nobility, who, notwithstanding their natural languor, have astonished the British officers by their bravery, whose country has been the source of our languages, our religions, and who represent the type of the ancient German in the Jat and the type of the ancient Greek in the Brahmin.[43]

The British bourgeoisie will construct railways and a new industrial base in

42. See the discussion on pp. 153–6 of Said's book.
43. K. Marx, 'The Future Results of the British Rule in India', in *Surveys From Exile*, Harmondsworth, 1973, pp. 323–4.

India: When a great social revolution shall have mastered the results of the bourgeois epoch, the market of the world and the modern powers of production, and subjected them to the common control of the most advanced peoples, then only will human progress crease to resemble that hideous pagan idol, who would not drink the nectar but from the skulls of the slain.[44]

The Indian proletariat, created in its own interest by the British bourgeoisie, will join the 'most advanced peoples' in the struggle against oppression, which it could never have done in the village system of agriculture and industry.

The bourgeoisie of the exploiting nations, not some 'Oriental' despot, is linked by Marx to pagan idols, thirsty for blood and victims. Now of course we have to critically notice the use of such terms as 'natural languor' of the Indian people, but really Said's argument about Marx's analysis of Indian society and the potential for revolution in India does not hold water. Of course the thrust of Said's argument is to dismiss Marx, along with the rest of the 'Occident', so that Said can largely ignore any detailed consideration of economics and material reality in relation to the discourse of Orientalism he wishes to examine. While Said's book is useful in examining cultural texts, it is of limited assistance in tackling any of the real contradictions embodied in such texts precisely for this reason. We cannot simply read visual or literary productions of black, Arab or Asian culture, or texts about these cultures, as discourses which construct a reality which has no link with the material world. Said ends his book by appealing for the dissolution of the 'Orient' and 'the Occident' in a 'common enterprise of promoting human community'.[45] This utopian and abstract plea seems pathetic in the face of the so-called 'ethnic cleansing', racist murders and the resurgence of fascism throughout Europe. It equally deprives us of a method with which to analyse the causes of the Gulf War or the recent betrayal of the Palestinian *intifada* in the 'peace deal' arrived at so undemocratically, which Said himself has condemned.

The current situation in Britain and in Europe requires some discussion before I consider the work of two women photographers whose work, in different ways, tackles issues of identity and the relation of the 'colonial' citizen to the imperial heartland.

The open antagonisms apparent within the British Conservative government over the European market reflect a dilemma in the British ruling class. While Britain exports over 50 per cent of its goods and about £60 billion of goods and services each year to its European Community partners, its finance capital's penetration of the US domestic market is deepening. Over 40 per cent of all foreign investments in the USA are from

44. Ibid., p. 325.
45. Said, p. 328.

British companies, especially chemicals and oil. As a result, Britain possesses one-third of all direct foreign investment in the USA ($120 billion). Britain's former imperial power is weakened along with its position in the world economy. As the world market fragments into three big trading blocs around the USA, Europe and Japan, the British bourgeoisie has some difficult economic and political choices to make. For Europe to function as a successful trading bloc, a single currency, a single market and a European central bank are required. Also the different European countries need uniform pay, conditions, maternity leave provisions and so on for their workforces, not so much to benefit the workers but to ensure a level playing-field without unfair advantage for European businesses or British ones.

The post-1992 market is planned as 'an area without internal frontiers in which the free movement of goods, persons, services and capital is ensured'. However the difficulties already seen in achieving this indicate the massively contradictory impulses driving nationalism and European unification apart. A result of this has been the increased severity of immigration legislation, the curtailing of rights to political asylum, and the rise of nationalism and fascism in Europe. At the time I write this, the openly fascist British National Party entered a candidate for an East London council election on the slogan of 'Rights for Whites'. He was narrowly elected. In an incident that was far from unique, forty-year-old Joy Gardner, an 'illegal' immigrant, was physically restrained in front of her five-year-old child as at least five policemen, as well as immigration officers, burst into her flat, forced her into a body harness and taped her mouth up. Her life support-machine was switched off four days later on 1 August 1993 in a North London hospital. A second post-mortem conducted at her family's insistence showed she had been killed because the flow of oxygen to her brain had been halted.

Non-EC nationals, of which there are an officially estimated nine million, have no rights to freedom of movement. In what is now known as the 'Fortress Europe' policy, EC states have been seeking to seal off their countries from 'bogus asylum seekers' and 'economic migrants'. Statements by former and current British prime ministers are clear on this point. Mrs Thatcher's Bruges speech in 1988 stated: 'From our perspective today, surely what strikes us most is our common experience. For instance, the story of how Europeans explored, colonised and civilised much of the world, is an extraordinary tale of talent, skill and courage.' European imperialisms exploited and colonised the rest of the world, but when workers from semi-colonial countries want to come to Europe, this haven of civilisation is barred to them. As John Major said at the Luxembourg Summit on 28 June 1991, a 'strong, tight perimeter fence around Europe' was needed. 'We must not be wide open to all comers simply because Paris,

Rome and London seem more attractive than Algiers and Bombay'.[46]

Legislation has been brought in to fine air transport companies who carry passengers without valid immigration documents. Deportation of immigrants and superfluous 'guest workers' is seen as both economic necessity and a 'solution' to the demands of a growing number of European neo-fascist parties. After the reunification of Germany thousands of 'guest-workers' with no employment or citizenship rights were told to leave. By October 1990, the German government was deporting 2,000 workers a week back to Angola, Mozambique and Vietnam. According to official figures, there were 78 racist attacks per day in Germany in 1991, while during 1989/90 70,000 racist attacks were recorded in Greater London, according to official figures.

Equal opportunities and anti-discrimination policies by local government bodies in Britain have been starved of funds by central government and have been attacked by the Right. It is true to say that in a situation where racism still persists and resources are the subject of intense competition, equal opportunities policies often remain paper positions rather than actual practice. However these policies have helped to fund exhibitions subsidised by local councils and regional bodies which attempt, to a far larger degree than previously, to encourage the exhibition of works by a mainly younger generation of British artists of colour, among whom are many women. Existing legislation, while only as effective as the political will and funding behind it, has enabled curators and education officers in museums and galleries to organise a growing number of exhibitions, such as *Black People and the British Flag* (Leicester City Gallery 1993), *Disrupted Borders* (Arnolfini Gallery Bristol 1993), *Crossing Black Waters* (Leicester City Gallery 1992) and *Shifting Borders* (Laing Art Gallery Newcastle 1992).

Shifting Borders examined notions of cultural, economic and national identity in the formation of the 'new' Europe. Among the exhibits in this show were works by the British artist Roshini Kempadoo (born 1959).[47] Her exhibit entitled *European Currency Unfolds* consisted of ten colour photographic images mounted on board, four of 84 x 84 cm and six of

46. For material on the European Community and Immigration, see the educational material produced by Steve Cohen, *Imagine there's no countries: 1992 and international immigration controls against migrants, immigrants and refugees*, produced by the Greater Manchester Immigration Aid Unit, 1992. For information, quotes and statistics in this section I have used the excellent documentation in *1992 and Race Equality Fact Pack*, produced by Birmingham City Council Race Relations Unit, Congreve House, 3 Congreve Passage, Birmingham B3 3DA, UK. The pack was published in December 1991 and costs £7.

47. For an interesting article and good reproductions of Kempadoo's work, see Frits Gierstberg, 'Cultural Identity and Representation', in *Perspektief*, no. 45, Rotterdam, Dec 1992/Jan 1993, pp. 7–18 (bilingual Dutch-English).

152 x 84 cm, two large banners and two panels of texts and credits. Several of the photographic panels are illustrated here (plates 50–3). The images are based on bank notes of various European member states. The note itself is the embodiment of the value of commodities. 'Money is the absolutely alienable commodity, because it is all other commodities divested of their shape, the product of their universal alienation. It reads all prices backwards, and thus as it were mirrors itself in the bodies of all other commodities, which provide the material through which it can come into being as a commodity.'[48]

Against this embodiment of alienated labour which has created value for the capitalists, reproduced in colour, the artist has constructed montages of black-and-white photographs either from found images or images made especially by her for this project. Thus the figures of famous men and women of national importance on the banknotes, for example, Berlioz, Delacroix, Dickens or Florence Nightingale, are replaced or overlayed with individuals or groups representing immigrant or semi-colonial labour. The detailed and rich printing on the banknotes contrasts with the black-and-white photographic images, which are tonally rich in a rather different way and contrast three-dimensionally with the flatness of the decorative pattern-making of the visual grids on the banknotes. The differing national responses to immigration and 'foreign workers' is seen in the various images. Germany (plate 50) has the possibility of expelling Turkish, Kurdish and Yugoslavian 'guest workers' among others, as it now has the option of luring skilled workers from the former East Germany while still paying them lower wages than West Germans. The words of the German national anthem are thrown into ironic contrast with economic reality: 'Unity, Right and Liberty for the German Fatherland.' In the Italian lire panel (plate 51) the left-hand photograph is taken from a Benetton advert, in turn taken from a press photograph, showing desperate refugees from Albania trying to come ashore at the Southern Italian port of Bari in 1991. They were forced back by the Italian immigration authorities and police. Their suffering was commodified through the advertising campaign, in its turn devoted to increasing the sale of commodities and profit-making.

The British ten-pound note (plate 52) is superimposed with images from former British colonies, whose economies still maintain their subordinate status although they have gained political 'independence'. Many of these semi-colonial countries are reliant on single-crop agriculture for sale to imperialist markets, which means they have no control over prices for their produce or any alternative means of sustaining the needs of their own populations through diversification of agricultural and industrial

48. Marx, *Capital Vol.1*, Harmondsworth, 1976, p. 205, from the section 'Money, or the Circulation of Commodities'.

production. The French franc note (plate 53) normally shows Debussy, composer of *La Mer*, who is replaced by a female figure from French 'outre-mer' former colonies. Below are the fascists who would like to send her back to where she came from, except that she was probably born in France. Changes in nationality laws now mean that even the fact of being born in a European country does not now automatically entitle people to legally claim that nationality. The point is, this woman, or the woman she represents, is as French as Debussy, but her colour, culture and social status do not entitle her to representation on banknotes, although it is partly through her exploitation (along with that of many others) that these banknotes have the value which they do. While these images refer to national particularities of European imperialist countries, there is also a common thread of economic exploitation and racial oppression on an international scale which is emphasised in the text added by Kempadoo.

Personally I see these works emerging from a tradition of Modernist photomontage work, rather than from the theoretical premises of Postmodernism. It is clear that a coherent world view and economic analysis of European imperialism, colonialism and exploitation of migrant workers is embodied in the visual and textual construction of these photographic images, which is quite different from the notions of ever-changing subjectivity, fragmentation and (de)construction through discourse which we have been told many times are the hallmarks of the Postmodern in cultural production.

Finally I want to look at a photographic work by the late Samena Rana (1955–92).[49] Rana's recent work is visually impressive and, at first sight, seems an ideal embodiment of Postmodern theories concerning fragmentation of the self, shifting positions and identities constructed through discourses of race, gender and (dis)ability (plate 54). Even the titles of her work suggest this, as in the series *Fragments of Self* for example. However Rana herself had definite views on her work as challenging, positive and coming 'to some kind of conclusion' within ongoing processes of representation and personal development. The visual richness and complexity of her work is presented as positive and enabling, rather than passive and fragmented – the partial experiences of her visualised world are seen as sources of experience and progression by a conscious and active individual, rather than as a de-centered subject in continual fragmentation in a world over which she has no control. One of

49. For an interview and good reproductions of Rana's very impressive work, see S. Rana, 'The Fear of Water', in S. Gupta (ed.), *Disrupted Borders. An Intervention in Definitions of Boundaries*, London, 1993, pp. 166–73, and the exhibition catalogue *Crossing Black Waters*, curated by Panchayat, City Gallery Leicester, 1992, edited by A. de Souza and S. Merali, 1992, pp. 63–4. An archive of Rana's work can be consulted at Panchayat, Unit 23, 11/18 Steward Street, Old Spitalfields Market, London E1 6AL.

the main points of Rana's later works is to assert a different identity for (dis)abled people in wheelchairs. She pointed out her distress when confronted by grey, social-realist charity images of the disabled, which she read as 'passive'. Her own works move from her past memories in sepia tones, memories of her childhood in Pakistan, to images saturated in colour, orange, purple, pink, yellow and blue; silk materials and jewellery combine with fragments of photos of the artist, her wheelchair, her possessions, broken bits of mirrors and movement of water. In some of the compositions the objects are placed under water and then photographed.

In plate 54, *Sensual Reflections*, the photographic dyes are shown beginning to dissolve and change the image as a process caught momentarily by a particular recording of a visual configuration. The placing of the images in series also shows Rana's images as part of a larger process of change, awareness and consciousness. Here different representations of the photographer are submerged along with an image of her wheelchair, which is, significantly, not allowed to define her identity. Rana's work attempted to embody her attempts, largely successful, to take responsibility and control over her own life and the way she was seen by others, asserting her own ideas of the possibilities open to women of colour in wheelchairs. However for Rana this was not only a matter of representation but also a matter of demanding and insisting on improvements and changes in a material sense, to allow her (and others) better access to cultural and educational facilities. Students at the polytechnic in London, where she was studying at the time of her death, protested in support of better facilities for disabled students when they discovered the ongoing problems she faced. Simply to see Rana's photographs as visualisations of a shifting subjectivity of fragmentary discourses of the feminine, the oriental, the disabled (the cripple?), tempting as they may seem if the works are taken on a purely formal level at the outset, would, I think simply reconstruct Rana in the passive role she so earnestly tried to challenge. She tried to construct her own discourses, not be defined by those of others.

In conclusion, I would argue that, while certain aspects of Postmodern theory may be helpful, its overwhelming tendency to idealist rather than materialist practice limits its usefulness when we come to analyse and understand even the most apparently 'Postmodern' images. Some of the most striking photographic work produced in recent years has, I feel, much more to offer the student of cultural history when seen as an embodiment of conflicting and contradictory materiality, as refracted through the struggles of conscious individuals to create works *in process* of analysing contemporary history, culture, economics and their place within that configuration. Some of the best work of contemporary British women

artists of colour necessarily engages with these issues as part of the materiality of their lives and attempts to produce conscious expression of these processes in visual terms.

Conclusion

It has been my aim in this book not to say the last word on Marxism and the study of art history, or indeed on Marxism and feminism(s), an impossible task in any case, but rather to open up debate and research in areas which, I feel, have been mistakenly closed off in the past. Marxism has been dismissed as a rigid, deterministic historical method, interested only in economic questions and 'blind' to gender, race, psychoanalytic investigation and, in fact, everything except the economic and material base of social relations. I hope I have shown that this is far from accurate, and that the development of a Marxist method for the study of cultural history and women's role in that history will increase, rather than diminish, our perceptions and knowledge of this sphere.

In addition, I hope I have demonstrated that in some cases, feminist scholars have not just placed a different emphasis on certain historical events but have actually made mistakes, including factual ones, in their presentation of the meaning(s) of cultural representations of women. If this book can encourage male and female students, academics and exhibition visitors, to re-engage, from a different perspective, with issues of gender, class and race in visual culture and in the societies in which we live, then its purpose will have been served. But only partially. 'The philosophers have only *interpreted* the world, in various ways; the point, however, is to *change* it.'[1] Marx's words have lost none of their burning necessity today. While I have written this book to argue for the necessity of a Marxist method for the study of women in history and culture, it is debatable whether the term 'Marxist art history' is a valid one. Is it really possible to be a Marxist art or cultural historian while engaging in purely theoretical practice as an academic? Marxism seeks to analyse and change *both* objective *and* subjective factors, being *and* consciousness. Thus it is also my hope that readers of this book will consider the implications of a Marxist understanding of women and history not only in terms of cultural interventions, but in terms of how the economic system based on private property and profit-making, from which women's oppression is ultimately derived, can be done away with. Without this, cultural, political and economic gains for certain groups of women will prove temporary gains, not permanent inalienable rights.

1. K. Marx, 'Theses on Feuerbach', no. XI, in Marx and Engels, *Selected Works*, p. 30.

Selected Bibliography

Barrett, M., *Women's Oppression Today. Problems in Marxist Feminist Analysis*, 4th edn, London, 1985

Berkin, C.R. and Lovett, C.M. (eds), *Women, War and Revolution*, New York and London, 1980

Birmingham City Council Race Relations Unit, *1992 and Race Equality Fact Pack*, Birmingham, 1992

Bonnell, V.E., 'The Representation of Women in Early Soviet Political Art', *The Russian Review*, vol. 50, July 1992, pp.267–88

——, 'The Peasant Woman in Stalinist Political Art of the 1930s', *American Historical Review*, 98:1, Feb. 1993, pp.55–82

Bonnet, M.J., *Un Choix sans équivoques*, Paris, 1981

Bridenthal, R., Grossmann, A. and Kaplan, M. (eds), *When Biology Became Destiny. Women in Weimar and Nazi Germany*, New York, 1984

Bruhat, J., Dautry, J., Tersen, E., et al., *La Commune de 1871*, 2nd edn, Paris, 1970

Buckley, M. *Women and Ideology in the Soviet Union*, Hemel Hempstead, 1989

Cameron, V.P., *Woman as Image and Image-maker in Paris during the French Revolution*, PhD thesis, Yale 1983, University Microfilms International, Ann Arbor, 1984

Cindy Sherman, catalogue of the exhibition, Padiglione d'Arte Contemporanea di Milano, 4 Oct.–4 Nov. 1990, by M. Meneguzzo, Milan, 1990

Clark, T.J., *Image of the People: Gustave Courbet and the 1848 Revolution*, London, 1973

——, *The Painting of Modern Life. Paris in the Art of Manet and his Followers*, London, 1985

Coontz, S. and Henderson, P. (eds), *Woman's Work, Men's Property: The Origins of Gender and Class*, London, 1986

Daubié, J., *La Femme Pauvre au 19ᵉ siècle,* Introduction by M. Perrot and A. Thierce, Paris, 1992

D'Eaubonne, F., *Histoire de l'Art et Lutte des Sexes*, Paris, 1977

Duberman, M., Vicinus, M. and Chauncey, G. Jr., *Hidden from History. Reclaiming the Gay and Lesbian Past*, Harmondsworth, 1991

Edwards, S., 'The Machine's Dialogue', *The Oxford Art Journal*, vol.3,

no.1, 1990, pp.63–76

Engel, B.A., *Mothers and Daughters: Women of the Intelligentsia in Nineteenth-century Russia*, Cambridge, 1983

English, D.E., *Political Uses of Photography in the Third French Republic, 1871–1914*, Ann Arbor, Michigan, 1984

Evans, R.J., *The Feminist Movement in Germany 1894–1933*, London and Beverley Hills, 1976

Evers, U., *Deutsche Künstlerinnen des 20 Jahrhunderts. Malerei, Bildhauerei, Tapisserie*, Hamburg, 1983

Femmes et la Révolution Française, Conference Papers, 3 vols, Toulouse, 1989

Fer, B., 'What's in a Line? Gender and Modernity', *The Oxford Art Journal*, vol.13, no.1, 1990, pp.78–88

Frascina, F., Blake, N., Fer, B. and Garb, T., *Modernity and Modernism. French Painting in the Nineteenth Century*, New Haven and London, 1993

Frevert, U., *Women in German History: From Bourgeois Emancipation to Sexual Liberation*, Oxford, Hamburg and New York, 1989

Freymond, J. (ed.), *La Première Internationale*, 2 vols, Geneva, 1962

Gierstberg, F., 'Roshini Kempadoo. Cultural Identity and Representation', *Perspectief*, no.45, Dec. 1992/Jan. 1993, pp.7–18, bilingual Dutch-English

Godineau, D., *Citoyennes Tricoteuses, Les Femmes du peuple à Paris pendant la Révolution Française*, Paris, 1988

Golomstock, I., *Totalitarian Art in the Soviet Union, the Third Reich, Fascist Italy and the People's Republic of China*, London, 1990

Guérin, D., *Fascism and Big Business*, New York, 2nd edn, 1973

Gutwirth, M., *The Twilight of the Goddesses, Women and Representation in the French Revolutionary Era*, New Brunswick, New Jersey, 1992

Hadjinicolaou, N., *Art History and Class Struggle*, translated by L. Asmal, London, 1978

Harris, A.S. and Nochlin, L., *Women Artists 1550–1950*, Los Angeles County Museum of Art, 1976

Harten, E. and Harten, H.C., *Femmes, Culture et Révolution*, Paris, 1989

Heresies (special issue on women and art in Russia and the Soviet Union), vol.7, no.2, 1992

Hilton, A., 'The Revolutionary Theme in Russian Realism', in Millon, H.A. and Nochlin, L. (eds), *Art and Architecture in the Service of Politics*, London and Cambridge, Mass., 1978

Hinz, B., *Art in the Third Reich*, Oxford, 1979

Hunt, L., *Politics, Culture and Class in the French Revolution*, 1984

Kollontai, A., *Selected Writings*, ed. A. Holt, London, 1978

Kruks, S., Rapp, R. and Young, M.(eds), *Promissory Notes. Women in the*

Transition to Socialism, New York, 1989

Lapidus, G.W., *Women in Soviet Society – Equality, Development and Social Change*, Berkeley, Los Angeles and London, 1978

Levy, D.G., Applewhite H.B. and Johnson, M.D. (eds), *Women in Revolutionary Paris, 1789–1795*, Urbana and London, 1979

Lipton, E., *Alias Olympia. A Woman's Search for Manet's Notorious Model and her own Desire*, London, 1993

Marand-Fouquet, C., *La Femme au temps de la Révolution*, Paris, 1989

Marx, K. and Engels, F., *Selected Works in One Volume*, London, 1973

Mayne, J., *Cinema and Spectatorship*, London and New York, 1993

McMillan, J.F., *Housewife or Harlot: The Place of Women in French Society, 1870–1940*, Brighton, 1981

Moses, C.G., *French Feminism in the Nineteenth Century*, Albany, New York, 1984

Mulvey, L., 'A Phantasmagoria of the Female Body: the Work of Cindy Sherman', *New Left Review*, vol.188, July/August 1991, pp.136–50

Phéline, C., *L'Image Accusatrice*, Paris, 1985

Pollock, G., *Vision and Difference. Femininity, Feminism and the Histories of Art*, London and New York, 1988

Profession ohne Tradition. 125 Jahre Verein der Berliner Künstlerinnen, exhibition catalogue, Berlinische Galerie, Museum für Moderne Kunst, Berlin, 1992

Rana, S., 'The Flow of Water', in S. Gupta (ed.), *Disrupted Borders. An Intervention in Definitions of Boundaries*, London, 1993

Rifkin, A., 'Cultural Movement and the Paris Commune', *Art History*, vol.2, no.2, June 1979, pp.201–20

Roberts, J., *Re-Negotiations: Class, Modernity and Photography*, Norwich Gallery, Norfolk Institute of Art and Design, England, 1993

Rouillé, A., *L'Empire de la Photographie. Photographie et pouvoir bourgeois 1839–1870*, Paris, 1982

——, 'Les images photographiques du Monde du Travail sous le Second Empire', *Les Actes de la Recherche en Sciences Sociales*, Sept. 1984, no.54, 1993, pp.31–43

—— (ed.), *La Photographie en France. Textes et Controverses: Un Anthologie 1816–1871*, Paris, 1989

—— and Marbot, B., *Le Corps et son Image. Photographies du Dix-Neuvième Siècle*, Paris, 1986

Rupp, L.J., *Mobilizing Women for War. German and American Propaganda, 1939–1945*, Princeton, New Jersey, 1978

Saslow, J., 'Disagreeably Hidden, Construction and Constriction of the Lesbian Body in Rosa Bonheur's *Horse Fair*', in N. Broude and M. Garrard (eds), *The Expanding Discourse: Feminism and Art History*, New York, 1992

Sayers, J., Evans, M. and Redclift, N. (eds), *Engels Revisited. New Feminist Essays*, London and New York, 1987

Schulkind, E., 'Socialist Women during the 1871 Paris Commune', *Past and Present*, no.106, Feb. 1985, pp.124–63

Scott, J.W., *Gender and the Politics of History*, New York, 1988

Sklavin oder Bürgerin? Französische Revolution und Neue Weiblichkeit 1760–1830, exhibition catalogue, Historisches Museum Frankfurt, 1989

Solomon-Godeau, A., *Photography at the Dock. Essays on Photographic History, Institutions and Practices*, Minneapolis, 1991

Stites, R., *The Women's Liberation Movement in Russia. Feminism, Nihilism and Bolshevism, 1860–1930*, new edn, Princeton, 1991

Tagg, J., *The Burden of Representation. Essays on Photographies and Histories*, Basingstoke, 1988

——, *Grounds of Dispute. Art History, Cultural Politics and the Discursive Field*, Basingstoke and London, 1992

Taylor, B. and van der Will, W. (eds), *The Nazification of Art. Art, Design, Music, Architecture and Film in the Third Reich*, Winchester, 1990

TEN.8 (special issue, *Critical Decade. Black British Photography in the 80s*) photopaperback, vol.2, no.3, Spring 1992

Theweleit, K., *Male Fantasies*, vol.1, *Women, floods, bodies history*, Oxford, 1987

Thönnessen, W., *The Emancipation of Women. The Rise and Decline of the Women's Movement in German Social Democracy 1863–1933*, London, 1976

Trotsky, L., *Women and the Family*, 2nd edn, New York, 1973

Usborne, C., *The Politics of the Body in Weimar Germany*, Basingstoke, 1992

Vogel, L., *Marxism and the Oppression of Women. Toward a Unitary Theory*, 2nd edn, New Brunswick, New Jersey, 1989

Waters, E., 'Childcare posters and the Modernisation of Motherhood', *SBORNIK: Study Group on the Russian Revolution*, 1987, part 13, pp.65–93

——, 'The Female Form in Soviet Political Iconography, 1917–32', in B. Clements, B. Engel and C. Worobec (eds), *Russia's Women, Accommodation, Resistance, Transformation*, Berkeley, Los Angeles and Oxford, 1991

Wilson, S., 'The Soviet Pavilion in Paris', in M. Cullerne Bown and B. Taylor (eds), *Art of the Soviets. Painting, Sculpture and Architecture in a One-party State, 1917–1992*, Manchester and New York, 1993

Wolff, J., 'Postmodern Theory and Feminist Art Practice', in R. Boyne and A. Rattansi (eds), *Postmodernism and Society*, Basingstoke, 1991

Workers Power and the Irish Workers Group, *The Degenerated Revolution.*

Selected Bibliography

The Origins and Nature of the Stalinist States, London, 1982
Yablonskaya, M., *Women Artists of Russia's New Age 1900–1935*, London,
 1990

INDEX

Index

Index